Digital Process and Print Series | Series Editor: Harald Johnson

Includes
Tips and
Techniques
from More
Than 20
Photographers
and Other
Artists!

301

Inkjet Tips
and Techniques

An Essential Printing Resource for Photographers

Andrew Darlow

ISBN-10: 1-59863-204-3

ISBN-13: 978-1-59863-204-0

Library of Congress Catalog Card Number: 2006927153

Printed in the United States of America

08 09 10 11 12 BU 10 9 8 7 6 5 4 3 2 1

Publisher and General Manager, Thomson Course Technology PTR:
Stacy L. Hiquet

Associate Director of Marketing:
Sarah O'Donnell

Manager of Editorial Services:
Heather Talbot

Marketing Manager:
Jordan Casey

Executive Editor:
Kevin Harreld

Project Editor:
Sandy Doell

PTR Editorial Services Coordinator:
Erin Johnson

Interior Layout Tech:
Bill Hartman

Cover Designer:
Mike Tanamachi

Indexer:
Katherine Stimson

Proofreader:
Melba Hopper

THOMSON

COURSE TECHNOLOGY ™

Professional ■ Technical ■ Reference

Thomson Course Technology PTR, a division of Thomson Learning Inc.
25 Thomson Place ■ Boston, MA 02210 ■ http://www.courseptr.com

This book is dedicated to the memory of Ms. Edwina M. Kohler.

Your support as an educator, adviser, mentor, and
friend were invaluable in helping me to achieve
so many of my dreams. You are dearly missed
and are always in my thoughts.

Foreword

From the birth of photography in the 19th century with the work of Frenchmen Joseph Nicéphore Niépce and Louis Jacques Mande Daguerre, Englishman William Fox Talbot, and American John Locke, until today, at the beginning of the 21st century, the ultimate goal of photographers has always been to show their best work as prints. Early prints were generally made in black and white, then often sepia-toned to make them not only appear more stylish but also make them more *lightfast*, or able to endure the test of time.

Throughout photography's comparatively short history, many prints did not last well, especially some made in the second half of the 20th century; sometimes photographs vanished from their media or paper within days, taking with them an important window to the past. This happened when some irresponsible manufacturers attempted to enhance their profits and please stockholders by moving from black and white to color products virtually overnight.

Today, with the best of modern inkjet printers and materials, we find ourselves at a point like no other in the history of photography. We can now photograph using a digital camera or scan an existing image and then immediately make a final print, generally on our media of choice without the need of a darkroom or lengthy procedures. Best of all, that final, correctly stored, picture, made using the best of materials, will outlive us all, carrying with it its information and aesthetic statement well into the future.

For someone like me, who has spent more than 50 years of his life photographing, this is not only monumental but exceedingly exciting. I would like to think of my best work living well into the future.

Andrew Darlow's dedication, concern, and research make this new volume an essential tool to anyone interested in printing and preserving their photographs.

Douglas Kirkland—Los Angeles, California
www.douglaskirkland.com

Acknowledgments

I'd like to first thank my wife Belinda, who has been my hero throughout the production of this book, and who has shared with me many of the best moments of my life, including the birth of our son, whose "ink footprints" grace the opening pages of the first chapter. My parents have had a tremendous influence on my life, and it's difficult to express how grateful I am for the opportunities they have given me, and for the many ways that they have brought art and culture into my life. My older brother Matthew has been not just a good friend (once we reached our teens), but he has set a strong, positive example for me in so many ways.

When I was 18 years old, the Ueno family invited me into their home in western Japan as an exchange student. It was an unforgettable experience that greatly influenced me in my decision to become a writer and photographer. I will always consider them a part of my family.

I've had the honor of working personally with many who have been advisers, mentors, and editors of publications. I thank the following people for sharing their knowledge and expertise in the areas of writing, publishing, printing, and photography: Brian Berk, Diane Berkenfeld, Katie Brennan, Michael Darlow, Sarah Coleman, Ken Crest, Val DiGiacinto, Jennifer Gidman, Marty Goldstein, Dan Havlik, Tina Kennedy, Lauren Lochetto, Dan Margulis, Alice Miller, Joe Oppenheimer, Larry Padgett, Marianne Pardal, Elmo Sapwater, Kathy Schneider, Gregory Sharpless, Joan Sherwood, Michel Tcherevkoff, John Timem, Richard Veloso, Liz Vickers, Maria Wakem, and Lauren Wendle.

A special place in my heart will always be reserved for the staff and faculty at the International Center of Photography in New York, where I had the opportunity to learn from and share my passion for photography and inkjet printing with hundreds of students from around the world. Many thanks to Willis Hartshorn, Phillip Block, Suzanne Nicholas, h. eugene foster, Shauna Church, Adam Eidelberg, Donna Ruskin, and Nancy Sirkis.

I would be far less informed about many of the tips and techniques described in this book without the online discussion groups and forums that I've been reading and participating in for about the last 10 years. Thanks especially to Joe Nalven and John Shaw, who co-moderate with me the digital-fineart Yahoo!Groups list. I'd also like to thank the following authors and photographers for their work in helping to further my

knowledge of Photoshop, color management, digital asset management, photography, and fine art printing: Kevin Ames, Scott Bourne, Russell Brown, Dan Burkholder, John Paul Caponigro, Amadou Diallo, Katrin Eismann, Martin Evening, Robert Farber, Greg Gorman, Michael Grecco, Judy Herrmann, R. Mac Holbert, JD Jarvis, Stephen Johnson, Scott Kelby, Thomas Knoll, Julieanne Kost, Peter Krogh, Jay Maisel, Deke McClelland, Michael Reichmann, Seth Resnick, John Reuter, Andrew Rodney, David Saffir, Jeff Schewe, Michael Starke, Uwe Steinmueller, Derrick Story, Eddie Tapp, Vincent Versace, and the late Bruce Fraser.

Special thanks to executive editor Kevin Harreld and series editor Harald Johnson, both of whom inspired me to bring this book to life, and helped to guide me through much of the journey from initial outlines to finished layouts. And a huge thank you goes out to project editor Sandy Doell, who greatly helped to shape the book into its final form. Also thanks to Bill Hartman for an interior design that far exceeded my expectations, Mike Tanamachi for designing a book cover that I am very proud to have my name on, proofreader Melba Hopper, and indexer Katherine Stimson.

I wish I could list here the hundreds of people who represent the many hardware and software companies who have always been there to answer my questions and provide information when I was a magazine editor and throughout the production of this book. I also would like to thank the many photographers and other artists who I've interviewed over the years and who have shared with me and others their tips, techniques, and imagery.

This book would not have been possible if not for the research and dedication of many inkjet printer and media manufacturers over the past 20–30 years. Their engineers, chemists, beta testers, and users have worked extremely hard to help improve the quality of the printers, inks, papers, and other media that we see on the market today. I especially wish to recognize the people in the printer divisions at Canon, Epson, and HP, whose products I use and trust for virtually all of my own inkjet printing.

Finally, I'd like to sincerely thank all of the guest artists and other individuals who contributed to this book. It is a true honor to share these pages with them.

About the Author

Andrew Darlow is a photographer, educator, and digital imaging consultant based in the New York City area. For over 15 years, he has consulted on the topics of digital photography, digital output, and color management for individuals and corporations. His commercial and consulting clients have included Brooks Brothers, Kenneth Cole, Tiffany & Co., Tourneau watches, Cigar Aficionado, and The Body Shop.

As Editorial Director of *Digital Imaging Techniques* magazine, he wrote and edited numerous articles and reviews on the topics of digital and fine art photography, inkjet printing, and Photoshop techniques. He has lectured and conducted seminars and workshops around the world at photo-related conferences, and for photography organizations and schools, including Advertising Photographers of America (APA), The Center for Fine Art Photography, Professional Photographers of America (PPA), the Arles Photo Festival, Columbia University, and the International Center of Photography (ICP) in New York.

His photography has been exhibited in group and solo shows, and his inkjet prints are held in numerous private collections. His work has been included in many photography publications, web sites, and books, including *PDN Gear Guide, PDNonline, Studio Photography & Design, Mastering Digital Printing* (Thomson Course PTR), and *Essentials of Digital Photography* (New Riders).

Andrew is editor and founder of The Imaging Buffet Digital Magazine and Podcast (www.imagingbuffet.com), and he publishes the Inkjet & Imaging Tips Newsletter, which includes news, tips, and techniques on fine art printing and digital imaging. Andrew can be reached via e-mail at imaging@andrewdarlow.com, and for more information, visit www.inkjettips.com.

About the Series Editor

Harald Johnson has been immersed in the world of commercial and fine-art imaging and printing for more than 30 years. A former professional photographer, designer, and creative director, Harald is an imaging consultant, the creator of the web site DP&I.com (www.dpandi.com), and the author of the groundbreaking books, *Mastering Digital Printing: The Photographer's and Artist's Guide to High-Quality Digital Output* (2003), *Mastering Digital Printing, Second Edition* (2005), and *Digital Printing Start-Up Guide* (2005). Harald is also the founder of YahooGroup's digital-fineart, the world's largest online discussion group on the subject of digital fine art and digital printing.

Contents

Chapter 2
File Preparation: An Overview

Chapter 3
Choosing an Inkjet Printer

Chapter 4
Color Management ...81

Chapter 7
Portfolio and Presentation157

Chapter 8
Specific Printer Tips and More189

Guest Artist Section

Chapter 10
Art Reproduction, Canvas, and Finishing251

Chapter 11
Portfolio and Marketing Tips275

Chapter 12
RIPs, B&W, and Color Management315

Chapter 13
Exhibitions, Editioning, and Image Tracking355

Chapter 14
Packing, Lighting, and Framing................................379

Chapter 15
Unique Art Applications...407

Using inkAID to Precoat Nonporous Surfaces for Printing*409*

Chapter 16
Additional Tips and Print Permanence......................441

Introduction

I love photography. One analogy I can make to help describe how I feel about the medium is to compare my passion for photography with Private Benjamin Buford "Bubba" Blue's obsession with shrimp from the movie *Forrest Gump.* I love making photographs. I love talking with photographers about their photography. I love looking at photographs online, in magazines, on billboards, in galleries, and in museums. I love working on photographs in Photoshop and other image editing software. I love visiting photography exhibitions, hearing photographers speak about their work during live presentations, and watching documentaries about photographers and their work. And as you might have guessed, I love printing my images as photographic prints in the traditional and digital darkroom.

I also love helping others to learn how they can produce better images and use their computers and printers to express their thoughts, feelings, and vision. These are the primary reasons I've written this book, and also why I've asked a group of photographers and other artists who I greatly respect to contribute to the book.

301 Inkjet Tips and Techniques contains specific tips and techniques related to digital output, and many additional online resources are referenced throughout the book. The tools necessary to make high quality prints in one's office, studio, or home that can stand the test of time for decades (or in some cases, centuries) have become much more affordable over the last 10 years. This book contains hundreds of examples of how you can start making high quality prints, or improve your existing printing workflow.

There are many books, online resources, and printer manuals with step-by-step instructions for making prints on inkjet printers. Although this book includes a number of step-by-step techniques, the book focuses more on other topics, including: how to find the right printers, how to save time and materials when prepping files and prints, how to manage your images better, how to create captivating portfolios and framed art, and how to determine if a RIP (Raster Image Processor) is right for your work.

As a consultant and instructor, I've been able to see first-hand the expression on many people's faces as a photograph of their children, or an image from their most recent magazine assignment, or a landscape image from a trip to the other side of the planet exits an inkjet printer. Often, they are not prepared for the emotion that comes over them, and those moments, for both them, and me, are priceless.

If through this book, I can help readers create images and prints that produce similar positive emotional reactions, then the time and effort spent gathering information, testing papers and printers, finding guest artists to share a similar passion for their work, and putting it all together, will have been time and effort very well spent.

Who This Book Is For

301 Inkjet Tips and Techniques was written for advanced amateur photographers, professional photographers, illustrators, painters, designers, and other artists who print their commercial and fine art work using inkjet printers. If you are in one or more of these categories, you will find many tips, techniques, and resources aimed at helping you choose the right printers for your needs, improve the quality of your images prior to printing, find appropriate papers and other materials, and understand more about color management and print permanence.

That being said, anyone who owns an inkjet printer, from a family with an "all-in-one" or 4 × 6-inch compact printer who wants to create scrapbooks that serve as a historical archive, to the production manager of a large printing company who needs to make four-color separation proofs can benefit from many of the tips in this book.

What Equipment You Need

Though no specific image editing software is necessary to benefit from most of the tips and techniques in the book, many of the tips reference Adobe Photoshop due to its popularity among photographers of all levels, its overall capabilities in the areas of retouching, sharpening, and converting to black and white, and due to the way in which the application integrates very well into a color-managed workflow. And when the word "Photoshop" is mentioned in the text, it primarily refers to Photoshop CS2 and CS3.

For those readers who do not own Photoshop CS, CS2, or CS3, Adobe Photoshop Elements is generally recommended because it contains many of the features found in Photoshop CS2 and CS3. Apple Aperture and Adobe Photoshop Lightroom are two other popular "color management- (or ICC-) aware" applications mentioned in the book, and step-by-step printing tutorials for both will be covered in detail on the book's companion site at inkjettips.com.

To do any of your own printing, you will, of course, need a computer and printer. Though many of the tips in the book apply to any operating system and any inkjet printer, the majority of tips focus on how to get optimal results from pigment-based printers made by Canon, Epson, and HP with computers that run the Windows XP,

Windows Vista, or Mac OSX operating systems. Dye-based inkjet printers are also covered, especially when they have received very favorable permanence ratings on specific papers or other media.

Monitor calibration hardware and software, as well as proper lighting, are important aspects of any repeatable, color-managed workflow, so I recommend first reading the tips that cover those topics in Chapters 4 and 14 if you do not currently use a monitor calibration device and a controlled lighting system.

How This Book Is Organized

The first eight chapters of this book include my photographs, tips, and techniques, and the balance of the book (Chapters 9–16) contains images, tips, and techniques individually written by more than 20 guest artists. The book can, of course, be read sequentially from Chapter 1 to 16, and the content from Chapters 1–8 is arranged in a way that generally follows a progression that one might take. For example, Chapter 1 is named "Getting Started," Chapter 2 is "File Preparation," Chapter 3 is "Choosing an Inkjet Printer," and Chapter 7 is "Portfolio and Presentation." However, the book was written to allow for exploration without having to follow along in any specific order.

Guest artist chapters are similar in layout to the first eight chapters, and they are organized into specific categories by chapter. For example, Chapters 9 and 10 cover inkjet paper, canvas, and coatings; Chapter 13 covers image tracking, editioning, and exhibitions; and Chapter 15 covers innovative art applications using inkjet printers. The table of contents and index should help you to more quickly find the information you are looking for, or you can enter specific words into the search box on the book's companion site at www.inkjettips.com to find which tips in the book match your search terms.

About the Book's Images

Most of the left-hand pages in *301 Inkjet Tips and Techniques* contain a full-page image on a white background. These pages, as well as the double-page images in each chapter's opening spread, display the photography and other imagery of guest artists, as well as my photography. In almost every case, left-page images have a caption at the bottom of the facing page that contains a significant amount of detail about the image, including: print size, the camera or process used to capture the image, the printer used, RIP or driver info, inkset, and lens and exposure data.

Decide Whether Inkjet Is Right for You

You might think that a book dedicated to tips for inkjet printing would skip all other printing technologies, but this book takes you a step further and helps you consider which technology is best for you. In fact, after reading this section, you might decide that inkjet printing is not right for your needs, or you might opt for an outside printing company to print your work for you. The aim here is to give you enough information to help you make the right decision for your imagery, style, and business requirements. Chapter 3, "Choosing an Inkjet Printer," will revisit some of the topics covered here, with specific suggestions for helping to choose the right inkjet printer for you based on several factors.

To find the web links noted in the book (L1.1, etc.), visit www.inkjettips.com or http://www.courseptr.com/ptr_downloads.cfm.

TIP 1 Determine your budget for a printer or multiple printers.
Every printer has a price tag. Find one that meets your budget, and don't forget shipping costs and any potential extras, such as a printer cable, an optional Ethernet adapter for network printing, RIP software, extended maintenance contract, electricity costs, and so on. If the work you do is time-sensitive, you should consider having a backup printer, which of course adds to the overall cost.

TIP 2 Figure in the added cost of ink and paper.
I've tested and used over a hundred different papers, canvases, and other materials over the last 10+ years, and I've spent thousands of dollars on sampler packs and boxes of paper. If you want to test and keep in stock a large variety of papers, consider the costs involved. Also, if you are unable to wait for ink to be shipped, or if you can't purchase it at a nearby store when you run out, then you will need to always keep extra ink on hand.

Photographer: Andrew Darlow; Image title: *Dancing Pepper*; Print Size: 17×22 inches; Paper: PremierArt Platinum Rag 335gsm; Printer Name: Epson Stylus Pro 4800; Ink Used: Epson UltraChrome K3; Driver: Standard Epson Driver (Mac OSX); Camera: 4×5 Sinar P2 w/ a Leaf DCB I Back; Lens: Sinaron Digital 60mm; F-stop: f/5.6; Exposure: 1/2 sec.

3

It's important to note that although many of the print sizes, printers, and papers listed in the captions represent actual prints from limited or open editions by guest artists in Chapters 9–16, in some cases the papers and printers noted by guest artists are suggested combinations based on their personal experiences. Similarly, most of the captions that accompany my images in Chapters 1–8 represent combinations of printers and papers that I've successfully tested or have seen in person but have not necessarily chosen to make available for sale as limited or open edition prints. This approach enabled me to include a wide variety of papers, canvases, and printers that I believe will be very helpful to others who are searching for combinations of high quality inkjet printers and media. To see the actual printers, papers, and print sizes I have chosen for many of my print editions, visit www.andrewdarlow.com.

Companion Web Site

The companion web site for this book can be found at www.inkjettips.com. I've created it for a number of reasons. First, it contains hundreds of links to product information, articles, and other resources that are mentioned or specifically referenced in the book. For example, you will often see links inserted in a blog-like style throughout each chapter. To go to any link (for example [L4.3], visit www.inkjettips.com and select the chapter number from the "Book Links" area (Chapter 4 is circled in red, below). You will then see a chart with all the links for Chapter 4, as well as related links to more information and resources.

You'll also find new content on the companion site, including video tutorials. Due to the number of brands of inkjet printers and the complexity of many printer drivers and RIPs, the companion site will allow me to cover this information in greater detail. The site will also have a resources section with information on books, color management tools, and much more. Information on consulting, workshops, and exhibitions, as well as my free Inkjet and Imaging Tips Newsletter can also be found on the companion site.

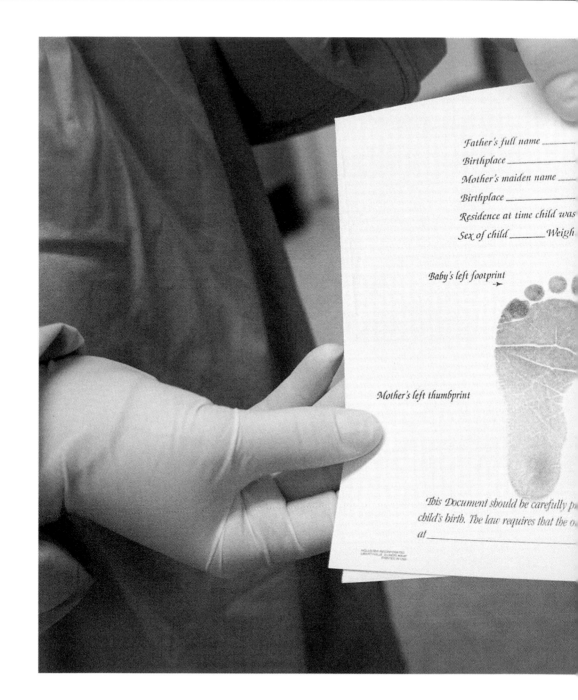

Photographer: Andrew Darlow; **Image Title**: *Ty 001*; **Print Size**: 24×18 inches; **Paper**: HP Premium Plus Photo Satin;
Printer Name: HP Designjet 90; **Ink Used**: HP Vivera; **Driver**: Standard HP Driver (Mac OSX); **Camera**: Canon EOS-D60;
Lens: Canon EF 28-135mm IS; **F-stop**: f/4; **Exposure**: 1/125 sec.

HISTORY

_____ Date _____

_____ Date _____

_pounds_____ounces. Length _____inches.

Baby's right footprint

Mother's right thumbprint

_family's heirloom record of the facts pertaining to your
_'not this document) be filed with the Vital Statistics Office.
_____from which an official copy may be obtained.

Getting Started

Decide Whether Inkjet Is Right for You

You might think that a book dedicated to tips for inkjet printing would skip all other printing technologies, but this book takes you a step further and helps you consider which technology is best for you. In fact, after reading this section, you might decide that inkjet printing is not right for your needs, or you might opt for an outside printing company to print your work for you. The aim here is to give you enough information to help you make the right decision for your imagery, style, and business requirements. Chapter 3, "Choosing an Inkjet Printer," will revisit some of the topics covered here, with specific suggestions for helping to choose the right inkjet printer for you based on several factors.

To find the web links noted in the book (L1.1, etc.), visit www.inkjettips.com or http://www.courseptr.com/ptr_downloads.cfm.

TIP 1 Determine your budget for a printer or multiple printers.

Every printer has a price tag. Find one that meets your budget, and don't forget shipping costs and any potential extras, such as a printer cable, an optional Ethernet adapter for network printing, RIP software, extended maintenance contract, electricity costs, and so on. If the work you do is time-sensitive, you should consider having a backup printer, which of course adds to the overall cost.

TIP 2 Figure in the added cost of ink and paper.

I've tested and used over a hundred different papers, canvases, and other materials over the last 10+ years, and I've spent thousands of dollars on sampler packs and boxes of paper. If you want to test and keep in stock a large variety of papers, consider the costs involved. Also, if you are unable to wait for ink to be shipped, or if you can't purchase it at a nearby store when you run out, then you will need to always keep extra ink on hand.

Photographer: Andrew Darlow; **Image title**: *Dancing Pepper*; **Print Size**: 17×22 inches; **Paper**: PremierArt Platinum Rag 335gsm; **Printer Name**: Epson Stylus Pro 4800; **Ink Used**: Epson UltraChrome K3; **Driver**: Standard Epson Driver (Mac OSX); **Camera**: 4×5 Sinar P2 w/ a Leaf DCB I Back; **Lens**: Sinaron Digital 60mm; **F-stop**: f/5.6; **Exposure**: 1/2 sec.

TIP 3 Think about the number of prints you plan to make in an average month.

If you only plan to make a print or two every month (especially if they are under 20 × 30 inches), then it might not make sense to invest in an inkjet printer. You'll probably spend much less over time having prints made by an outside company.

TIP 4 Decide how much control you want to have over your prints.

Having your own inkjet printer offers a level of control that is difficult to match with an outside provider, as long as you keep your system calibrated and profiled (discussed in Chapter 4, "Color Management and Driver Tips"). Having your own printer is especially helpful when making test prints. If you use an outside printing company, in some cases, proofs will need to be sent back and forth between you and the company until the prints are "just right," which can be frustrating.

TIP 5 Determine your quality requirements.

Many of today's inkjet printers (even very inexpensive models) can produce excellent quality images. However, some inkjet printers will print slowly in high quality mode, or they will only produce photo-quality prints on relatively expensive coated papers. Depending on these factors, you might choose color laser, continuous-tone digital photo output, or dye-sublimation printing for a certain percentage of your printing.

TIP 6 Consider buying a color laser printer.

If your quality requirements are not extremely high, and if you don't require output over 8.5 × 14 inches (tabloid-sized color laser printers are considerably more expensive), you may want to choose a color laser printer for the majority of your in-house printing. Color laser printers are generally faster than inkjet, with a very good color range, and with print quality that comes close to that of inkjet when used with good quality bond papers (copy papers). Heavier, more expensive, gloss and matte papers made for color laser printing can yield even better images with excellent color, contrast, and sharpness.

Color toner and other color laser consumables are also generally less expensive per sheet when compared to inkjet, but a full replacement set of toners can be very expensive. Color laser is also an excellent choice for custom-made cards because of the quality and speed at which cards can be printed. The image on page 4 was printed on a Dell 3100cn Color Laser Printer (L1.1) using Avery Matte Ivory Note

Photographer: Andrew Darlow; **Image title**: *Endurance*; **Print Size**: 5.5x8.5 inches; **Paper**: Avery Matte Ivory Note Cards (Embossed)**; Printer Name:** Dell 3100cn Color Laser; **Ink Used:** Dell Color Toner; **Driver**: Standard Dell Driver (Mac OSX); **Camera**: 4x5 Sinar P2 w/ a Leaf DCB I Back; **Lens**: Sinaron Digital 60mm; **F-stop & Exposure**: Unrecorded

Cards Embossed (L1.2). Two cards come pre-scored on a letter-sized sheet, and after folding, each card measures 4.25 × 5.5 inches. Another group of color laser printers that I've used successfully with many types of paper (including matte, gloss and note-card stock) are the Konica Minolta magicolor series (L1.3).

Two custom cards printed on a Dell 3100cn Color Laser Printer, shown standing up and flat. The credit line (seen on the right side of the flat card) was printed at the same time as the sneakers by inverting the text in a Photoshop document.

TIP 7 Consider using a continuous-tone digital photo service.

Instead of making your own inkjet prints in-house, you might want to choose to have all or just certain sizes of prints (for example, all prints over 13 inches wide) printed using one of the most popular printing technologies used today—direct color digital photo printing. Most traditional photo labs and many retail/drug stores use machines made by companies such as Fujifilm, Kodak, Noritsu, and others to produce semi-gloss and glossy color prints with the same characteristics as hand-printed color darkroom prints.

Specific photo papers used for this process have been tested to achieve good to excellent longevity before noticeable fading under normal gallery conditions. For example, Fuji's Crystal Archive paper has been rated from 40 to 60+ years based on

Photographer: Andrew Darlow; **Image title**: *Red Rose*; **Print Size**: 16x20 inches; **Paper**: Fuji Crystal Archive Matte; **Printer Name**: Durst Lambda; **Camera**: Nikon N90; **Film**: Color Negative; **Lens**: Sigma 28-105mm w/screw-on filter-sized diopter lens; **F-stop & Exposure**: Unrecorded

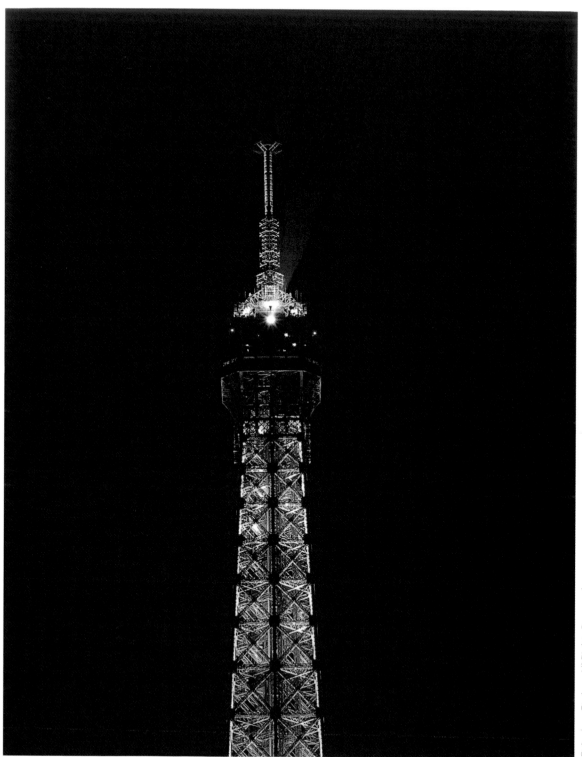

independent testing by Wilhelm Imaging Research (L1.4). Costs for these prints are generally competitive with in-house inkjet print costs (without the need to purchase equipment), and there are many online services that offer digital photo output.

TIP 8 Consider buying a dye-sublimation printer or using an outside print provider.

Dye-sublimation printers come in many sizes and can produce sharp images with excellent color, contrast, and detail. Some models can be powered via battery and are very convenient for printing images outside the home or studio. Estimated print longevity varies considerably between models, and Wilhelm Imaging Research (L1.4) lists some data on a variety of dye-sublimation printers.

TIP 9 Consider the amount of computer knowledge necessary to start printing your work.

It doesn't take a lot of computer knowledge to find the print button, but to make quality prints consistently without wasting a lot of time and materials takes a moderate to significant time investment. Once you have a system "dialed in," and once you understand the steps from capture to print, the time it will take to consistently make good prints can be reduced considerably.

TIP 10 Think about the space necessary for a printer.

Some printers take up very little space, and others can have a big footprint in a room. Since many people will be placing inkjet printers in a home environment, it's important to consider not only the size, but how paper is loaded and how easy it is to get to areas such as the paper roll. Some heavier papers need to be loaded from the back of the printer which means that the printer can't be placed against a wall unless you want to move it every time you print on heavier stock.

TIP 11 Consider how far the printer will be from the computer.

If a printer shares a desk with a computer, just about any cable will work fine, but as distance grows, problems can arise. Ethernet can generally distribute a more reliable signal over long distances (over 100 feet) compared with FireWire or USB. However, I have used an inexpensive USB extension cable (it added 15 feet to a 12-foot cable without any problems), and repeaters can be purchased to extend USB or FireWire for a total distance of over 80 feet (L1.5).

Photographer: Andrew Darlow; **Image title**: *E.T. 001*; **Print Size**: 40×60 inches; **Paper**: HP Artist Matte Canvas; **Printer Name**: HP Designjet Z3100; **Ink Used**: HP Vivera; **Driver**: Standard HP Driver (Windows XP); **Camera**: Sony CyberShot DSC-F828; **Lens**: Built-in Carl Zeiss 28-200mm; **F-stop**: f/8; **Exposure**: 2 sec.

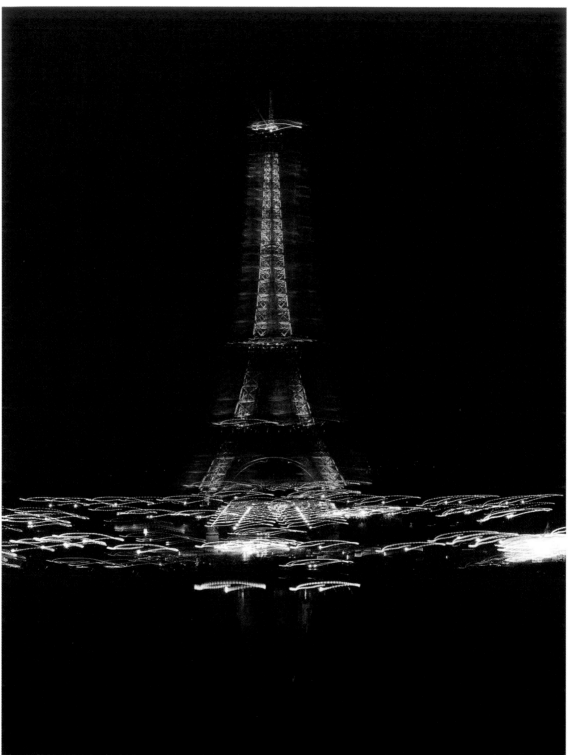

TIP 12 Take into account your time.

Are you able to invest the time and care it takes to prepare files for printing, hand-feed paper when necessary, load rolls of canvas or paper (if you choose to use rolls), wait for prints to finish printing, and then trim them properly when necessary? In many cases, you can actually save time by printing yourself, but it's a good idea to think about this important detail before making a purchase.

The most common cable types for inkjet and laser printers are shown here. (Left to right) Ethernet Cat. 5e connector, USB connector for the computer (the other end, for the printer, is square), a USB extension cable connector, and an IEEE 1394 connector (a.k.a. FireWire).

Photographer: Andrew Darlow; **Image title**: *E.T. 002*; **Print Size**: 17×22 inches; **Paper**: Canon Heavyweight Satin Photo Paper; **Printer**: Canon imagePROGRAF iPF5000; **Ink Used:** Canon LUCIA; **Driver**: Standard Epson driver (Mac OSX); **Camera**: Sony CyberShot DSC-F828; **Lens**: Built-in Carl Zeiss 28-200mm; **F-stop**: f/8; **Exposure**: 2 sec.

Using Outside Printing Companies

There are many companies that can make prints for you from your digital files, negatives, or prints. Many of these companies are run by photographers and other artists who print their own work using the same equipment that they use for their clients' prints. Our guest artist section (Chapters 9–16) features a number of artists who produce prints for clients. Their bios will often state whether they do printing for others. A company specializing in fine art output is often called an *atelier*, which is a French term that means art studio.

TIP 13 Ask for a sample print.

Many companies are happy to send you a sample print at no charge, or they will sometimes charge a nominal fee to send a sample. Some will even print your full image (or a portion of an image) on a few different papers at a discounted rate if you are interested in possibly using their services.

TIP 14 Visit in person if possible.

The best way to get a feel for a printing company is to see their facilities in person. The most valuable part of this type of visit is to see sample prints that they've done for other artists. Working on-site also allows you to proof images under the lighting that your printmaker is using, which will generally be very consistent (such as a 5000-degree Kelvin light box). Some printmakers have more than one lighting setup, which is even better because it allows you to see how your work will look in different situations. For example, at Fine Print Imaging in Fort Collins, CO (L1.6), you can review your prints under typical gallery lighting (using 3500–4000-degree Kelvin halogen spotlights), or in lighting that simulates the walls of a typical home with daylight streaming in through windows (about 5000 degrees Kelvin), or even under typical office lighting (overhead warm white fluorescent lights).

Photographer: Andrew Darlow; **Image title**: *E.T. 003*; **Print Size**: 46x60 inches; **Paper**: HP Matte Canvas; **Printer Name:** HP Designjet 5000; **Ink Used:** HP UV (Pigment); **RIP:** Onyx RIP (Windows XP); **Camera:** Sony CyberShot DSC-F828; **Lens:** Built-in Carl Zeiss 28-200mm; **F-stop:** f/4.5; **Exposure:** 1 sec.

13

This area of Fine Print Imaging in Fort Collins, CO is often used by customers to see their work in different lighting situations. (left) A canvas print is viewed under traditional gallery spotlights. The same print can also be viewed under fluorescent lighting, seen in the ceiling. (right) In the same room, light from the outside can be used to simulate a home or business setting, or a combination of halogen spotlights and natural daylight, as shown here, can be tested.

TIP 15 Match your lighting.

If you can't work on-site with your fine art printmaker, it is important that you view your prints in a similar quality of light. For example, you can view your images in a darkened room in your home or studio, with the same quantity and type of bulbs focused on your prints, and from the same distance and angle as your printmaker does in his studio. This may require you to invest in a color-corrected light box, or you and your printmaker can both use a high quality set of halogen lamps. One well-regarded manufacturer is SoLux (L1.7). Their bulbs come in a range of color temperatures and beam spreads, from narrow spot to flood, and they also make fixtures and lamps that are well-suited to their bulbs. See Chapter 14, "Packing, Lighting, and Framing," for more on this topic.

TIP 16 Buy a smaller version of a similar printer.

To reduce the cost and time spent proofing projects, consider buying a printer that is similar to the one your printmaker is using. An example would be for you to purchase an Epson Stylus Photo R2400 (13 inches wide) if your printmaker has an Epson Stylus Pro 9800 (44 inches wide) because both use the exact same inks (L1.8). Another example of two printer models that use the same exact inks are the Canon imagePROGRAF iPF5000 (17 inches wide) and the Canon imagePROGRAF iPF9000

Photographer: Andrew Darlow; **Image title**: *E.T. 004*; **Print Size**: 24×30 inches; **Paper**: Epson Premium Semimatte Photo Paper; **Printer Name**: Epson Stylus Pro 7600; **Ink Used**: Epson UltraChrome K2; **Driver**: Standard Epson Driver (OSX); **Camera**: Sony CyberShot DSC-F828; **Lens**: Built-in Carl Zeiss 28-200mm; **F-stop**: f/2.5; **Exposure**: 1/5 sec.

15

(60 inches wide, L1.9). And another example of two printers with the same inkset are the HP Photosmart Pro B9180 (13 inches wide) and the HP Designjet Z2100 (24 or 44 inches wide, L1.10).

It's also important that each set of printers be calibrated and profiled. Even though the paper and ink used are the same with each set of printers, some differences in color and density are to be expected. However, there are some techniques that can help you make your prints more closely match those of your printmaker. See Chapter 4, "Color Management & Driver Tips," for techniques related to this topic.

TIP 17 Ask your printmaker to keep a sample of each approved image.

If you plan to print a specific image again as part of an edition, ask your printmaker to keep a sample print of the final approved image and/or keep one on file yourself. If you'd like to have very tight control over your images (in other words, if you would like to only have a specific number of final prints in circulation), you can write with an ink-based pen or marker, in one or more areas of the sample, print the words "Test Print—not for sale." Even a year or more after the first prints are made, the sample can be taken out of storage and used as a reference without having to send your printmaker a print. See Chapter 13, "Exhibitions, Editioning, and Image Tracking," for more about creating editions of prints.

A sample showing how a print can be marked up so that it can be kept as a proof, without affecting the size of the final print edition. However, you may want to (or in some cases, you may be required by law) to disclose the number of test prints that exist on a "written instrument," such as a Certificate of Authenticity.

Photographer: Andrew Darlow; **Image title:** *Paris 004*; **Print Size:** 17×22 inches; **Paper:** Hawk Mountain Peregrine Velvet 250; **Printer:** Canon imagePROGRAF iPF5000; **Ink Used:** Canon LUCIA; **Driver:** Canon Print Plug-In for Photoshop (Mac OSX); **Camera:** Sony CyberShot DSC-F828; **Lens:** Built-in Carl Zeiss 28-200mm; **F-stop:** f/4.5; **Exposure:** 1/10 sec.

Photographer: Andrew Darlow; **Image title:** *Barcelona 003;* **Print Size**: 60×40 inches; **Media**: HP Artist Matte Canvas; **Printer Name**: HP Designjet Z3100; **Ink Used**: HP Vivera; **Driver**: Standard HP Driver (Windows XP); **Camera**: Sony CyberShot DSC-F828; **Lens**: Built-in Carl Zeiss 28-200mm; **F-stop**: f/5; **Exposure**: 1/5 sec.

Chapter 2

File Preparation: An Overview

Transforming Your Images from Pixels to Prints

To achieve great prints from your files, you can wait for the planets to align, and say a few of your favorite magic words. Or, you can prepare your files in a logical way using a structured workflow. Whether you are printing scanned negatives, transparencies, drawings, digitally captured paintings, scanned 3D objects, or digital photographs, these tips should help make the process faster and easier. Though not exactly a step-by-step tutorial, the tips in this chapter are presented in the order I usually approach my printing projects. Throughout the book, more tips for preparing files will be covered—the more you know about optimizing your images, the better your prints will be.

To find the web links noted in the book (L2.1, etc.), visit www.inkjettips.com or http://www.courseptr.com/ptr_downloads.cfm.

TIP 18 Find appropriate imaging books and look for good magazine and web resources.

Regardless of how your work originates (from a film scan, digital photograph, or direct scan with a digital camera), you can benefit from reading books, magazines and online resources that cover various imaging topics. A list of recommended books, magazines and web sites are available at inkjettips.com, with many specific suggestions for photographers and other artists (L2.1).

TIP 19 Learn the difference between DPI and PPI.

Designers, photographers and others who work with digital files often misunderstand the difference between the terms DPI and PPI. DPI, or dots per inch, is used to define a printer's resolution (for example, many inkjet printers can print a certain number of dots per inch, and this can be specified in the printer software as a number, such as 360 DPI, 720 DPI, 1440 DPI, etc). PPI, or pixels per inch, represents a digital image's resolution on a monitor or in a digital file (the number of pixels across a distance of one inch, such as 200 PPI, 300 PPI, etc.).

Photographer: Andrew Darlow; Image title: *NYC 002*; Print Size: 17×22 inches; Paper: Hahnemühle Fine Art Pearl; Printer Name: Canon imagePROGRAF iPF5000; Ink Used: Canon LUCIA; Driver: Canon Print Plug-in for Photoshop (Mac OSX); Camera: Canon EOS-D60; Lens: Canon EF16-35mm f/2.8L; F-stop: f/19; Exposure: 1 sec.

TIP 20 Learn about resolution and file dimensions.

Far too often, resolution is perceived as being complicated, but it doesn't have to be. One of the best ways to help grasp resolution is through a simple illustration. A common file might be 8 by 10 inches at 300 PPI. This translates to 2400 pixels (8 × 300 pixels) by 3000 pixels (10 × 300 pixels), or 7,200,000 pixels total (very similar to the files that a 7-megapixel camera produces). Unless we know that the file is 8 by 10 inches, we would not know how many pixels per inch it is. The same 2400 × 3000 pixel file could also be represented as 4 × 5 inches at 600 PPI, or 2 × 2.5 inches at 1200 PPI.

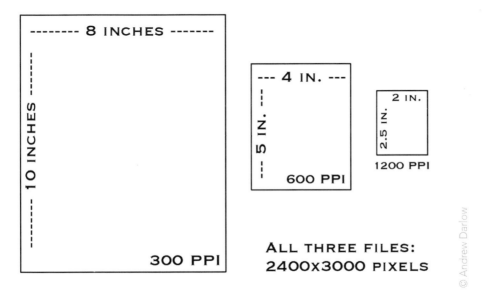

These three illustrations show how three different files, each with the same exact number of pixels (2400×3000) can have very different dimensions because of their different resolutions (PPI).

TIP 21 Choose an appropriate resolution for your prints.

For optimum quality, there are some rules of thumb with regard to what PPI you need at final print size for high quality prints from bitmapped images such as scans and digital photos. Setting your image to exactly 180 PPI, 240 PPI, or 360 PPI at its final output size can result in better print quality because of the way in which those PPI numbers are handled by some print drivers and RIPs when files are printed at 100%. RIPs (Raster Image Processors) are described in greater detail in Chapter 5, "Black and White and RIPs."

Photographer: Andrew Darlow; **Image title**: *L.A. 002*; **Print Size**: 13×19 inches; **Paper**: Ilford Galerie Classic Smooth Pearl; **Printer Name**: Epson Stylus Photo R2400; **Ink Used**: Epson UltraChrome K3; **Driver**: Standard Epson Driver (OSX); **Camera**: Canon EOS-D60; **Lens**: Canon EF16-35mm f/2.8L; **F-stop**: f/5.6; **Exposure**: 3 sec.

23

In most cases, you will see no difference in print quality if your resolution is somewhere between the suggested numbers (for example, 268 PPI). This is important because it is much more convenient to have just one version of a file to make various sized prints. If every file had to be resized to exactly 180 PPI, 240 PPI, or 360 PPI at its final print size, it would create the need for additional files. For smaller prints (under 8 × 10 inches) use higher resolutions (about 300 PPI) at the final print size. When making large prints (over 30 × 40 inches) you can usually get very high quality results with lower resolutions (even as low as 100–150 PPI at the final print size). I recommend doing your own tests to determine if you can see differences in print quality at various resolutions.

TIP 22 See how file sizes change as PPI increases in The Resolution Chart.

Another visual representation of resolution can be seen in the following chart. The chart shows approximate file sizes for RGB uncompressed TIFF files based on their dimensions (along the left side) and their resolution in pixels per inch (across the top). Uncompressed files, as opposed to compressed files, such as JPEG, do not degrade in quality when saved because no image data is discarded to compress the file. A very large file (for example, 16 × 20 inches at 300 PPI) when opened in a program like Photoshop might actually be very small (when measured in megabytes) if it was saved as a JPEG (especially if saved as a low- or medium-quality JPEG).

FILE DIMENSIONS	100PPI	150PPI	200PPI	230PPI	269PP1	320PPI	400PPI	650PPI	RES 30 762PPI	RES 40 1016PPI
35mm (24mmx35mm)	40k	89k	157k	208k	284k	402k	628k	1.815	2.49	4.4325
6cm x 4.5cm	123k	276k	490k	648k	870k	1.23	1.92	5.0625	6.9525	12.375
6cm x 6cm (2.25" sq.)	164k	368k	653k	847.5k	1.1625	1.635	2.5575	6.7425	9.3	16.5
6cm x 7cm	191k	429k	762k	982.5k	1.3575	1.905	2.9775	7.875	10.8	19.2
6cm x 9cm	245k	551k	960k	1.2675	1.7475	2.4525	3.8325	10.125	13.875	24.75
4" x 5"	586k	1.29	2.2875	3.03	4.17	5.8575	9.15	24.15	33.225	59.1
5" x 7"	1.005	2.25	4.005	5.295	7.2975	10.275	16.05	42.3	58.125	103.35
8" x 10"	2.2875	5.1525	9.15	12.075	16.725	23.475	36.6	96.675	132.9	236.25
8.5" x 11"	2.6775	6.0225	10.725	14.175	19.5	27.375	42.825	113.025	155.325	276.15
11" x 14"	4.41	9.9	**17.625**	**23.325**	**32.1**	**45.15**	**70.5**	186.15	255.825	454.8
11" x 17"	5.3475	12.075	21.375	28.275	39	54.825	85.575	226.05	310.65	552.3
14" x 18"	7.2075	16.2	28.875	38.175	52.575	73.8	115.35	304.65	418.65	744.225
16" x 20"	9.15	20.625	36.6	48.45	66.75	93.75	146.475	386.85	531.6	945.075
20" x 24"	13.725	30.9	54.9	72.675	100.125	140.625	219.75	580.2	797.4	#######
24" x 30"	20.625	46.35	82.425	108.975	150.15	210.975	329.625	870.3	1196.1	NA
30" x 40"	34.35	77.25	137.325	181.65	250.275	351.6	549.3	#######	NA	NA
36" x 48"	49.425	111.225	197.775	261.525	360.375	506.25	NA	NA	NA	NA
40" x 60"	68.7	154.5	274.65	363.225	500.55	703.125	NA	NA	NA	NA
48" x 96"	131.85	296.625	527.325	697.425	961.125	NA	NA	NA	NA	NA

© Andrew Darlow

This resolution chart helps to determine appropriate file sizes for digital printing.

To use the chart, just choose a print size, then select a resolution to determine the file size. For example, choose 11 × 14 inches and 200 pixels per inch. In the box where they meet (17.63 MB) is the file size. The chart is especially helpful for determining how large a file should be scanned or prepped to make a specific size print. As you can see in the highlighted area of the chart, when you double the PPI and keep the same dimensions (for example, 11 × 14 at 400 PPI), the file size quadruples (70.5 MB).

TIP 23 Use Photoshop as a Resolution Calculator.

Much like The Resolution Chart (but much more precise and flexible), Adobe Photoshop's File>New dialog box and Image>Image Size dialog box are excellent tools for examining different print sizes and for determining what sizes the files will become when resolution or image dimensions change. Also note that the Color Mode (for example, RGB or Grayscale) and 8-bit versus 16-bit, seen below the width, height, and resolution boxes, will affect the file size. An RGB file will be three times the size of a grayscale image with the same width, height, and resolution and a 16-bit file will be twice the size of an 8-bit file.

(Left) The File>New dialog box in Photoshop being used as a resolution calculator. Notice how the Image Size on the right changes depending upon what numbers are inserted into the width, height, and resolution boxes. (Right) The Image>Image Size dialog box can also serve as a resolution calculator.

TIP 24 Set your file size to its print size.

In most cases, I recommend sizing your images to 100% of their print size to minimize the chance of making an error when printing an initial print, or when reprinting an image for an edition. However, if you are making extremely large prints, or importing your image files into a RIP or page layout program, there may be a good reason to keep the files at a smaller size, such as 50% of the print size. Images can then be output at 200% or any other zoom level.

TIP 25 Calibrate and profile your monitor and printer, and print a standard calibration image.

These tips are covered in greater detail in Chapter 4, "Color Management and Driver Tips," but it is important to note them here because it is at this stage that you want to make sure your monitor and printer are in a calibrated and profiled state to begin the testing process. A standard calibration image, such as the very popular PhotoDisc target, or the custom-made smaller target I created are available for download (L2.2) to help you judge the quality of your screen and test prints.

TIP 26 Print a test at multiple resolutions and with different settings.

Because every printer model is different, you can find just the right settings by running a few tests. First, output a test print of a small image, or a small section of an image, at different printer resolutions, such as 720 DPI, 1440 DPI, etc. Then print the same cropped section from an image at different resolutions, such as 180 PPI, 240 PPI, etc. It's best to start at higher resolutions and then size down your file in increments to test it at lower resolutions. You don't want to size up or "interpolate" your file when doing this test because that will degrade image quality.

You can also print with certain features checked, then unchecked, such as "High Speed," which on Epson printers causes the printer to print in bi-directional mode (the print head puts down ink in both directions), as opposed to uni-directional.

The Epson Stylus Photo R2400 driver shown with two possible configurations (circled in red).

Photographer: Andrew Darlow; **Image title**: *L.V. 003*; **Print Size**: 13×19 inches; **Paper**: Oriental Graphica RC Professional Luster; **Printer Name**: Epson Stylus Photo R2400; **Ink Used**: Epson UltraChrome K3; **Driver**: Standard Epson Driver (OSX); **Camera**: Canon EOS-D60; **Lens**: Canon EF16-35mm f/2.8L; **F-stop**: f/5.6; **Exposure**: 3 sec.

If a lower resolution printer setting and low- to medium- resolution file yields a print that matches your quality needs, then you will be able to print your work much faster, using considerably smaller files.

TIP 27 Take notes and change file names when necessary.

Regardless of the testing that you do, be sure to label your prints with details such as: Date of Test, File Name, Printer Name, Paper Name, Printer Profile used, Printer Resolution, File PPI, and any check boxes you may have chosen (such as "finest detail"). It will serve you well as you start printing a series of tests. I've prepared a worksheet and made it available for download to make the process easier (L2.3). Just print it on standard bond paper and use a glue stick or tape to adhere a section to the front or back of your test prints. Or you can print the document on crack and peel adhesive label sheets (L2.4), and then cut them out and affix them to your prints. If you plan to do multiple tests on the same paper, writing just a reference number, then filling out the form can avoid potential problems with the label coming off inside the printer.

You can also take screen shots of the print dialog boxes that you have set up, or you can keep track of your settings by inputting text (called "metadata") in Photoshop or another software program—Chapters 13 and 16 have more tips that cover this. If you make adjustments to an image file as you make test prints, it's a good idea to rename the file to avoid confusion. I like to use m1, m2, etc. after the file name as I make edits and new prints (for example, 20070628NYC003m2.psd).

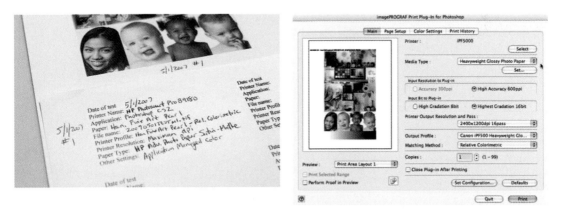

(Left) A test print using the worksheet mentioned in Tip 27. (Right) A screen shot of the Canon imagePROGRAF iPF5000 Print Plug-in for Photoshop, which simplifies the process of setting profiles and output quality choices.

Photographer: Andrew Darlow; **Image title**: *Barcelona 004*; **Print Size**: 35x50 inches; **Media**: HP Artist Matte Canvas; **Printer Name**: HP Designjet Z3100; **Ink Used**: HP Vivera; **Driver**: Standard HP Driver (Windows XP); **Camera**: Sony CyberShot DSC-F828; **Lens**: Built-in Carl Zeiss 28-200mm; **F-stop**: f/5; **Exposure**: 1/5 sec.

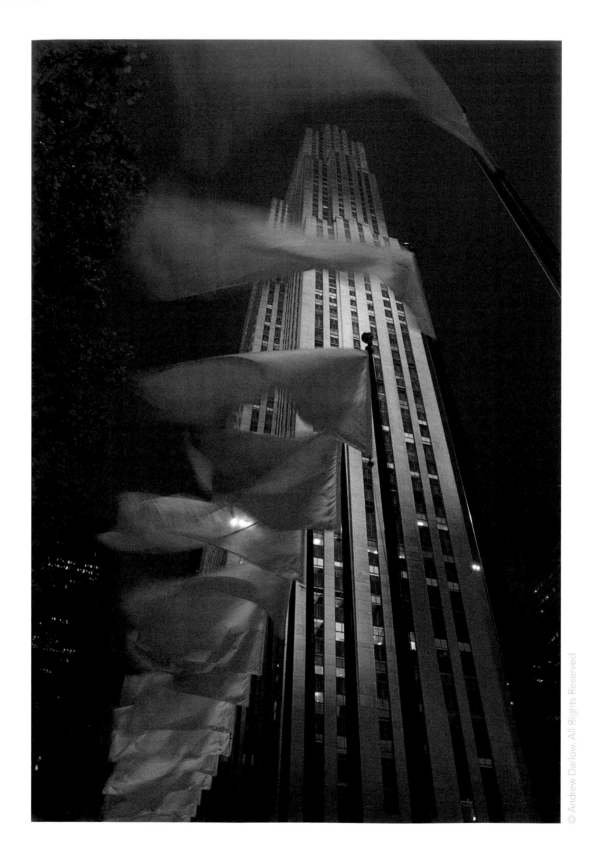

TIP 28 Interpolate in steps using Bicubic Smoother or Sharper.

Sometimes, your image won't be large enough to print well at its native size. If you are unable (or simply prefer not) to rescan your original film, or if your digital camera file has been captured at its largest size, then you should consider interpolating, or creating new pixels from your original image. In Photoshop CS2 or Photoshop Elements (L2.5), you can interpolate up and hold good detail by choosing the image size option and then entering a resolution about 50% larger than the current resolution, making sure that the "Resample" box is checked, with Bicubic Smoother selected in the dialog box.

If you want to go larger, you can do so by repeating the process, but your image will get softer and more pixilated as you interpolate up. Conversely, you can size down your files and retain better image quality (compared with just using Bicubic) by choosing Bicubic Sharper.

(Left) Photoshop's Image>Image Size dialog box before interpolating, and with Bicubic Smoother selected.
(Right) The Image Size dialog box after upsizing by 50% (note the change in file size—circled in red).

TIP 29 Interpolate using special software.

A number of software options exist to help make images larger with the goal of retaining as much image detail as possible. Most of these are sold in the form of plug-ins for Adobe Photoshop or Adobe Photoshop Elements. One of the most popular of these programs is named Genuine Fractals from onOne Software (L2.6). Another interpolation plug-in from onOne is named Pxl SmartScale, and another option is Alien Skin Software, with their plug-in, Blow-Up (L2.7). Plug-ins add to the

Photographer: Andrew Darlow; **Image title:** *NYC 004*; **Print Size:** 17x22 inches; **Paper:** Hahnemühle Fine Art Pearl; **Printer Name:** Canon imagePROGRAF iPF5000; **Ink Used:** Canon LUCIA; **Driver:** Canon Print Plug-In for Photoshop; **Camera:** Canon EOS-D60; **Lens:** Canon EF16-35mm f/2.8L; **F-stop:** f/11; **Exposure:** 1/4 sec.

31

functionality of programs and they are commonly used in Photoshop. To keep information as current as possible, I've compiled a list of interpolation options with comments about those that I have used (L2.8).

TIP 30 Interpolate using the print and scan method.

Another interpolation method takes more work but can produce excellent results. To use this method, print a sharp glossy print using a high quality inkjet printer or a direct digital printing process, and then have the print drum scanned (or scanned on a high quality flatbed scanner) to achieve an appropriate file size. Make sure the print has no lines with jagged edges or imperfections, or they will be magnified when scanning. I've seen bus-sized graphics printed from high quality scans of 16 × 20 inch photographic prints.

TIP 31 Interpolate through the driver.

Another option is to size your file up by printing at a certain percentage in your printer's driver. A printer driver is the software that controls your printer. It interprets your digital file and translates it into a series of dots. I generally don't interpolate in the driver, but it will work, and it is worth testing. Just note that there are two places to increase image size when printing from Photoshop—the File>Print with Preview window and the File>Page Setup window. I recommend setting the File>Page Setup option to 100% and doing any driver resizing in the File>Print with Preview dialog box.

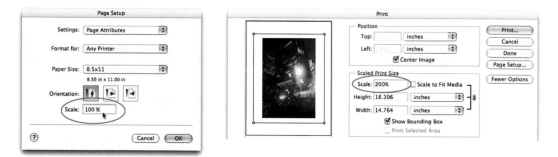

(Left) The File>Page Setup dialog set to 100%. (Right) The File>Print with Preview (File>Print in Photoshop CS3) dialog box set to 200%.

TIP 32 Know some sharpening history and Photoshop's built-in options.

The use of sharpening techniques has been an important concern in the art world for hundreds (if not thousands) of years. An illustration of this was shown by Photoshop Hall of Fame member and author Dan Margulis (L2.9), when he printed in his book, *Professional Photoshop*, an image of a 16th Century painting by El Greco, to demonstrate how the artist painted a halo around the hand of Jesus to create the illusion of sharpness. Margulis then demonstrated a number of sharpening techniques using Photoshop's built-in tools, and they are still valid today.

Photoshop has a filter called Smart Sharpen, which can be effective, though my favorite sharpening techniques in Photoshop are Unsharp Mask and an approach known as High-Pass Sharpening (L2.10).

Photos © Andrew Darlow

(Left) An image before using High-Pass sharpening.
(Right) The same image after High-Pass sharpening was applied (using the soft light blending mode).

TIP 33 Sharpen with care and keep sharpening on a separate layer (or layers).

Some printer and paper combinations will show artifacts or unnatural halos if images are sharpened too strongly, and others will benefit from aggressive sharpening. Either way, I recommend sharpening on a separate layer in Photoshop so that you can dial back the intensity (opacity) and tailor the sharpening for different printers, monitors, projectors, etc. To do this, duplicate your background layer, and then apply sharpening to it. By duplicating a sharpening layer, the effect of multiple sharpening

layers can be viewed. If you have a multi-layered Photoshop document that you would like to sharpen without flattening the layers, there is a special key command that can be used in Photoshop to merge all the layers into a single layer (L2.11). As with most things related to inkjet printing, make test prints to determine what level of sharpening looks good to you.

(Left) Photoshop's Layer Palette, showing how two duplicate layers of the background could be used as separate sharpening choices by enabling the eye—circled in red.
(Right) Using the merge shortcut in Photoshop's Layer Palette to make a new layer comprised of the layer contents that are below it.

TIP 34 Try sharpening using other options.

Sharpening can also have the effect of adding noise, and PixelGenius offers a fantastic sharpening tool called PhotoKit SHARPENER (L2.12) to help control the amount of noise in areas that you would generally not want sharpened, such as solid dark areas, while sharpening areas that contain detail. The software has options for sharpening prior to editing (called Capture Sharpening) and other options for sharpening based on a number of factors, such as your chosen output device. There are several excellent workflow PDFs on the PixelGenius web site for the software, as well as for other PixelGenius products (L2.13).

Another tool worth investigating is Nik Software's Nik Sharpener Pro 2.0 (L2.14), which has a very easy to use interface, with the ability to sharpen or not sharpen by selecting different color ranges. I also came across a great review of "Fractal Sharpening," by Uwe Steinmueller (L2.15). He describes a process using Noel Carboni's dSLR Fractal Sharpen Actions (L2.16) which is well worth investigating. And another plug-in suite that I learned about (and saw impressive results from) in a book by George DeWolfe (L2.17) is called Optipix (L2.18), from Reindeer Graphics. The

Photographer: Andrew Darlow; **Image title**: *NYC 005*; **Print Size**: 13x19 inches; **Paper**: HP Advanced Photo Paper, Satin-Matte; **Printer Name**: HP Photosmart Pro B9180; **Ink Used**: HP Vivera; **Driver**: Standard HP Driver (OSX); **Camera**: Fujifilm FinePix S20 Pro; **Lens**: Built-in lens (35mm equiv: 35-210mm); **F-stop**: f/4; **Exposure**: 1/2 sec.

software includes sharpening plug-ins including Refocus, Safe Sharpen, Edge Enhancer, and Detail Sharpener. Reindeer Graphics also has a free "Select Edges" plug-in on their web site which can make a dramatic difference in many images when used properly.

TIP 35 Add noise in Photoshop to create film grain in your images.

Adding noise to digitally captured or upsized images can often make them look less "digital" and more like images captured on traditional film. I first saw the power of this in a presentation by photographer and PixelGenius member Jeff Schewe (L2.19), who enlarged a file from a 3.1 megapixel Canon EOS-D30 digital SLR using Photoshop (prior to the built-in Bicubic Smoother option) to about 20 × 30 inches, added noise, then printed the image on an inkjet printer. The final print looked very natural—similar to what I would expect from a pro lab that makes digital or dark-room prints.

Following are the settings I often use when adding noise to images using Photoshop's noise filter (Filter>Noise>Add Noise)—Uniform, with Monochromatic checked. Photoshop's preview at 100% (1:1) will give you a good overview of what to expect, but to really see the effect, it is best to make test prints using different noise settings. You may be surprised how well "noisy" images onscreen look when printed. Noise should also be applied on a separate layer, just like sharpening (refer to Tip 33).

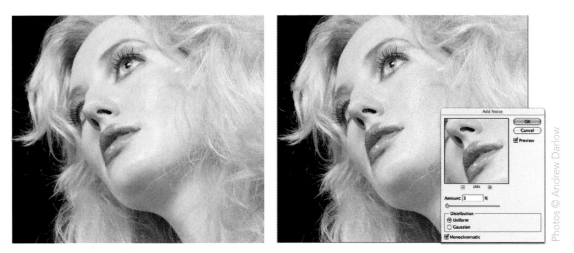

Before and after effect of adding noise with Photoshop's Filter>Noise>Add Noise filter. The photo on the right shows the settings that were used.

Photographer: Andrew Darlow; **Image title**: *E.T. 014*; **Print Size**: 17×22 inches; **Paper**: Epson Premium Semigloss; **Printer Name**: Epson Stylus Pro 4800; **Ink Used**: Epson UltraChrome K3; **Driver**: Standard Epson Driver (OSX); **Camera**: Sony CyberShot DSC-F828; **Lens**: Built-in Carl Zeiss 28-200mm; **F-stop**: f/8; **Exposure**: 2 sec.

TIP 36 Add or remove noise using other software options.

PixelGenius makes PhotoKit for Photoshop and Photoshop Elements. The product is fantastic, and includes a wide range of effects, including options to quickly add noise in ways that simulate a number of different film grains (L2.20). Another great piece of software for adding "grain" as well as simulating many film stocks is Alien Skin Software's Exposure (L2.21). The software has a powerful, easy-to-use interface, and like most of the software mentioned here, can be tested by downloading a sample from the company's web site.

Now that you know how you can add noise, there are a number of well-made plug-ins and standalone software programs for reducing noise in digital images, and the results can be truly amazing (L2.22).

(Left) A dialog box showing noise options in PixelGenius's PhotoKit.
(Right) An extreme grain "profile" applied using Alien Skin Software's Exposure plug-in.

TIP 37 Save your layered file and flatten before printing.

It's easy to end up with a file stacked high with layers. My recommendation, primarily when printing very large files with more than two layers, is to flatten your Photoshop or Photoshop Elements Layers before printing to save time and to reduce the chance of printer errors. Be sure to save the layered file first, and then save the flattened file with another name, such as 20070628NYC003m2F.psd (F for flattened). If edits are necessary, then reopen the layered file and flatten it again before printing.

Photographer: Andrew Darlow; **Image title**: *NYC 006*; **Print Size**: 17×22 inches; **Media**: Canon Heavyweight Satin Photo Paper; **Printer Name**: Canon imagePROGRAF iPF5000; **Ink Used**: Canon LUCIA; **Driver**: Canon Print Plug-in for Photoshop; **Camera**: Fujifilm FinePix S20 Pro; **Lens**: Built-in lens (35mm equiv: 35-210mm); **F-stop**: f/2.8; **Exposure**: 1/45 sec.

39

TIP 38 Understand the benefits of working in 16-bit color or grayscale mode.

Images can be scanned from film or processed from RAW digital camera files into 8-bit files (256 levels of gray per channel, e.g., RGB) or high-bit files called 16-bit in Photoshop, containing thousands of levels of gray per channel. RAW digital camera files (unlike JPEG files) are not compressed or processed in the camera, and by shooting in a camera's RAW format, significant adjustments can be made in contrast and color via software such as Photoshop's built-in Camera Raw, Adobe Photoshop Elements, Adobe Photoshop Lightroom, Apple iPhoto, and Apple Aperture.

Photoshop offers many of the same tools for editing 16-bit images as it does for 8-bit images, and editing in 16-bit can help reduce banding. Banding appears in images as visible bands of color or gray—often seen in a stair-stepped pattern. Gradients in skies and skin tones also tend to look smoother when adjusted in 16-bit color. Sharpening can be done when in 16-bit color mode in Photoshop, which can give images a cleaner overall look.

TIP 39 Consider printing from 16-bit files, especially with grayscale images.

When printing to an inkjet, many drivers, plug-ins and RIPs will allow you to print directly from the 16-bit file. It is important to note, however, that 16-bit files are twice the size of 8-bit files (assuming there are no extra layers), and in many cases, you will not see any discernable difference in your print quality between images that begin as 8-bit versus 16-bit files. Also note that your scans or digital camera RAWs need to originate in 16-bit color. You can't just change a file from 8-bit to 16-bit and expect it to magically gain the advantages of high-bit data. I personally think that when scanning black and white negatives in grayscale (one channel), 16-bit should almost always be chosen because grayscale images are more prone to visible banding, and the file size will still be lower than an 8-bit RGB file.

Photographer: Andrew Darlow; **Image title:** *L.V. 006*; **Print Size:** 18×24 inches; **Paper:** HP Premium Plus Photo Satin; **Printer Name:** HP Designjet 90; **Ink Used:** HP Vivera; **Driver:** Standard HP Driver (Mac OSX); **Camera:** Canon EOS-D60; **Lens:** Canon EF16-35mm f/2.8L; **F-stop:** f/4.5; **Exposure:** 1/15 sec.

Photographer: Andrew Darlow; **Image title**: *Train Impression 002*; **Print Size**: 60×40 inches; **Media**: HP Artist Matte Canvas; **Printer Name**: HP Designjet Z3100; **Ink Used**: HP Vivera; **Driver**: Standard HP Driver (OSX); **Camera**: Sony CyberShot DSC-F828; **Lens**: Built-in Carl Zeiss 28-200mm; **F-stop**: f/3.2; **Exposure**: 1/200 sec.

Chapter 3

Choosing an Inkjet Printer

Chapter 3

Choosing an Inkjet Printer

How to Choose Your Next Inkjet Printer

Okay, you're ready to buy an inkjet printer. Where do you start? How do you decide? What will you do? People often ask me which printer they should buy, and I usually answer by asking them a few questions. In this chapter, a checklist will be used to help you choose an inkjet printer. I will then cover some of the major items to consider when making a purchase decision, followed by a list of features and opinions about specific photo-quality printer models from 4 to 60 inches in width. New printers are constantly being released, so check inkjettips.com for information on the latest and greatest machines (L3.1). Every printer and ink formulation is different, and that's why specific dye- and pigment-based printers are examined in this chapter based on my personal experience and research. I also recommend reading other user reviews online to learn about specific printer, ink, and paper combinations.

Throughout this chapter, the terms metamerism, gloss differential, and bronzing will be mentioned. *Metamerism* is a phenomenon that occurs when two samples, such as a glossy inkjet print and coated watercolor inkjet print, visually match in one type of light but not in another. However, in practice, the term has been used to describe how a single print visually changes in appearance when viewed under different light sources, such as a standard household bulb compared with natural sunlight at noon in New York City. If a print shifts dramatically, you may hear someone say that it "exhibits bad metamerism." The actual term for a print's (or other object's) appearance looking similar when viewed under different light sources is *color constancy*, and I believe "poor color constancy" is a better description term for when a considerable visual shift between different light sources is observed in a print.

Gloss differential is an uneven look across the surface of a print (especially around areas such as people's heads), and is most often seen in dark and light areas of pigment-based prints on glossy paper or glossy film. *Bronzing* is an effect that makes medium to dark tones look bronze in color when viewed at certain angles, and is most often seen on glossy or semi-gloss papers.

To find the web links noted in the book (L3.1, etc.), visit www.inkjettips.com or http://www.courseptr.com/ptr_downloads.cfm.

*Longevity testing performed by Wilhelm Imaging Research. For specific information, visit www.wilhelm-research.com.

Photographer: Andrew Darlow; **Image title**: *Train Impression 004*; **Print Size**: 13x17 inches; **Paper**: Epson UltraSmooth Fine Art Paper; **Printer Name**: Epson Stylus Photo R2400; **Ink Used:** Epson UltraChrome K3; **Driver**: Standard Epson Driver (OSX); **Camera**: Sony CyberShot DSC-F828; **Lens**: Built-in Carl Zeiss 28-200mm; **F-stop:** f/8; **Exposure**: 1/30 sec.

A note on pricing: Like many products in the electronics industry, inkjet printer prices can fluctuate over time and manufacturers' suggested list prices may be very different from street prices, due to rebates, trade-in discounts or other reasons. For the most accurate pricing, I recommend checking a few reputable resellers.

(Left) An example of what bronzing looks like on a semi-gloss paper (circled in blue). (Center and right) A simulation of how the same print might look if it had poor color constancy under two different types of light, or under lights with two very different color temperatures.

All printer photos throughout this chapter are courtesy of the respective printer manufacturer. Also, when a printer's "width" is mentioned, that stands for the maximum sheet width that should be inserted into the printer.

TIP 40 Fill out the InkjetSelector checklist.

Choosing an inkjet printer (or printers) is kind of like choosing a car. Many models will do the job, but only a select few will meet most of your requirements. To get started, on the following pages is the super-powerful InkjetSelector, a form I created with 70 parameters to help you choose your ideal printer. Feel free to copy the form (for your own use only of course), then fill it out, bring it to a store that sells inkjet printers, or send it to a reseller or consultant who knows a lot about inkjet printers and who can give you advice. Now sharpen your pencils and happy searching!

Photographer: Andrew Darlow; **Image title**: *Barcelona 008*; **Print Size**: 16×20 inches; **Paper**: PremierArt Platinum Rag; **Printer Name**: Canon imagePROGRAF iPF5000; **Ink Used:** Canon LUCIA; **Driver**: Canon Print Plug-In for Photoshop (OSX); **Camera**: Sony CyberShot DSC-F828; **Lens**: Built-in Carl Zeiss 28-200mm; **F-stop:** f/5; **Exposure:** 1/4 sec.

After filling in the first 9 lines, either check the box next to each item that is an important feature or rate each item with a 0–5 (0 = not important/not applicable, 3 = nice to have, but not necessary, 5 = must have feature, or ? = I don't know or I have no idea what you're talking about).

InkjetSelector Checklist

- ☐ Cost must not exceed $ _____.
- ☐ Printer's max. sheet width must be at least _____ inches.
- ☐ Printer must weigh under _____ pounds.
- ☐ Must accept individual cartridges at least _____ ml _____ not applicable.
- ☐ Must accept single sheets at least _____ mm thick, or _____ gsm thick.
- ☐ Must make a photo quality 4 × 6 print in under _____ seconds.
- ☐ Must make a photo quality 8 × 10 print in under _____ seconds.
- ☐ Must make a photo quality 16 × 20 print in under _____ seconds.
- ☐ Must be these brands only _____.
- ☐ Must be an all-in-one device (fax optional). YES NO
- ☐ Must be an all-in-one device w/ fax. YES NO

Ink and Longevity Related

- ☐ Must have individual cartridges.
- ☐ Must have pigment-based inks (all colors).
- ☐ Must have some or all dye-based inks.
- ☐ Must have on-board matte black and photo black pigment inks (no swapping necessary).
- ☐ Must have a gloss enhancer "ink."
- ☐ Must have at least one gray ink in addition to a black ink (for better monochrome output).
- ☐ Must have at least two gray inks in addition to a black ink.
- ☐ Must produce water-resistant prints on compatible glossy inkjet papers.
- ☐ Must have longevity ratings under normal gallery conditions of at least 20 years on at least one paper.
- ☐ Must have longevity ratings under normal gallery conditions of at least 40 years on at least one paper.

☐ Must have longevity ratings under normal gallery conditions of at least 70 years on at least one paper.

☐ Must have longevity ratings under normal gallery conditions of at least 70 years on many matte and glossy papers.

☐ Must have a user replaceable ink maintenance tank.

☐ Must have an automated print head alignment option.

☐ Must have an automated head cleaning option.

Stand and Paper Feed

☐ Must come with a stand.

☐ Must have an optional stand.

☐ Must be able to be placed on a table.

☐ Must be able to feed heavy sheets (300 gsm+) from the top feed tray.

☐ Must have a top feed tray that holds multiple sheets.

☐ Must have a straight paper path for single heavy sheets.

☐ Must have a paper cassette.

☐ Must come with a roll feed system.

☐ Must have an optional roll feed system.

☐ Must have a take-up roll (good for print jobs to be laminated).

☐ Must have a built-in cutter.

Software Connectivity

☐ Must have built-in or optional USB 2.0 connectivity.

☐ Must have built-in or optional FireWire connectivity.

☐ Must have built-in or optional Ethernet connectivity.

☐ Must have built-in PictBridge connectivity.

☐ Must come with software or a driver option that optimizes black and white and toned monochrome printing.

☐ Must come with layout/nesting software for Mac.

☐ Must come with layout/nesting software for Windows.

☐ Must come with poster making software (layout tools and clip art).

☐ Must come with a Photoshop plug-in for direct printing from high-bit files.

☐ Must come with a plug-in for direct printing from RAW camera files.

☐ Must be compatible with ColorByte Software's ImagePrint RIP.

☐ Must be compatible with the ColorBurst RIP.

☐ Must be compatible with Ergosoft's StudioPrint RIP.

☐ Must be compatible with the Harrington QuadTone RIP.

Color Management

☐ Must have a built-in densitometer.

☐ Must have a built-in spectrophotometer.

☐ Must come with printer profiles.

☐ Must have a driver that has a "no color management/application color management" option.

Other

☐ Must be able to print on CDs/DVDs.

☐ Must have a built-in color LCD screen.

☐ Must be able to print borderless on cut sheets.

☐ Must be able to print borderless on roll paper.

☐ Must be able to print borderless on roll paper and cut sheets.

☐ Must have scanner/fax capability.

☐ Must have automatic duplexing.

☐ Must have built-in media card slots (from digital cameras).

☐ Must have a color screen on the printer for computer-free printing.

☐ Must have Bluetooth wireless capability (standard or as an option).

☐ Must have Wi-Fi capability (standard or as an option).

☐ Must have infrared wireless capability (standard or as an option).

☐ Must have a built-in battery-powered option.

☐ Must be relatively quiet (almost silent with minimal fan noise) when printing.

☐ Must have an on-site one year parts/labor warranty included.

☐ Must have longevity ratings under normal gallery conditions of at least 70 years on at least one paper.

☐ Must have longevity ratings under normal gallery conditions of at least 70 years on many matte and glossy papers.

☐ Must have a user replaceable ink maintenance tank.

☐ Must have an automated print head alignment option.

☐ Must have an automated head cleaning option.

Stand and Paper Feed

☐ Must come with a stand.

☐ Must have an optional stand.

☐ Must be able to be placed on a table.

☐ Must be able to feed heavy sheets (300 gsm+) from the top feed tray.

☐ Must have a top feed tray that holds multiple sheets.

☐ Must have a straight paper path for single heavy sheets.

☐ Must have a paper cassette.

☐ Must come with a roll feed system.

☐ Must have an optional roll feed system.

☐ Must have a take-up roll (good for print jobs to be laminated).

☐ Must have a built-in cutter.

Software Connectivity

☐ Must have built-in or optional USB 2.0 connectivity.

☐ Must have built-in or optional FireWire connectivity.

☐ Must have built-in or optional Ethernet connectivity.

☐ Must have built-in PictBridge connectivity.

☐ Must come with software or a driver option that optimizes black and white and toned monochrome printing.

☐ Must come with layout/nesting software for Mac.

☐ Must come with layout/nesting software for Windows.

☐ Must come with poster making software (layout tools and clip art).

☐ Must come with a Photoshop plug-in for direct printing from high-bit files.

☐ Must come with a plug-in for direct printing from RAW camera files.

☐ Must be compatible with ColorByte Software's ImagePrint RIP.

☐ Must be compatible with the ColorBurst RIP.

☐ Must be compatible with Ergosoft's StudioPrint RIP.

☐ Must be compatible with the Harrington QuadTone RIP.

Color Management

☐ Must have a built-in densitometer.

☐ Must have a built-in spectrophotometer.

☐ Must come with printer profiles.

☐ Must have a driver that has a "no color management/application color management" option.

Other

☐ Must be able to print on CDs/DVDs.

☐ Must have a built-in color LCD screen.

☐ Must be able to print borderless on cut sheets.

☐ Must be able to print borderless on roll paper.

☐ Must be able to print borderless on roll paper and cut sheets.

☐ Must have scanner/fax capability.

☐ Must have automatic duplexing.

☐ Must have built-in media card slots (from digital cameras).

☐ Must have a color screen on the printer for computer-free printing.

☐ Must have Bluetooth wireless capability (standard or as an option).

☐ Must have Wi-Fi capability (standard or as an option).

☐ Must have infrared wireless capability (standard or as an option).

☐ Must have a built-in battery-powered option.

☐ Must be relatively quiet (almost silent with minimal fan noise) when printing.

☐ Must have an on-site one year parts/labor warranty included.

TIP 41 Decide whether you want a printer with dye or pigment inks.

The printer and ink you choose greatly determines the overall image quality and permanence of your prints. A few recommendations follow for any of the printers you are considering: First, check the number of milliliters of ink per cartridge and the overall cost per cartridge, and then determine whether or not the cartridges are individual or combined with multiple inks in a cartridge. In general, individual cartridges are preferred since a combined cartridge will need replacing as soon as one of the colors registers as empty. Also check to see whether inks are all dye, all pigment, or a mix of the two.

In the past, inkjet printers that used dye-based inks had a clear advantage in overall color gamut (number of colors that can be printed) and in "smoothness" with regard to the way the ink sat on the paper surface (especially on glossy or semi-gloss papers). Today's high-end pigment-ink–based inkjet printers produce smooth prints rivaling any dye-based printer. Many pigment-based printers produce a very large color gamut, with excellent waterfastness and very good longevity when paired with a wide range of glossy and matte papers. One advantage I still see with dye-based printers is that their print heads tend to clog less, reducing the frequency of print head cleanings. Dye-based prints also tend to show less gloss differential and bronzing than pigment-based prints, though gloss enhancer coatings and advancements in ink and paper technology have reduced the gloss differential and bronzing issues.

Three of the major manufacturers, Canon, Epson, and HP, have all produced a line of pro-level printers with pigment-based inks. In addition, both Kodak and Lexmark make pigment-based printers in a number of configurations, though primarily in the popular 8.5-inch-wide size category. The primary negative features of most dye-based printers were, and still are in many cases, the following: a faster overall rate of print fading compared with pigment inks (especially on matte papers), a color shift on some papers after a few hours or days (especially when compared with pigment inks), or a color and/or density shift when prints are exposed to ozone or pollutants in the air.

Swellable papers (as opposed to micro-porous papers) are formulated in a way that reduces the ozone/pollutant issues significantly. Dye-based prints also tend to run or smudge more than pigment-based inks when they come in contact with moisture, but new ink and paper formulations are proving to be resistant to water. Epson's Claria inkset is one example of a dye-based product that in many ways performs more like a pigment ink than a traditional dye-based ink. See Chapter 6, "Inkjet Paper, Canvas and Coating," for more on this topic.

TIP 42 Consider a 4- or 5-inch-wide printer.

Not everyone needs a 44-inch-wide printer (or even a letter-sized printer). If your primary print size is about 4 × 6 inches, then a dedicated 4- or 5-inch-wide printer may be the best choice for you. Most printers in this class have a maximum width of 4 inches, and can also print sizes such as 4 × 8 inches (for folding cards) or 4 × 12 inches (for panorama prints), though most people will primarily print 4 × 6-inch prints on them. In this category, the Canon PIXMA mini260 and PIXMA mini320 (L3.2), the Epson PictureMate Flash-PM280 (L3.3), and the HP Photosmart 475 (L3.4), stand out with regard to image quality, speed, cost per print, computer-free operation (if desired), built-in memory card slots, and other special features.

One special feature found in the Epson PictureMate Flash is the ability to copy/archive files from the device to a built-in CD burner (many other printers in this class have the ability to archive images to an external CD burner). What sets the HP Photosmart 475 and Canon PIXMA mini320 apart are their ability to print 5 inches wide, which allows for the printing of 5 × 7 inch (or longer) prints. The Photosmart 475 also comes with a remote control for viewing images and videos from your media cards on a TV. All three models mentioned have a battery-powered option and optional Wi-Fi and/or Bluetooth adapters for wireless printing from laptops, cell phones, or other mobile devices.

Independent longevity tests have shown that the Epson PictureMate Flash and HP Photosmart 475 achieved estimated display ratings before noticeable fading of 96 and 82 years, respectively. A four-inch-wide Canon printer (the Selphy DS700) using

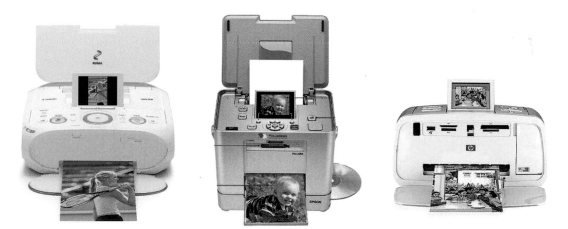

(From left to right) The Canon PIXMA mini260, Epson PictureMate Flash, and HP Photosmart 475.

Photographer: Andrew Darlow; **Image title:** *Air 002*; **Print Size:** 17×22 inches; **Paper:** Canon Heavyweight Satin Photo Paper; **Printer Name:** Canon imagePROGRAF iPF5000; **Ink Used:** Canon LUCIA; **Driver:** Canon Print Plug-In for Photoshop (OSX); **Camera:** Sony CyberShot DSC-F828; **Lens:** Built-in Carl Zeiss 28-200mm; **F-stop:** f/8; **Exposure:** 1/640 sec.

ink and paper similar to the Canon PIXMA mini260 achieved an estimated rating of 41 years before noticeable fading.*

The supplies for these printers are often sold in a kit that includes both ink and paper. The advantage is that you know your cost of materials (about 20–40 cents per 4 × 6 print), but the disadvantage is that your media choices are limited. You will also generally find that the ink cartridges that are bundled in packs with paper will almost always make more than the number of prints stated on the box. To make the most of the remaining ink, you can either cut down larger sheets to four inches wide or buy packages of compatible paper. See Chapter 8, "Specific Printer Tips and More," for a tip on using a 4- or 5-inch-wide printer for letter-sized output.

TIP 43 Consider an all-in-one printer.

One of the most popular types of inkjet printers on the market is called the all-in-one. These are the "Swiss Army Knives" of inkjet printers, and features vary significantly between models and manufacturers. Some of the following features are commonly found in this class of printer: scanning; faxing; color and black and white-copying via a flatbed; auto document feeder; auto duplexing (ability to print on both sides of a single sheet without user intervention); built-in color LCD display; optional wireless connectivity; and direct printing from cameras, media cards, and/or through a computer link. Output quality from virtually all of the current-model all-in-ones can be outstanding on matte and gloss papers, and depending on the specific model and types of documents you are printing, cost per print will vary. Many different ink types (all dye, all pigment, and hybrid) and cartridge configurations are used in all-in-ones, so investigate them before purchasing.

There are many models to choose from in this category from Canon, Dell, Epson, HP, Kodak, Lexmark, and others. Look at the specs for the scanner (some models scan both prints and film); and read reviews from others who own the printers. Some printers, like the Canon PIXMA MP510, have two paper trays, which allow users to keep two types of paper (such as bond paper and photo paper) loaded at the same time. One of the most interesting features of some all-in-ones is the ability to print a special contact sheet (a print or series of prints with thumbnail images of what is on the media card). After printing, small ovals under each photo on the contact sheet can be filled in, and after re-scanning on the flatbed glass, the photos you "ordered" will magically be printed. If this is a feature you'd like, make sure it is available for the printer you purchase.

*Longevity testing performed by Wilhelm Imaging Research. For specific information, visit www.wilhelm-research.com.

(Left) Epson's Stylus Photo RX580 (L3.4) all-in-one featuring Epson's dye-based Claria ink (L3.5). (Right) Canon's PIXMA MP510 (L3.6) all-in-one, which contains two paper trays so that different types of paper can be loaded.

An example of prints being selected by filling out a contact sheet generated by an HP all-in-one printer.

TIP 44 Consider a mobile letter-sized printer.

Have you ever traveled and desperately craved your inkjet or color laser printer? I have, and it's a lifesaver to have a printer to make original prints to be photocopied for seminar attendee handouts, or to print boarding passes, model releases, speeches, web pages, or other information. There are a few compact printers on the market that make letter-sized high quality prints. Two of them are the Canon PIXMA iP90 (4 lbs, L3.7) and the HP Deskjet 460 (4.6 lbs, L3.8). I've used the Canon iP90 and find that it produces excellent images and text on matte and gloss paper. The HP Deskjet 460 has a number of ink configuration options (four- and six-color) and even has built-in memory card slots. For many, these printers can serve as your only inkjet printers for both home and when you're on the road, but your running costs will generally be higher overall per page compared with many other printers because neither one uses individual ink cartridges for color printing.

Both printers have optional compact batteries as well as Wi-Fi and Bluetooth wireless options which can be purchased separately. The PIXMA iP90 also has built-in wireless infrared compatibility. I recommend checking with the companies (or ask other users) to ask what their recommended "travel scenario" is with regard to whether or not to keep the inks in the printer during transit. If you want to secure the print heads, I recommend carefully taping the print head to the printer when in transit (I use painter's masking tape), but make sure you put a large note on the printer so that you remember that you've done that. If you do remove the inks, be sure to put them in sealed plastic bags.

Another letter-sized printer that's not as small and full-featured but is much less expensive than the two already mentioned is Canon's PIXMA iP1700 (6.6 lbs, L3.9).

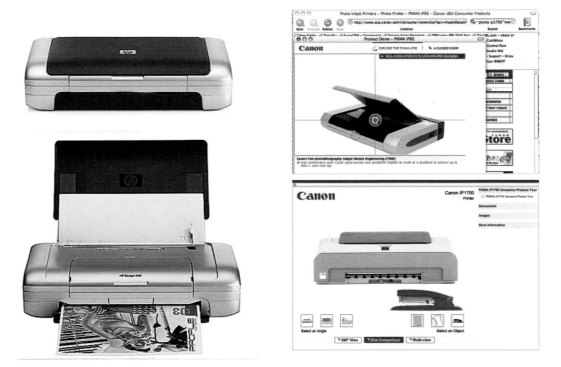

(Left) HP's Deskjet 460 in the open and closed position. (Right top) Canon's PIXMA iP90 shown on Canon's web site within the interactive 360-degree view. (Right bottom) Canon's PIXMA iP1700 shown on the Canon web site with a virtual size-comparison tool. The button to launch the online interactive viewing features is on the right side of many Canon printers when you select them on the web site.

Photographer: Andrew Darlow; **Image title**: *Barcelona 009*; **Print Size**: 17×22 inches; **Paper**: PremierArt Platinum Rag; **Printer Name**: Canon imagePROGRAF iPF5000; **Ink Used**: Canon LUCIA; **Driver**: Canon Print Plug-In for Photoshop (OSX); **Camera**: Sony CyberShot DSC-F828; **Lens**: Built-in Carl Zeiss 28-200mm; **F-stop**: f/4; **Exposure**: 1/30 sec.

TIP 45 Consider a letter-sized dedicated photo printer.

The number of letter-sized photo-quality printers on the market is staggering. Instead of making specific suggestions here, I would recommend you first fill out the InkjetSelector Checklist, then read about the suggested printers below, since many letter-sized printers share similar features with 13-inch and wider models. Reading reviews from other users can also be helpful. Inkjettips.com also has links to personal and editorial reviews. Some of the most important features that I believe are important to know about when selecting a letter-sized photo quality printer are the following: overall color and monochrome print quality; compatibility with your operating system; longevity of prints on various papers; speed (while maintaining high quality); ink and cartridge type; maximum paper thickness; whether or not inks need to be swapped to get optimum results on matte and gloss papers; whether or not CD/DVD printing is supported; and the cost of the printer and its supplies.

TIP 46 Consider the Epson Stylus Photo R1800.

The Epson Stylus Photo R1800 (L3.10) is a 13-inch-wide printer with a unique set of built-in capabilities. I've seen many prints made on the R1800, and I particularly like that the Matte and Photo Black inks are always installed, which means that no manual switching of inks is necessary in order to get good quality prints on both matte and gloss/semi-gloss papers. The prints made with the Gloss Optimizer enabled on glossy papers are ultra-smooth and mirror-like in appearance, with less gloss differential, metamerism and bronzing compared with semi-gloss and gloss prints not coated with the Gloss Optimizer.

Selected features:

+ Seven UltraChrome Hi-Gloss pigment inks for excellent color gamut and longevity (100–200 years or longer)* plus a Gloss Optimizer cartridge for better protection and a more even surface on glossy papers.
+ Ability to get optimum results on matte and gloss papers without swapping black ink cartridges.
+ Prints on inkjet-compatible CDs and DVDs.
+ Includes a built-in roll paper holder, rear paper feed for thicker papers, a top media feed for sheets as narrow as 3.5 inches wide, and borderless printing support for many paper sizes.
+ Two standard connectivity options: USB 2.0 and FireWire.

Recommendations/Concerns: I would recommend this printer to almost anyone who wants a quality 13-inch-wide pigment-ink color printer. Only one black ink is used at any one time, and there is no special built-in software for optimizing monochrome (black and white) printing, as there is on the Epson Stylus Photo R2400. However, the Quadtone RIP software (see Chapter 5, "Black and White," for more info) can be used with the printer, which can improve monochrome output quality without changing the standard inks. However, cartridges are not nearly as large as those used with the Epson Stylus Pro series of printers, which may be a concern for medium- to high-volume users. The Epson Stylus Photo R800 is a letter-sized version of the R1800.

Cost: About $550.

Epson Stylus Photo
R1800 (13-inch width).

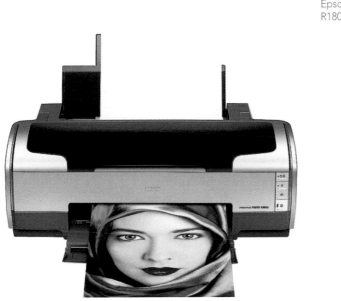

TIP 47 Consider the Epson Stylus Photo R2400.

Overview: The Epson Stylus Photo R2400 (L3.11) is a 13-inch-wide printer with a variety of hardware and software features. I've used this printer extensively and have found prints to be sharp, with very fine detail and smooth transitions on both matte and gloss papers. This printer also prints with little to no discernable quality difference in uni- and bi-directional mode, which means that you can print faster by checking "high speed" in the printer driver without sacrificing quality. Like with all the printers using the UltraChrome K3 pigment inks, bronzing, gloss differential, and

metamerism are less of a problem compared with earlier pigment inks made by Epson, such as the UltraChrome K2 inks.

Selected features:

+ 8-color UltraChrome K3 pigment inks have excellent color gamut and longevity (100–200 years or longer)* .

+ Monochrome printing with the Epson Advanced Black and White mode (and Light-Light Black ink) produces very even-toned prints, with the ability to adjust toning dramatically.

+ Includes a detachable roll paper holder and paper cutter.

+ Manual front paper feed for thicker papers, a top media feed for sheets as narrow as four inches wide and borderless printing support for many paper sizes.

+ Two standard connectivity options: USB 2.0 and FireWire.

Recommendations/Concerns: I would recommend this printer to photographers and other artists who want a well-built 13-inch-wide pigment-based ink color printer. It is necessary to switch from matte black to photo black ink to get optimum quality on matte and glossy/semi-gloss papers. This does not waste much ink, but it is inconvenient for people who frequently switch back and forth between paper types. Speaking of ink, like the Stylus Photo R1800, ink cartridges are not nearly as large as those used with the Epson Stylus Pro series of printers, which may be a concern for medium- to high-volume users.

Cost: About $750.

The Epson Stylus Photo R2400 (13-inch width).

Photographer: Andrew Darlow; **Image title**: *Air 004*; **Print Size**: 30×40 inches; **Media**: HP Artist Matte Canvas; **Printer Name**: HP Designjet Z3100; **Ink Used**: HP Vivera; **Driver**: Standard HP Driver (Windows XP); **Camera**: Sony CyberShot DSC-F828; **Lens**: Built-in Carl Zeiss 28-200mm; **F-stop:** f/6.3; **Exposure**: 1/1000 sec.

TIP 48 Consider the Epson Stylus Photo 1400.

Overview: The Epson Stylus Photo 1400 (L3.11) is a 6-ink 13-inch-wide printer with ultra-fine detail and very fast output speeds (under two minutes in photo mode for an 8 × 10-inch borderless print). The primary feature that separates this printer is its inkset. Although dye-based, the inks (delivered in individual cartridges) perform in many ways similar to pigment-based inks, including water resistance and longevity.

Selected features:

✦ 6-color Epson Claria "Hi-Definition" dye-based inks have excellent color gamut and longevity on many matte and gloss/semi-gloss papers (80–100 years or longer)*.

✦ Prints on inkjet-compatible CDs and DVDs, and includes software with backgrounds and other graphics.

✦ USB 2.0 connectivity.

✦ A top media feed for up to 120 sheets of plain paper or 20 sheets of Epson Premium Photo Paper Glossy. Prints borderless on paper as narrow as 4 inches wide.

✦ Front PictBridge port for direct printing from compatible cameras.

✦ Bundled software includes Adobe Photoshop Elements, Epson Easy Photo Print for helping to set up layouts and make prints, as well as Web to Page for easy printing of web pages (Web to Page is for Windows only).

The Epson Stylus Photo 1400 (13-inch width).

Recommendations/Concerns: I would recommend this printer to photographers and other artists who want a well-built 13-inch-wide dye-based ink color printer with very good expected print longevity and waterfastness. There is no need to swap inks for matte and gloss/semi-gloss printing, and having six inks means fewer cartridges are necessary to keep in stock (if you need to always have a cartridge ready for replacement) compared with some other printer models. However, there is only one black ink, compared with up to four black/gray inks found on other printers. This means that more color ink will probably be used to produce black and white and toned monochrome prints compared with the Epson Stylus Photo R2400 and other pro-level printers. Ink cartridges are also not nearly as large as those used with the Epson Stylus Pro series of printers, which may be a concern for medium- to high-volume users.

Cost: About $400.

TIP 49 Consider the HP Photosmart Pro B9180.

Overview: HP's Photosmart Pro B9180 (L3.12) is a sturdy, 13-inch-wide printer with a very respectable feature set. I've used this printer extensively to make glossy and matte prints, and find the output to be sharp and crisp, with a wide color palette. Monochrome quality is superb, thanks to the combination of black inks used when making monochrome prints, on matte or gloss papers. The main cassette tray, which holds sheets of paper, is a great feature in my opinion for those who want to make a series of prints (as long as the paper is not too thick) without having to constantly load sheets into a top-feed tray.

Selected features:

+ 8-color HP Vivera pigment inkset (using 27-milliliter individual cartridges).
+ Inks have been independently tested on a range of papers to last over 200 years before noticeable fading.*
+ Main tray is able to hold up to 200 sheets of 3.5 × 5- to 13 × 19-inch paper, and a manual-feed specialty media tray can handle single sheets up to 1.5 mm thick.
+ Closed-loop automatic calibration system utilizes a built-in densitometer to optimize color accuracy.
+ Two standard connectivity options: USB 2.0 and Ethernet.
+ Comes with the HP Photosmart Pro Print plug-in for Adobe Photoshop for direct printing from Photoshop.

Recommendations/Concerns: I would recommend this printer to photographers and other artists who want a quality 13-inch-wide pigment-based ink color printer. The manual feed tray (for heavier sheets) is particularly well constructed, though sheets must be fed one at a time. I also like printing through the HP Photosmart Pro Print Plug-in for Photoshop because all of the page setup and printer controls are on one easy-to-navigate screen.

Cost: About $650.

The HP Photosmart Pro B9180 (13-inch width).

TIP 50 Consider the Canon imagePROGRAF iPF5000.

Overview: The Canon imagePROGRAF iPF5000 (L3.13) is a 17-inch-wide production-level quality pigment-ink printer. It uses a new dual print head with 30,720 ink nozzles and comes with a very comprehensive suite of software. I've been using the printer to output a number of my fine-art prints and find the look of both color and monochrome output to be sharp and detailed, with a nice grain structure, smooth tonal range, and natural color palette. I especially like the output on matte water-color papers and fiber-like coated inkjet papers, and I like the flexibility of being able to print directly to the printer from the supplied Print Plug-in for Photoshop.

Selected features:

✦ 12 LUCIA-branded pigment inks—eight color inks and four gray/black inks for a very wide color gamut and expected print longevity of 100 years or longer.* Printer comes with starter cartridges that hold 90 ml, and replacement cartridges hold 130 ml each.

✦ Ability to get optimum results on matte and gloss papers without swapping black ink cartridges.

Photographer: Andrew Darlow; **Image title**: *Barcelona 010*; **Print Size**: 13x17 inches; **Paper**: HP Hahnemühle Smooth Fine Art; **Printer Name**: HP Photosmart Pro B9180; **Ink Used**: HP Vivera; **Driver**: HP Photosmart Plug-in for Photoshop; **Camera**: Sony CyberShot DSC-F828; **Lens**: Built-in Carl Zeiss 28-200mm; **F-stop**: f/3.5; **Exposure**:1/160 sec.

✦ Auto calibration and head alignment.

✦ Very fast output (about five minutes for a 16 × 20-inch print, even at high quality settings).

✦ A special monochrome photo mode helps to optimize the quality of black-and-white images.

✦ Two standard connectivity options: USB 2.0 and Ethernet. A FireWire card is optional.

✦ Media handling options include a front-loading cassette for up to 250 pre-cut sheets, a top-loading manual feed tray, a front straight-path manual feed for media up to 1.5 mm thick and an optional roll feed (necessary for borderless printing).

✦ Two print plug-ins for printing high-bit files directly from Adobe Photoshop or Canon's DPP (Digital Photo Professional), plus additional poster-making software and graphics for Windows users.

Recommendations/Concerns: I would recommend this printer to someone who wants a quality pigment-ink printer for moderate- to high-volume printing. This is a large and heavy printer (about 100 lbs.), especially when compared with the 17-inch-wide Epson Stylus Pro 3800 (about 43 lbs.). One item that can be frustrating if you plan to use a variety of different paper sizes is the need to specify the printer's paper type and size on the printer's LCD and in the driver (or in the Photoshop plug-in).

Cost: About $1,800 (add $250 for the optional Canon Auto Roll Feed Unit).

The Canon imagePROGRAF iPF5000 (17-inch width).

Another pigment-ink printer from Canon worth a look is the 13-inch-wide Canon PIXMA Pro9500 (L3.14). The printer contains an inkset similar to that of the iPF5000, but with a much smaller form factor, and 10 LUCIA pigment inks instead of 12, including on-board matte and gloss printing capability without the need to swap the Matte Black and Photo Black inks.

TIP 51 Consider the Epson Stylus Pro 3800.

Overview: The Epson Stylus Pro 3800 (L3.15) is a 17-inch-wide pigment-ink printer with a size and weight (43.2 lbs.) considerably smaller than other 17-inch-wide models. I've seen many prints made with it and find the look of both color and monochrome output to be sharp, with very smooth transitions and bright, saturated color. The stated output speed is also very respectable—5.5 minutes for a 16 × 20-inch print in high speed (bi-directional) mode and 1440 dpi.

Selected features:

+ 8-color UltraChrome K3 pigment inks (9 total cartridges) in 80 ml pressurized carts, with a wide color gamut and expected print longevity of 100–200 years or longer.*
+ Automatic switching between Matte and Photo Black inks, with minimal ink usage when making the switch (about 1.5 or 4.5 ml of ink is used when switching, depending on whether the change is from Photo to Matte Black or vice-versa).
+ Monochrome printing with the Epson Advanced Black and White mode (and three black inks) produces very even-toned prints, with the ability to adjust toning dramatically in the driver.
+ A top-loading high capacity feeder can hold up to 120 sheets, from 4 × 6 to 17 × 22 inches; a second top-loading manual sheet feeder is optimized for fine-art papers; and a front straight-through manual sheet feeder allows for single sheet loading of media up to 1.5 mm.
+ Two standard connectivity options: USB 2.0 and Ethernet.

Recommendations/Concerns: I would recommend this printer to a photographer or other artist who wants a quality 17-inch-wide pigment-ink printer that operates more like a 13-inch-wide model, but with much larger cartridges. The built-in Ethernet option and optional ColorBurst LE RIP are both very valuable features. There is no roll-feed built-in or available, and I prefer a closed paper tray like the one on the

Epson Stylus Pro 4800. However, the high-capacity feeder (similar to that found on many letter-sized and 13-inch-wide printers) performs a similar function.

Cost: About $1,300 (add $200 for the Professional version which includes the ColorBurst LE RIP).

The Epson Stylus Pro 3800 (17-inch width).

TIP 52 Consider the Epson Stylus Pro 4800.

Overview: The Epson Stylus Pro 4800 (L3.16) is a sturdy 17-inch-wide pigment-ink printer. I've made many prints on this machine, and it has a number of features worth mentioning. Image quality on matte and gloss papers is sharp and detailed, with a wide color range. The well constructed covered paper tray makes printing multiple jobs on the same paper more convenient, and having the ability to use either 110 ml or 220 ml cartridges can save money for medium to high volume users.

Selected features:

✦ 8-color UltraChrome K3 pigment inks in 110 ml cartridges (220 ml cartridges optional), with a wide color gamut and expected print longevity of 100–200 years or longer.*

✦ A high capacity paper tray can hold paper up to 17 × 22 inches. Other load options include front, top, and roll paper paths.

✦ Monochrome printing with the Epson Advanced Black and White mode (and three black inks) produces very even-toned prints, with the ability to adjust toning dramatically in the driver.

✦ Two standard connectivity options: USB 2.0 and FireWire (Ethernet is optional).

Photographer: Andrew Darlow; **Image title**: *Barcelona 011*; **Print Size**: 13×18 inches; **Paper**: Epson Premium Glossy; **Printer Name**: Epson Stylus Photo R2400; **Ink Used:** Epson UltraChrome K3; **Driver**: Standard Epson Driver (OSX); **Camera**: Sony CyberShot DSC-F828; **Lens**: Built-in Carl Zeiss 28-200mm; **F-stop:** f/3.5; **Exposure**: 1/50 sec.

69

Recommendations/Concerns: I would recommend this printer to a photographer or other artist who wants a high-end 17-inch-wide pigment-ink printer with multiple paper feed options. I have not had much success loading paper from the top feed, so I recommend using the front feed option when feeding paper too heavy for the paper tray. One significant issue with the Stylus Pro 4800 is the cumbersome and expensive process when switching between Epson's Matte Black and Photo Black inks. About $35–60 in ink is used to make the switch, and the process takes about 15-25 minutes with a lot of cartridge swapping required. An alternative to cartridge swapping is available to owners of ColorByte Software's ImagePrint RIP, and is described in Chapter 5.

Cost: About $1,900 (add $500 for the Professional version which includes the ColorBurst LE RIP and an Ethernet card for network printing).

The Epson Stylus Pro 4800 (17-inch width).

TIP 53 Consider the Epson Stylus Pro 7800/9800.

Overview: The Epson Stylus Pro 7800 (24 inches wide, L3.17) and Stylus Pro 9800 (44 inches wide, L3.18) are production-level pigment-based ink printers with identical specs. I've examined many prints made on these machines, and much like the Stylus Pro 4800, image quality on matte and gloss papers is sharp and detailed, with a wide color range. The printer's straight paper path makes loading convenient, and having the ability to use either 110 ml or 220 ml cartridges can save money for medium to high volume users.

Selected features:

◆ 8-color UltraChrome K3 pigment inks in 110 ml cartridges (220 ml cartridges optional), with a wide color gamut and expected print longevity of 100–200 years or longer.*

◆ Front feed for cut sheets holds paper up to 1.5 mm thick. Both printers also have built-in roll paper holders that use the same paper path.

◆ Monochrome printing with the Epson Advanced Black and White mode (and three black inks) produces very even-toned prints, with the ability to adjust toning dramatically in the driver.

◆ Two standard connectivity options: USB 2.0 and FireWire (Ethernet is optional).

Recommendations/Concerns: I would recommend either of these printers to a photographer or other artist who wants a high-end, yet affordable 24- or 44-inch-wide pigment-ink printer with a front-feed manual paper tray and roll-feed. Like the Stylus Pro 4800, a significant issue with the Stylus Pro 7800/9800 is the necessary process for switching between Epson's Matte Black and Photo Black inks. About $40–$70 in ink is used to make the switch, and the process takes about 15–25 minutes with a lot of cartridge swapping required. As mentioned in the previous tip, an alternative to cartridge swapping is available for owners of ColorByte Software's ImagePrint RIP, and is described in Chapter 5.

Cost: About $3,000 (SP 7800) and about $5,000 (SP 9800) (add $500 for the Professional version which includes the ColorBurst LE RIP and an Ethernet card for network printing).

The Epson Stylus Pro 9800 (44-inch width).

TIP 54 Consider the HP Designjet 90/130.

Overview: The HP Designjet 90 (18 inches wide, L3.19) and HP Designjet 130 (24 inches wide, L3.20) are high quality dye-based ink printers with almost identical specs. I've made many prints on the Designjet 90, and find image quality on gloss and semi-gloss papers to have a look similar to color prints made in a darkroom or on a continuous tone digital printer, but with a brighter overall color palette. Both printers have a built-in paper tray that can hold cut sheets up to 18 × 24 inches. The Designjet 90nr and Designjet 130nr come with roll holders and Ethernet connectivity and the Designjet 90gp, adds a colorimeter with display profiling and calibration software plus ICC profiles made with GretagMacbeth (now X-Rite) hardware and software.

Selected features:

+ HP Vivera fade-resistant dye-based inks, with an expected print longevity of 80 years or longer with specific papers.*
+ Built-in front paper tray for cut sheets up to 18 × 24 inches. Both printers also have optional roll paper feed options.
+ Both printers' front paths can be used for sheets up to 63.9 inches long (even longer with a RIP), and the rear path can accommodate heavy sheets and other materials.
+ Two standard connectivity options: USB 2.0 and Parallel, with an Ethernet option.
+ Built-in densitometer self calibrates to specific papers to assure consistent color and density.

Recommendations/Concerns: I would recommend either of these printers to a photographer or other artist who wants a very affordable, high quality 18- to 24-inch-wide printer. Paper choice is important for both longevity and image quality, and my favorite paper to use with the Designjet 90 is HP Premium Plus Satin Photo Paper (L3.21) because of its heavy weight, subtle surface texture, expected longevity, and ability to hold shadow detail. I generally don't recommend printing on matte papers with these machines, and swellable inkjet papers (like HP Premium Plus Satin Photo Paper) are ideal for use with the printers. The amount of ink that one can get from a full set of cartridges is astonishing. I've printed over 100 18 × 24-inch prints on the Designjet 90, and only two of the six inks are showing that they will need to be changed soon. Inks are not very water-resistant on the papers I've tested, so I recommend a light spray of the print's surface after printing with PremierArt's Print Shield Spray (L3.22).

Photographer: Andrew Darlow; **Image title**: *Air 003*; **Print Size**: 17×22 inches; **Paper**: Epson Premium Semigloss; **Printer Name**: Epson Stylus Pro 4800; **Ink Used**: Epson UltraChrome K3; **RIP**: Epson Pro Edition (ColorBurst LE, OSX); **Camera**: Sony CyberShot DSC-F828; **Lens**: Built-in Carl Zeiss 28-200mm; **F-stop:** f/8; **Exposure:** 1/640 sec.

Cost: About $1,000 (Designjet 90) and about $1,300 (Designjet 130). For the Designjet 90, add $150 for the nr version and $350 for the gp version, and for the Designjet 130, add $600 for the nr version and $800 for the gp version.

The HP Designjet 90 (18-inch width).

TIP 55 Consider the HP Designjet Z3100.

Overview: The HP Designjet Z3100 (L3.23) is a 12-ink pigment-based inkjet printer, with 24- and 44-inch-wide versions. The Z3100 runs on 11 HP Vivera pigment color inks (four of them black or gray), plus a twelfth Gloss Enhancer "ink" that provides better gloss uniformity and helps reduce metamerism and bronzing on gloss and semi-gloss papers. I've seen prints made with the Z3100, and find image quality on gloss, semi-gloss, and matte papers to be sharp and detailed, with vibrant color, and a pleasing grain structure. The printer also comes with four black or gray inks that help to make monochrome prints look more smooth and neutral. Monochrome prints made with the Z3100 have a very sharp, gelatin-silver look (especially when printed using the Gloss Enhancer), and in my experience show only a minimal visual change when moved between different types of lighting.

Selected features:

+ Preliminary initial independent testing of the new HP Vivera Pigment inks has yielded an estimated display life of over 200 years on a range of papers before noticeable fading.* The 44-inch-wide version comes with 12 full 130 ml cartridges, and the 24-inch version ships with 12 starter cartridges that hold 69 ml. Replacement cartridges hold 130 ml each.

+ Uses i1 Color Technology from X-Rite to automate calibration and profiling on virtually any media through a built-in spectrophotometer.

✦ The printer can switch between Photo Black (for gloss/semi-gloss papers) and Matte Black (for matte and fine-art papers), without having to change ink cartridges, and no ink is used while switching.

✦ Grayscale files can be printed so that only the black (matte or photo black) and gray inks are used. On matte papers, four separate black/gray inks are used when this option is enabled, and on semi-gloss/gloss papers, three separate black/gray inks are employed. This produces prints with smoother tones and greater longevity compared with using a mix of black and color inks. A special driver setting allows users to control the color toning applied to black and white prints.

✦ Built-in 40 GB hard drive for storing paper profiles, and for print spooling. Print spooling is when data is copied to memory (such as a hard drive), and in this case, spooling helps to free up your computer for other tasks when printing.

✦ Two standard connectivity options: USB 2.0 and Ethernet.

✦ Uses an exclusive charged pigment technology known as EET, which helps resist pigment settling.

✦ Has a roll paper feed, a top feed for cut sheets, and a rear feed for heavy media up to .88 mm thick.

The HP Designjet Z3100 (24- and 44-inch-wide models).

Recommendations/Concerns: I would recommend the HP Designjet Z3100 to a photographer or other artist who wants a very high quality pigment-ink–based 24- to 44-inch-wide printer. Estimated longevity of the inkset on most papers is also unmatched by its competition.* The built-in spectrophotometer makes profile-making and overall calibration easy for virtually any user. Unlike some other printers, it's necessary to get behind the printer to load rolls or heavy individual sheets. Also, the maximum paper thickness is respectable, but less than that of some other printers in its class.

Cost: About $4,100 (24-inch model) and about $6,300 (44-inch model).

TIP 56 Consider the HP Designjet Z2100.

Overview: The HP Designjet Z2100 (L3.24) is an 8-color pigment-based inkjet printer, with 24- and 44-inch-wide versions. I've seen many prints made with the Z2100, and made prints of my own work on the machine. Like the Designjet Z3100, I find image quality on gloss, semi-gloss, and matte papers to be sharp and detailed, with vibrant color, a pleasing grain structure, and little gloss differential or bronzing. The printer shares the same exact inkset as the HP Photosmart Pro B9180.

Selected features:

✦ Preliminary initial independent testing of the new HP Vivera Pigment inks has yielded an estimated display life of over 200 years on a range of papers before noticeable fading.* The 44-inch-wide version comes with eight full 130 ml cartridges, and the 24-inch version ships with eight starter cartridges that hold 69 ml. Replacement cartridges hold 130 ml each.

✦ Uses il Color Technology from X-Rite to automate calibration and profiling on virtually any media through a built-in spectrophotometer.

✦ Built-in 40 GB hard drive for storing paper profiles, and for print spooling.

✦ Grayscale files can be printed so that only the black (matte or photo black) and gray inks are used. On matte papers, three separate black/gray inks are used, and on semi-gloss/gloss papers, two separate black/gray inks are employed. This produces prints with smoother tones and greater longevity compared with using a mix of black and color inks. A special driver setting allows users to control the color toning applied to black and white prints.

✦ The printer can switch between Photo Black (for gloss/semi-gloss papers) and Matte Black (for matte and fine-art papers), without having to change ink cartridges, and no ink is used while switching.

✦ Two standard connectivity options: USB 2.0 and Ethernet.

✦ Uses an exclusive charged pigment technology known as EET, which helps resist pigment settling.

✦ Has a roll paper feed, a top feed for cut sheets, and a rear feed for heavy media up to .88 mm thick.

Recommendations/Concerns: I would recommend the HP Designjet Z2100 to a photographer or other artist who wants a very high quality pigment-ink–based 24- to 44-inch-wide printer. The built-in spectrophotometer makes profile-making and overall calibration easy for virtually any user, and if the charged pigment technology works as advertised, that can help avoid the practice of shaking cartridges from time to time. Unlike some other printers, it is necessary to get behind the printer to load rolls or heavy individual sheets, and the maximum paper thickness is respectable, but less than that of some other printers in its class. Also, there is no Gloss Enhancer cartridge on-board, like the HP Designjet Z3100.

Cost: About $3,400 (24-inch model) and about $5,600 (44-inch model).

HP also has released an 8-color 42- and 60-inch-wide printer series named the HP Designjet Z6100 (L3.25).

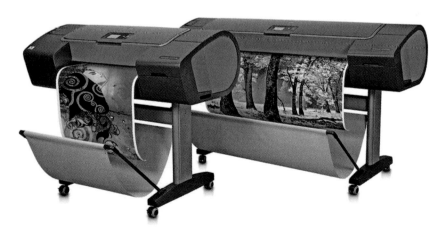

The HP Designjet Z2100 (24- and 44-inch-wide models).

TIP 57 Consider the Canon imagePROGRAF 8000/9000.

Overview: The Canon imagePROGRAF 8000 (44 inches wide, L3.26) and imagePROGRAF 9000 (60 inches wide, L3.27) share many of the same features as the 12-color Canon imagePROGRAF iPF5000, but in a larger form factor. I've seen very large prints made with the imagePROGRAF 8000 and 9000 on glossy and matte papers, and they were stunning. Please refer to Tip 50 for more about the inkset and bundled software.

Additional selected features:

+ Roll and cut-sheet print capability, with four-sided borderless printing available up to the full width of the printer when printing from the roll.
+ Two high-capacity cartridge sizes available: 330 ml and 700 ml.
+ Built-in 40 GB hard drive for faster job processing (spooling).
+ Built-in densitometer self-calibrates to assure consistent color and density.
+ Non-firing Detection and Compensation Function helps assure that nozzles are not clogged.
+ Two standard connectivity options: USB 2.0 and Ethernet.

The Canon imagePROGRAF 9000 really stands out from the crowd due to its 60-inch width, speed, and image quality. This class of Canon imagePROGRAF printers (iPF 5000, 8000, and 9000), with their dual print head design, are among the fastest print-ers on the market. As with most speed tests, judge for yourself whether the quality is acceptable at a specific setting and ask other users for their opinions.

Cost: About $15,000 (imagePROGRAF 9000) and about $6,000 (imagePROGRAF 8000).

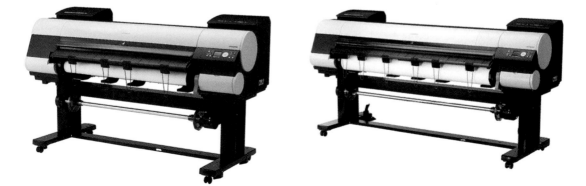

(Left) The 44-inch-wide Canon imagePROGRAF 8000. (Right) The 60-inch-wide Canon imagePROGRAF 9000.

Photographer: Andrew Darlow; **Image title**: *Barcelona 012*; **Print Size**: 17×22 inches; **Paper**: Hahnemühle Fine Art Pearl; **Printer Name**: HP Designjet Z3100; **Ink Used**: HP Vivera; **Driver**: Standard HP Driver (OSX); **Camera**: Sony CyberShot DSC-F828; **Lens**: Built-in Carl Zeiss 28-200mm; **F-stop**: f/3.2; **Exposure**: 1/30 sec.

Photographer: Andrew Darlow; **Image title:** *Sunflower Breeze*; **Print Size:** 18×22 inches; **Paper:** Epson Textured Fine Art Paper by Crane; **Printer Name:** Epson Stylus Pro 7600; **Ink Used:** Epson UltraChrome K2; **Driver:** Standard Epson Driver (OSX); **Camera:** Nikon N90; **Film:** 35mm Fuji Color Slide; **Lens:** Sigma 28-105mm w/screw-on filter-sized diopter lens; **F-stop & Exposure:** Unrecorded

Chapter 4

Color Management

Color Management Tips and Techniques

Color management can be confusing for anyone (even seasoned pros) to fully grasp. The sheer number of terms used, such as "relative colorimetric," "gamut mapping," and "assign profile," and the many types of hardware and software sold to help people implement color management, such as "spectrophotometers" and "monitor colorimeters," require significant time and effort to learn. However, by following a few tips and understanding some basic principals, you will be able to better control the color, density, and consistency of your prints, whether they originate as scanned film, digital captures, or from work created entirely on a computer.

In this chapter, I will cover some of my favorite hardware and software tools and offer tips for understanding and using color management. My focus will be on helping you to set up a system that works for you, regardless of your budget. Because there are so many products, terms, and concepts surrounding profiling and color management, I have compiled on the companion web site for this book a list of recommended resources, including links to many informative books and web sites, beginning with the International Color Consortium's web site (ICC, L4.1**).**

The ICC (International Color Consortium) was established in 1993 by eight industry vendors to establish cross-platform standards to help people better predict the color they will get from different devices. ICC profiles, such as the printer profiles you might see on printer and paper manufacturer web sites, are now used and recognized by many color management products and graphics hardware and software, including printer driver and RIP hardware and software, Photoshop, Photoshop Lightroom, and Apple Aperture.

To find the web links noted in the book (L4.1, etc.), visit www.inkjettips.com or http://www.courseptr.com/ptr_downloads.cfm.

Photographer: Andrew Darlow; **Image title**: *Orange Serenity*; **Print Size**: 18×22 inches; **Paper**: Epson Textured Fine Art Paper by Crane; **Printer Name**: Epson Stylus Pro 7600; **Ink Used**: Epson UltraChrome K2; **Driver**: Standard Epson Driver (OSX); **Camera**: Nikon N90; **Film**: 35mm Fuji Color Slide; **Lens**: Sigma 28-105mm w/screw-on filter-sized diopter lens; **F-stop & Exposure**: Unrecorded

Several different step-by-step workflows can be followed to make prints using proper color management. Because there are many different printer manufacturers, photo editing applications, and three major Operating Systems (Mac OSX, Windows XP, and Windows Vista), I've put together links to a number of driver- and application-specific workflows for Mac and Windows users (L4.2). These resources will be updated as new applications, printers, and operating systems are introduced and upgraded.

Two screen shots of the ICC (International Color Consortium) web site (www.color.org). Many helpful resources can be found by navigating through the links on the left side of the site.

TIP 58 Understand drivers, RIPs, firmware, and plug-ins.

Many mistakes related to color management are made due to incorrect settings in the software used to send images to printers. By understanding drivers, RIPs, and plug-ins, you can learn how to configure them properly. A printer driver is a program that converts data, such as photos and text, into the dots that are output on paper or other materials through a printer. When you click Print, you are almost always using a printer driver. RIPs (Raster Image Processors) are similar, but they often have additional features, such as image nesting (grouping multiple images on a single page). Additional information on RIPs can be found in Chapters 5 and 12.

Photographer: Andrew Darlow; **Image title**: *Yellow Blur*; **Print Size**: 18×22 inches; **Paper**: Epson Textured Fine Art Paper by Crane; **Printer Name**: Epson Stylus Pro 7600; **Ink Used**: Epson UltraChrome K2; **Driver**: Standard Epson Driver (OSX); **Camera**: Nikon N90; **Film**: 35mm Fuji Color Slide; **Lens**: Sigma 28-105mm w/screw-on filter-sized diopter lens; **F-stop & Exposure**: Unrecorded

All computers running Mac OSX and Windows come pre-loaded with printer drivers for many existing inkjet printers. That can be very convenient because it avoids the need to download software from a CD or from your printer manufacturer's web site; you just connect your printer to your computer via a cable (or wirelessly) and start printing. However, I generally recommend downloading the newest drivers and firmware from your printer manufacturer's web site because you will often find additional driver features and important compatibility updates there. Drivers can usually be found under the heading "Software and Driver Downloads," or "Drivers and Downloads."

A print plug-in is a piece of software that can simplify the printing process by allowing you to print directly from within a program (usually Adobe Photoshop). Firmware is internal software that enables a device, such as a printer, to perform many different tasks. Firmware can often be updated on printers to give additional functionality, such as faster print speeds, or to improve compatibility with different devices. One example would be a firmware update that allows additional digital camera models to print directly from the PictBridge port located on the front of an inkjet printer.

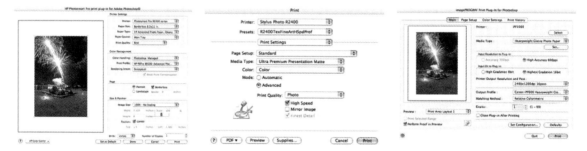

(Left) The main dialog box for the HP Photosmart Pro print plug-in for Adobe Photoshop, being used with the HP Photosmart Pro B9180 printer. (Center) One of the printer driver dialog boxes for the Epson Stylus Photo R2400. (Right) The main dialog box for the Canon ImagePROGRAF Print Plug-in for Photoshop, being used with the Canon ImagePROGRAF iPF5000 printer. All three are shown in Mac OSX. Very similar options are available for Windows XP and Windows Vista.

TIP 59 Understand the basics and benefits of color management.

Defining color management can be helpful to many who are unsure what the term means. Many people describe color management as the use of color profiles (often with the aid of hardware or software) to improve consistency and color matching between different devices. These devices include: digital cameras; scanners; monitors (also known as displays); digital projectors; and printers. So why should we bother learning this stuff, and why should anyone consider purchasing color management hardware or software? For photographers, printmakers, and other artists, implementing a color management system has many advantages. Here are four of the main reasons I employ color management in my workflow:

1. A color managed computer monitor (or multiple monitors) can help you to see your images with more accurate color, detail, and density. For example, as long as you have a good quality monitor and take into account things like room lighting, neutral colors should look neutral on your screen after calibrating and profiling. Also, if you were to bring a file to another company that uses color management properly, your images should appear very similar on their calibrated and profiled monitors.

2. With proper calibration and profiling, a color-managed system can help you to achieve better and more consistent display to print matching, and by using soft proofing (explanation to come later in this chapter), you can often better predict what your prints will look like before sending them to your printer, or to an outside service provider. That can save a significant amount of time, ink, and paper.

3. Better color matching is possible between different printers when using color management, even when making prints on devices that use different technologies, such as color laser and inkjet printers. This is beneficial whether you are trying to closely match output between two printers in the same room or between printers located on different continents.

4. Virtually any printer can be profiled, even if you don't own the printer, and even if you don't own any of your own specialized profiling hardware or software. A number of examples follow throughout this chapter, and additional step-by-step descriptions of how you can make custom output profiles for inkjet printers, as well as other printers, like color laser printers and continuous-tone photo lab printers, can be found on our companion site (L4.3).

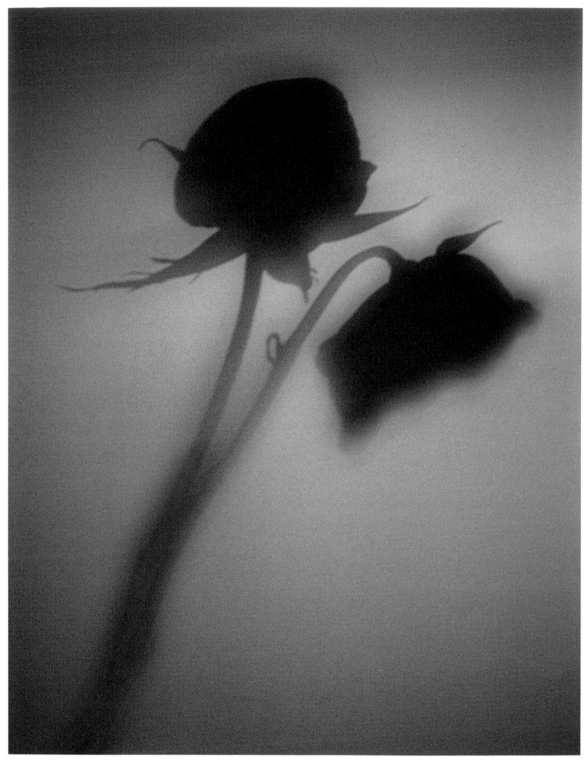

TIP 60 Learn the difference between calibrating and profiling.

Calibrating a device, such as a monitor or printer, is different from profiling a device. In photography and digital printing, calibrating means to bring a device, such as a flat screen monitor, to a repeatable operating state, usually with the expectation that it will maintain that state over days or months before having to be recalibrated. For example, a factory that makes Plasma or LCD flat panel TV displays will generally set all the individual units of a particular model to a certain calibrated standard, with the brightness, contrast, and color settings set to specific starting points. LCD computer displays are shipped to users in a similar fashion, with the brightness, contrast, or color level adjustment set at specific default settings. A monitor can then be calibrated more accurately using various software or hardware tools (see Tip 62 for more on monitor profiling software and equipment).

After you calibrate your monitor, you can create and install a profile for it so that your images will look more accurate onscreen. To help you understand what a monitor profile does, think of it as being like a Photoshop adjustment layer or curve that is applied to and "fixes" the images you see on your screen. On machines running Windows XP, Windows Vista, or Macintosh OSX, you can choose from existing monitor profiles, or you can create your own. Although you can create monitor profiles using only software, such as Apple OSX's built-in Display Calibration Assistant, I highly recommend using a hardware device for monitor profiling.

The issue of calibration also applies to inkjet printers. Most inkjet printers have print heads and use multiple inks, and as they age or when ink is changed, the tiny nozzles that eject ink from the print head can clog or become misaligned over time, leading to subtle changes in performance, such as lower ink output or less overall color saturation. These changes are referred to as *drift*. Indoor temperature and humidity can also affect consistency over time, or even right out of the box. For example, two printers that are calibrated at the factory may perform differently if they are operated in locations with very different climates or elevations. These issues and solutions to the problems are discussed in more detail in the following tip.

Printer profiles are small files that are usually stored on your computer, and printer profiling means creating a printer profile for a specific combination of paper, ink, and printer driver or RIP settings. Driver or RIP settings may include the paper type you choose in the driver (for example, Glossy Paper), the print quality you select (for example, 1440 DPI), or other specific settings. The best printer profiling results can be achieved with dedicated color management hardware and software, but you

Photographer: Andrew Darlow; **Image title:** *Roses' Shadow*; **Print Size:** 18×22 inches; **Paper:** Epson Textured Fine Art Paper by Crane; **Printer Name:** Epson Stylus Pro 7600; **Ink Used:** Epson UltraChrome K2; **Driver:** Standard Epson Driver (OSX); **Camera:** Nikon N90; **Film:** 35mm Fuji Color Slide; **Lens:** Sigma 28-105mm; **F-stop & Exposure:** Unrecorded

don't have to make your own profiles to get great results. Tips 63 and 64 have more information on printer profiling. When created and used properly, printer profiles can help you achieve far more accurate and consistent results.

What flavor is your profile? Profiles are generally categorized in the following ways: input profiles (for scanners and cameras); display profiles (for monitors and projectors); editing space (or working space) profiles, which are often embedded in digital files, such as JPEG or TIFF files; and output profiles (also known as printer profiles).

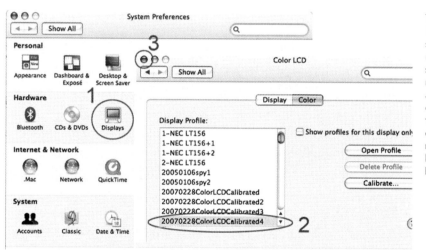

The Displays System Preference Pane in OSX showing previously created monitor profiles. The steps for selecting a monitor profile are noted in red from one to three, and can be accessed by choosing System Preferences from the Apple menu. Clicking on the word "Calibrate" on the right side of the window will launch Apple OSX's built-in Display Calibration Assistant.

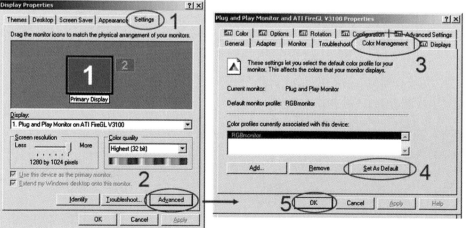

The Windows XP Advanced Displays Preference with available profiles showing. The steps for selecting a monitor profile are noted in red from one to five, and can be accessed by choosing Start>Control Panels>Display.

TIP 61 Understand calibration, maintenance, and linearization.

Calibrating printers is possible with a combination of auto or manual head align-ments, nozzle checks, and other tools. Also falling under the "maintenance" head-ing, head alignments help to keep your printer producing sharp output, and nozzle checks are especially important because, without reliable ink flow through your printer's inkjet nozzles, it is very difficult to make consistent prints. Every printer and operating system is different, so look for the printer utility software so that you can run tests or any necessary alignments or cleaning cycles. A number of companies have automated this process on many of their printers by adding auto nozzle checks, auto head cleanings, and auto head alignments. This can save a significant amount of time—just ask someone like me who prided themselves on how well they could read the somewhat cryptic manual head alignment patterns with a loupe.

Some people run a head cleaning, then an auto nozzle check, and then an auto head alignment before every new print session. Others skip those steps entirely until they see a visible problem, such as missing ink or a decrease in print quality. I recommend running two basic nozzle checks before every important print session (sometimes the first test will give a false positive because of the way ink is sitting in the heads). However, if you find that your printer consistently requires no head cleanings (some printers do periodic head cleanings when the machines are not being used), then you may be able to skip the step.

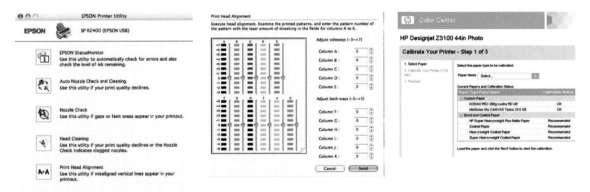

(Left) The Epson Printer Utility Screen for the Epson Stylus Color R2400. (Center) The manual head alignment utility for the Canon PIXMA iP90. (Right) The HP Designjet Z3100 calibration utility. A single custom or HP-branded paper can be linearized in about 10 minutes.

91

In addition to basic calibration/maintenance, some printers and software programs enable you to linearize your printer. Linearization is a type of calibration that can help bring a printer in line with the standards that are set by the manufacturer for the same brand of printer just coming off the assembly line. One way it works is by printing out a series of color bars on a specific paper. Those bars are then scanned by the printer and read back into the printer's memory. The 13-inch-wide HP Designjet Pro B9180 works in this way. In other cases, a linearization chart is printed and read off-line with a device such as the X-Rite i1PRO Spectrophotometer. Those measurements create a linearization file that is imported into the computer, and a printer profile is then made. Together, the linearization and profiling steps should help with color matching from print to print over time, and also between different machines that use the same approach, regardless of where they are located.

This also means that the vendor-supplied profiles, which are often loaded when you install a printer driver (or available on the manufacturer's web site), should perform better on your linearized machine because they were created on a machine that was originally producing color in a very similar way. A few printers on the market, including the HP Designjet Z2100, Z3100, and Z6100, have a spectrophotometer that's mounted on the printer carriage (L4.4). These printers can perform a "calibration," which is a linearization. The printer first outputs a linearization chart on virtually any media. The chart is then read by the built-in spectrophotometer, and the printer creates a calibration file for that specific media. After that, the printer can output a profiling target for the same media using the calibration settings, and the chart can be read using the machine's embedded spectrophotometer, resulting in the creation of a custom printer profile. Another advantage to this system is that from time to time, just new calibrations can be made on specific papers without having to make new custom profiles because the printer will be brought back to a "calibrated and linearized" state after a calibration is run.

Most RIPs, including the RIP made by ColorBurst Systems (L4.5) and bundled with the Epson Professional Edition series of printers, have a similar linearization option. In this case, linearization is performed by printing out a series of color bars, then reading those back into a computer with a device such as the i1PRO spectrophotometer. The main advantage is that once you run the linearization on a specific paper, the supplied profiles made by the RIP manufacturer (ColorBurst makes many available for Epson and non-Epson branded media) should give you very accurate output. The results I've seen on linearized Stylus Pro printers and the ColorBurst RIP are impressive. See Chapter 12 for more specific information about RIPs.

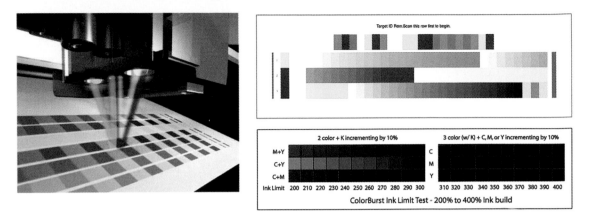

(Left) A calibration target for the HP Designjet Z3100, created with the printer's embedded spectrophotometer (the light is simulated, and shows how the spectrophotometer mounted on the printer carriage reads the color patches). (Right) A linearization chart and ink limit test, made with the ColorBurst RIP. The ColorBurst RIP is available in a number of different configurations and for a number of different printers. (Left) Image courtesy HP

Epson also makes available on some of its web sites outside the United States a free utility for linearizing printers called Epson ColorBase (L4.6). The utility also requires a spectrophotometer or similar device, and there are some helpful first-hand reports available online from users around the world (L4.7). This utility may be ideal for companies that own multiple machines of the same brand and model, for example, three Epson Stylus Pro 9800 printers, and it can also help to improve the quality of the many profiles that are available from the company.

However, in my opinion, the majority of people (especially if you operate your printers within the manufacturers' recommended temperature and humidity range) will see the greatest improvement in their print quality and consistency just by doing nozzle checks and head cleanings when necessary and by having custom profiles made for their specific printer, ink, paper, and resolution settings.

TIP 62 Set up, calibrate, and profile your display.

One of the most important steps for getting quality, accurate, and consistent prints is to calibrate and profile your computer monitor. Though your monitor will never give you an exact match to a print on paper, calibrating and profiling can improve things considerably. There are numerous hardware and software options for Mac and Windows users, and, for best results, I recommend using a hardware device known as a colorimeter or spectrophotometer. I've had very good success with products from ColorVision (the Spyder2 colorimeter, L4.8) and X-Rite (the Eye-One Display 2 and

i1PRO, L4.9). Both companies' web sites have information about hardware/software bundles, as well as resources for learning more about color management. Both X-Rite and ColorVision make their monitor calibration hardware available with different software in a range of user levels and price points. Pantone also offers monitor calibration and profiling tools in the $100 range (called the huey and hueyPRO) that are worth investigating (L4.10).

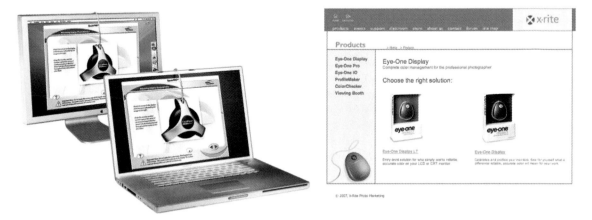

(Left) A ColorVision Spyder 2 colorimeter shown on both an LCD display and a laptop computer screen. (Right) Two monitor profiling hardware/software bundle offerings from X-Rite. (Left) Image courtesy Datacolor

Many variables go into monitor profiling, and a quick tip is to try to create a lighting environment that is consistent without letting too much light fall directly on your monitor. Overhead light and light from directly behind your monitor can create unwanted glare and reduce the accuracy of the images you are viewing. Some companies, such as EIZO (L4.11), which makes some of the finest LCD displays in the world, make monitor hoods for some of their products to shield them from some of the light in a room. A collapsible monitor hood can also be constructed inexpensively using black matboard and tape, and, for situations when you want to significantly shade a laptop screen, some companies, such as Hoodman Corporation (L4.12), make laptop shades to help eliminate glare.

Photographer: Andrew Darlow; **Image title**: *Barcelona 002*; **Print Size**: 24×30 inches; **Paper**: HP Artist Matte Canvas; **Printer Name**: HP Designjet Z3100; **Ink Used**: HP Vivera; **Driver**: Standard HP Driver (Windows XP); **Camera**: Sony CyberShot DSC-F828; **Lens**: Built-in Carl Zeiss 28-200mm; **F-stop:** f/3.5; **Exposure**: 1/320 sec.

(Left) A few of EIZO's LCD Monitor Hoods, shown on its standard and widescreen monitors. (Right) Hoodman Sun Shades are made in various sizes to fit a variety of different notebook computers.

TIP 63 Use and install supplied printer profiles.

Virtually every printer manufacturer ships printer profiles for the papers they offer along with their driver software. Many companies that make RIPs and many paper manufacturers also create custom profiles for their papers, which takes considerable time because each printer and paper combination that the company wants to support needs to have a unique profile. Many printer manufacturers update their profiles as new papers are introduced, so check manufacturer web sites for new profiles. For owners of Epson Stylus Pro printers, I highly recommend one particular set of profiles made for Epson by Bill Atkinson. They can be found in the driver download area on the company's web site.

Installing printer profiles is not always straightforward; I recommend reading the readme file (or PDF guide) that often comes with the profiles, and there are guides on our companion site that can help you navigate the waters on Mac OSX or Windows-based machines (L4.13).

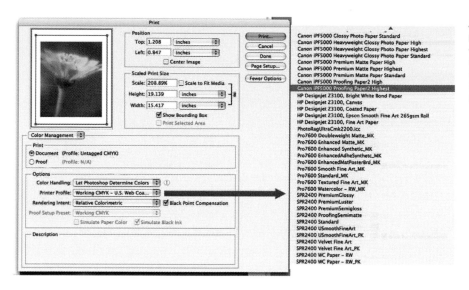

An example of printer profiles from a few different manufacturers viewed inside of Photoshop's File>Print with Preview screen.

TIP 64 Have custom profiles made, or make your own.

I've found that good custom profiles are the best choice for most photographers who want accurate and consistent results from their inkjet printers, because they are tailored to one specific printer—yours. Many companies and individuals specialize in making custom profiles for photographers, graphic designers, and other artists. Cost per profile generally ranges from about $25 to $100. Links to some of these providers can be found on our companion site (L4.14).

There are many hardware/software bundled options for making your own printer profiles. Two leading companies in the field whose products and support I respect greatly are ColorVision (L4.15) and X-Rite (L4.16). In 2006 X-Rite acquired GretagMacbeth, which resulted in a very significant partnership in the world of color management hardware, software, and training services. I've had very good success making custom profiles for both dye- and pigment-based printers with both the X-Rite i1PRO spectrophotometer and X-Rite i1Match 3 software, as well as with ColorVision's PrintFIX PRO 2.0, which includes the Datacolor 1005 Data Spectrocolorimeter patch reader and PrintFIX PRO software.

Numerous hardware/software bundles are available from both companies, and their prices have become well in the reach of many professional photographers and serious amateurs. I believe that a good way to help make a purchase decision is to first look at the options available, including costs, features, accessories and expandability

(whether there is an upgrade path), and then ask other users what their actual experiences are making profiles with different equipment. If you can work with a friend or hire a consultant who owns profile-making hardware and software, that is another excellent way to "try before you buy."

Four of the standout features of ColorVision's PrintFIX PRO 2.0 system with regard to making printer profiles are as follows: The user guide PDF and the help sections within the software are very comprehensive—both include a great deal of color management information, as well as step-by-step workflow advice to help make sure your displays and printers are working properly before creating custom printer profiles; the company has included an extended grays target, which can improve neutral and tinted black and white print quality on virtually any printer; the PrintFIX PRO software allows users to import curves from Photoshop (.acv files), which allows adjustments similar to what can be achieved when making RGB curves in Photoshop, but with the benefit of having the adjustments (for example, contrast curves) incorporated into your printer profiles; and the software includes targets for smaller printers or smaller media, including 4 × 6-inch and 5 × 7-inch sizes, as well as printable CDs and DVDs.

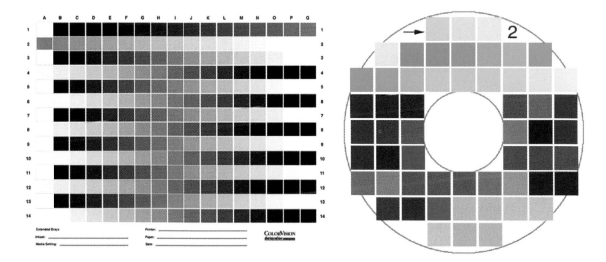

(Left) ColorVision's letter-sized extended grays target from its PrintFIX PRO profiling software. (Right) One of ColorVision's profiling targets for CDs and DVDs.

X-Rite makes available an extensive range of profile making and editing tools. X-Rite's ProfilerMaker 5 software modules are used by photographers, commercial off-set printers, packaging, automotive, and many other industries to help create and edit profiles. The software can be especially useful when used for making profiles for different types of lighting, or for spot color matching. Spot colors are specific colors, such as reflex blue or fluorescent orange, and they are often used to match logos or similar colors that fall outside the printable range of a standard printing press.

Most photographers, however, do not require one of the ProfileMaker software options. Instead, within the X-Rite family of products, I would recommend a more affordable option, with bundled hardware and software, such as the i1Photo LT. One of the advantages of the X-Rite hardware and software options are that they allow for multiple patch reading. For example, with the handheld X-Rite i1PRO spectrophotometer and a letter-sized profile target containing 288 patches, a strip of about 20 patches can be read in about 3 seconds for a total scanning time of about 4 minutes for the entire chart. In some cases, like with the X-Rite i1iO or X-Rite i1iSis spectrophotometers, completely hands-free patch reading is possible, allowing for much larger targets (even in the 2000-3000 patch range) to be read. However, the completely automated systems are more costly than the handheld options described in this Tip. The question of how many patches you really need to measure for good quality prints is one that can be debated—your experience will really be the deciding factor.

The ColorVision PrintFIX PRO Data Spectrocolorimeter needs to read one patch at a time with the user pressing the top of the device when measuring each patch. That being said, a 225 patch letter-sized chart will only take the average user about 5–10 minutes to read with the PrintFIX PRO 2.0 hardware and software. For those who wish to get the benefits of ColorVision's PrintFIX PRO extended grays target, that chart requires about five minutes to read, and the data from both targets is then used to generate a custom printer profile.

As mentioned in Tip 61, the HP Designjet Z2100, Z3100, and Z6100 printers have a unique feature—an embedded spectrophotometer mounted on the printer carriage used for both calibrating and making profiles for specific media. The system uses i1 color technology, and through an on-screen Wizard, it's possible to calibrate and make printer profiles for HP as well as non-HP branded media automatically, and within just about 25 minutes. It works by optimizing the placement and printing of a calibration target with 64 patches on roll media or sheets as small as A4 (8.3 × 11.7 in.). It then optimizes the placement of and prints a profiling target with about 465

profiling patches on roll media or sheets as small as A3 (11.7 × 16.5 in.). I've used the system successfully with a number of glossy, semi-gloss, and matte papers, as well as canvas.

Links to reviews and much more info from various manufacturers can be found on each company's web site, as well as our companion site (L4.17).

(Left) The Colorvision PrintFIX PRO 2.0 Suite. (Right) X-Rite's i1Photo family of products. (Left) Image courtesy Datacolor (Right) Image courtesy X-Rite

TIP 65 Consider dry down time and the patch reading surface.

Every paper, canvas, or other media will react to different types of ink differently. In general, dye-based inks need more time (up to 24 hours in some cases) to stabilize in color. Pigment-based inks will generally stabilize within 3–10 minutes on matte papers, and may require slightly more time on some films or glossy papers. You can do your own visual test by printing a color chart, such as those I make available on the book's companion site (L4.18). Then wait a day.

The following day, make a new print using the same settings, and, after printing, immediately view both prints under a color-controlled light, such as a 5000 degree Kelvin light box or a task lamp (see Chapter 14 for a number of suggested lighting options). Neutrals will probably show the greatest color difference (if there is any discernable difference). If you notice a difference, come back to the light box every 5 minutes to see if you observe any other changes. Measurements can also be taken with a spectrophotometer, which is a more accurate way to observe changes.

Photographer: Andrew Darlow; **Image title:** *Barcelona 001*; **Print Size:** 24×30 inches; **Media:** HP Artist Matte Canvas; **Printer Name:** HP Designjet Z3100; **Ink Used:** HP Vivera; **Driver:** Standard HP Driver (Windows XP); **Camera:** Sony CyberShot DSC-F828; **Lens:** Built-in Carl Zeiss 28-200mm; **F-stop:** f/2.5; **Exposure:** 1/200 sec.

However, people will be the ones looking at your prints (not spectrophotometers). If you note at what point you see no difference between the prints, that will be the time to wait before scanning a profiling target, or before making any color decisions, such as whether or not to do retouching in Photoshop.

With regard to patch reading, if you measure a target, it is a good idea to use a few sheets of the same paper that the target is printed on below the target so that the color of your table does not influence the measurements. X-Rite makes a very nice scanning ruler and foldable backing board which, together, help to keep profiling targets firmly in place, and I highly recommend it. I've taped down targets to a table with Gaffer's tape (or masking tape) in the past, which is a less elegant solution, but it helps to keep them from moving around.

(Left) A profiling target being read with an i1PRO Spectrophotometer and ruler with a few sheets of paper under it. (Right) A similar profiling target being read using an i1PRO, newer version of the ruler, and X-Rite's i1 foldable backing board. (Left) Photo © Andrew Darlow (Right) Image courtesy X-Rite

TIP 66 Soft proof and choose the right rendering intent for your work.

Soft proofing can help you to see what your prints will look like before actually printing. It's not an exact science, but it can be very helpful for quickly testing a few profiles (especially newly created custom profiles) to see if there are any strange irregularities, like big color shifts. Most photographers use Photoshop's built-in soft proofing tools, but soft proofing is also possible in other programs, such as ColorVision's PrintFIX PRO 2.0 software and Canon's ImagePROGRAF Print Plug-in for Photoshop. It's important to note that soft proofing depends on a good quality, well-calibrated display. A tutorial for soft proofing in Photoshop, and information about rendering intents, such as when to use Perceptual vs. Relative Colorimetric, can be found here: (L4.19).

TIP 67 Avoid double profiling.

Have you ever made a print and for some reason it has a ghastly shade of red (or other color) throughout? You may have output an image with settings that caused "double profiling." There are a number of ways to print using profiles, which can lead to this error. The problem usually occurs because a profile is selected in Photoshop's "File>Print with Preview" dialog box, along with the choice to "Let Photoshop Determine Colors," and when the file is sent to print, the driver software is not set to "No Color Adjustment" (on Epson printers), or "Application Managed Colors" (on HP printers). That means that Photoshop converted the file for printing "on-the-fly," and the driver software also used its built-in profiles to profile the data, leading to double profiling.

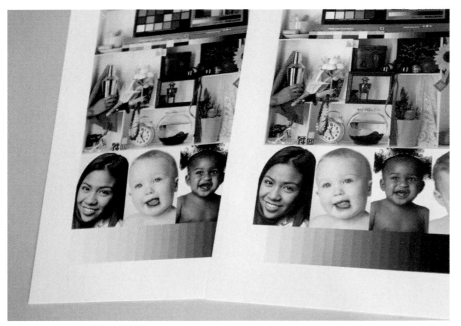

The inkjet print on the left was output incorrectly with settings that caused "double profiling." The print to the right was output properly using the same paper, and on the same printer.

TIP 68 Decide which working space profiles to use.

One of the most common questions asked by photographers is, "Which working space profile should I choose when converting RAW files, when scanning, or when setting up my digital camera?" Working space profiles (or editing space profiles) are generally embedded inside files, such as TIFFs, PSDs, and JPEGs. If you shoot in RAW mode, the working space profile setting (usually sRGB or Adobe RGB [1998]) that you can often choose in your digital camera, has no real meaning until you

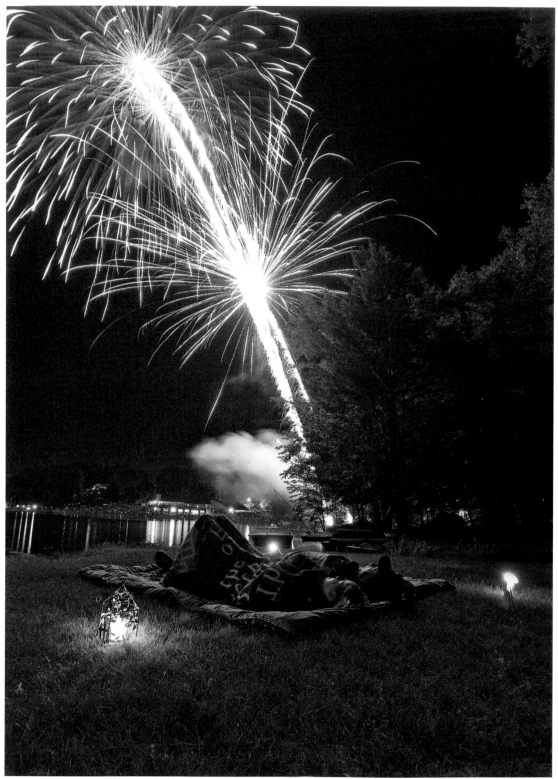

export your file and choose a working space profile using RAW processing software. When you scan film or a print, you will also have different working space profiles from which to choose. To capture a very wide range of colors, I recommend choosing ProPhoto RGB or Adobe RGB (1998).

Some of the most common working space profiles are sRGB, Adobe RGB (1998), ColorMatch RGB, and ProPhoto RGB. ProPhoto RGB is a color space with an extremely wide gamut, which means that it can hold a very wide range of color. This is primarily important because, as better monitors and more advanced printers are introduced, you are able to display and print more saturated colors. If you convert a RAW file from a digital camera and embed a very wide working space profile like ProPhoto RGB, then you will have an insurance policy as new technologies are introduced. However, if you export RAW files using a working space with a smaller gamut, such as sRGB, you cannot regain the additional colors that were lost by not starting with a wider working space. Over the last few years, I've primarily used Adobe RGB (1998), which has a smaller gamut than ProPhoto RGB, but I'm now converting many of my RAW digital camera files into the ProPhoto RGB working space when exporting them as 16-bit PSD or TIFF files, and I've been satisfied with the results.

Converting from a wide gamut working space to a smaller gamut working space can be done easily in Photoshop using Edit>Convert to Profile. This can be helpful when working with applications that are not "color management aware," like most Internet browsers. Because of this problem, a photo displayed on a web page that is in a wide gamut space, such as Adobe RGB (1998), will usually look desaturated when viewed in most browsers. The solution to this problem is to open the file in a color management-aware application like Adobe Photoshop, choose Edit>Convert to Profile, and then choose sRGB as the working space profile (be sure to then save it as a new file so that you retain the benefits of the larger color space profile).

When using wide-gamut working space profiles, it is critical to keep the profiles embedded in your files when moving files from computer to computer, and it is also important to know how to properly open and save files that contain embedded profiles. In virtually all cases, you want to "Use the embedded profile" when presented with a dialog box that asks the question, and always set your imaging program to warn you when opening files with a different embedded profile. In Photoshop, these can be set under Edit>Color Settings. Screen shots of Photoshop's Color Settings and Embedded Profile Mismatch dialog boxes can be found on page 106, and I recommend looking over some of the linked articles on the companion site that cover this topic in greater detail (L4.3). Also, in Chapter 12, Tip 199 has information about CMYK working space profiles.

Photographer: Andrew Darlow; **Image title**: *PA 001*; **Print Size**: 18×24 inches; **Paper**: HP Premium Plus Photo Satin; **Printer Name**: HP Designjet 90; **Ink Used**: HP Vivera; **Driver**: Standard HP Driver (Mac OSX); **Camera**: Canon EOS 20D; **Lens**: Tamron 11-18mm Di II; **F-stop**: f/4.5; **Exposure**: 13 sec.

(Left) Photoshop's Edit>Convert to Profile screen with sRGB chosen as the destination working space profile (circled in red). (Center) Photoshop's Edit>Color Settings area with the Color Management Policies outlined in Red. (Right) Photoshop's warning dialog box came up because the embedded profile (sRGB) did not match the Working Space Profile (Adobe RGB [1998]). "Use the embedded profile," selected in red, is the correct option to choose in this case.

For those who choose to shoot photographs with your digital camera in JPEG mode, I generally recommend that intermediate to advanced users choose Adobe RGB (1998) from their camera's menu settings. However, many people (including many pros) choose to use the sRGB working space for all their digital photos; sometimes that is the only option. For many situations—including making inkjet prints, online image uploading, gallery viewing, and photo ordering through an online photo sharing site like Flickr.com—sRGB can do a very acceptable job.

One advantage of using sRGB is that it allows you to have just one version of all your photographs, which makes photo management easier. I don't recommend that approach for most professional or advanced amateur photographers who will probably want to display and reproduce a broader range of colors, but it is certainly a valid approach for working with images and getting good quality prints. And if you do decide to shoot in JPEG and use sRGB, keep in mind that controlling exposure, particularly in the highlights, is critical to image quality.

There are many good arguments for using ProPhoto RGB and other working space profiles, and I've selected a few articles and books that are worth investigating to learn more about setting up color settings in Photoshop and other programs, deciding which working space profiles to use, and when to use "assign profile" versus "convert to profile" (L4.20).

TIP 69 Learn about color gamuts and tools for mapping gamuts.

Color gamut can be defined as all the colors that can be represented or reproduced by a specific device (or by human vision). The human eye can perceive a very wide range of color, from bright white to deep shadows. Most computer monitors can also display a very wide range of colors, but their color gamut is generally not as wide as the human eye. Most inkjet printer/paper combinations can also represent a wide

range of colors (especially on glossy papers). Every paper and ink combination has a gamut (or possible range of colors), which can be measured and mapped using software, and several software programs are available for viewing profiles in a 2D or 3D space.

Free and low-cost gamut mapping utilities are available for Mac OSX and Windows users. Mac OSX users can access a gamut mapping and gamut comparison application called ColorSync Utility, located in the Applications>Utilities folder, and links to a number of programs for Mac and Windows users, as well as related resources, can be found here: (L4.21).

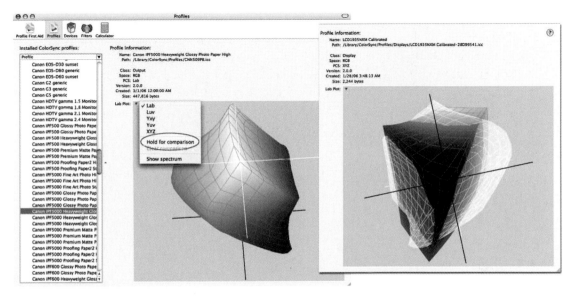

The ColorSync Utility, which comes with Mac OSX. On the left is one portion of a 3D gamut map of a printer profile. It represents a glossy paper printed on the Canon imagePROGRAF iPF5000 inkjet printer. On the right, after choosing "Hold for comparison," an NEC LCD monitor's gamut can be seen as a wireframe intersecting with the printer profile. The areas of the wireframe that poke out are areas of the color spectrum in which the monitor profile's gamut is wider than the Canon iPF 5000's printer's gamut (using that specific glossy paper's profile). Conversely, where the dark areas poke out, the printer/paper combo has a wider gamut than the monitor, based on the monitor profile that was used for the comparison.

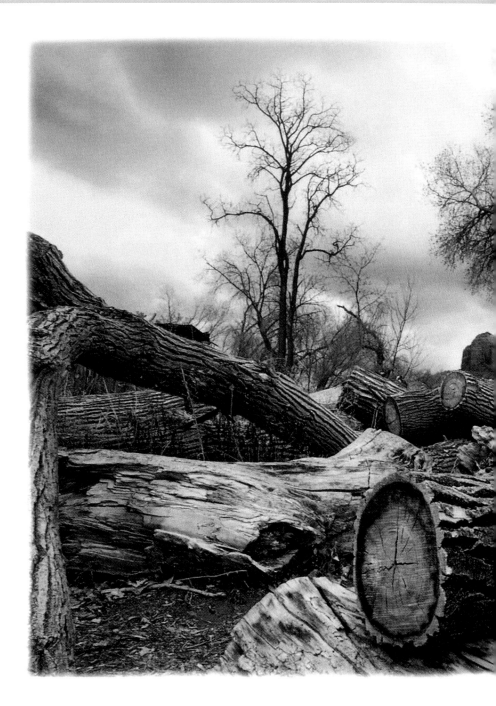

Photographer: Andrew Darlow; **Image title**: *Sedona 008*; **Print Size**: 30×20 inches; **Paper**: HP Artist Matte Canvas; **Printer Name**: HP Designjet Z3100; **Ink Used**: HP Vivera Pigments; **Driver**: HP Built-in Driver (Mac OSX); **Camera**: Nikon N90; **Film**: Ilford XP2 B&W film (developed in C41); **Lens**: Vivitar 17-28mm f3.5-4.5; APO, **F-stop** & **Exposure**: Unrecorded

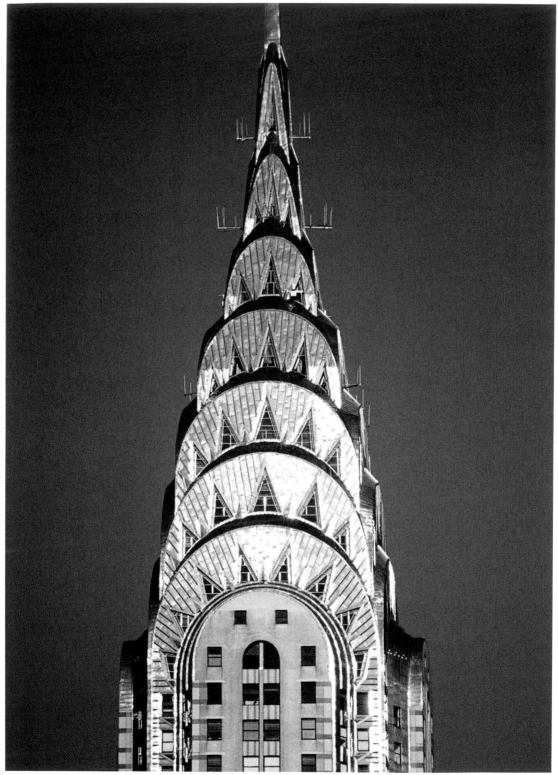

Black and White Tips and Techniques

There is something magical about a black and white print. The term *black and white print* has been widely used to describe monochrome (single-toned) or split-toned (multi-toned) prints traditionally made in a darkroom using the Gelatin Silver Print process. Alternative processes (L5.1) such as Cyanotype, Van Dyke brown, and platinum/palladium (Pt/Pd) prints are also often labeled as black and white. It's important to note that even if prints have a significant color tone, like a blue-toned Cyanotype or sepia-toned Gelatin Silver print, they are often classified as black and white. In the world of inkjet printing, we can create prints that resemble virtually any darkroom process, often with estimated longevity ratings that rival darkroom-processed prints.

The following tips will explore some of the many options currently available, with tips for improving the quality of your black and white digital files and prints. In addition to the information in this chapter, in Chapter 12, "RIPs, B&W, and Color Management," a few of our guest artists describe how they are using some of the most popular RIPs (Raster Image Processors) on the market today to produce their fine art black and white prints; and Chapter 8, "Specific Printer Tips and More," includes tips which can be used to make better black and white prints. And as usual, there are a number of recommended books and resources listed on our companion web site (L5.2).

Please note: A number of terms, such as gloss differential and bronzing are mentioned throughout this chapter. These terms and others are described in the opening section of Chapter 3, "Choosing an Inkjet Printer." Another set of terms often used are "toning" and "tinting." In a traditional darkroom, toning can be used to produce a certain color in a print, from warm to cool. Some popular toning formulas for Silver Gelatin are Selenium, Sepia or Gold Tone. In the digital darkroom, the word toning is still often used, but in addition, the term "tinting" is also used to describe when color is added to a single-toned (generally neutral) black and white image. Split toning has traditionally also been done in the darkroom, and usually

To find the web links noted in the book (L5.1, etc.), visit www.inkjettips.com or http://www.courseptr.com/ptr_downloads.cfm.

Photographer: Andrew Darlow; **Image title**: *Chrysler Building*; **Print Size**: 17×22 inches; **Paper**: Hahnemühle Fine Art Pearl; **Printer Name**: Epson Stylus Pro 4800; **Ink Used**: Epson UltraChrome K3; **RIP**: Epson Pro Edition (ColorBurst LE, OSX); **Camera**: Nikon N90; **Film**: 35mm Fuji P-800 color negative; **Lens**: Sigma AF 70-300mm f/4-5.6 APO; **F-stop** & **Exposure**: Unrecorded

results in highlights and shadows with different tones, such as cool highlights and warm shadows, or vice versa. Selective toning is something that can be done, and I like to employ that technique with some of my images. That's done by first converting an image to black and white, and then selectively toning a specific area. This can be seen in a few of the full-page images throughout this chapter, including *Dog on 45* and *New York 011*.

A range of simulated "toned prints," from cool (simulating a selenium tone), to neutral, to warm (simulating a sepia tone), to split-toned, to selectively toned. Photos © Andrew Darlow.

TIP 70 Look at books and darkroom prints as a guide for color and density.

There are thousands of history, art, and medical books with vintage and contemporary images reproduced from a wide range of prints or produced from scanned film or digital capture. By using these as a reference, a more "authentic" color and density range can often be more easily achieved in your prints. Of course, inkjet prints don't have to emulate any particular process, but there are certain qualities of darkroom prints (such as the look of film grain) that can be used as a visual guide when prepping files before printing. There are also many lessons that can be learned from examining darkroom-made prints, whether they are Gelatin Silver or an Alternative Process.

Many museums allow visitors to view their collections, or you might come across some gems at an antique store or outdoor market, which is even better since you can then purchase prints to use as a guide while you are working. Also consider the sharpness of your images. Some darkroom processes produce relatively soft images on certain papers, and some produce extremely fine detail. Test a few different levels of sharpness until you find just the right look.

TIP 71 Choose a color printer with multiple black and gray inks.

Due to the popularity of black and white printing, inkjet printer manufacturers have been creating inksets with multiple black and gray inks. Depending upon the company, the darkest black inks are generally called Matte Black or Photo Black, and the lighter shades of black have a number of names depending upon the manufacturer. A few of these names are Gray, Light Gray, Light Black, and Light Light Black. The reasoning behind this is that by using multiple black inks, high quality black and white images (especially neutral-toned black and white images) can generally be printed with less overall color ink compared to an ink set with just one black ink. Advantages of using less color ink in the mix are longevity (color inks generally fade faster than black inks) and a smoother, more even-toned Gelatin Silver darkroom look, especially when viewed with a loupe. In some cases, such as the HP Designjet Z3100 (L5.3), three or four of the system's black inks (and none of the color inks) can be enabled when printed by selecting "Print in Grayscale" in the printer driver. With this setting enabled, three black inks are used with semi-gloss or gloss media, and four black inks are used when printing on matte media.

I've made black and white prints (from cool- to warm-toned) on gloss and matte papers, as well as canvas, using printers from Canon, Epson and HP that contain a mix of multiple black inks and color inks. In my experience, all three companies' multi-black ink printers can produce darkroom-quality black and white prints. This makes it possible for photographers to achieve fantastic color and black and white prints from the same inkset. Canon's LUCIA pigments, Epson's UltraChrome K3 pigments, and HP's Vivera pigments are used by each company respectively in its branded pro-level printers. A few of the pigment-ink based printer models that fall into this category include the Canon imagePROGRAF iPF5100 (L5.4), Epson Stylus Pro 3800 (L5.5), and HP Photosmart Pro B9180 (L5.6). All three companies have produced inksets and software, such as Epson's "Advanced Black and White Printing Mode," and Canon's "Monochrome Photo Mode" that enable their users to easily

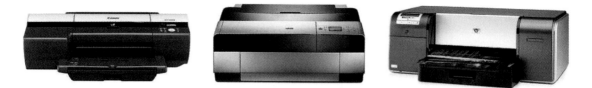

(Left) The Canon imagePROGRAF iPF5100. (Center) The Epson Stylus Pro 3800. (Right) The HP Photosmart Pro B9180. Photos courtesy Canon U.S.A., Epson America, and Hewlett-Packard, respectively.

113

produce very consistent black and white prints. For more information about printers with multiple black and gray inks, refer to Chapter 3, "Choosing an Inkjet Printer," and for specific tips for getting great black and white prints from some of these pigment-ink printers, see Chapter 8, "Specific Printer Tips and More."

TIP 72 Consider a dedicated black and white inkset.

For more than 10 years, companies have been developing ways to replace the standard color inksets designed by printer manufacturers with inksets that contain only shades of gray or a mix of grays and other colors, such as warm or cool grays. By adding some color to the mix, users can achieve toning effects similar to toned prints made in a traditional darkroom. I've tested some of the systems and have seen many stunning prints made with several of these inksets. In some cases, both a dedicated black and white inkset and software, such as a RIP, are required to get good results.

A few of the most popular companies offering dedicated black and white inksets are Vermont PhotoInkjet (L5.7), Lyson (L5.8), MIS Associates (L5.9), and Media Street (L5.10). Because this is a constantly evolving topic, I recommend joining a free online discussion group named *DigitalBlackandWhiteThePrint* (L5.11). It has extensive archives with a tremendous amount of information on the topic of dedicated black and white inksets, as well as information on black and white inkjet printing with

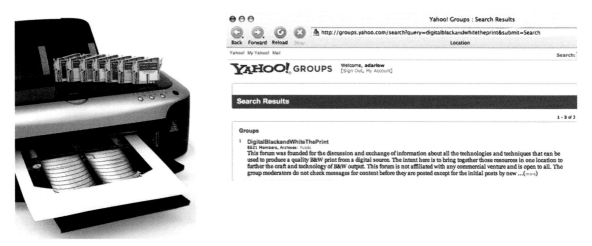

(Left) An Epson Stylus Photo R2400 printer with a set of Piezography Neutral K7 pigment inks in pre-filled cartridges from Vermont PhotoInkjet. This dedicated black and white inkset is designed for matte papers and canvas, but not glossy papers. For split-toning effects, one of the neutral inks can be swapped out for an ink from the company's Piezography Sepia K7 inkset. Also check the company's web site for new K7 inksets. (Right) A screen shot of the *DigitalBlackandWhiteThePrint* newsgroup's description page in the Yahoo! Groups directory.
(for the left image) Photo courtesy Vermont PhotoInkjet.

full-color inksets. You can post questions for the group's many helpful members to learn about their hands-on experiences with specific papers, inks, and printers. And there is also another Yahoo! Group specifically for users of Piezography inks (L5.12).

TIP 73 Print with a single black ink only.

In some cases, excellent quality prints with dots invisible to the naked eye can be made using just a single black ink. One advantage of this approach is that your print will be a single tone, and as long as you use the same paper, you can produce prints with the same tone, print after print. The disadvantages are that it is often difficult to avoid banding (small lines in your print), and it is also difficult with most printers to match the smoothness of an inkjet print made with multiple inks. Many printer drivers and RIPs have a setting that allows just a single black ink to be used, and here are a few things you can do to optimize the quality of black ink only printing. These tips can also be used to maximize output quality regardless of your printer and inkset:

✦ Do an automatic or manual head alignment and head cleaning. With just one ink being used, it is especially important to have your printer in optimum working order.

✦ Print a test chart with both gradients and images using different driver media types to determine if certain areas of the tonal scale look better with different settings. Links to a few test charts can be found here (L5.13).

✦ Print using your printer's highest quality output settings. I recommend making a few test prints using a few different quality settings (for example, 1440 and 2880 dpi). You will generally find that high quality black ink only printing requires unchecking "high speed." In some drivers or RIPs, choose "unidirectional" for optimum results.

✦ Check the archives and ask for advice from members of the "Digital Black and White the Print" newsgroup (mentioned in the previous tip). This is a popular topic that has been discussed widely, and many of the group's members are making high quality prints in this way. Every paper will also produce a different look, so getting advice from others who are having success with different printer, ink, and paper combinations can save you a lot of time and effort.

✦ Every image is different, but in general, optimize your images by having a good contrast range, without blowing out your highlights. Also, work in high-bit color when possible (for example, 16 bits/channel in Photoshop).

✦ You can print high quality black ink only prints while in various color modes (for example, RGB, CMYK, and Grayscale), but RGB or Grayscale mode are generally recommended.

✦ Good black and white conversions will help to make your black ink only prints look their best. See the following tip for suggestions for converting from color to black and white.

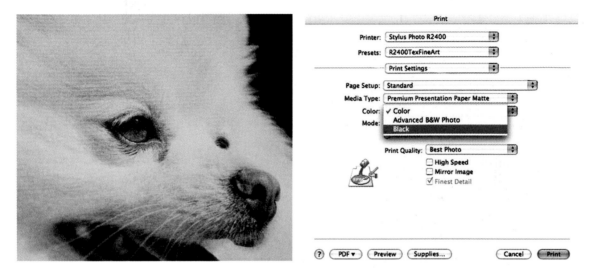

(Left) A close-up of a black ink only print showing banding. (Right) One of the Epson Stylus Photo R2400 printer driver's screens. Choosing "Black" under the section "Color:" allows for single black ink printing, as opposed to a mix of color and black ink printing with the other two choices. The highest quality setting (Best Photo) is selected under "Print Quality:" for the Premium Presentation Paper Matte media setting (setting "Media Type:" to other paper settings may allow only medium- or high-quality output settings to be chosen under the Print Quality section). High Speed (also under Print Quality) is off to help achieve optimum quality output.
(for the left image) Photo © Andrew Darlow.

TIP 74 Optimize your color to black and white conversions and toning.

Converting from color to black and white is as much an art as a skill. The most important thing to remember is that there is no best method for everyone. The best approach is the one that is within your budget, gives you results that you like, and the one which you can use effectively. You may even decide to use multiple tools depending upon the type of images that you are converting. Many books and articles have covered this topic, and new tools are being introduced every day to help photographers improve the look of their black and white files.

Photographer: Andrew Darlow; Image title: *Dog on 45*; Print Size: 17×22 inches; Paper: PremierArt Platinum Rag; Printer Name: Canon imagePROGRAF iPF5000; Ink Used: Canon LUCIA; Driver: Canon Print Plug-In for Photoshop (OSX); Camera: Hasselblad 500ELX; Film: Ilford XP2 B&W film (developed in C41); Lens: 80mm f/2.8 Planar T* CFE; F-stop and Exposure: unrecorded

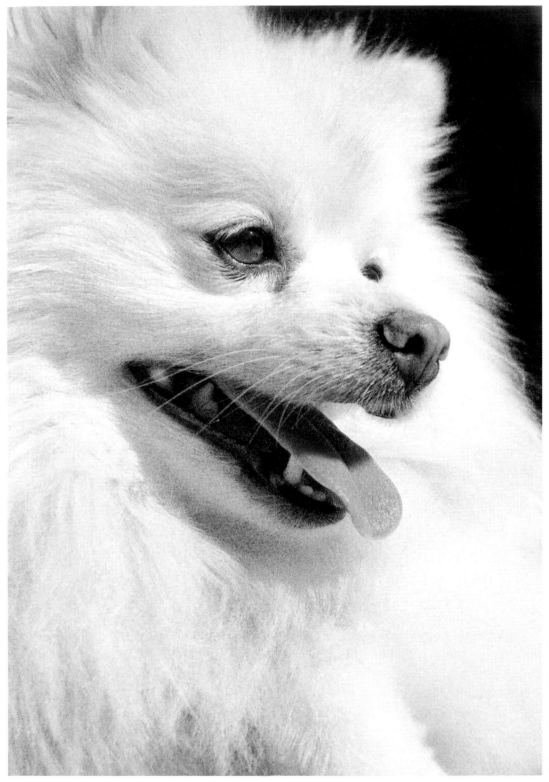

On the book's companion site, I've compiled a list of books, online articles, plug-ins, and software related to converting from color to black and white (L5.2). The value of shooting in RGB color or scanning color film—as opposed to setting your camera to grayscale, or scanning in grayscale—is that the three channels in an RGB file offer a tremendous amount of flexibility. Black and white film photographers have often used filters in front of their lenses, such as a red filter to darken skies. When you shoot in color, you can get similar results, but with far greater control, because instead of just one "film channel," you are capturing three separate channels of information, which can then be optimized to produce black and white images and prints.

There are a few standout tools that I like to use for converting to black and white and for simulating certain black and white films. Adobe Photoshop Lightroom's Grayscale Mix option (L5.14) is the first. Apart from having many other functions, within Lightroom's Develop module (under Grayscale Mix–circled in red, below left), Lightroom allows you to choose specific areas of an RGB file and then mix the RGB channels intuitively by first clicking on the Target Adjustment – Grayscale Mix button (circled in blue, below left). Scrolling with your mouse wheel, or pressing the up and

(Left) Adobe Photoshop Lightroom's Develop Module showing the Grayscale Mix option (circled in red) and the Target Adjustment - Grayscale Mix button (circled in blue). (Right) Lightroom's "Basic" section of the Develop Module, with the "Recovery" and "Fill Light" adjustments circled in green. The original color image prior to conversion is also shown. Notice how the green background was made almost black by adjusting that color range in the Grayscale Mix area of Lightroom.

Photographer: Andrew Darlow; **Image title**: *Canine 002*; **Print Size**: 13x19 inches; **Paper**: Hahnemühle Photo Rag Satin; **Printer Name**: Epson Stylus Photo R2400; **Ink Used**: Epson UltraChrome K3; **Driver**: Standard Epson Driver (OSX); **Camera**: Canon EOS-D60; **Lens**: Canon EF 16-35mm f/2.8L; **F-stop**: f/5.6; **Exposure**: 1/3000 sec.

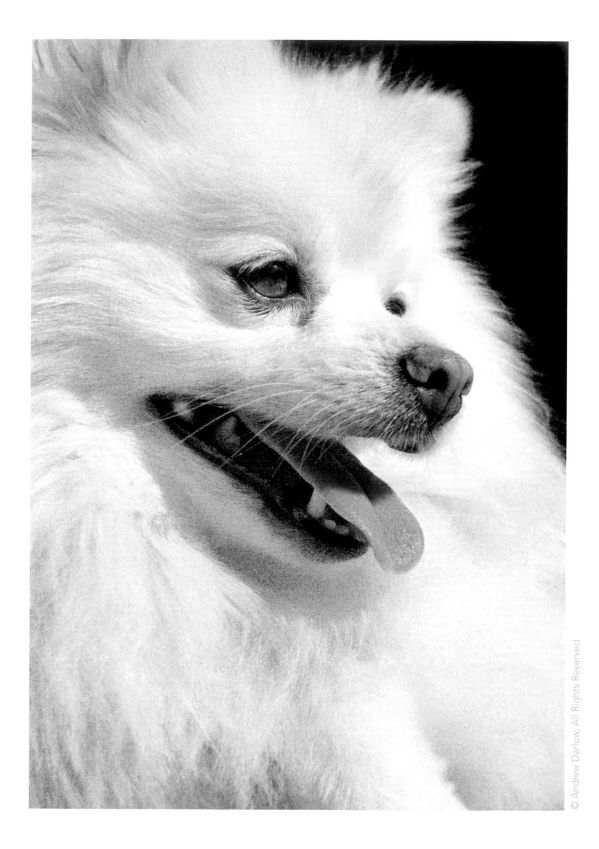

down arrows on your keyboard will mix the channels depending upon what color range you are targeting. It is especially powerful when used together with the "Recovery" and "Fill Light" adjustments available under the "Basic" section of the Develop module. The Recovery adjustment helps to bring detail back to the highlight areas, and the Fill Light adjustment helps to open up shadows while preserving overall contrast and detail. Settings can also be saved and applied to other images, or shared with others.

Please also note: The first full-page image of the dog on page 118, *Canine 002*, was produced using the Adobe Lightroom settings shown in the screen shot on page 119, and the second full-page image, on page 120, was toned using just the tinting control in Photoshop CS3's Black and White Adjustment interface.

Adobe Photoshop CS3's Black and White adjustment (Image>Adjustments>Black and White, L5.15) has a very similar interface, but works inside of Photoshop CS3. If you use it, I highly recommend first creating an Adjustment Layer. This will offer more control, and, more importantly, the adjustments you make can then be saved and applied to other images. An Adjustment Layer can be created by clicking the black and white circle at the bottom of the Layers palette, followed by selecting Black and White from the list of choices. Photoshop CS3's Black and White adjustment also allows for tinting to be done on images. Tinting is similar to toning in the darkroom, but this tool offers far more control over the range of color that can be produced.

Alien Skin Software's Exposure plug-in is also well worth checking out. It has an interface with presets that emulate many different film stocks, and in some cases, can produce what I like to call "clumpy grain." Certain classic black and white films, such as Kodak T-MAX 3200 have a unique grain structure that makes the grain appear to be clumped together. It is very easy to configure and save settings, and the preview window is fantastic. In general, if you plan to use any filter or plug-in, I recommend first optimizing your black and white files using a tool such as the two Adobe products mentioned previously.

And for those who want a very well thought out Photoshop tutorial on this subject and others, I recommend investigating Vincent Versace's black and white techniques, which are available in his book, *Welcome To Oz* (L5.16), or as video tutorials on DVD from Acme Educational (L5.17).

Photographer: Andrew Darlow; **Image title**: *Canine 002*; **Print Size**: 13×19 inches; **Paper**: Oriental Graphica Double-Weight Fiber-Based Smooth Glossy Paper; **Printer Name**: Epson Stylus Photo R2400; **Ink Used:** Epson UltraChrome K3**; Driver**: Standard Epson Driver (OSX); **Camera**: Canon EOS-D60; **Lens**: Canon EF 16-35mm f/2.8L; **F-stop**: f/5.6; **Exposure**: 1/3000 sec.

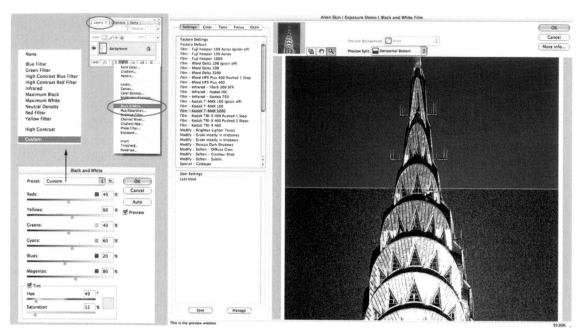

(Left, bottom) Adobe Photoshop CS3's Black and White adjustment interface showing the Tint adjustments (just the two boxes at the bottom) used to create the warm-toned full-page version of *Canine 002*. Some Presets, such as Infrared (to simulate infrared film) come with the Black and White adjustment and can be found by selecting the pop-up window next to "Preset." The tool works in a way very similar to Lightroom's black and white adjustment, and is primarily made to convert color images to black and white. (Left, top) The layers palette in Photoshop CS3 with the Black and White adjustment layer icon selected (circled in red). Selecting this brings up the same Black and White adjustment dialog box in a separate layer, which makes editing easier. (Right) Alien Skin Software's Exposure plug-in interface with the Black and White Film conversion setting, and the preset "Kodak T-Max 3200" setting. The "Horizontal Bottom" preview setting is used to show the before (top) and after (bottom). If OK is selected in this example, the image will take on a very grainy look, and it can be saved on a separate layer. This plug-in also has a channel mixing feature and many other creative effects.

TIP 75 Consider a RIP for better black and white.

There are many RIPs (Raster Image Processors) on the market that are used to produce both color and black and white inkjet prints. RIPs are in many ways similar to printer drivers. They convert the data in an image file or other document into the dots that are printed on paper or other substrates. In many cases, RIPs are purchased because of their ability to produce exceptional black and white (neutral and toned). Some of the most popular RIPs used by photographers are the following: ColorBurst RIP by ColorBurst Systems (L5.18); ColorBurst RIP LE (available with select Epson printers under the name "Professional Edition," L5.19); StudioPrint RIP by ErgoSoft (L5.20); ImagePrint RIP by ColorByte Software (L5.21); and Quad Tone RIP (L5.22). With the exception of the Quad Tone RIP, all of these RIPs are discussed in either Chapter 8 or 12, and each can help to produce top quality black and white prints.

Quad Tone RIP (L5.23) was created by a very talented photographer named Roy Harrington. It is an inexpensive and effective way for owners of many types of Epson inkjet printers (from letter size to 44 inches in width) to produce high quality, even-toned black and white prints. Quad Tone RIP is installed like a printer driver and can be run with printers using the standard Epson inksets, or by using a dedicated black and white inkset, such as the Piezography Neutral K7 inkset from Vermont PhotoInkjet. I've tested the system with a few different printers and full color inksets, including the Epson UltraChrome K2 inks in an Epson Stylus Photo 2200, as well as an Epson Stylus Pro 4000. With the UltraChrome K2 printers, I especially saw great improvements to the black and white output compared with the output from the built-in printer drivers. Many different tones can be achieved with the system, and they can be saved like any other print settings in the printer driver. When compared with the UltraChrome K3 printers from Epson and Epson's advanced black and white mode, the differences are not as dramatically different in my opinion, but I think that the RIP is still worth testing.

When installing the program on Windows-based machines, I recommend using QTRgui, a very user-friendly front-end to Quad Tone RIP, developed by Stephen Billard. QTRgui is incorporated into the Windows download. I would especially rec-ommend users of any of the Epson printers that use the UltraChrome K2 inkset and owners of the Epson Stylus Photo R800 and R1800 printers to try the Quad Tone RIP

Print from a cool/neutral tone curve.

Print from a warm tone curve.

Print from a sepia tone curve.

Print from 50/50 warm/sepia tone.

(Left) The Quadtone RIP Print dialog box. (Right) Four sample tones created by changing the Curves and Blending options in the Print dialog box.
Photos © Roy Harrington

because of the way it can improve the look of black and white prints made with those machines. There is also a QuadToneRIP forum, which is an excellent place to ask questions and learn more about how to get the most from the software (L5.24).

TIP 76 Buy a small printer and use it for proofing.

One of the people to whom I often look for advice on all things related to black and white printing is Paul Roark (L5.25). Paul's photography and prints are stunning, and he recommends that if you're not making more than a few prints every week, you should consider purchasing a letter-sized printer (or even a 13-inch-wide desktop printer), and use one of the many black and white printing options available. The desktop printer can then be used to make proofs to send to an outside printmaker who is using the same (or similar) inkset in a larger machine.

You'll find a similar tip in Chapter 1, but it's important to note here because certain dedicated black and white inksets, especially when used in printers in the 24- to 44-inch range, are susceptible to inconsistent output if not used on a consistent basis (about every few days). Since most people will not use their printer that much, Roark's advice can help save time and money in the long run. Roark also notes that having a similar printer with the same inkset as an outside printmaker can help reduce the amount of proofing that is necessary, and paper choice can be much easier once you've had a chance to experiment. That being said, a proof made with any inkjet printer (even if it is a different brand from the one used by your printmaker) can serve as a helpful guide for color and overall density.

Roark adds that the easiest way for a service bureau to match the output from your system is to send them a test print of a standard "21-step" test file (L5.25) that has been printed with your setup. These are easily read with a spectrophotometer, and a good service bureau should be able to match the test strip. Once a service bureau has matched your preferred paper and print tone, future prints using the same paper and profile should be very easy.

TIP 77 Use the gloss enhancer with compatible papers if available.

Some printers, such as the Epson Stylus Photo R1800 (L5.26) and HP Designjet Z3100 (L5.27), ship with a separate cartridge filled with a clear liquid called "gloss optimizer" (Epson's name for it) or "gloss enhancer" (HP's name for it) that, when used, can help even out the gloss differential and bronzing sometimes seen when printing with pigment inks and glossy or semi-gloss inkjet papers. In my testing on the HP Designjet Z3100 printer, the gloss enhancer had a very positive effect on

black and white prints, evening out the surface of multiple semi-gloss and glossy papers, while virtually eliminating bronzing effects. I've also seen glossy prints made on Epson Premium Glossy Photo Paper with an Epson Stylus Photo R1800 with the gloss enhancer enabled. The prints had a very smooth, mirror-like gloss finish, similar to a traditional Cibachrome print. Black and white images on gloss and semi-gloss papers with the gloss enhancer enabled can take on a super smooth "made in the darkroom" look and feel.

TIP 78 Coat your prints to reduce bronzing and gloss differential.

Spraying black and white prints with a lacquer-based fixative such as PremierArt Print Shield (L5.28) or a water-based coating (often used on canvas-based prints) can also help to reduce bronzing and gloss differential. Black and white prints are especially prone to bronzing, and coating can make a significant difference. Fixatives can also help to protect prints before binding them into books. Chapters 6 and 10 contain more information about coating paper and canvas, and include some important safety precautions.

TIP 79 Consider participating in a print exchange.

A print exchange is a great way to learn more about inkjet printing. I included this tip in this section because many of the best and most inspiring print exchanges in which I've had an opportunity to participate have centered on black and white printing. One common approach for a print exchange is for a group of people to each produce about 10 to 15 prints of the same exact image on the same paper, and usually within a specific theme (for example, black ink only printing).

Each participant then creates a text document describing the process they used, such as the name of the printer, type of ink, paper type, driver settings, and quite often, the process (film, camera, scanner, software used to process the file, 8-bit or 16-bit, and so on). Each person then mails the prints to a person who collates and ships out a collection of prints to all of the participants. You may be able to find ongoing print exchanges by posting a question about it or doing a search in the archives of the "DigitalBlackandWhiteThePrint" newsgroup described earlier in the chapter. Or consider starting your own!

A print exchange mailing package. Each participant sent the print exchange organizer a group of about 20 identical prints, and within a few weeks, each participant received a package with 20 different black and white prints. The print on the left is entitled *Clearing Storm* © Paul Roark, and the print on the right is entitled *Anasazi Ruin, Mule Canyon* © Roy Harrington. Photo © Andrew Darlow

TIP 80 Visit trade shows and exhibitions.

I highly recommend visiting exhibitions and trade shows, such as the PhotoPlus Expo, held in the fall of each year in New York City (L5.29). Events like the PhotoPlus Expo allow you to see hundreds of print samples made on a vast array of printers and papers, and with a variety of ink types. I recommend burning a CD with a few sample files of your work in sizes from 8 × 10 to 16 × 20, with both color and black and white images ganged up in each file in advance. Many companies will be more than happy to print your work at the show. This will allow you to get a better idea of a particular system's output quality before making a purchase. Exhibitions of black and white images are very common throughout the world, and one place to find exhibitions, gallery shows, and other events is at this link on our companion site (L5.30).

Photographer: Andrew Darlow; **Image title**: *Paris 011*; **Print Size**: 24×36 inches; **Canvas**: Hawk Mountain Papers Pallida Fine Art Canvas; **Printer Name**: HP Designjet Z3100; **Ink Used**: HP Vivera Pigments; **Driver**: HP Built-in Driver (Mac OSX); **Camera**: Nikon N90; **Film**: 35mm color transparency; **Lens**: Sigma 28-105mm f/3.8-5.6; **F-stop and Exposure**: unrecorded

(Left) The entrance to the PhotoPlus Expo in New York City. (Right) David Tobie, Product Technology Manager of Datacolor, Inc., shows two inkjet prints of his photographs made on an Epson Stylus Pro 3800 inkjet printer at the company's booth on the show floor at the PhotoPlus Expo. The prints (one black and white, one in color) were made using custom profiles generated with ColorVision's PrintFIX PRO Suite of profiling hardware and software, which includes an extended grays target to help achieve better black and white output from a wide variety of printers.
Photos © Andrew Darlow

TIP 81 Find appropriate papers for black and white.

There are hundreds of high quality papers on the market specifically made for inkjet printing. By choosing papers with slightly different shades (for example, warm white versus bright white), you can produce subtle, but noticeable toning effects. This can be especially useful if you are printing with black ink only, because the single ink will produce a single color. Color inksets that have multiple gray and black inks allow for a full range of toning, either by changing papers, by adjusting the image in a program like Photoshop, or by making adjustments in the driver or RIP.

In the past, my favorite paper types for printing black and white were matte papers and watercolor-based papers. However, a group of papers has emerged that I believe offers another excellent choice for black and white printing. Many of the papers in this class (L5.31), which I and a number of other photographers call "fiber gloss" and "fiber semi-gloss," have a look and feel similar to heavyweight air-dried glossy, semi-gloss, or matte fiber darkroom prints. What really sets them apart in many cases is their ability to reproduce very deep, rich blacks. See Chapter 6, "Inkjet Paper, Canvas, and Coating," for many specific paper tips and links to reviews and additional information.

Photographer: Andrew Darlow; **Image title**: *New York 011*; **Print Size**: 24×36 inches; **Canvas**: Piezo Pro Matte Canvas for Epson; **Printer Name**: Epson Stylus Pro 7800; **Ink Used:** Epson UltraChrome K3; **Driver**: Standard Epson Driver (OSX); **Camera**: Nikon N90; **Film:** 35mm color negative; **Lens**: Vivitar 17-28mm f3.5-4.5; **F-stop and Exposure**: unrecorded

TIP 82 Control your midtones and shadows with specific tools.

In recent versions of Adobe Photoshop, you will find a tool named Shadow/Highlight (under Image>Adjustments>Shadow/Highlight). The primary way I use it is to help reveal detail in the areas between the midtone and shadows (about the 50–90% density range on a scale from 0–100). Other software programs have similar tools, sometimes with different names, such as "Fill Light"(in Adobe Photoshop Lightroom), "Highlights and Shadows" in Apple Aperture, and "Shadows/Highlights" in Adobe Photoshop Elements. As long as you don't overdo it, I think you will be very impressed with the results of this tool when used on a wide variety of images. It is especially good for improving the look of outdoor night scenes, as well as tuxedos and other dark clothing when photographed during weddings and parties.

In Photoshop, the tool can be used with virtually all color modes, including Grayscale, RGB, and CMYK. The default settings in Photoshop will often be too strong, so I recommend you open one of your photos, or an image such as one of the test images that includes photographs. (L5.13 on our companion site has links to a number of these.) Then choose the Shadow/Highlight adjustment, select "Show More Options," set the sliders to a good starting point, and click on "Save as Defaults" in the bottom left of the dialog box. An often overlooked slider in the dialog box is the Midtone Contrast slider, which can also improve the look of many black and white or color images—both for images printed on inkjet printers, as well as those which will be printed using offset printing presses or laser printers.

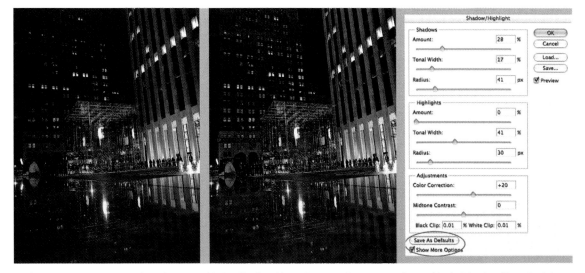

(Left) Image prior to using Photoshop's Highlight/Shadow filter. (Center) After running the Highlight/Shadow filter. (Right) The Shadow/Highlight filter's dialog box used for the image, with Save As Defaults and Show More Options circled in red.

When printed on a traditional offset printing press, such as those used by newspapers and magazines, many ink and paper combinations can result in images with "flat" midtones and shadows due to "dot gain." Dot gain is when a printed dot expands when it hits paper, and it occurs to some degree with almost every printer and paper combination. The Midtone Contrast adjustment, used with or without the Shadow/Highlight adjustment, can help to reduce "muddiness," or the apparent blending together of tones in an image.

In Chapter 16, Tip 295, R. Mac Holbert shares a step-by-step Photoshop technique for adjusting midtone contrast. I've found it to be very powerful and flexible, and I highly recommend following the steps or running the Photoshop action that is provided through a link in the same tip. To properly test the effect on your specific printer and media, it's a good idea to make prints before and after using the technique, and at different intensity settings. As described in the tutorial, the intensity is adjustable through the opacity setting in the midtone contrast layer that you create.

TIP 83 Keep your lighting in mind.

Most prints made with the latest pigment-based inksets from Canon, Epson, and HP (and some other manufacturers) will not show a significant change in color when moved between common types of light sources, such as daylight to indoor incandescent lighting. However, black and white prints are especially susceptible to slight shifts in appearance under different lighting conditions, and this can be especially problematic when evaluating prints containing people.

If you make a print that is visually neutral under warm incandescent light (like a standard light bulb—approximately 3000 degrees Kelvin) and then view the same print under daylight at noon (approximately 5500 degrees Kelvin), the skin tones may appear greenish (most people, as you may have guessed, would prefer not to look green in their photos). I generally check my prints in light that's 4000 to 5000 degrees Kelvin, which means that if the prints are moved into tungsten-balanced lighting, the image may appear warmer, which is generally more tolerated, compared with the green skin tone example. For more lighting information and resources, see Chapter 14, "Packing, Lighting, and Framing."

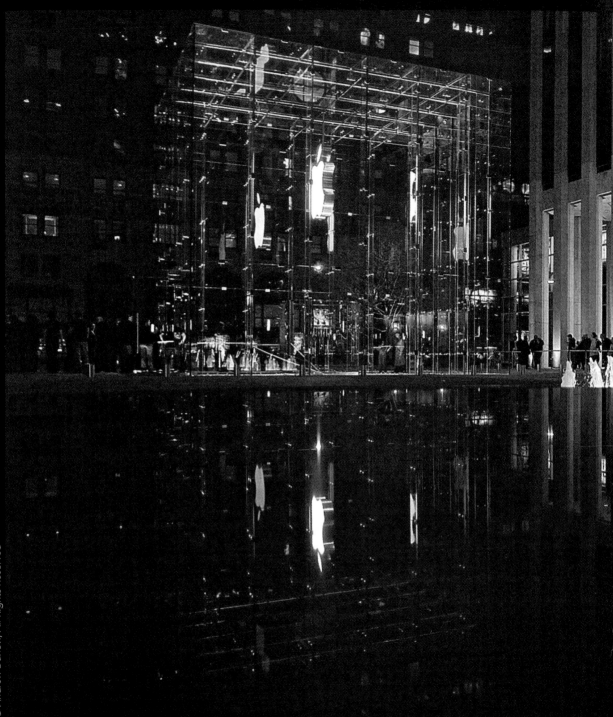

Photographer: Andrew Darlow; **Image title**: *59th and 24/7*; **Print Size**: 22×17 inches; **Paper**: Canon Heavyweight Satin;
Printer Name: Canon imagePROGRAF iPF5000; **Ink Used:** Canon LUCIA**; Driver:** Canon Print Plug-In for Photoshop (OSX);
Camera: Canon EOS-D60; **Lens**: Canon EF 16-35mm f/2.8L; **F-stop**: f/2.8; **Exposure**: 1/45 sec.

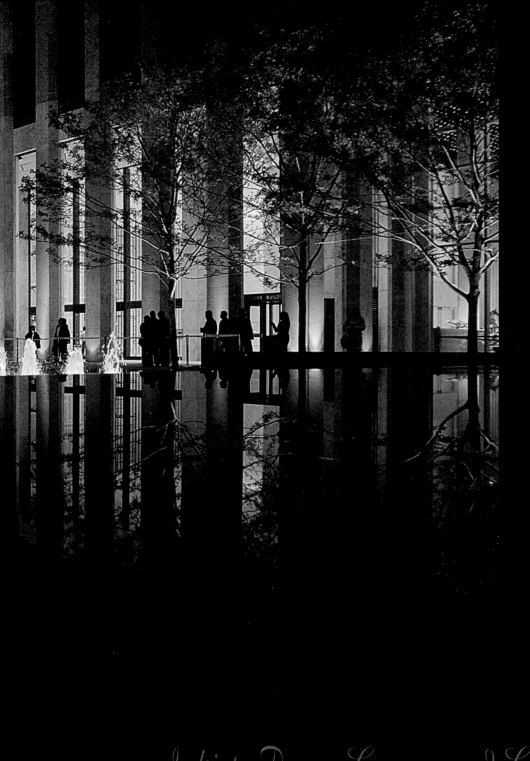

Chapter 6

Inkjet Paper, Canvas, and Coating

Inkjet Substrate Selection and Usage

The number of inkjet-compatible papers, canvases, films, and other substrates on the market today is staggering. Many office supply stores have huge sections filled with everything from pre-hinged scrapbook pages, to 500 sheet packs of inkjet-compatible office paper, to scored note card paper, to 13 × 19-inch packages of fine-art paper. Large camera stores that cater to professional and advanced amateur photographers usually have even more options. And if you search online, that's where the real fun begins. There are literally thousands of choices on the web from scores of manufacturers and suppliers. The following tips are designed to help clear the haze—first with recommendations for finding the right substrates for your printer, style, and budget, and then with suggestions for helping you to get the most from the products you choose.

Because there are so many papers, canvases, and other print materials on the market, with new papers being added on a frequent basis, I've put together a list of paper manufacturers, suppliers, and reviews on inkjettips.com (L6.1). And below is a helpful guide to understanding how paper thickness and weight are determined, courtesy of author (and this book's Series Editor, Harald Johnson) (L6.2).

To find the web links noted in the book (L6.1, etc.), visit www.inkjettips.com or http://www.courseptr.com/ptr_downloads.cfm.

Weighing In on Paper

When it comes to choosing among all the different types of papers for inkjet printing, two key paper characteristics are often misunderstood: weight and thickness. The standard measurement of paper weight for inkjet papers is grams per square meter (gsm). This is more accurate than the Imperial system that measures paper by its "basis weight," or the weight in pounds of 500 sheets of a standard size, usually 17 × 22 inches. Knowing a paper's weight is only partially useful information. A much more important thing to know is a paper's thickness, which is not necessarily related to its weight. Within one brand of paper, heavier weights may be thicker, but Brand X of one weight may be thicker than Brand Y with the same weight.

Caliper or thickness is a more useful paper measurement since each printer model prints best with papers of a certain thickness range (and have a maximum thickness they will print). A paper's caliper is measured in mils, also called "points" in commercial printing. One mil is 1/1,000th of an inch, and it is determined by the combination of substrate, additives, and coating.

(Excerpted from Harald Johnson's book, *Mastering Digital Printing*, Second Edition, Thomson Course Technology PTR)

Photographer: Andrew Darlow; **Image title**: *New York 012*; **Print Size**: 13×19 inches; **Paper**: Epson Premium Semigloss; **Printer Name**: Epson Stylus Photo R2400; **Ink Used**: Epson UltraChrome K3; **Driver**: Standard Epson Driver (OSX); **Camera**: Canon EOS-D60; **Lens**: Tamron AF18-200mm F/3.5-6.3 XR Di II; **F-stop**: f/5.6; **Exposure**: 1/6 sec.

TIP 84 Do some research before buying paper or other substrates.

Due to the number of inkjet-compatible papers, canvases, and other substrates on the market, a little research can help you narrow your search for a few appropriate paper options. There are thousands of online reviews by journalists and others who have tested many inkjet papers. A list of newsgroups, as well as individual links to recommended articles can also be found on this book's companion site (L6.3). One newsgroup that I moderate is called the digital fine-art group (L6.4). There you can ask questions of the 7,500+ members and search through the archives for many paper recommendations.

Two of the most common terms used in the industry are *acid-free* and *lignen-free*. The term acid-free is used to describe paper or canvas that is *basic*, with a pH level of 7 or higher. Lignen is an acidic part of wood pulp and can contribute to the yellowing of paper. Although environment plays a role, if you want to have your papers and canvases last for many years before turning yellow (or another interesting color), choose acid-free and lignen-free materials. Many inkjet products, whether made from 100% cotton rag or wood pulp, are acid- and lignen-free. Check material specs carefully to make sure.

Another tip is to look for sample packs of paper or swatch books from different companies so that you can test their product without making a large investment. One company I've known for many years, Hawk Mountain Papers, based in Pennsylvania, produces an impressive line of acid-free single- and double-sided art papers (L6.5). The company offers three different sample packs called "Starter Packs" with between 26 and 30 sheets each (most of them 11 × 17 inches in size). Each sample pack is affordably priced, and each pack also includes a coupon that can be used to save money when making a future purchase from the company. Five additional companies with sample packs (or sample rolls) that allow for experimentation with many high quality papers (or in some cases, canvases) include Breathing Color (L6.6), Inkjet Art Solutions (L6.7), Red River Paper (L6.8), Shades Of Paper (L6.9), and UltraFineOnLine (L6.10).

TIP 85 Consider glossy/semi-gloss RC inkjet papers.

For a combination of image quality, quick drying time, longevity, and value, many photographers select Resin-Coated (RC) inkjet papers. This class of papers is one of the most popular, and there are two major types: those with microporous coatings and those with swellable coatings. In most cases, papers with microporous coatings

Photographer: Andrew Darlow; **Image title**: *Arles 001*; **Print Size**: 30×40 inches; **Canvas**: Breathing Color Chromata White; **Printer Name**: Epson Stylus Pro 9800; **Ink Used**: Epson UltraChrome K3; **Driver**: Standard Epson Driver (OSX); **Camera**: Sony CyberShot DSC-F828; **Lens**: Built-in Carl Zeiss 28-200mm; **F-stop**: f/2.5; **Exposure**:1/2 sec.

should be used with pigment ink-based printers, and papers with swellable coatings should be used with dye ink-based printers.

Examples of high quality microporous papers that I've used successfully with pigment-based printers include: Canon Heavyweight Glossy Photo Paper (300gsm); Canon Heavyweight Satin Photo Paper (300gsm); Epson Premium Semi-Gloss Photo Paper (250gsm); Epson Premium Glossy Photo Paper (250gsm); HP Advanced Photo Paper, Satin-Matte (250gsm); HP Premium Instant-dry Satin Photo Paper (260gsm); Ilford Galerie Smooth Pearl Paper (280gsm); Ilford Galerie Smooth Gloss Paper (280gsm); Kodak Professional Inkjet Photo Paper-Lustre Finish (255gsm); Kodak Professional Inkjet Photo Paper-Gloss Finish (255gsm); Oriental Graphica RC Professional Luster Photo Paper (250gsm); and Oriental Graphica RC Professional Glossy Photo Paper (250gsm).

With certain inksets, such as HP's Vivera dye-based inks, swellable papers offer better longevity, better image quality, and protection from airborne contaminants (including ozone) compared with papers with microporous coatings. One of my favorite

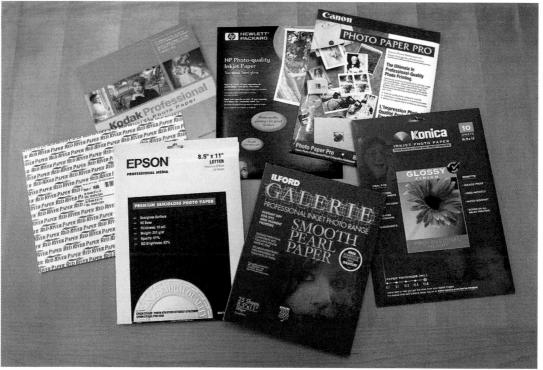

A selection of glossy and semi-gloss RC papers and their packaging.

swellable papers, which I've used with the HP Designjet 90 (18-inch-wide printer), is HP's Premium Plus Photo Satin Paper (L6.11). Another popular swellable paper that I've used successfully is Ilford Galerie Classic Pearl (L6.12). Also worth noting is Epson's Claria inkset (used in Epson's 13-inch-wide Stylus Photo 1400 [L6.13]). Even though the Claria ink is dye-based, it has received very good estimated longevity and water-resistance ratings on papers with microporous coatings. To see those ratings and a wealth of other printer and ink-related information, I highly recommend visiting wilhelm-research.com (L6.14).

TIP 86 Consider fiber gloss/semi-gloss inkjet papers.

For many years, the darkroom-made fiber print look and feel was difficult to achieve with inkjet-compatible papers. Recently, a new class of papers has come onto the market called fiber gloss and fiber semi-gloss inkjet papers, and when I first set my eyes and hands on a fiber semi-gloss print, I immediately fell in love. These papers bridge the gap between gloss and matte because they have a glossy or semi-gloss finish on the print side, but a cotton fiber or alpha-cellulose backing, without any RC base. There's a certain "made in the darkroom" look and feel to many of the papers in this class. Many of them are able to retain image detail and hold both deep shadows and bright colors, and they're especially impressive when used to print black and white images.

All the testing I've done on these papers has been with pigment-based inksets on pro-level printers from three manufacturers (Canon, Epson, and HP). There are many fiber inkjet papers I really like. One fiber semi-gloss paper that stands out is Hahnemühle FineArt Pearl (285gsm, L6.15). It has the feel of a fine darkroom-made print, with a smooth, yet slightly textured surface. I believe that pigment inks are currently the best choice for use with fiber inkjet papers because of their water resistance, shadow density, color gamut, and estimated longevity. However, some dye-based inks (especially the Claria ink set from Epson) may also perform well with these papers because of their favorable preliminary ratings from Wilhelm Imaging Research on some gloss and matte papers with coatings similar to those used on fiber gloss/semi-gloss inkjet papers.

Other papers in this class have a fiber base but look very much like glossy RC inkjet papers. However, their fiber base makes them feel more substantial in weight than comparable RC inkjet papers. A few examples include Innova Art FibaPrint White Gloss (300gsm, L6.16), Oriental Graphica Double-Weight Fiber-Based Smooth Glossy Paper (290gsm, L6.17), and Oriental Graphica Fiber-Based Glossy Photo Paper (320gsm, L6.18).

Most of the papers in this class perform best with the same inks and paper settings that would be used with glossy or semi-gloss papers, but one notable exception is PremierArt Platinum Rag (285gsm, L6.19). When printing on this off-white paper, the ink and paper settings normally used for matte papers should be used. Like most papers, this one is difficult to describe in words, but I will say that it is very "elegant," and particularly nice for black and white warm-tone portraits and landscapes.

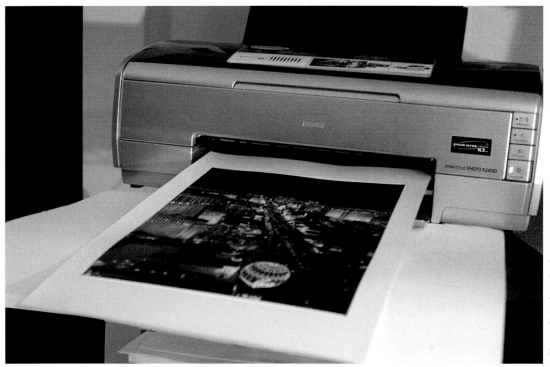

A 13×19-inch print on Oriental Graphica's FB Glossy Photo Paper after being printed on an Epson Stylus Photo R2400 (13-inch-wide printer).

TIP 87 Consider matte and watercolor inkjet papers.

This class of papers, like RC glossy and semi-gloss papers, is extremely diverse. There are single- and double-sided options, and many different weights, surface tones, and textures available, from very smooth, heavyweight art papers, to thin, textured sheets. In addition to cost, there are several items that should be considered when choosing a matte inkjet paper. On the following page are five recommended criteria to use before making a purchase.

Photographer: Andrew Darlow; **Image title**: *New York 013*; **Print Size**: 30×50 inches; **Canvas**: InteliCoat Magiclee Torino 20G; **Printer Name**: HP Designjet Z3100; **Ink Used**: HP Vivera Pigments; **Driver**: Standard HP Driver (Mac OSX); **Camera**: Canon EOS-D60; **Lens**: Canon EF 16-35mm f/2.8L; **F-stop**: f/2.8; **Exposure**: 1/30 sec.

✦ **The paper's weight.** Most inkjet papers are usually measured in gsm (grams per square meter). A medium-weight matte or watercolor inkjet paper is about 250gsm. Heavier papers are often good choices when making large prints because they will often sit flat under a mat in a frame without having to be mounted.

✦ **One- or two-sided coating.** Double-sided papers can reduce proofing costs because you can make test prints on both sides, and double-sided papers can also be a good choice for books, portfolios, business cards, and portfolio pieces.

✦ **OBAs (Optical Brighting Agents).** OBAs are clear or white dyes that are used to make papers appear whiter under visible light, and many matte papers, including acid-free art papers, contain them. Some papers contain no OBAs, such as Epson UltraSmooth Fine Art Paper (L6.20) and Hahnemühle Museum Etching (L6.21). Papers without OBAs generally have a print surface which is slightly warmer in color compared with papers that contain OBAs. I personally use several papers with OBAs for my print editions, and many paper manufacturers and end users have published information about this often debated topic (L6.22). Most vintage darkroom black and white fiber papers contained (and still contain) OBAs, and inkjet papers containing OBAs are more prevalent than those without OBAs.

✦ **Susceptibility to flaking.** Flaking looks like small pin holes in a paper's surface and is usually more apparent in the dark areas of a print. Flaking can often be reduced by brushing the print surface with a drafting brush before printing, but I recommend avoiding papers that are very prone to this problem, especially if you will be putting the prints in an album or in a portfolio where they will be stacked on top of each other.

✦ **Susceptibility to scuffing.** Scuffing can occur on the surface of a print from the printer itself as the paper is guided through the internal rollers and/or wheels. One of the most common reasons for scuffing comes from touching the paper surface before or after printing. Using cotton gloves when handling rolls of paper or canvas can help protect the fragile surface of many papers. Matting prints is one way to help reduce scuffing and flaking when showing prints. Using acid-free interleaving sheets in books and between individual prints is another way to help reduce scuffing and flaking (L6.23).

TIP 88 Consider matte, semi-gloss, or gloss canvas.

There is something very special about printing on canvas. Specially coated inket-compatible canvas can offer a look and feel similar to a 500-year-old oil painting (or a contemporary acrylic painting), and there are many different weights, surfaces, and materials available, including canvas made from 100% cotton or from blends of poly-ester and cotton (known in the industry as poly/cotton). One type is not necessarily better than another because there are many variables that contribute to each prod-uct. Though most canvases are sold on rolls, some can be purchased in sheet form.

You will need to consider several issues before purchasing any canvas. First, find out whether the canvas is considered acid-free. Then determine whether the canvas is appropriate for conventional stretching or mounting to a board. Then find out how many visible cotton seeds (if any) can be expected per square foot. Cotton seeds sometimes show up either as light or dark spots embedded in the canvas (especially 100% cotton canvas), and depending upon the canvas, seeds may protrude slightly from the surface. Also, it's good to know whether the canvas will show cracks in the printed area and/or coating when stretched on stretcher bars, especially where the canvas wraps around the edges of the artwork. A good quality canvas, plus a good spray or brushed-on coating, can reduce the chances of this occurring. And much like inkjet papers, every canvas also has a certain base color, from very warm to bright white.

Photo © Andrew Darlow

This close-up shows an inkjet-compatible matte canvas with some visible cotton seeds (the pencil is pointing to a seed). Next to it, on the right, is another canvas with virtually no visible seeds. Cotton seeds (especially when they look like dark spots) can sometimes end up in places where you don't want them, but depending on the work you are doing, they can create a look that helps add a genuine canvas feel to the art.

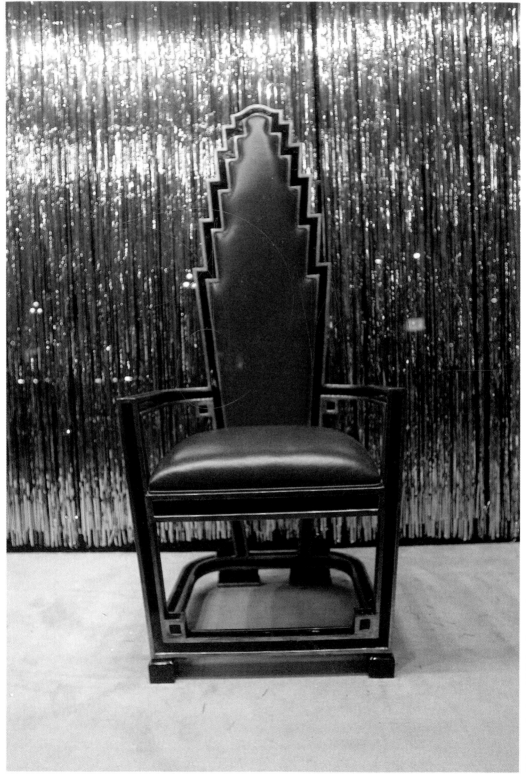

Examples of high quality matte canvas that I've used successfully with pigment-based printers include: HP Artist Matte Canvas (380gsm [L6.24]); Hawk Mountain Papers Pallida 19 Mil Premium Water Resistant Fine Art Canvas (L6.25); Piezo Pro Matte Canvas for Epson (375gsm [L6.26]); and Sihl 3647 Lisa Artist Canvas (350gsm [L6.27]). One particular high quality gloss canvas that I like a lot (especially for portraits) because of its elegant surface after printing with pigment inks (and ease of coating via spray) is the InteliCoat Magiclee Torino 20G 20 Mil Glossy Stretch 100% Cotton Canvas (L6.28). All canvas products, in my opinion, should be protected with a spray and/or brush-on coating (especially matte canvases). See Tip 92 later in this chapter for more about coatings.

TIP 89 Consider other substrates.

Gloss, semi-gloss, and matte papers are, by far, the most popular inkjet substrates used by photographers. However, many other substrates can be used creatively and for commercial applications. One popular group of products is "inkjet-compatible film." A subset of this group is film that look similar to high-gloss papers, called Glossy White Films. One product in this class that I've tested with pigment inks is Oriental Graphica Glossy White Film (L6.29). The paper is super-smooth and shiny, renders very sharp detail, and makes skin tones almost glow in certain light. However, like virtually all films, this product needs to be handled with care before and after printing because it is very susceptible to scratches.

Other products in this category are backlit films with built-in diffusion, made for trade show displays or any lightbox (or window, L6.30), and transparent films, used for display or creative uses, including image transfers to wood or handmade papers (L6.31). Transparent films are also used to create digital negatives for darkroom contact printing (L6.32). There are also printable films that turn into decals which can be applied to your favorite surfaces, such as iPods (L6.33). There are even inkjet-coated shrinkable plastic sheets that reduce in size about 75% when heated, and become hard plastic keepsakes— yes, I'm doing my part to help bring back the 70's (L6.34)!

Other inkjet-compatible products include iron-on transfer sheets (L6.35), inkjet-printable fabrics (L6.36), and papers with a canvas-like texture (L6.37). Another product type I particularly like is inkjet printable magnet sheets (L6.38), which can be used to create magnetic business cards, custom frames (just cut out the center area after

Photographer: Andrew Darlow; **Image title**: *San Francisco 001*; **Print Size**: 30x45 inches; **Paper**: Canon Heavyweight Satin; **Print Size**: 40x30 inches; **Canvas**: HP Artist Matte Canvas; **Printer Name**: HP Designjet Z3100; **Ink Used:** HP Vivera Pigments; **Driver**: HP Built-in Driver (Mac OSX); **Camera**: Canon EOS-D60; **Lens**: Canon EF 16-35mm f/2.8L; **F-stop**: f/2.8; **Exposure**: 1/30 sec.

printing), calendars, and other uses, such as advertising signs for the sides of cars or other vehicles. And one that really takes the cake (literally) is a complete edible ink system that can be purchased with edible icing sheets and an inkjet printer. This system allows you to reproduce images of you and/or your clients for placement on cakes, cookies, etc. Yummy (L6.39)!

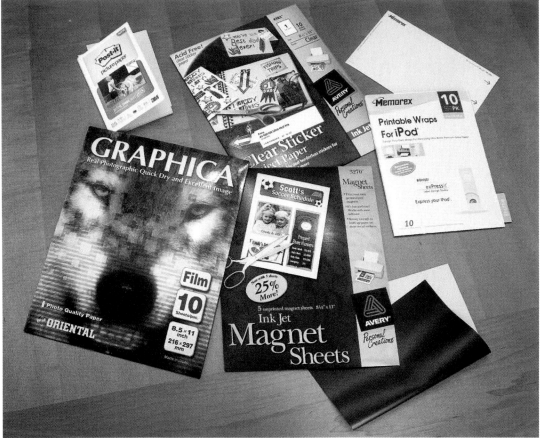

A collection of inkjet-compatible products. (Clockwise, starting from top left) 3M Post-it Picture Paper, Avery Clear Sticker Project Paper, Memorex Printable Wraps for iPod, Avery Magnet Sheets, and Oriental Graphica Glossy White Film.

Photo © Andrew Darlow

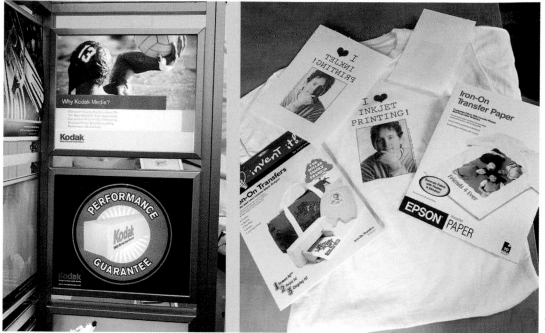

Photos © Andrew Darlow

(Left) Examples of a trade-show display using backlit inkjet materials. (Right) A few fabric transfer paper packages, with a printed transfer sheet and a finished T-shirt after ironing. I recommend finding a heat-resistant firm board to put under your T-shirt or other fabric, instead of a pillowcase, towel, or ironing board. A 12x36-inch-wide smooth, unfinished wood shelf from a hardware store worked very well for me when I did some transfers. I just placed the wood into the center of the T-shirt and ironed on the transfer following the manufacturer's directions. In the sample shown here, the art was trimmed to avoid letting too much of the clear transfer material show. If you add a square, circular, or irregular border (about 1/4 inch wide) around an image like this and then trim to just outside the border, you can avoid the "T-shirt transfer look" on the edges where the transfer meets the material.

With the two transfer papers I tested (their packages are shown in the photo), both left behind some yellow color on the transfer sheet in certain areas after the sheet was pulled away from the shirt, but that did not reduce the transfer quality. According to the manufacturers, virtually any dye- or pigment-based inkjet printer should perform well. Both brands worked well using matte or photo black ink from the two Epson pigment ink-based printers I used. I think that cloth bags and many types of jackets are ideal items to transfer artwork onto because the transfers are water-resistant when applied to most fabrics. Unlike clothing, bags and jackets don't have to be cleaned nearly as often, which helps preserve their vibrancy.

TIP 90 Use a gloss enhancer/gloss optimizer on semi-gloss and gloss papers.

This tip was also mentioned in the last chapter with regard to black and white tips, but it is important to mention here as well. Some printers, such as the Epson Stylus Photo R1800 and HP Designjet Z3100, ship with a separate cartridge filled with a clear liquid that, when used, can help even out the gloss differential and bronzing

sometimes seen when printing with pigment inks and glossy or semi-gloss inkjet papers. The gloss enhancer/gloss optimizer is applied in a way similar to any other ink at the same time a print is made, but it can be applied in a number of ways. Depending upon the paper used, you may find that using a higher quality printer driver or RIP setting will be necessary to avoid some mottling in your prints (especially with the gloss enhancer setting enabled—see photos below to see what mottling looks like). I've primarily seen this issue with some of the fiber semi-gloss papers (that class of papers is described in Tip 86). Most inkjet-compatible papers can be used with higher-speed settings without any mottling, and a quick test can help to determine how fast you can run your printer with or without the gloss enhancer.

Photos © Andrew Darlow

(Left) Example of "ink mottling" on Hahnemühle's FineArt Pearl, printed at medium speed on an HP Designjet Z3100. (Right) Notice the mottling is gone in this sample, which was printed on the highest quality setting. In both cases, the gloss enhancer in "Econo" mode helped even out the print surface, reduced bronzing, and gave the print slightly more protection from scratches.

TIP 91 Decide whether to use sheets, rolls, or both.

The decision to purchase papers, canvas, or other substrates as sheets or rolls can be a difficult one because each has its advantages and disadvantages. Here are some reasons I generally prefer cut sheets over roll media:

✦ Sheets generally come out of their package evenly cut to size, and ready to feed into a printer with very little handling and often without the need for any cuts after printing. Roll-fed paper and canvas, however, will need to be cut at some time. Thus, I find sheets less susceptible to damage compared with rolls.

✦ All the cut sheets in a specific package are virtually identical, unlike roll-fed paper, which tends to curl more as paper nears the end of the roll. Also, heavier papers tend to come off the printer with a curl, as opposed to sheets, which

Photographer: Andrew Darlow; **Image title**: *The Corcoran 002*; **Print Size**: 30×50 inches; **Canvas**: HP Artist Matte Canvas; **Printer Name**: HP Designjet Z3100; **Ink Used:** HP Vivera Pigments; **Driver**: Standard HP Driver (Mac OSX); **Camera**: Canon EOS 5D; **Lens**: Canon EF 16-35mm f/2.8L; **F-stop**: f/2.8; **Exposure**: 1/6400 sec.

149

are generally flat. This can make framing of roll-fed papers more difficult, even after working to flatten out the print. See Chapter 8 for a few tips to help flatten out roll papers.

+ In most cases, test prints can more easily and economically be made on cut sheet material. For example, on one letter-sized sheet, about five small test prints can be printed.

+ Switching between multiple types of paper to print projects or do testing is easier with sheets compared with rolls because most printers have only one roll holder.

And here are a few reasons why someone might choose roll media:

+ In a situation where you want to gang up multiple prints on a page and print them to a large format printer, roll printing can be more productive than sheet-fed printing.

+ Very long panoramas can easily be printed on roll media if sheets of that size are not available.

+ Roll paper can be cut down to many different sizes in advance and allowed to flatten.

+ Roll papers can be left unattended for extended periods of time while printing, especially if you use a media take-up roll, which is a roll that is used for the paper to wind itself around in order to easily transport the printed material.

+ Roll papers are also generally better when you want lamination and/or mounting to be done to your images, because many laminators are built to accept rolls.

With regard to cost, it is difficult to say whether sheets or rolls are more economical. Because of the greater amount of waste with roll paper (there is always some waste), sheets are often more economical in the long run. You may also be surprised at the similarity in price between 13 × 19- and 17 × 22-inch papers. This is probably due to the amount of waste that can occur when 13 × 19 sheets are cut down from larger rolls. In many cases, I personally would prefer to buy the larger sheets and cut them down, but it really depends upon what size printer you have, and whether you want to handle and cut paper. Some people just want to print, mat (or place in a portfolio), and be done, which I certainly respect.

TIP 92 Use sprays or brush-on coating options.

Post-print coating of inkjet papers, canvases, and other substrates can give them a very different look and feel, and in some cases, can significantly extend their estimated display life before noticeable fading or color shift. Post-print coating means to apply some type of coating after printing. Wilhelm Imaging Research has published the results of multiple accelerated tests that demonstrate the effects that some coatings can have on different inkjet papers and canvases. The specific coatings used in their published tests are PremierArt Print Shield Spray (L6.40) and PremierArt Eco Print Shield Coating (L6.41). I have successfully used PremierArt Print Shield Spray on many papers and canvases and recommend it highly. It comes in a handheld aerosol spray can and can add some contrast to matte inkjet papers and canvas without leaving streak marks. However, it can also reduce contrast when used on certain materials, so testing is suggested. It can also help to reduce bronzing and gloss differential (especially on gloss and semi-gloss papers). Like many sprays, it contains solvents, so it's important to use a mask in a properly ventilated area whenever it is used.

There are many non-toxic coatings that can add considerable density and protection to matte or glossy canvases, although I prefer to use them with matte canvases. I like using three- to six-inch-wide foam brushes (L6.42), and some of my favorite coatings are made by Liquitex because of the natural, varnished oil painting look that can be achieved when the coatings dry. To keep the product from drying too quickly, and to achieve a semi-gloss look, I mix four parts gloss Liquitex Gloss Varnish - Flexible Surface (L6.43) with two parts Liquitex Acrylic Permanent Matte Varnish (L6.44). I then add one part distilled water and mix it well. For prints under 16 × 20 inches, a 35mm film canister-full of the mixture is enough for two coats. The film canister is easy to fill, cover, shake, and then wash out or recycle. For larger batches, I use a larger plastic container to mix the contents.

I then tape the canvas to a piece of foam board (usually with painter's tape), pour the coating mixture into a disposable paper bowl, and apply the coating in one direction. After waiting a few seconds, I coat the canvas in the opposite direction. I then apply a second coat in a similar fashion a few minutes later. This hand-applied coating approach can also give a unique look (and protective surface) to matte inkjet papers. I've used the technique to coat a watercolor inkjet print that I then applied to the cover of a print portfolio. Another brand of non-toxic coating that I've used successfully is PremierArt Eco Print Shield (L6.45). Others can be found on the book's companion site (L6.46).

A company with a much more sophisticated coating setup is Fine Print Imaging, located in Ft. Collins, Colorado (L6.47). The company works with many professional artists and photographers and has a large dedicated spray booth and prep room to handle large canvas prints.

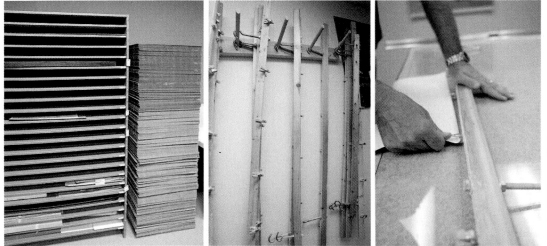

Photos © Andrew Darlow

(Left) One of the many print racks at Fine Print Imaging. They are used to hold original artwork or customer guide prints prior to being scanned, and then prior to being shipped back to clients. (Center) Custom-made holders for canvas produced by Fine Print Imaging, produced using wood, metal hooks, and commonly available mini spring clips (L6.48). (Right) A demonstration of how the canvas can be easily attached to a holder. Note that the clips are on the opposite side of the holder. The clips are opened by applying pressure to the back of the canvas holder.

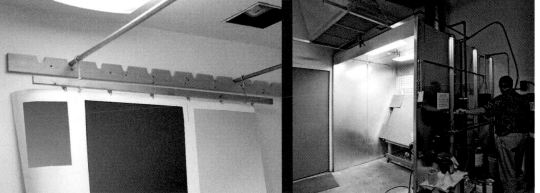

Photos © Andrew Darlow

(Left) The canvas prep room and drying area (also called the curing room) at Fine Print Imaging. Artwork is hung in the room to dry after printing, and the art is returned to the room for 30 minutes to an hour between coatings and after the final coating. Most canvas prints are coated twice. The artwork on the canvas shown in the photo has been replaced with the green, gray, and blue areas to respect the privacy of the artists. (Right) Mark Lukes, the company's president, turning on the air exhaust and ventilation system in the spray booth area at Fine Print Imaging.

Photographer: Andrew Darlow; **Image title**: *New York 014*; **Print Size**: 17×22 inches; **Paper**: Hahnemühle Photo Rag Pearl; **Printer Name**: Canon imagePROGRAF iPF8000; **Ink Used:** Canon LUCIA**; Driver:** Standard Canon Driver (Windows XP); **Camera**: Canon EOS-D60; **Lens**: Canon EF 16-35mm f/2.8L; **F-stop**: f/8; **Exposure**: 1/500 sec.

TIP 93 Use inkjet-compatible labels for tracking, exhibitions, and more.

Though not very glamorous, a very popular category of media is inkjet-compatible address shipping labels (clear and opaque). If you, like me, are someone who enjoys testing many types of papers and other materials, I highly recommend labeling the back of all your test prints and the inside of your roll materials with the exact name of the paper or material. This can be done by writing on address labels (L6.49) and placing them on the material, or by using a pen, pencil, or marker directly to the back of the print. You can also pre-print labels with headings, such as Printer Name, Profile, and Driver/RIP settings. After writing in the information, you can then just affix the label to the print. This subject is also covered in Chapter 2 (Tip 27).

Inkjet-compatible address labels are also a very good choice for use as placards during exhibitions (they go on the wall next to prints and usually include the artists name, process and image title). These generally do not damage the walls, which is another significant benefit. They can also be adhered to the back of prints and mats, or to a clear plastic bag that's holding a matted print. And, of course, you can use them for just about any type of mailing. Be sure to do a test first before printing a full sheet, just in case your printer's ink is not compatible. Some labels may not say inkjet compatible, but they still may work fine (especially if you are just printing text). Some labels will be more water-resistant than others, which is an important consideration for mailing.

(Left) A print and roll, both labeled with an Avery self-adhesive label. (Right) A print on the wall during an exhibition at the Center for Fine Art Photography in Ft. Collins, CO (L6.50) with two clear inkjet-compatible self-adhesive labels used as placards. The labels shown are Avery #8663 (L6.51). The show placards were printed on a dye-based inkjet printer—most labels are compatible with dye- and pigment-based inkjet printers.

Photographer: Andrew Darlow; **Image title:** *L.V. 008*; **Print Size:** 17×22 inches; **Paper:** Epson Ultra Premium Photo Paper Luster; **Printer Name:** Epson Stylus Pro 3800; **Ink Used:** Epson UltraChrome K3; **Driver:** Standard Epson Driver (OSX); **Camera:** Canon EOS-D60; **Lens:** Canon EF 16-35mm f/2.8L; **F-stop:** f/4.5; **Exposure:** 1/4 sec.

Photographer: Andrew Darlow; **Image title**: *Faces 004*; **Print Size**: 22x17 inches; **Canvas**: InteliCoat Magiclee Torino 20G Glossy Canvas; **Printer Name**: HP Designjet Z3100; **Ink Used:** HP Vivera Pigments**; Driver:** HP Built-in Driver (Mac OSX); **Camera:** Canon EOS 5D; **Lens:** Canon EF 28-135mm IS; **F-stop:** f/11; **Exposure:** 1/160 sec. (w/ strobes)

Portfolio and Presentation

Portfolio and Presentation Options

An inkjet print on paper, canvas or other material can definitely be enjoyed, shared and/or sold as is, right out of a printer. However, when prints are placed in mats, portfolio cases, boxes, portfolio books, albums, scrapbooks, or frames or stretched on stretcher bars or mounted to materials like acrylic or other substrates, a transformation occurs. Many commercial and fine-art photographers use portfolio books to present their work to potential clients. Because of the flexibility of paper options, there are many self-promotion materials that can also be produced using inkjet printers, such as business cards and unique leave-behinds.

In this chapter, a number of tips and techniques related to portfolios and the presentation of work will be discussed and explained. With so many options available and new products constantly being added, additional links and information can be found at www.inkjettips.com (L7.1). Also see Chapter 11 for more tips related to this topic.

(Left) Five inkjet prints displayed on a table. Each was output on coated watercolor paper, and measures approximately 18 × 24 inches. (Right) One of the five prints, entitled *Orange Serenity*, shown framed and displayed with two other flower prints during an exhibition in New York City.
Photos © Andrew Darlow

To find the web links noted in the book (L7.1, etc.), visit www.inkjettips.com or http://www.courseptr.com/ptr_downloads.cfm.

Photographer: Andrew Darlow; **Image title**: *Roses are Red*; **Print Size**: 17×22 inches; **Paper**: Hahnemühle Museum Etching; **Printer Name**: Epson Stylus Pro 7800; **Ink Used**: Epson UltraChrome K3; **Driver:** Standard Epson Driver; **Camera**: 4x5 Sinar P2 w/ a Leaf DCB I Back; **Lens**: Sinaron Digital 60mm; **F-stop & Exposure**: unrecorded

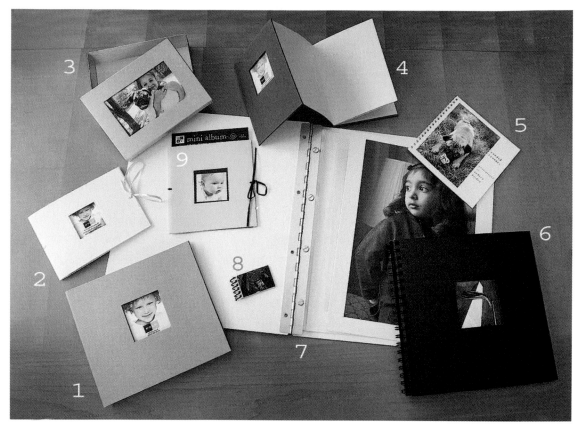

A small sampling of portfolio and presentation options that can be used with inkjet prints. A short description of each follows: (1) Kolo Cortina Lux Scrapbook; (2) Kolo Vineyard Paper Album. It has a saddle-stitch binding with two staples; (3) Pina Zangaro Boro aluminum photo box; (4) Kolo Toto Accordian Photo Album; (5) Hand assembled book, bound using white double loop Wire-O wire closures and a hand-operated binding machine from James Burn International (Model EB-32); (6) A simple wire bound book from an art supply store. Two pieces of heavy faux-leather covers with about 50 sheets of heavy black acid-free paper inside give the album a high-end look and feel. A window is cut out to allow the first photo to show through; (7) Pina Zangaro Vista 14×11 Screwpost Cover (Style: Snow). Screwpost books are also called "post-bound." A Pina Zangaro 14" clear Adhesive Hinge Strip is attached to the left side of the inkjet print shown in the photo, which allows it to be easily bound into the portfolio; (8) A small, business-card sized book with black plastic coil binding; (9) Matchmakers DCWV Mini Album. It has a saddle-stitched binding with one staple.

Featured photos, except for the Kolo and Matchmakers products © Andrew Darlow. Product photo © Andrew Darlow.

Photographer: Andrew Darlow; **Image title**: *Faces 003*; **Print Size**: 18×24 inches; **Paper**: HP Premium Plus Photo Satin; **Printer Name**: HP Designjet 90; **Ink Used**: HP Vivera Dye Inks; **Driver**: Standard HP Driver (Mac OSX); **Camera**: Canon EOS 5D; **Lens**: Canon EF 28-135mm f/3.5-5.6 IS; **F-stop**: f/13; **Exposure**: 1/160 sec. (w/ strobes)

TIP 94 Consider albums and portfolio books with plastic sleeves.

There are hundreds of albums and portfolios on the market that are essentially books with clear plastic sleeves, ready for prints to be inserted. The names of the plastic materials used include acetate, polyester, polypropylene, or vinyl. In some albums and portfolios, plastic is attached to a paper backing, and in other cases, the whole page is made from a plastic material. Page sizes generally range from traditional photo albums with 4 × 6 inch pockets to books 11 × 14 inches or larger. The primary advantages of these types of books are that they keep prints protected from handling and allow for frequent rearrangement and replacement of prints. The primary disadvantages are that the prints usually look more subdued behind the plastic, the plastic sheets can get damaged, and the "romantic" feeling of ink on paper (especially with matte paper) is in many ways lost. If you do choose to protect your work with any type of plastic material, make sure that it is free of PVC (polyvinyl chloride), which can damage inkjet prints, photographs or other printed materials.

Depending upon the materials used, the price of these books will vary widely, but a good quality 11 × 14 inch off-the-shelf portfolio book from a company such as PRAT (L7.2), whose products are very stylish and well made, can be found for about $50-75. Another company whose products I've used is Itoya (L7.3). Itoya makes many popular and affordable portfolio books, as well as portfolio books with built-in easels for holding prints, which are good for small group presentations. Lineco (L7.4) also offers a number of top-load post-bound pages with plastic protective pages in its PopArt Digital Series.

Custom-made portfolios, from companies such as The House of Portfolios in New York City (L7.5) can cost significantly more, but a custom portfolio can give your presentation a very distinguished look and feel. Custom portfolios are generally made by hand, and one common feature of custom portfolios that I recommend is to have your name and/or logo foil stamped or debossed on all of your protective cases or portfolio books. Even off-the-shelf books can be stamped, and this small detail can make a significant impact. The House of Portfolios web site FAQ section has a lot of good information, including suggestions for how to choose the right type of pages for your portfolio. The site also contains a very interesting virtual "Plant Tour."

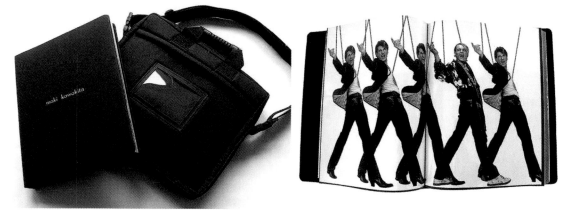

(Left) Photographer Maki Kawakita's (L7.6) portfolio and portfolio case, produced by The House of Portfolios in New York City. The custom lettering is stamped with silver foil. (Right) This book format allows for precise alignment of prints, with an almost seamless look.
Photos © Maki Kawakita

The type of prints you choose for your books is very important. For example, if you plan to have over 100 prints in an 11 × 14 inch album, the weight of the paper will have a significant impact on the overall thickness and weight of the book. To reduce the weight, consider printing on both sides of a double-sided gloss or matte paper (L7.7). Or you can print on thin paper with a weight of about 150–215gsm, such as Epson Photo Semigloss Paper (170gsm, L7.8), Canon Satin Photo Paper (190gsm, L7.9) or Oriental Graphica Glossy White Film (215gsm, L7.10). Some prints will not be compatible with some plastic pages, so it's best to do some research or testing before finalizing on a portfolio and paper combination.

In general, matte prints will have fewer compatibility issues compared with glossy prints. One of the problems that can occur with some glossy prints is that they can stick to or be damaged by plastic protective sheets, especially when subjected to extreme heat and humidity. I have found high quality albums and portfolios with plastic inserts that accept prints sized from about 2 × 2 to 11 × 14 inches in many photo retailers and general retail stores, including Adorama (L7.11), B&H Photo (L7.12), Kohls (L7.13), Ritz Camera (L7.14), and Target (L7.15). During a visit to my local Kohls, I noticed the sola faux-leather albums (L7.16) and purchased a few to use as gifts and mini portfolios. You can make a very big impression with a mini portfolio.

TIP 95 Consider albums and portfolio books without plastic sleeves.

Many photographers (including me) prefer the look of albums and portfolios without any plastic sleeves. This approach can offer a more traditional book-like feel to a portfolio, and there are several tips and techniques for finding and assembling this type of book. The primary disadvantages of this approach are that the book's pages won't be protected by a plastic covering, and, thus, they will be more susceptible to damage. Another disadvantage is that if your book is traditionally bound, it will be difficult to make changes to the layout. One way around this is to use a post-bound system commonly found in the scrapbook industry.

Here are four options to consider, with some recommended brands and products:

Books and Albums with Blank Pages

There are many albums made by companies that contain just blank pages, on which prints can be mounted. One well-known company that makes a wide range of these types of products is Kolo (L7.17). Another company that makes many high quality presentation products, including pre-hinged acid-free black mounting sheets (with or without plastic sheet protectors), is Pina Zangaro (L7.18). The non-plastic sheet approach can give a portfolio a vintage feel (especially if you use photo corners), and it is important to use acid-free materials, such as Kolo's Self Adhesive Photo Mounts or Lineco's Quick-Stick Photo Tabs (L7.19) to mount prints in a book. Thinner prints (under 200gsm) are generally better to use, because they will reduce the bulk of the portfolio. Another company worth mentioning is Xyron (L7.20). Xyron produces inexpensive machines for many purposes, including laminating and applying acid-free adhesives. Their handheld Adhesive Runners can also help to make the process of adhering prints to blank pages much easier.

Yet another option is to attach plastic photo mounting sleeves to blank pages, which will protect every print behind a plastic covering, but will still give the feeling of a real book. Easy Mounts are one brand to consider, and they can be found at specialty retailers such as The Celine Company (L7.21) and Jenni Bick Bookbinding (L7.22). The disadvantage of these is that the prints can move a lot inside the sleeves when turning pages, so you may want to apply a small piece of double-stick adhesive on the back of your prints for added stability. Stores in your area that specialize in scrapbooking are often an excellent place to find bookmaking supplies and to learn about other options for presenting your work.

Photographer: Andrew Darlow; **Image title**: *Faces 012*; **Print Size**: 18×24 inches; **Paper**: Epson Premium Semi-Gloss; **Printer Name**: Epson Stylus Photo R2400; **Ink Used:** Epson UltraChrome K3 Pigments; **Driver**: Standard Epson Driver (Mac OSX); **Camera**: Canon EOS 5D; **Lens**: Canon EF 24-70mm f/2.8L; **F-stop**: f/8; **Exposure**: 1/125 sec. (w/ strobes)

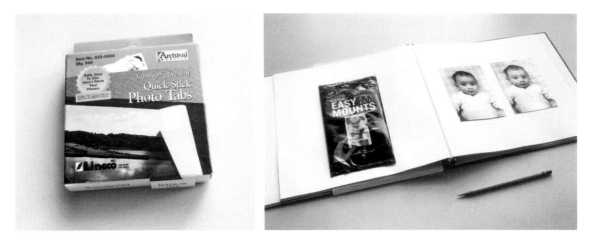

(Left) Lineco's Quick-Stick Photo Tabs. They are acid-free, and have a self-adhesive strip on both sides. I would not use these for inkjet prints that cannot be reprinted because there is a chance that a print will be damaged if lifted off the paper on which it is mounted. They work well for adhering prints to blank pages of books from companies such as Kolo. (Right) A 12×12 inch scrapbook portfolio with two Easy Mounts attached, and one inkjet print inserted into each. They can be adhered vertically or horizontally.
Photos © Andrew Darlow

Books with Pre-Hinged Printable Pages

A number of companies offer pre-hinged, punched inkjet papers which can be fed through an inkjet printer. Most of the hinges are made of paper or plastic, and are attached to the paper with an adhesive. After printing, you just place them into a post-bound book. A few of the companies that offer these in the form of kits in multiple sizes and with multiple paper options are Hahnemühle (L7.23), Innova Digital Art (L7.24), Kolo (L7.25), Lineco (L7.26), Moab (now Moab by Legion Paper, L7.27), and Stone Editions (L7.28). Additional options from Lineco, including many different cover colors, and in some cases, hinged top-load polyester insert pages can be found by searching online for "Lineco Pop Art."

Another company, Rag and Bone (L7.29), offers two book sizes and more than 30 cover options of their post-bound Digital Photo Album. Each book comes with ten double-sided, matte finish hinged pages and access to their "online print center," where customers can choose a page template, insert their own digital images and text, and then make prints on their own inkjet printer.

Moab's Chinle Digital Book v2 (L7.30) is a bit different because the pages made for their books are scored and punched to create the hinge, instead of having a separate hinge attached. The books are available in 8 × 8- or 12 × 12-inch sizes, and come with black leather covers and a black leather slipcase, but no pages. Double-sided pre-hinged pages made by the company are available separately. I recommend doing a test on the same paper (without the scored hinges) that is intended for use in the books before making a final decision. For example, if three different papers are available for a book, as with the Chinle Digital Book v2, you can purchase a sample kit that includes those three papers and print some test images before buying a package of the pre-hinged paper. The non-scored paper will also come in handy for doing tests while making your portfolio, since it is the same exact paper, but is less expensive per sheet than the scored and punched paper.

Depending upon the specific brand and product, translucent interleave sheets (often referred to as vellum) are sometimes included, or they can be purchased separately. The translucent sheets can add a high-end look and feel to a portfolio, and they can also help to avoid ink transfer between pages, which can be a problem with some matte and watercolor inkjet papers. Three coats of a protective spray, such as PremierArt Print Shield (L7.31) can eliminate this problem, but I recommend asking others about their experiences with specific products before making a purchase.

Attachable Hinges for Use with Post-Bound Books

A good option is to purchase pre-punched hinges with adhesive strips, which can then be attached to virtually any paper and placed into a post-bound book. The primary advantages are that you can use any paper you like, and you can also choose any cover that fits your style. Pina Zangaro (L7.32) makes hinges in sizes from 8.5 to 19 inches in width that are punched to fit in many of their screwpost covers, and Print File (L7.33) makes attachable hinges in 8.5- and 11-inch widths. Another good option is to leave additional space on the edge of your print, and create your own hinge by scoring one side of the paper with a bone folder (L7.34) and making holes in the appropriate places along the edge of the paper. Or you can have a professional book binder create or attach hinges for you, which you can then insert into a custom or off-the-shelf cover. Just remember to take into account the amount of white space that might be lost on the left or right side of each page due to the hinges. Making a complete mockup of your book (possibly on less expensive paper) can save a lot of time, effort, and materials.

Perfect-Bound Books

Over the last few years, books with flush spines have become much more affordable. Also known as perfect-bound books, this type of book is usually held together with glue and has no visible binding strips or screwposts. They often look as good as (or even better than) coffee table books sold in bookstores. The downside is that they usually can't be rearranged like a post-bound book; if you make a mistake while putting one together, you may have to discard materials and start over.

If you plan to produce a significant number of books, there are many bookmaking products on the market at varied price points. The Photobook Pro (about $25,000) from Digital Portal Inc./KIS Photo-Me Group (L7.35) is geared toward the retail segment, especially photo labs, and allows you to insert prints into an automated machine which scores, glues, folds and binds the pages. Minutes later a bound book, from 3.5 × 5 to 12 × 18 inches, appears. The machine can also produce double-sided photo products from single-sided prints, including photo greeting cards and calendars. Another company that caters to higher-volume customers by offering equipment and training is ExactBind (L7.36). Its products are used to create on-demand and medium-size runs of school yearbooks, hardcover books, directories and other products. Prices for the systems the company represents range from about $12,000 to $20,000.

For those who want a fairly low-cost, easy to use system for your home or studio, Coverbind (L7.37) makes a number of affordable Thermal Binding Machines and compatible hard and soft cover options. A tip to consider when thermal binding is to attach page hinges (or print on pre-hinged sheets) when binding papers heavier than 8 mil thick (about 200gsm). This can help keep pages much flatter after binding, while still retaining the feel of a coffee table book. Some office-supply retailers, such as Staples (L7.38), can also do affordable hardcover binding for you.

Epson makes the Epson StoryTeller Photo Book Creator (L7.39), a kit that comes with Epson glossy paper, a hardback book cover and Epson StoryTeller Publisher software on CD (Windows only). The CD contains many page layouts for the front cover and inside pages. It's available in either a 5 × 7 or 8 × 10 inch size. There are also a number of companies who will accept orders via the Internet, and usually within a week, they will send you back a hardcover, perfect-bound book. In some cases, these companies use a high-speed inkjet printing technology. One example is Blurb, Inc., based in San Francisco (L7.40); I was very impressed by the quality of the printing and binding of Blurb's sample books when I visited their booth at a New York City trade show.

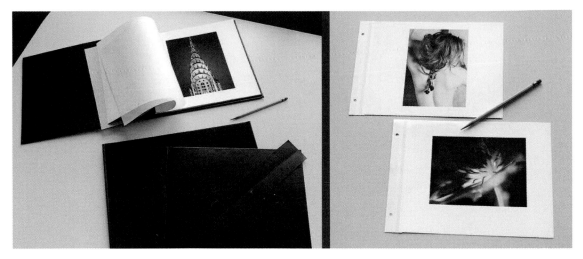

Lineco's Digital Album Combo Pack (shown assembled, without the included metal corner storage box). This Combo Pack comes with 20 double-sided printable pages. It also comes with 20–25 frosted translucent vellum interleaving sheets, which are printable, and look great with text. Included are expansion screws to allow as many as 40–50 pages to be bound in one album. An extra set of black leather covers is placed in the foreground to show how they look prior to assembly. (Right) These two prints were output on inkjet compatible watercolor paper, and self-adhesive hinges were then attached so that they could be inserted into a traditional post-bound album.
Photos © Andrew Darlow

Another place to find high quality books with features such as recessed areas to affix prints, or slip-in mats is in the wedding and event book industry. There are many companies that produce high-quality products in this category, and a few standouts, in my opinion, are ArtZ (L7.41), Capri Album (L7.42), Jorgensen Albums (L7.43), Kambara USA (L7.44), Leather Craftsmen (L7.45), Taprell Loomis (TAP, L7.46) and Zookbinders (L7.47). Many of these companies will accept your photographic or inkjet prints and incorporate them into a custom book that is absolutely magnificent. Many also provide do-it-yourself albums that use the same high-quality materials as their custom books. I have had the opportunity to attend a tour of the Leather Craftsmen factory in New York and was very impressed by their facility, the entire bookmaking process, and the quality of their work.

TIP 96 Consider a wire or plastic bound book.

One of the fastest, easiest, and least expensive ways to produce a portfolio is by having a group of prints bound with a simple wire or plastic coil or comb binding. My preference is to use a metal wire binding, such as the Wire-O system (L7.48) because in my opinion, it offers a higher quality look and feel. I decided to purchase a hand-operated binding machine by James Burn International (Model EB-32) to make my own promotional books, but for most people, I recommend using an office supply store to do the binding. Staples (L7.49) offers affordable, and in my experience,

good quality wire and plastic binding services. Check your local area for small- to medium-size printing companies. They will often offer binding services—sometimes with more wire and coil color options compared with large retail stores. Binding pages is also great for putting together printed proofs for brides, high school seniors, children, and family portraits.

Wire- and plastic coil-bound books make for excellent leave-behinds, and after binding, they can also be sold like any other book. They are especially captivating in very small sizes, such as four by four inches square. To add to the overall look and feel, I recommend making a thick cover for your books, made from matboard, thick paper or other material. You can also cut a square out of the cover to allow for the first image to show through. The opening photo in this chapter shows three different wire and plastic coil binding options, including a photo album with a cutout for a photo to show through.

TIP 97 Make books using saddle stitching, ribbon bindings, or fasteners.

Sometimes, keeping it simple is the best way to produce a book. Saddle stitching looks like staples from a handheld stapler placed along the center of a book or brochure. Many consumer magazines and advertising brochures are saddle-stitched (usually with two or three staples). A few of the softcover albums shown in this chapter's opening pages (numbers 2 and 9) were saddle stitched. The advantages of saddle stitching are affordability, widespread availability of materials and machinery to create saddle-stitched bindings, and the ability to easily remove the staples and re-bind if a mistake is made. Almost any size portfolio can be saddle stitched, and one idea is to creating a portfolio that looks and feels like a magazine found on a newsstand. That can be done by printing on double-sided letter-size gloss or semi-gloss paper, followed by binding with three staples.

Creating layouts for saddle-stitched jobs can be tricky because the pages usually need to be printed in spreads that do not run consecutively. If you take apart a brochure, you will see how the pages are laid out. Many applications come with built-in software for booklets, and other software is also available (L7.50). You can also produce the pages of a book manually by first producing a mock-up before printing the final job. Also, a regular stapler will often not be long enough to reach inside the center of a book, so I recommend having a printer in your area do the saddle stitching for you, or you can purchase a stapler that is made for binding books, such as the Sparco Long Reach Stapler (available for under $35, L7.51). And if you

Photographer: Andrew Darlow; **Image title**: *Faces 006*; **Print Size**: 13×19 inches; **Paper**: Kodak Professional Lustre Inkjet Paper; **Printer Name**: Epson Stylus Photo R2400; **Ink Used**: Epson UltraChrome K3 Pigments; **Driver**: Standard Epson Driver (Mac OSX); **Camera**: Canon EOS 5D; **Lens**: Canon EF 28-135mm f/3.5-5.6 IS; **F-stop**: f/6.3; **Exposure**: 1/100 sec. (w/ strobes)

want to make your saddle-stitched albums stand out from the crowd, you can purchase colored staples that fit into regular staplers. Making Memories is one company that sells inexpensive staple multipacks with 250 each of five colors (L7.52).

Other fasteners can also be used to bind paper together. For example, round head brass fasteners (a.k.a. brads) are inexpensive, and are commonly used by writers to hold their scripts together (L7.53). They come in multiple sizes, shapes and colors, and can be used to bind inkjet prints together to create books, mini portfolios, greeting cards and many other items (L7.54). A hammer can be used to help secure the fasteners, and in some cases, you may want to use a special washer made for paper fasteners. In Tip 103, Helen Golden demonstrates how she uses brass fasteners to create a hand made portfolio. Aluminum screw posts are another option. Like brass fasteners, they are designed to be inserted in standard 1/4-inch punched or drilled holes, and come in many sizes to accommodate various paper thicknesses (L7.55).

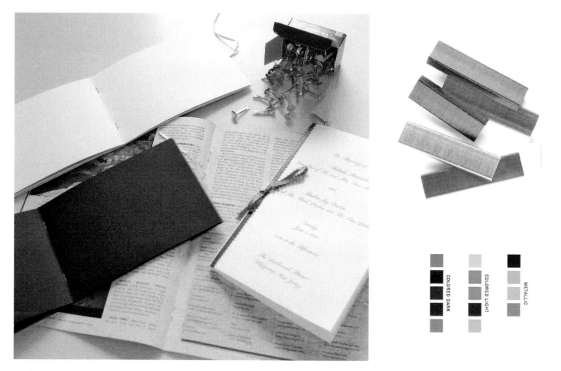

(Left) A closeup of two saddle-stitched Kolo Vineyard Paper Albums placed on a color glossy magazine (title: Digital Imaging Techniques). The magazine is also bound using saddle stitching. A close-up of a ribbon-bound wedding program and a box of brass fasteners. (Right) A set of colored staples named "Colored Light" from Making Memories, with swatches showing the three available sets of colored staples offered by the company.
(Left) Photo © Andrew Darlow; (Right) Photo courtesy Making Memories

A simple ribbon, cord (or even a rubber band) can also be used as a binding (especially if there are just a few sheets to bind). The ribbon binding method can add elegance to a book containing baby photos, and it is ideal for wedding programs, which are often distributed to guests at weddings for use during the ceremony.

TIP 98 Choose good cutters and a self-healing mat.

There are many ways to cut paper, cardboard, canvas, and other materials. For very clean, precise cuts, I primarily use the double-rail RotaTrim Mastercut Professional Rotary Cutter (L7.56). These cutters are self-sharpening, extremely accurate and reliable even after years of use. They are ideal for cutting films, paper, and canvas before and after printing and come in widths from 12 to 54 inches. RotaTrim makes larger trimmers (powered and non-powered), as well as a lower cost single-rail series called the RotaTrim Eurocut that may be ideal for some photographers who don't need a heavy-duty cutter. An excellent PDF with information about the products I mentioned, plus additional cutters and other accessories, such as safety straight edges for cutting by hand, can be found on Bogen Imaging's web site (L7.57).

Another well-regarded brand that I've used successfully over the years is Dahle (pronounced like the artist known for his distinctive mustache, L7.58). Dahle has multiple grades of cutters, including their Premium Rolling Trimmer, which is able to cut up to 30 sheets of paper, or 4-ply matboard. All of the Dahle rotary cutters I've seen in person and online will cut in both directions without any modifications. However, the

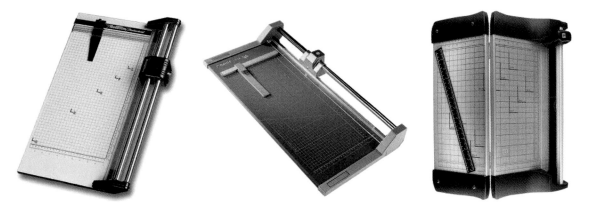

(Left) The RotaTrim Mastercut Professional Rotary Cutter. (Center) The Dahle Premium Rolling Trimmer. (Right) The Making Memories Precision Paper Trimmer.
Photos courtesy Bogen Imaging, Dahle North America, and Making Memories, respectively.

RotaTrim Mastercut cutters require a simple modification (shown here: L7.59), to be able to cut in both directions. Otherwise, the RotaTrim Mastercut can only cut properly when used in one direction. Please read the recommendations carefully if you decide to make this modification to your cutter.

I have not tested the following product, but an inexpensive rotary cutter (about $50) from Making Memories has a number of features worth noting: it can cut up to 12-inch wide materials; it can fold and be used in the folded and unfolded positions, which makes it portable and allows it to take up less space on a table when not in use; and it also comes with a thin magnetic ruler that holds paper more securely to the trimming board prior to cutting (L7.60).

Another popular type of cutter is the Guillotine cutter. I have found that these cutters can function well, but they are generally not as accurate as rotary cutters because of the way the blade can cause the paper to move slightly as it is cut. There are also some significant safety issues to consider compared with rotary trimmers, although some models have protection for the blade throughout the entire cut. I use guillotine cutters primarily for cutting cardboard and matboard because some boards can damage rotary trimmers.

Cutters that accommodate large sheets of foam board are generally expensive (over $500), but they can be a lifesaver in high volume situations (L7.61). A more flexible alternative that costs much less is to combine a self-healing cutting mat, safety ruler, and a good quality utility knife. This combination can be used on a table, or even a floor if necessary, and using all three makes cutting large sheets much easier.

Several companies make good quality healing mats and safety rulers, and one that I recommend is Speedpress (L7.62). Their self-healing mats are available in sizes up to 6 × 12 feet, and they offer a few safety rulers, which can save your hands from potential injury. They also have a non-slip base that can help protect the material you are cutting while helping to keep the ruler steady during cuts. They have a new mat called the Magic Cutting Mat that, according to the company, allows you to cut without leaving visible marks. The company also sells centering rulers, which can help save time when measuring and making cuts. On a similar note, see Tip 222 in Chapter 14 to read about a recommended utility knife from a professional framer.

Photographer: Andrew Darlow; **Image title**: *Faces 007*; **Print Size**: 13×19 inches; **Paper**: Hahnemühle Photo Rag Satin; **Printer Name**: Epson Stylus Photo R2400; **Ink Used:** Epson UltraChrome K3 Pigments; **Driver**: Standard Epson Driver (Mac OSX); **Camera**: Canon EOS D60; **Lens**: Canon EF 16-35mm f/2.8L; **F-stop**: f/2.8; **Exposure**: 1/30 sec.

TIP 99 Use pre-cut mats or have mats custom cut.

One of the best ways to show prints in a way that gives them a fine-art feel, with min-imal risk of damage, is to have them matted. There are many types of mats available from many different manufacturers (L7.63), and your print sizes will generally deter-mine your mat size. There is no "right" amount of mat space to leave around your prints, and I recommend experimenting on a computer by creating different sized backgrounds around your work until you are satisfied with the result. Some people choose to mat their work flush to their images, but in most cases, my preference is to leave about a one-half inch border around my prints and about a three-quarter of an inch border on the bottom to allow for a signature and print number. I don't recom-mend signing the mat, because the print is the actual artwork, and some clients may want to change the mat right after purchasing, or in the future.

For most prints over 4 × 6 inches, I prefer 8-ply rag mats because of their thickness and high-end look and feel, but using 8-ply mats can add to the cost, weight, and thickness of a portfolio box filled with prints. In addition, if you plan to create a series of prints for a portfolio box (like in the photo that follows), I recommend choosing a mat size that matches an off-the-shelf portfolio and portfolio case size, such as 11 × 14 or 16 × 20 inches. You can find affordable pre-cut or custom cut mats online, and there are many high quality custom frame shops that can custom cut and hinge mats (L7.64).

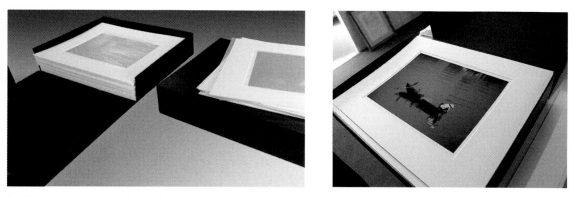

(Left) A stack of photographer Richard Ehrlich's matted prints in a clamshell portfolio box from Light Impressions. Interleaving tissue was placed under each mat to help protect the print surface. (Right) A close-up of one of the prints from a series of photographs photographed in Vietnam by Richard Ehrlich (L7.65).

176

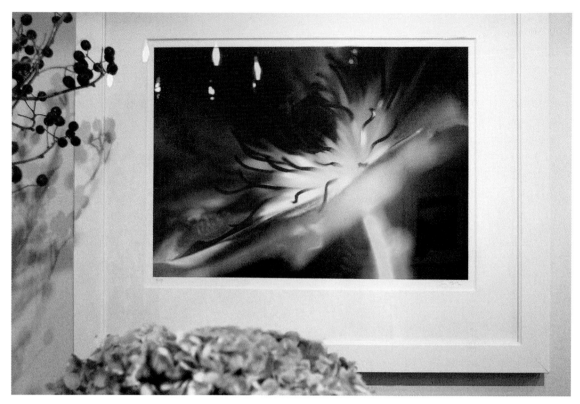

A framed print by Andrew Darlow displayed during an exhibition of flower photography prints in New York City. All prints were numbered in the bottom left, signed in the bottom right, matted using 8-ply rag matboard, and custom framed in white wood frames. Most of the frames were created at the same size so that extras could be ordered in case of damage, and so they would look balanced when grouped together during an exhibition or on the walls of a client's home or office.
Photo © Andrew Darlow

TIP 100 Find the right boxes, cases, and online resources.

There are many stylish portfolio cases and storage boxes made from matboard, acrylic, or even aluminum, and there are also many cases available to hold portfolios. To find the right case or box, I recommend that you visit an art supply store and look carefully at the specs before making a purchase. Some cases look great, but they may easily get scratched or damaged, or they may add unnecessary weight to your overall portfolio. Also check travel or computer/office supply stores for portfolio cases, since they often have very high quality and affordable cases tailored to business people. Often, a portfolio box will fit nicely in a bag made for a notebook computer.

A few portfolio box and case suppliers and manufacturers that I recommend are Pearl Paint (L7.66), Pina Zangaro (L7.67), RT Innovations (L7.68), Sam Flax (L7.69), Light Impressions (L7.70) and University Products (L7.71). An excellent online source with many tips for hinging prints, cleaning and removing paper from acrylic sheets, and assembling metal picture frames is Frame Destination (L7.72). Another great online and printed resource is Décor Magazine (L7.73), which caters to framing professionals and those who want to learn more about the creative ways in which people frame and display artwork. For many additional links and resources related to matting and framing and to learn more about an excellent newsgroup that covers many related topics, I recommend visiting the Art Show Photography Forum companion site, run by Larry Berman and Chris Maher (L7.74).

(Left to Right) Three recommended online resources for matting, framing, and marketing: Frame Destination, Décor Magazine, and the companion site for the Art Show Photography Forum.

TIP 101 Mount your work on acrylic or other materials.

The question of whether or not to mount prints is one that can be endlessly debated. When I can avoid any mounting, I choose that option because any adhesive is capable of altering a print in some way. That being said, there are many acid-free glues, films, and materials that are used to mount and support photographic prints, and by using the proper materials and following certain guidelines, you can reduce the chance of having problems in the future. Matboard (made from cotton and/or wood pulp) is used extensively by framers for mounting prints, and I believe 8-ply rag matboard can be a good long-term option for mounting matte or watercolor inkjet prints. Acid-free foam board (L7.75) is another mounting option, but most foam products are susceptible to bowing over time.

One of the most widely used mounting materials is the acrylic sheet. Acrylic glazing (or acrylic sheets) look similar to glass in their clear form, and they are available in

varying thicknesses and colors. Acrylic is commonly used for face-mounting (behind the plastic, so you can see the print through the plastic) or front mounting (on top of the plastic, like a board). Some artists choose to display their face-mounted prints by floating the pieces off the wall with the whole plastic sheet exposed (no frame). This can look fantastic, but there is great potential for damage to the corners and face of the acrylic. Unlike a framed piece, which can be reframed, if the acrylic is damaged, the print can't easily be re-mounted. Acrylic is very smooth and affordable, so it is also commonly used for front mounting prints that are then placed in frames with or without mats. Abrasion-resistant and UV-resistant forms of acrylic are also available, though most acrylic has some UV protection. I've found the Acrylite brand of acrylic sheets to be of excellent quality (L7.76).

Another popular mounting material is Sintra (L7.77), a closed-cell, expanded plastic that is very smooth, lighter than acrylic, and available in many thicknesses. It can be cut more easily than acrylic, which is one of the main reasons why it is so popular. There are many other mounting materials used for artwork, including aluminum, which is very strong, but heavy, and Dibond (L7.78), which consists of two pre-painted sheets of .012 inch aluminum with a solid polyethylene (plastic) core. Dibond is available in multiple colors, is half the weight of aluminum, and is very resistant to warping, oxidation or deterioration.

A look at the construction and features of Dibond panels from Alcan Composites USA, Inc.'s web site.

TIP 102 Frame it right and consider standard sizes.

Framing, in my opinion, is as much an art as sculpture and photography. Good quality, archival framing can make a print look its best, and there are many frame options available, from metal to hand-carved wood. If you are having a gallery show with multiple prints, or if you plan to sell framed prints at art shows or other venues, my recommendation (much like with mat sizes) is to standardize with a few frame sizes, such as 16 × 20 inches and 20 × 24 inches.

This can help to reduce inventory, and make it easier to quickly fulfill client orders. The other advantage is that you can sell unframed matted prints, and your clients will then be able to either purchase a standard-sized frame from a retail store or have a custom frame made by a professional framer. Standardizing can also be helpful if you are planning to hang prints in your home or office. Changing work is much easier and less costly when mat and frame sizes are the same.

Photographer Richard Ehrlich shows a 60×40-inch shadowbox frame with one of his images. The print was made on an Epson Stylus Pro 9600 on Epson UltraSmooth Fine Art paper, and the depth of the frame is about one inch. In this case, the print extends to the edges of the frame.
Photo © Andrew Darlow

Photographer: Andrew Darlow; **Image title**: *Faces 008*; **Print Size**: 17×22 inches; **Paper**: Ilford Galerie Smooth Pearl; **Printer Name**: Canon imagePROGRAF iPF5000; **Ink Used**: Canon LUCIA Pigments; **Driver**: Standard Canon Driver (Mac OSX); **Camera**: Canon EOS 5D; **Lens**: Canon EF 28-135mm f/3.5-5.6 IS; **F-stop**: f/10; **Exposure**: 1/160 sec. (w/ strobes)

One of my favorite types of framing (especially for prints over 16 × 20 inches) is the shadowbox. Though usually thought of for framing thicker items like medals and sports jerseys, I consider a shadowbox to be any frame with a space between the backing board and the glass or acrylic. Spacers are placed along the inside edges of the frame and are usually made from matboard, foam board, or plastic. A print can then be mounted to or, in some cases, just placed up against the backing of the frame to create a very clean and simple presentation.

A variation of this approach is to float-mount a print to a backing board using hinges, which creates a 3D effect similar to the look of a piece of cloth attached to a board. Watercolor papers with deckled edges look particularly good using this approach.

A shadowbox frame featuring a hinged inkjet print by photographer James Nicholls (L7.79). In this case, the edges of the print have been carefully torn to create a deckled edge, and it floats inside the frame, which gives it a very interesting look and feel. Some framers offer torn deckling as a service. Instructions for creating your own torn deckled edges can be found here: (L7.80).
Photo © Andrew Darlow

Photographer: Andrew Darlow; **Image title**: *Faces 005*; **Print Size**: 17×22 inches; **Paper**: Canon Heavyweight Satin Photographic Paper; **Printer Name**: Canon imagePROGRAF iPF8000; **Ink Used:** Canon LUCIA Pigments; **Driver**: Canon Print Plug-In for Photoshop (Mac OSX); **Camera**: Canon EOS 5D; **Lens**: Canon EF 24-70mm f/2.8L ; **F-stop**: f/11; **Exposure**: 1/160 sec. (w/ strobes)

TIP 103 Make your own custom business card/promo pieces.

Imagine being able to give a mini version of your work in the form of a business card, but made on the same or similar paper, and with the same printer you use to make your fine-art prints. Whether you make your own prints, or even if you have someone else making them, this approach can help you to set your work apart from the crowd. Two examples of this approach in action are from two artists, Dorothy Simpson Krause (L7.81) and Helen Golden (L7.82). I find both women's work beautiful and thought-provoking, and when I met them in person, each presented me with a card about 3 × 5 inches, featuring an image and their contact information. Dorothy Krause printed multiple card images on a 13 × 19-inch sheet of HP Hahnemühle Smooth Fine Art Paper using an HP Photosmart Pro B9180 printer, and then cut them out to create a total of 15 cards per sheet.

Dorothy Simpon Krause's custom-printed business card/promo piece layout.
Image and layout © Dorothy Simpon Krause

Helen Golden's cards are a little more involved. To produce them, she first makes business card "blanks" by using a desktop inkjet printer to print her name, web site, and contact info at the highest quality. The paper she often uses is a heavy, good quality 8.5 × 11-inch paper stock such as Starwhite Tiara 80 lb. Cover Smooth (L7.83). She then uses the same printer with the same high quality paper that she uses to make her art prints and makes mini versions of the work (each about two by three inches). To save time and material cost, she will often include extra space in the file and will insert the mini versions at the same time that she prints her much larger art prints. Other times, she will print the mini versions on extra pieces of the same high quality paper, which is left over from prints and image test strips.

She then cuts the 8.5 × 11-inch Starwhite Tiara paper into six pieces, and "tips in" the individual art prints to the white cards using Scotch #908 Acid-Free Tape (L7.84) in a 3M ATG 700 Adhesive Applicator (L7.85). Golden takes the idea even further by producing portfolio books with tipped-in prints 4.5 × 7 inches in size. She also uses that size print for hand made greeting cards, which she sells or uses for promotional purposes.

(Left) Helen Golden's promo cards before and after her work is tipped in. The 8.5×11-inch sheet of paper is partially cut to show how it all comes together. (Right) An example of how Golden prepares her print files so that she has full-size art prints, as well as smaller versions of her work for business cards, art cards and portfolio books.
Photos © Helen Golden

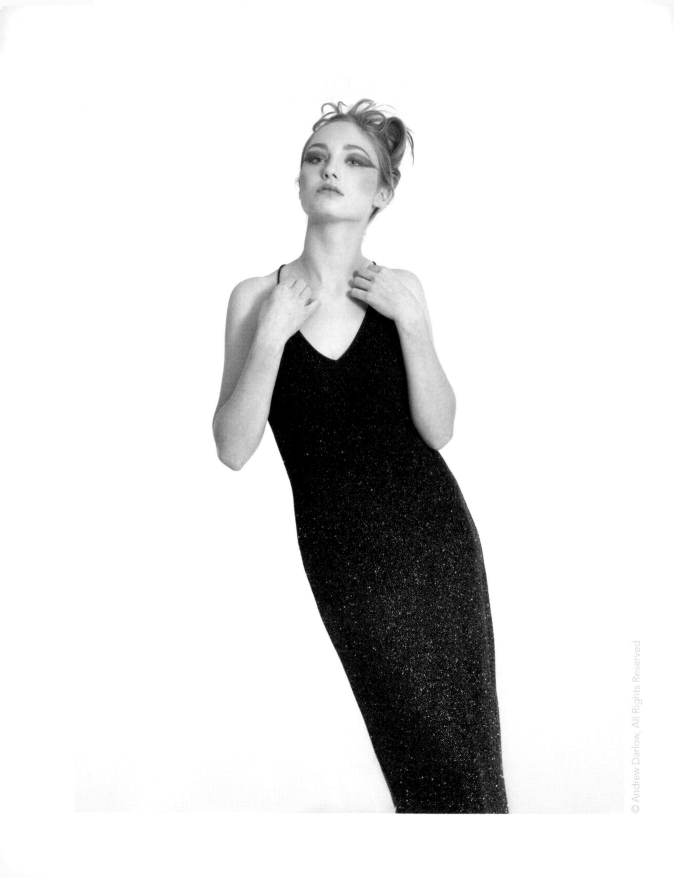

And to top it all off, she found just the right see-through case to protect and carry her business cards. On that note, another tip would be to first find an appropriate case for your cards, and then design your promo pieces to fit.

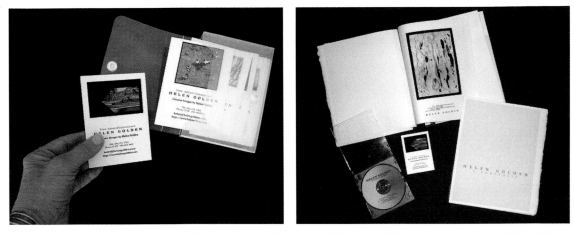

(Left) Helen Golden's mini portfolio case for her promo cards. (Right) Golden's PR (Public Relations) Kit, with a full-size CD and a handmade 8.5×11-inch portfolio.
Photos © Helen Golden

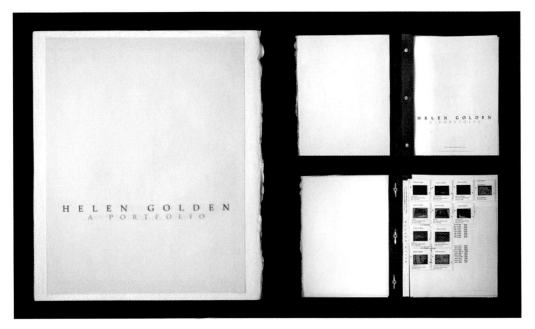

Helen Golden uses brass fasteners in a simple, yet elegant way to keep everything securely together (including 35mm slides, which are much heavier than a standard sheet of paper) in her handmade 8.5×11-inch portfolio.
Photos © Helen Golden

Photographer: Andrew Darlow; **Image title**: *Faces 009*; **Print Size**: 17×22 inches; **Paper**: Oriental Graphica Glossy Film; **Printer Name**: HP Designjet Z3100; **Ink Used**: HP Vivera Pigments; **Driver**: HP Built-in Driver (Windows XP); **Camera**: Canon EOS-D60; **Lens**: Canon EF 16-35mm f/2.8L; **F-stop**: f/2.8; **Exposure**: 1/30 sec. (w/ strobes)

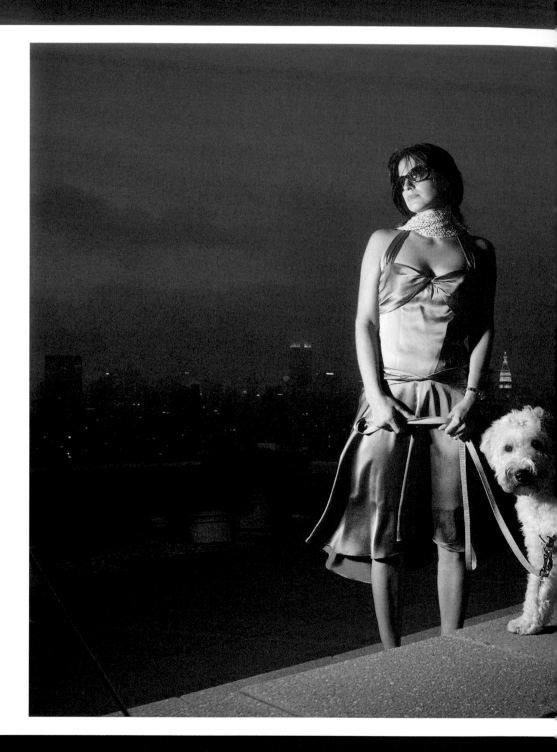

Photographer: Andrew Darlow; **Image title**: *Faces 014*; **Print Size**: 19×13 inches; **Canvas**: PremierArt Matte Canvas;
Printer Name: HP Photosmart Pro B9180; **Ink Used**: HP Vivera**; Driver**: HP Photosmart Pro Print Plug-in for Photoshop (OSX);
Camera: Canon EOS 20D; **Lens**: Tamron 18-200mm f/3.5-6.3 Di II; **F-stop**: f/6.3; **Exposure**: 1/40 sec.

Chapter 8

Specific Printer Tips and More

Getting Specific

Throughout the first seven chapters, I've primarily covered tips and techniques that can be used with virtually any inkjet printer. However, there are many brands and types of printers on the market, each with a unique set of features. In this chapter, I will highlight some tips that can be used with specific printers or types of printers, and with specific operating systems. I'll end the chapter with tips aimed at helping you save time, space, and money, and I'll also mention some amazing free and inexpensive resources that can help you to expand the ways in which you use your printer(s). Because there are so many types of printers and printer driver options, additional tips will be added, and information will be updated periodically on our companion site (L8.1).

TIP 104 How to use compact photo printers more effectively.

Have you ever traveled somewhere and wanted to make a print from a web page, give a print to a photo subject, or needed to quickly print something for a business meeting or presentation? I certainly have. There are a few portable printers on the market that can print 8.5 inches wide (see Tip 44 in Chapter 3 for some specific options). However, there are many compact and very affordable inkjet printers available that are capable of making 4×6, 5×7, or in some cases, even 4×12-inch panoramic prints. Here are some tips for how to use compact photo printers more effectively:

This may sound obvious, but consider bringing a compact printer with you when you travel. Most people just don't think about it, but most compact printers can be placed in a carry-on bag, or even in checked luggage. If you do place it in checked luggage, I recommend keeping the ink cartridge (or cartridges) in separate sealable bags, and if you carry it on a flight or drive with the printer, always keep it in an upright position. In all cases, the printer should be in its own waterproof plastic bag just to be extra safe. Most printer companies also sell travel bags made for their compact printers (L8.2).

To find the web links noted in the book (L8.1, etc.), visit www.inkjettips.com or http://www.courseptr.com/ptr_downloads.cfm.

Photographer: Andrew Darlow; **Image title**: *Faces 017*; **Print Size**: 11×14 inches; **Paper**: Oriental Graphica White Film; **Printer Name**: Epson Stylus Photo R2400; **Ink Used**: Epson UltraChrome K3 Pigments; **Driver**: Standard Epson Driver (Mac OSX); **Camera**: Canon EOS 5D; **Lens**: Tamron 18-200mm f/3.5-6.3 Di II; **F-stop**: f/10; **Exposure**: 1/200 sec.

For years, professional photographers who shoot with film have used instant film such as Polaroid Type 669 (L8.3) to help make sure that their exposures are correct. However, instant prints are more than just an exposure guide. They are also used by photographers, makeup artists, hairstylists, and others to help establish the overall look and feel of a scene. Being able to make prints during a digital photo shoot with a compact printer can help the art director and client to better visualize how the photos will look in a printed ad, and it also allows photographers to share prints with those who are involved with the job. There is something about a print that just can't be replicated on a screen.

If you begin with a letter-sized document and want to print it to a compact printer, there can be problems with formatting. Assuming you don't want to shrink the text down to fit completely onto a smaller page (for example 5 × 7 inches), a text-only letter-sized document should reflow when you change the paper size in your program's Page Setup dialog box from 8.5 × 11 to 4 × 6. You will see the type change in the document so that it fills multiple pages instead of just one page, and the document should print without a problem.

However, what do you do if you want to create an 8.5 × 11-inch handout or other document using a 4 × 6 inch printer? You could split a page up in Photoshop visually by using the virtual ruler and guides, followed by copying four 4 × 5.5-inch sections to four new 4 × 6 files, but that takes quite a bit of time and effort. Instead, there are programs for Mac OSX and Windows that will do a much better job by splitting up your file inside of the program without any cutting and pasting. However, you will probably need to cut and paste the actual prints together after printing to make a believable composite. For Windows, Digital Camera Poster Creator is a good choice (L8.4), and for Mac OSX, DoubleTake (L8.5) is a good option. I've tested both successfully, and I like the fact that I can print directly from DoubleTake (under File>Poster Setup). Digital Camera Poster Creator is a little different. It works by splitting your image into separate files, which are then saved to a new folder. These programs can also be used with larger printers to make posters or banners for trade shows, parties or point of purchase (POP) signs.

A few compact inkjet printers are available that can print larger than 4 × 6 inches. For example, Canon offers the PIXMA mini320 (L8.6), that can output 4 × 6-, 5 × 7-, and 4 × 8-inch prints, and HP makes the Photosmart A616 (L8.7) and Photosmart A716 (L8.8) printers, which are both capable of making 4 × 6-, 5 × 7-, and 4 × 12- inch (panoramic) prints. Apart from just having the ability to make photo prints, having the panoramic printing option is helpful if you want to quickly create a letter-sized document to be photocopied for a presentation when you are on the road. Just cut a

Photographer: Andrew Darlow; **Image title**: *Canine 007*; **Print Size**: 24x24 inches; **Paper**: Hawk Mountain Condor Natural; **Printer Name**: HP Designjet Z3100; **Ink Used**: HP Vivera Pigments; **Driver**: HP Built-in Driver (Mac OSX); **Camera**: Canon EOS D60; **Lens**: Canon EF 16-35mm f/2.8L; **F-stop**: f/19; **Exposure**: 1/125 sec.

(Left) Two 8×12 inch prints, each made from four 4×6 prints, output on the Epson PictureMate Deluxe Viewer Edition (L8.6) using Digital Camera Poster Creator software. The pink notice on the prints signifies that I am using the trial version of the software. (Right) The HP Photosmart A716 compact printer.
(Left)photo ©Andrew Darlow (right) Photo courtesy HP

letter-sized sheet of paper in two, then print both halves using the software recommended earlier in this tip. Then paste them together so that there is only one seam.

Virtually all compact printers have optional battery packs and DC car adapters, which makes them ideal for when you are outside or on location doing a photo shoot without AC power, or when you are at a party or other event. Having a printer can also make a stock photographer's job of securing model releases much easier. Many people will be more willing to be photographed and to sign releases if they know that they will receive a photograph a few minutes after it is taken. Compact printers can be used with digital cameras to make prints for sale at events such as street fairs and they can also be used to print directions, postcards, and mailing labels when you're on the road. In addition, you can print multiple images on one sheet of inkjet paper, either without a computer through the built-in software on some compact printers, or by creating a contact sheet in a software program such as Adobe Photoshop, Adobe Photoshop Lightroom, Apple Aperture or Microsoft Expression Media (formerly iView Media Pro).

Most compact printers can be hooked up to external CD burners to back up media cards, but the Epson PictureMate Flash (L8.9) has a built-in CD burner. This makes it capable of computer-free printing and image backup of files from media cards, cameras or mobile phones. And some of the HP Photosmart compact printers, Canon

194

compact printers and Epson PictureMate printers can also utilize an optional Bluetooth Print Adapter, which allows wireless printing from mobile phones and other devices.

Though not inkjet printers, some of the dye-sublimation printers on the market are even smaller than compact inkjet printers. Some of these include the Canon Selphy CP740 (L8.10), CP510 (L8.11), or CP710 (L8.12); Kodak EasyShare Dock Dye Sublimation Printer (L8.13); and the Olympus P-S100 Digital Photo Printer (L8.14). As with any printer, I recommend checking online reviews, cost per print, and longevity ratings for any printer you are considering. My favorite site for estimated longevity ratings is wilhelm-research.com.

TIP 105 How to save ink with Epson Stylus Pro printers.

Some of Epson's Stylus Pro printers, including the Epson Stylus Pro 4800, 7800, and 9600, can have just one of the black inks installed at a single time. Matte black is designed to optimize density when printing on matte papers, and photo black is designed for semi-gloss and glossy papers. It's possible to switch between the two, but it takes about 15–25 minutes to make the switch, and about $40–$70 in total ink is wasted every time a changeover is made. In the case of the Epson Stylus Photo R2400, which takes smaller cartridges (similar to those shown in Tip 110), there is less ink used because there are no long tubes running from the cartridges to the print heads. Also important to note is that either inkset can be used with many water-resistant matte canvases. Here are two ways to save ink when using these printers.

If you go through the standard changeover procedure and have less than a certain percentage of ink in any cartridge, you will be asked by the printer to install a new cartridge. However, the partly-filled cartridge that was installed should not be discarded because it may still have enough ink for many more prints. Just place the cartridge that the machine asks you to replace in a plastic sealable bag—a Ziploc gallon-size bag works well; then finish the procedure, and when you are done, re-install the low-ink cartridge that the machine said needed to be replaced, and place the new cartridge in the sealable bag.

Another option is to use the "Phatte Black" system from ColorByte Software (L8.15), which allows you to print on both matte and gloss paper and other media without changing inks. This system uses a specially programmed matte black ink cartridge that replaces the standard Epson Light Light Black cartridge. It also requires the ImagePrint RIP (L8.16) from ColorByte Software. Color and black and white printing

capabilities are retained, and the same print quality can be expected after making the change. You can also easily return to the original setup with not much loss of ink if you decide not to continue to use the system.

The ImagePrint RIP is a software-based application that is available for a number of different pro-level printers. It is highly regarded by many photographers and other artists, and I recommend it because of its layout tools, as well as the quality of the many custom ICC printer profiles that the company has built. I especially like the profiles that are specifically made for neutral or toned black and white printing. Another benefit of the RIP is that the maximum print length is longer than that possible with the standard Epson Stylus Pro printer drivers.

The RIP can be used with or without the Phatte Black system, and the only additional cost to owners of the RIP is for the purchase of the specially modified matte black ink cartridge. Ken Chernus (L8.17), a California-based photographer, has used the Phatte Black system for over a year and especially likes the fact that he does not have to switch back and forth between black inks just to print a semi-gloss or gloss contact sheet for a client. Prior to setting up the Phatte Black system, Chernus did a standard changeover to Photo Black because he had the Matte Black installed in his printer. Prior to doing the Phatte Black changeover, the Epson Photo Black must be installed as if you were going to normally print on semi-gloss or glossy papers.

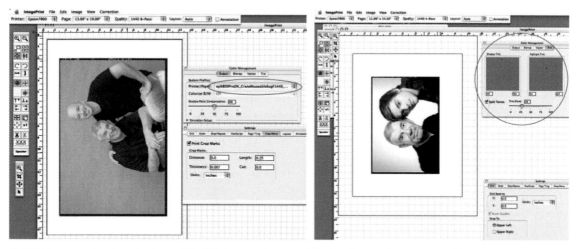

(Left) This screen shot from the ImagePrint RIP shows a photograph by Ken Chernus being prepped for a 13×18-inch color print. The Phatte Black color profile for Crane Museo Silver Rag is circled in red and can be recognized by the "DK" in the profile name. (Right) Another photograph by Ken Chernus being prepped for output through the ImagePrint RIP. When printing black and white, Chernus chooses an ImagePrint Grayscale printer profile. He then selects a highlight and shadow tone mix (from cool to warm) depending upon the look he wants, using ImagePrint's Tint Picker dialog box (circled in blue). Photos © Ken Chernus

Photographer: Andrew Darlow; **Image title**: *Faces 015*; **Print Size**: 4×6 inches; **Paper**: Epson PictureMate Glossy Photo Paper; **Printer Name**: Epson PictureMate Deluxe Viewer Edition; **Ink Used:** Epson PictureMate Color Ink**; Driver**: Standard Epson Driver (Windows XP); **Camera**: Nikon D1X; **Lens**: Nikkor 50mm f/1.8 ; **F-stop**: unrecorded; **Exposure**: 1/10 sec.

Chernus then followed a one-time step-by-step procedure provided by ColorByte Software to purge the Light Light Black ink. He primarily prints color and black and white on an Epson Stylus Pro 7800, and his favorite papers are Hahnemühle Photo Rag (L8.18), Moab Entrada Rag Natural (L8.19), and Crane Museo Silver Rag (L8.20). Silver Rag is best when treated like a semi-gloss paper, so the Phatte Black system is ideal because it allows Chernus to switch between his primary papers without spending additional time or wasting ink. After switching to the Phatte Black system, it's important to install the profiles specifically made for the system. They have DK in their titles and are available free to ImagePrint RIP owners at the company's web site. ColorByte also makes multiple printer profiles for each paper based on the anticipated lighting conditions under which prints will be viewed. Chernus notes that he almost always uses ColorByte's "F3" profiles, which are made for prints that will be viewed under mixed lighting conditions. If the F3 profiles are not available for a specific paper, ColorByte recommends using the F2/ECWF2 profiles.

In Chapter 12, photographer Kirk Gittings (L8.21) also shares tips about how he uses the ImagePrint RIP.

TIP 106 Pre-feed with any printer, and save time with the HP Designjet series printers.

If you've done any printing with a printer that feeds paper from an open tray (and in some cases, a closed cassette-type feed), you can often reduce feed problems by following these tips and techniques:

Use your printer's paper feed option. Many printers have a button that allows you to "pre-feed" a single sheet into the printer so that it moves to a place where it is firmly under the paper transport rollers and ready to print before you send a print job. This can help avoid possible misfeeds, and can also help to improve image quality because the paper will not have to travel as far prior to when the printer begins printing. This can also be helpful when feeding heavy sheets of paper, which tend to have more feed problems. With some papers, you can increase the percentage of successful paper feeds by guiding the paper in with a gentle push after pressing the paper advance button.

I've also found that a heavy sheet (about 300gsm) of watercolor inkjet paper placed in the printer tray behind the paper you are feeding can help any paper feed more easily. Another thing to realize is that many printers have different adjustments (manual and through software) for handling different paper thicknesses. This is important to keep in mind, because you can damage your printer by feeding a sheet of paper that is too thick if the print head strikes the paper. The thick or wide setting is meant for envelopes and heavy papers (generally over 200gsm), and adjusting the lever near the feed tray on some printers can help improve paper feeding. In some cases, like the HP Designjet Z2100 and Z3100 series, the head height is adjusted automatically based on the paper type that you select in the printer driver. And if you weren't sure how to feed paper completely through the printer quickly without using your computer, the paper advance button will eject the sheet of paper when pressed a second time on most printers.

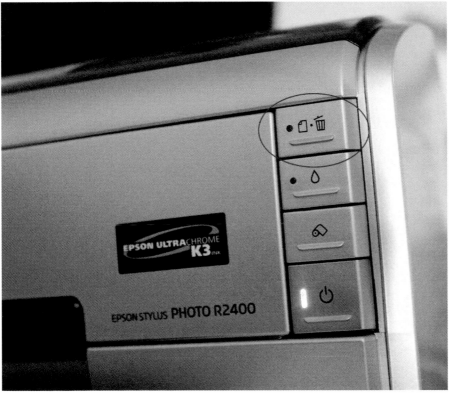

(Left) The paper advance button on an Epson Stylus Color R2400 (circled in red).
Photo © Andrew Darlow

Clean your printer's paper feed rollers. Inside virtually every inkjet printer are a series of small rollers made from plastic and/or rubber that guide paper or other materials through the printer. With use, they can pick up some of the coatings used on some inkjet papers (especially matte papers), plus dust and lint, resulting in paper feeding problems. One approach is to spray the center portion of one side of a sheet of heavy-weight matte paper such as Wausau Exact Vellum Bristol Paper, 67 lb (L8.22) with Windex Blue glass cleaner or a similar cleaner that does not contain ammonia. Then send the paper through 2 to 3 times (or use separate sheets each time) using the paper feed option. Spraying the middle will help keep the paper stable and, thus, help to avoid misfeeds. You can also spray an area across the 11-inch width of the paper, and feed the paper horizontally, which will cover virtually all of the feed rollers on 13-inch-wide printers. You can also put through a sheet sprayed with distilled water after sending through a sheet sprayed with the glass cleaner if you are concerned about possibly damaging the rubber or plastic components with the chemicals in the glass cleaner. An easy way to eliminate any residue after cleaning the rollers is to send a few sheets of plain matte paper through a few times using the paper feed option.

A product specifically made for cleaning rubber parts is Blow-Off Rubber Rejuvenator (L8.23). It comes in an aerosol can with a helpful straw to reach tight spaces or to focus the spray onto a small area (similar to the red straw packaged with WD-40). Cleaning sheets are also available, which are sheets of paper that contain a slightly sticky surface. One brand that I've used successfully is PathKleen Printer Roller Cleaner (8.5 × 11-inch sheets, L8.24). For larger printers, you can follow the suggestions for spraying and running through matte paper, but, instead, use inkjet paper the same width of your machine.

(Left) An 8.5x11-inch sheet of Wausau Exact Vellum Bristol Paper, 67 lb sprayed across the 8.5-inch side with Windex Blue prior to being sent through an inkjet printer. (Right) A PathKleen Printer Roller Cleaner sheet (notice the grid-like pattern with the sticky, tape-like material applied). The brown release sheet is removed before feeding the sheet through a printer. Photos © Andrew Darlow

Fan out multiple sheets of paper before loading. Quickly fanning out sheets of paper by holding them in one hand and using your other hand to create a fanning effect can help to avoid the problem of having multiple sheets of paper being picked up by the rollers at the same time.

Keep your printer covered when not in use. I generally recommend placing a plastic bag or specially made cover over any printer when not in use, especially if you have pets. This can reduce dust and pet hair collecting on the rollers and inside the printer, and it should help to reduce misfeeds and print head clogging. I don't recommend sealing your printer completely with a plastic cover, but, instead, I would just make sure that it is covered so that dust cannot enter the paper feed slots or other open areas that lead directly to where the print head travels while printing. The plastic bag in which most printers are wrapped can usually serve as a cover.

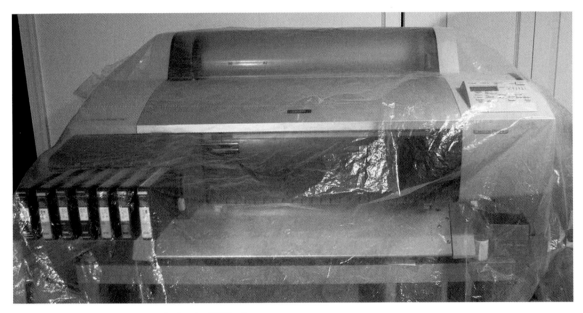

A plastic bag covering an Epson Stylus Pro 7600 printer.
Photo © Andrew Darlow

The HP Designjet series of printers share some similar printer driver options, and the following tips can help you to achieve high quality prints faster:

Save time after prints are completed on the Designjet 90/130 printers. The following tip can save a significant amount of time if you own an HP Designjet 90 (18 inches wide) or HP Designjet 130 (24 inches wide). When you make a print on either of the machines, and the print has completed, there is an internal timer in the printer designed to allow the ink to dry. The amount of delay can be adjusted through a slider in the printer driver, and the default is set to about halfway, which will cause the paper to pause for about four to eight minutes before being ejected. With the paper I generally use (HP Premium Plus Photo Satin), I've found the prints to be dry to the touch almost immediately after printing, so if the papers you use also come out dry immediately after printing, you can save a few minutes of waiting by moving the slider to the left. Or you can press the button under the LCD display as soon as

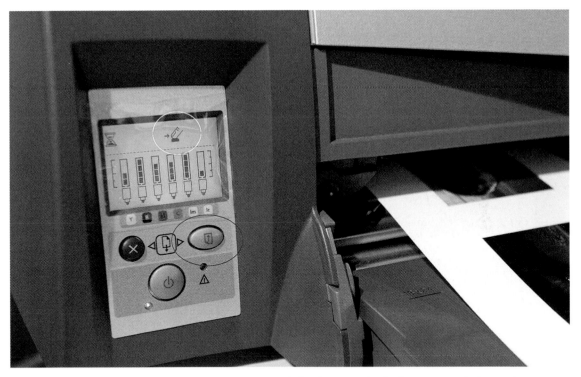

The icon of a finger on the HP Designjet 90 LCD screen signals that the print is finished. By pressing the button that is circled in blue, the print will eject. The amount of time which the print will pause before ejecting can be set in the printer driver.
Photo © Andrew Darlow

Photographer: Andrew Darlow; **Image title**: *Canine 004*; **Print Size**: 13×19 inches; **Paper**: Innova Smooth Cotton High White; **Printer Name**: Epson Stylus Photo R2400; **Ink Used**: Epson UltraChrome K3 Pigments; **Driver**: Standard Epson Driver (Mac OSX); **Camera**: Canon EOS D60; **Lens**: Canon EF 28-135mm IS; **F-stop**: f/8; **Exposure**: 1/20 sec.

you see the icon that looks like a finger appear on the LCD screen. That will cause the paper to immediately eject very quickly, so I recommend being ready for it by flipping up the paper stopper on the top of the paper cassette.

Save time by adjusting printer driver settings for HP Designjet printers. Though this was mentioned in general in Chapter 2 (Tip 26), you can reduce your printing times considerably with the Designjet 90 and 130 printers if you keep the box labeled "Maximum Detail" unchecked in the printer driver (only certain combinations of paper and print quality will enable it to be checked). Instead, I recommend choosing "Best" next to "Quality" because that will produce very high quality output and good print speeds. The same suggestions can be applied to the HP Designjet Z2100 and Z3100 printers. Keeping "Maximum Detail" and "More Passes" unchecked can help speed print times, while still producing very high quality output. A few comparison tests using a standard test file such as the PhotoDisc target (L8.25) or one that you create can help you to save time without sacrificing quality. You may find that an even faster setting produces work at the quality level you require.

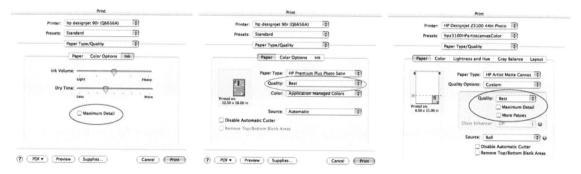

(Left) One of the printer driver screens for the HP Designjet 90 with Maximum Detail unchecked (circled in red). (Center) Another printer driver screen for the HP Designjet 90 with Best Quality selected (circled in green). (Right) One of the printer driver screens for the HP Designjet Z3100 with "Maximum Detail" and "More Passes" unchecked (circled in blue). All three screen shots are from the Mac OSX version of the printer drivers.

TIP 107 How to quickly tone black and white images and create compelling image effects.

In Chapter 5, I covered a few options for converting from color to black and white, as well as a few ways to tone black and white images. In Photoshop and Photoshop Elements, there is tool called "Hue/Saturation" that is both powerful and very easy to use. You can also achieve many of the same effects in other image editors. The Hue/Saturation tool is most effective for creating toned black and white images when you already have a good quality black and white image to adjust. One of the most

creative uses for the Hue/Saturation tool is for creating a faded color look by reducing saturation (similar to a hand-colored black and white print, or a 70's retro earth-tone look). The tool is also fantastic for ghosting back or darkening areas of an image to drop in text. The possibilities, as they say, are endless. The following techniques are designed to help you get the most from the tool.

The top slider of the Hue/Saturation dialog box is Hue, which adjusts the color balance (similar to the color temperature or white balance adjustment on a camera); the second is Saturation, which adjusts how saturated (or bright) the color is. Reducing the saturation by moving the slider to the left can help create a faded, hand-colored look. The third is Lightness, which I generally use when I want to create a ghosting or darkening effect. Be sure to check "Preview" to see your adjustments as you make them, and check "Colorize" to easily create a range of toned black and white images. You can also just adjust the Lightness slider without checking Colorize to lighten or darken an area. That's how I usually create the ghosting effect described earlier. However, for the photos shown in this tip, I wanted a slightly different tone in the ghosted box, so I checked the Colorize box.

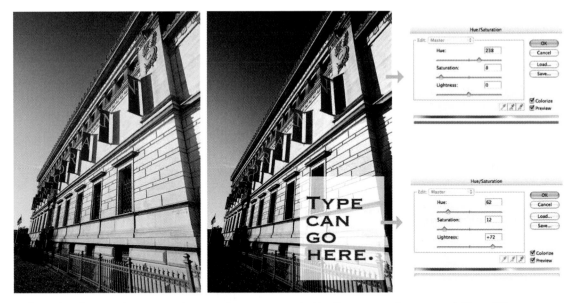

(Left) A color photograph prior to making an adjustment using the Hue/Saturation adjustment tool. (Center) The same photo after making two separate adjustments to the image: (1) changing the tone to a cool tone, and (2) ghosting back a section and adding text. (Right) The actual Hue/Saturation adjustments used to create the overall toning, and the adjustments used to create the ghosted back area. Before doing the toning shown here, the original color image was first converted to black and white (but kept in RGB mode) using Photoshop's Channel Mixer tool. For best results, it's important to first optimize the look of your black and white images before using the Hue/Saturation tool to adjust their tone. Photos © Andrew Darlow

Our companion site has links to more image editing techniques. One of the featured photographers on the companion site is Victoria Cooper (L8.26), who shares information about how she has transformed dozens of traditional Polaroid transfers into large scale inkjet prints, and how she achieves the look of Polaroid transfers by "toning" in Photoshop.

TIP 108 How to uncurl roll or sheet paper.

One of the most frustrating things that artists often have to deal with is curled paper. This is primarily an issue when printing on paper from a roll (especially as you reach the end of a roll), but I've also seen curled paper in cut-sheet boxes. Learning how to uncurl paper can help avoid the dreaded "head strike" or paper jam problem described earlier that can occur on some printers, and it makes for a better presentation when delivering prints to clients. Flat paper is also easier to frame and mount, and less likely to show unevenness when matted. One way to uncurl paper is by placing weight on the paper with the curled side down—usually that's the print side. A box of paper or sheets of MDF (medium density fiberboard, L8.27), like the type commonly used for shelving and furniture, work well as weights. For more stubborn curls, you can roll the print in the opposite direction around a tube. A room with medium to high humidity (over 50 percent) will generally help paper to uncurl more easily, and you can achieve this by laying out your prints in a humid room (for example, near a running shower, or in a room with a humidifier) for about 15 minutes just before rolling or flattening them. This should help to remove the curl, especially when used with the following rolling technique.

I've prepared a step-by-step rolling tube technique that I use for uncurling paper, and photographs are provided to illustrate the steps. I recommend using a lightweight piece of canvas, or a similar material—I generally use leftover coated inkjet canvas for this purpose. The diameter of the tube will usually determine how well the paper gets uncurled. I recommend a two- to three-inch diameter tube for prints under about 16 × 20 inches, and a three- to five-inch tube for prints over 16 × 20 inches. Every paper reacts differently, so you may have to experiment to find just the right tubes and just the right time to keep the prints rolled up when uncurling your favorite papers.

Here are the steps: (1) Place a print with the curled area facing down on the canvas. It should be about three to six inches from the edge of the canvas so that when you begin rolling the canvas around the tube, only the canvas (not the tube) will be touching the print. Make sure that the print meets the canvas on the roll completely

straight. If the prints are very curled, a second person can make the process much easier. Also, the tube, as well as the piece of canvas should be at least one inch wider than the art on both sides. (2) Roll the canvas very tightly, using medium downward pressure as you roll. (3) If your paper has just a slight curl, wait about a minute and then unroll it in the opposite direction, with medium pressure. It may need to be rolled again if the curl does not come out to your satisfaction, or you may need to leave the print rolled around the core for a longer amount of time. Ten minutes can make a big difference in the amount of curl that will come out compared with just a minute, and keeping a print rolled up for a day will generally have an even greater effect. (4) If you keep the paper rolled around the core for more than a minute, I recommend using about two or three pieces of tape on the outside of the roll to hold the canvas tightly wound around the core. I also recommend de-curling just one print at a time (especially with prints on matte paper) unless they are placed side by side prior to rolling, and not stacked. A sheet of very thin protective paper can help to protect very fragile print surfaces (especially prints with a lot of heavy dark ink coverage). However, a sheet of paper placed on a print and then rolled can also cause marks in the print, so it's a good idea to do a test first. A good protective paper option to consider is Renaissance Paper, available in up to 32 × 40 inch sheets at Light Impressions (L8.28). An advantage of using Renaissance Paper is that it can also be used for print interleaving when showing work in a portfolio, or when transporting prints. (5) When you unroll the print, do it very carefully, and apply the same type of pressure as when you initially rolled it up.

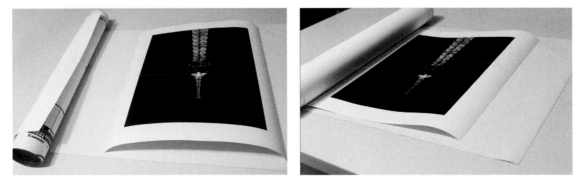

(Left) A three-inch-diameter tube with a curled print from a roll. I recommend using tape under the very front edge of the canvas (where it touches the tube) to adhere the canvas to the tube. Double-sided tape (such as carpet tape) is recommended because you don't want to create uneven bumps under the canvas. (Right) This image shows the beginning of the rolling process. It's important to keep the paper straight and to apply medium pressure (similar to the way you might roll up a carpet).

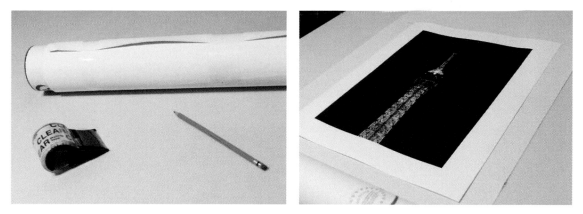

(Left) The 25-inch-long tube used for uncurling prints, with three pieces of packing tape attached to hold the rolled print in place. (Right) After about 10 minutes, the print is unrolled, and becomes almost completely flat.
Photos © Andrew Darlow

A commercial product made to eliminate printer curl is the D-Roller (L8.29). It comes in two sizes, and the company's web site has helpful information and tips for selecting and using the product. There is an excellent video demonstration of the D-Roller by Michael Reichmann from The Luminous Landscape on his site (L8.30), and links are provided on our companion site to some good online discussions that describe how a number of people are de-curling their prints (L8.31).

TIP 109 Consider a printer stand, wall shelving, or organizer.

If you have multiple printers, or even just one, a printer stand, shelving, or a free-standing organizer can add space and improve organization in your home, office, or studio. Printer stands are sometimes included when you purchase a printer (especially printers that print over 24 inches in width), and, in other cases, they are optional. In almost all cases, they come with wheels so that they can be easily moved around a room, and, in some cases, to allow for rear paper loading. Some printers (even large ones like the Epson Stylus Pro 7800) can be used on top of desks. For smaller printers, desktop printer stands can free additional space and allow you to run two printers in a relatively small space. Those types of stands, which are often made from plastic, are widely available at stores such as Office Depot (L8.32). A number of printer stands from different companies can also be found on Amazon.com (L8.33). You can also try searching for "monitor stands" to see additional options, since in many cases monitor stands have similar specs. Some stands have no

Photographer: Andrew Darlow; **Image title**: *Canine 003*; **Print Size**: 17×22 inches; **Paper**: Moab Entrada Rag Natural 300gsm; **Printer Name**: Canon imagePROGRAF iPF5000; **Ink Used**: Canon LUCIA Pigments; **Driver**: Standard Canon Driver (Mac OSX); **Camera**: Canon EOS 5D; **Lens**: Tamron 18-200mm f/3.5-6.3 Di II; **F-stop**: f/10; **Exposure**: 1/200 sec.

209

drawers, and others have multiple drawers and slots for paper and other materials. The most important thing to keep in mind is to not exceed the maximum weight (of the printer) that is recommended for the stand.

(Left) A simple but sturdy tabletop printer stand on a desk with a computer and three printers. Three printers fit comfortably on the table, and all can print without getting in the way of the other. Also notice the calculator stored under the stand. (Right) A wire shelving unit holding an Epson Stylus Pro 4000 printer and supplies. Two additional wire shelving units can be seen to the left and right. They primarily are used to hold print storage boxes.
Photos © Andrew Darlow

Another option that I've seen used effectively to hold printers (especially in school environments) is traditional wall shelving. Shelving brackets and strong wood shelves are inexpensive and widely available at home improvement stores such as The Home Depot (L8.34). A shelf can span an entire wall, or just a small section of it. One tip is to cut a slot in the very back of the wood shelf where the shelf meets the wall, to allow for the printer and power cables to snake through. Also consider that you will need to load paper (often from the top feed slot), so try not to place the shelf too high. Some printers require space behind them, but you may be able to place them sideways on a shelf, or, in some cases, turn them when necessary. Less traditional, but very good options for holding printers and supplies are wire storage racks. They are commonly found in stores such as Bed Bath & Beyond (L8.35) and are available in high-tech chrome, black, white, and other colors. Other advantages are that they allow for many different size configurations and shelf heights, and, in most cases, wheels can be purchased for them. They have no nails or screws, and they are also fairly easy to transport in small vehicles, since the shelves and connecting bars are all separate prior to installation.

Free-standing printer carts are widely available in office supply stores and online. One advantage of these is that they often come with wheels. This can be very helpful in photo studios with multiple sets, or for people who do workshops or on-location printing. An unconventional, but good option for photographers is to use storage cabinets, such as the Sears Craftsman 5-Drawer Roll Away Cabinet (L8.36). The Craftsman cabinets are heavy duty, many come with wheels and drawers, and most are lockable. Sears also makes some well-made rolling carts, including a few with built-in power strips and pegboards on the side (L8.37). The pegboards look like they would be perfect for holding lightweight accessories, such as tape, and long items, such as rulers.

Another tip for users of heavy desktop printers who want to occasionally rotate the printer is to keep furniture slider disks under all four corners of the printer. Or, if you prefer, they can be placed there when needed. Furniture slider disks are inexpensive, and can be found at home improvement stores such as Lowe's (L8.38) or online (L8.39). One brand that will work well is called "Moving Men" (L8.40). Another option is to place a laminated shelf made from MDF under your printer, which should make it easier to then rotate the printer on most tables.

A Canon imagePROGRAF iPF5000 on a table with furniture sliders under four corners (two shown) to allow the printer to be easily rotated if necessary. The primary reasons for rotating the printer would be to change roll paper or to feed a thick sheet from the back of the machine.
Photos © Andrew Darlow

TIP 110 Save ink and learn to save your print settings.

Inkjet ink has been called "liquid gold" for good reason. It can be expensive, especially when doing high-volume printing. Every printer has a different method for printing color and black and white, but most printers have at least one dedicated black ink cartridge that's used primarily for text documents. However, if you print a black and white document using the inkjet printer driver's color mode (generally that's the default), you may be using ink from most or all of the color cartridges, in addition to any black or gray cartridges. Most inkjet printers have either a separate black ink cartridge plus a combined color ink cartridge, or they have separate black and separate color ink cartridges. Thus, it makes sense to set up a saved print setting for just printing black and white documents so that you can use only the ink in the black cartridge. Not all printer drivers allow this black ink only setting to be created, but many do.

A small sampling of ink cartridges: (1) Two individual 130ml cartridges, compatible with some of the Canon imagePROGRAF series of printers. (2) A tri-color cartridge and black ink cartridge for the Canon PIXMA iP90 portable inkjet printer. (3) Two individual ink tanks from HP. This specific type of cartridge is used in many of HP's Designjet printers, as well as the HP Photosmart Pro B9180 printer. (4) Two Epson individual ink cartridges. This specific type of cartridge is used in many of Epson's printers, including the Epson Stylus Photo R2400 and the Epson Stylus Photo 1400 (5) A six color combined ink cassette from Epson, called the PictureMate Photo Cartridge. This type of cartridge is used with all of Epson's compact 4x6 inch PictureMate printers.
Photo © Andrew Darlow

Links to a video demonstration of how to save print settings for black ink-only or full-color printing on Mac OSX and Windows (L8.41) and a link to an article with more ways to save ink, can be found on our companion site (L8.42). A piece of software is also available for Windows users called InkSaver 2.0 (L8.43). The software allows you to set a specific level of ink reduction (from 0–75%), and a sample page can be printed to help determine the amount of ink reduction that is acceptable to you. This probably is not a good idea if you are making art prints for sale, but for everyday printing of web pages and business documents, it may help to save you a considerable amount of money. Also, if you plan to print hundreds of business-related documents every month containing black text, I would highly recommend a laser printer. Many laser printers are inexpensive, have a lower operating cost per page compared with inkjet printers, output very sharp text, and are usually faster than inkjet printers. Using a laser printer for black text and an inkjet primarily for color images can also help to extend the life of your inkjet printer (L8.44).

TIP 111 Place prints on paper prior to hanging on a wall.

Framed prints and stretched canvas are usually fragile and can be easily scratched or marked up when prepping them for exhibition or shipping. Putting your prints on inexpensive newsprint paper, white poster bond paper, or pieces of scrap paper you may have in your home or studio can be very helpful for a few reasons. First, if you have an exhibition, the paper can be rolled out along the walls, and framed or stretched pieces can be placed on them before committing to the final placement and hanging. This can be especially helpful with large group exhibitions. The added benefit is that the artwork will be protected from any dust or dirt that may be on the floor. In addition, the artwork will be less likely to scratch a wood floor. The paper may also help to protect the floor during installation in case a hammer, nail, or frame is dropped.

Most art supply, framing supply, and shipping supply companies, including Dick Blick Art Materials (L8.45), Uline Shipping Supplies (L8.46), and U.S. Box Corp. (L8.47) sell inexpensive roll paper. If you are placing printed canvas or fragile artwork directly on the paper, you may want to use an acid-neutral or acid-free paper such as Pacon Corporation's White Fadeless Art Paper (L8.48), because some inexpensive roll papers have a relatively high acid content. In most cases, newsprint or even Kraft paper (often used by framers to wrap framed art) will do the job. Many shipping and frame supply companies sell Kraft paper in sheets and rolls, and some offer indented Kraft paper, which has a softer, non-abrasive surface that may help keep art from sliding and falling if propped against a wall. Indented Kraft paper (L8.49) can be used to wrap fragile items, such as framed art, and it can also be crumpled and used to fill

the space in boxes when shipping items. Since frames can scratch or damage some walls if placed against them before hanging, pieces of lightweight paper can be cut from a roll, folded in half, and placed over just the top of each frame before leaning them against a wall.

(Left) The product page for indented Kraft paper on Uline.com. (Right) A few framed prints placed on a 24-inch-wide sheet of newsprint paper prior to being hung on the wall. The artwork was part of a show at The Center for Fine Art Photography in Ft. Collins, Colorado (L8.50). Using this system helps the exhibition staff work out the proper spacing between framed prints, and it also helps them to more easily determine where each piece should be hung. The framed print on the left is by Gwen Laine (L8.51), and the next two prints to the right are by Don Dudenbostel (L8.52).
Photo © Andrew Darlow

TIP 112 Decide whether you should keep your printer on.

The question of whether or not to keep your printer on is a common one. In some cases, the manufacturer will specifically recommend that the printer is kept on so that periodic maintenance can be performed. Keeping a printer on will generally keep the printer in a "sleep" mode after a certain length of time elapses after printing so that the energy consumption is minimal. A few examples of this are the HP Photosmart Pro B9180, the HP Designjet Z2100, and the HP Designjet Z3100 print-ers. These printers periodically send very small amounts of ink through the print heads to help reduce the chance of clogging. Canon also recommends keeping some of their printers, including the imagePROGRAF iPF5000 on so that the printer can do periodic head cleanings. With regard to most Epson printers, I generally turn all my current Epson printers off unless I plan to use them throughout the day. As new printers are introduced by manufacturers, this information may change, so it's important to treat every printer individually.

Photographer: Andrew Darlow; **Image title**: *Canine 006*; **Print Size**: 18×24 inches; **Paper**: HP Premium Plus Photo Satin; **Printer Name**: HP Designjet 90; **Ink Used:** HP Vivera Dye Inks**; Driver**: Standard HP Driver (Mac OSX); **Camera**: Canon EOS 5D; **Lens**: Canon EF 16-35mm f/2.8L; **F-stop**: f/9.5; **Exposure**: 1/60 sec.

Regardless of the printer you have, be sure not to turn your printer off using the on/off switch on a power strip in lieu of the printer's power button because your printer may have to go through a special procedure when turned off using the normal power button. As I've recommended in the past, read the manual and ask other users on discussion boards what their experiences have been with various printers.

TIP 113 Discover resources for scrapbooking and paper arts.

Many people only think of their inkjet printers as devices to make prints to give to friends and family, to place in albums without adding text or graphics, or to frame as art. However, due to the popularity of scrapbooking and free (or low cost) "do-it-yourself" paper arts resources, it's now easy for just about anyone to start making compelling paper-based art with an inkjet printer. With a computer and Internet connection, you can access hundreds of designs, templates, and other projects, including printable calendars, cards, and 3D paper crafts. Here are some tips and resources to get you started on an exploration of what's available. More links can also be found on our companion site (L8.53):

Find free online resources with downloadable kits and templates. There are many online resources available, including Canon's Creative Park (L8.54), an extensive web site with many free downloadable layouts and graphics that can be used for personal use. The quality of the designs are amazing, and downloadable options include pop-up cards, cars, 3D animals, buildings of the world, photo frames, and much more. There are also instructions and files available to help you produce a 16 page 4.25 × 5.5-inch book from just four sheets of single sided 8.5 × 11 inch paper (L8.55). To make the book, just download the template for the book and replace the images with your photos and text. You will need to fold each page carefully for the book to look its best, and, to do that, I recommend scoring the pages first with a bone folder or similar object (L8.56). The page numbers at the bottom of each section will help guide you as you build the book. Then print the pages out on paper that will fold easily. Then bind the book using one of the options described in Chapter 7. On Canon's Creative Park site, you'll also find some detailed Photoshop tutorials, such as this one (L8.57) that uses one of the techniques I describe in Tip 107.

Epson has an area of its web site called "Epson Creative Zone" (L8.59) with many free downloadable projects, including scrapbook page designs, greeting cards, mini accordion albums, and award certificates. Under the "StoryTeller" section, there are about 15 different themes that were designed to be used with Epson's StoryTeller Photo Books (L8.60). All of the downloadable project art is Mac- and Windows-compatible. Epson also has a number of acid-free matte papers that are

(Left) A few completed 3D paper craft projects from Canon's Creative Park web site (the pen is just for scale, and is not made from paper!). (Right) A 3D Yellow Labrador Retriever paper craft from the Creative Park web site. It was printed on a Canon printer using the Canon Matte Photo Paper shown in the photo (170gsm, L8.58). The printed pieces were then carefully folded and assembled.
Photos © Andrew Darlow

ideal for scrapbooking and related projects. In addition to 8.5 × 11-inch single- and double-sided papers, the company has 12 × 12-inch inkjet paper called PremierArt Matte Scrapbook Photo Paper for Epson (L8.61), which is the ideal size for use with many scrapbooking pages and albums.

Another online resource filled with an incredible array of projects is HP's Activity Center (L8.62). The site has a Mac- and Windows-compatible online design wizard that allows you to quickly add text, change text color and fonts, upload photographs, and print business and family-related documents (even custom trading cards) directly to any printer. Or you can export the finished document to a PDF file so that you have a standalone, printable archived version, which I recommend. Some of the other projects include a great one-page travel checklist, many brochure layouts, animal origami, gift boxes and printable gift wrap, wedding-related projects, and many more. There is also an extensive amount of projects that incorporate graphics from the movie *Shrek the Third*. HP offers Brochure and Flyer Paper in both glossy and matte versions. Both papers are double-sided and work well for many paper and bookmaking projects (L8.63).

Also, I recommend reading the terms of use of every web site from which you download content, because in many cases, the artwork may only be used for personal, non-commercial use.

(Left) The main page of Epson's Creative Zone web site. (Right) The main page of HP's Activity Center web page.

Discover available software and online layout/design web sites. There are a number of software titles and web applications available to help build scrapbook pages, cards, calendars, and other paper-based art. Most are made only for the Windows operating system, and most include hundreds (sometimes thousands) of projects, images, and fonts. I recommend asking others their experiences with specific software titles, and I also recommend reading user reviews. Amazon.com has some very good reviews of scrapbooking software. One very popular and affordable photo editing software title, Adobe Photoshop Elements 5 (Windows version, L8.64), has many well-designed card, calendar, scrapbook, and CD/DVD cover templates, as well as more than 100 digital frames. The current Mac OSX version is Elements 4.0. It also has many templates, including calendars, cards, and book layouts. Both the Mac and Windows versions allow you to create designs, then save them to PDF and print on any printer, or, in some cases, send them to an outside company right from within the program. Adobe also makes a free program called Photoshop Album Starter Edition (Windows only) with basic image editing functionality, as well as the ability to make prints, or order prints, photo books, and other items online. Apple makes it easy to create cards, calendars, and books through its iPhoto application, which is part of the Apple iLife software suite (L8.65). And Apple Aperture takes book creation to an even

higher level, with added features and the ability to create books while still retaining all of Aperture's editing tools and non-destructive editing capabilities (L8.66).

In a way similar to the online design wizard offered by HP, the web site scrapblog.com is a powerful way for Mac and Windows users to create layouts that can then be shared online, or exported to JPEG format and printed to virtually any inkjet printer. Many of the sample designs are breathtaking, and all can be customized. There is a bit of a learning curve, but the company has videos to help you get started, as well as tips, such as how to create a photo book with Scrapblog for under $10 (L8.67). Another good resource is this step-by-step scrapblog tutorial by Michael Pick on the web site masternewmedia.org (L8.68). And if you are looking for a web site with active forums and interviews, tips, and products related to scrapbooking, I recommend Scrapbook.com (L8.69).

Join scrapbooking and paper arts-related forums, listen to podcasts, and read books and magazines. Like some of the online groups I've suggested throughout the book, there are many discussion groups that cover scrapbooking and paper arts. An excellent one which I subscribe to, and which has been running since 1999, is a Yahoo! Group called Layouts (L8.70). Members can upload small files of their layouts to share them with others, and, if the layouts incorporate paper or digital designs produced by a company, credit is generally given with links to the designs. This can help you to discover new designs and other resources.

Podcasts (audio or video programs that you can subscribe to) are another great source of information related to photography and paper arts. One of my favorite scrapbooking and paper arts-related podcasts is SCRAPcast (L8.71). The show's host, Lynette Young, is a former scrapbook store owner, and some of the topics she covers include tips for organizing photos, how to choose the right adhesives, how to make custom greeting cards, ideas for setting up scrapbooking get togethers

(Left) An overview of Photoshop Elements 5.0 on Adobe.com. The Flash-based interactive animation shows many of the features of the program, including a number of page layout options. (Center) The home page for Memory Makers magazine. (Right) The home page for Scrapbook.com.

(a.k.a. "crops"), and much more. She has also interviewed a number of authors and photographers on the show.

Books and magazines are another great way to learn more about how you can incorporate your inkjet prints into scrapbook designs or other albums. One particular magazine that amazes me every time I pick up a copy is Memory Makers (L8.72). The overall print quality of the publication, amount of tips and suggestions, and creativity of the featured designs are very impressive. They also have a comprehensive web site with photo and design tips, as well as videos of scrapbook-related products and events.

TIP 114 Donate or recycle your inkjet-related items.

In this final tip of my section of the book, I think it is critical to understand the impact that we all have on our earth when we throw out items containing ink and plastic (and, for that matter, any plastic or electronic materials). Virtually all inkjet cartridges can be recycled, and recycling keeps many potentially harmful materials out of landfills.

Some companies will recycle specific brands of used inkjet and laser cartridges, and, in some cases, they will even pay a specific amount per cartridge. Staples (L8.73), for example, pays $3 per recycled cartridge in the form of store merchandise certificates. Also consider recycling the packaging that your inkjet cartridges come in. If the package has a recycle logo or a notice that it can be recycled, you can usually discard it with plastic bottles and similar items. Also consider recycling mobile phones, laser printer toner cartridges, computers, and, of course, batteries. Many communities have free drop-off centers for batteries and other electronic trash, and some companies, like Staples, will recycle old printers, computers, and other items for a per item fee. I also recommend doing a search on your printer or ink manufacturer's web site to see what suggestions and options they offer for recycling. Most have a section dedicated to recycling.

Donating working printers to nonprofit organizations such as The Salvation Army (L8.74) can help those organizations earn money from the sale of the equipment. By donating a printer to a school (and possibly some time to help them set it up), you may be able to help them to greatly expand their art program. There is also a good chance that some of your equipment's value can be deducted on your tax return. I recommend checking with a tax professional with regard to how to properly account for these types of donations.

Photographer: Andrew Darlow; **Image title**: *Dalmatian Contemplation*; **Print Size**: 17x22 inches; **Paper**: Media Street Royal Renaissance 309 gsm; **Printer Name**: Epson Stylus Pro 7800; **Ink Used:** Epson UltraChrome K3; **Driver:** Standard Epson Driver; **Camera:** Minolta X-700; **Film:** Kodak T400CN (developed in C41); **Lens:** Minolta 50mm f/1.8 MD; **F-stop** & **Exposure:** Unrecorded

© Richard Ehrlich

© Raphael Bustin

© Kirk Gittings

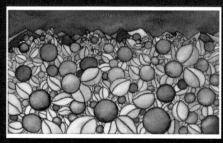

© Stephanie Ryan

© Bonny Lhotka

© Joel Meyerowitz

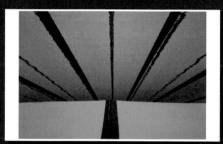

© Harald Johnson

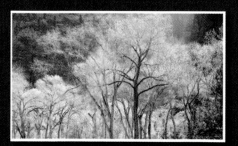

© Phil Bard

© R. Mac Holbert

© Amadou Diallo

© Dorothy Krause

© Mark Harmel

© Matthew Wakem

© Karin Schminke

I n Chapters 1–8, I shared many of my thoughts and suggestions about topics related to inkjet printing. Because I have learned so much from others over the years, I decided to invite a select group of very knowledgeable and talented photographers and other artists to contribute to the book.

Chapters 9–16 are all "guest artist" chapters, containing images, tips, and techniques. Guest artist tips are written from each person's own perspective, and I'm extremely pleased to be able to showcase their imagery, as well as their tips and techniques.

Throughout the remainder of the book, our guest artist chapters will cover many subjects related to inkjet printing, including: image capture; image editing; color management; portfolio and presentation; inkjet papers; lighting and exhibiting; and canvas and coatings. I sincerely appreciate their excellent work and thank them for their contributions.

Guest Artist Section

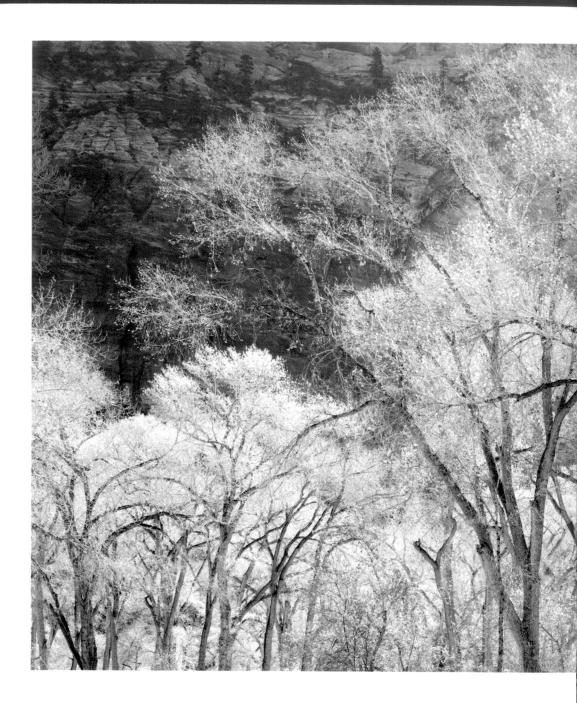

Artist: Phil Bard; **Image title**: *The Grotto*; **Print Sizes**: 38×22, 67×40 inches; **Paper**: Hahnemühle Photo Rag, Hahnemühle

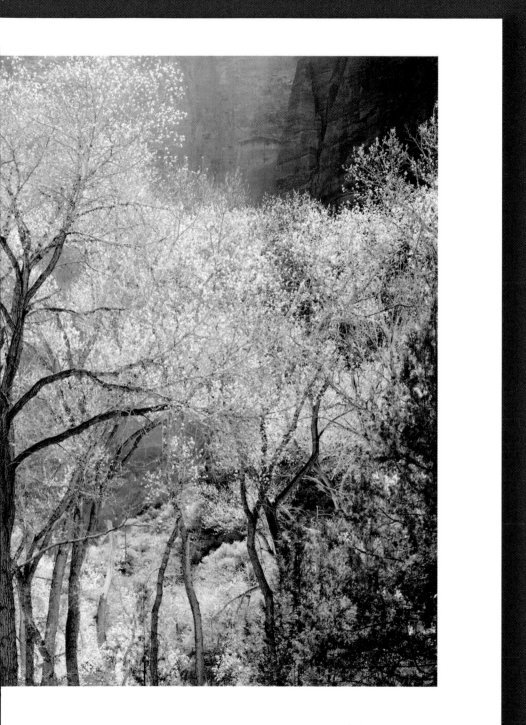

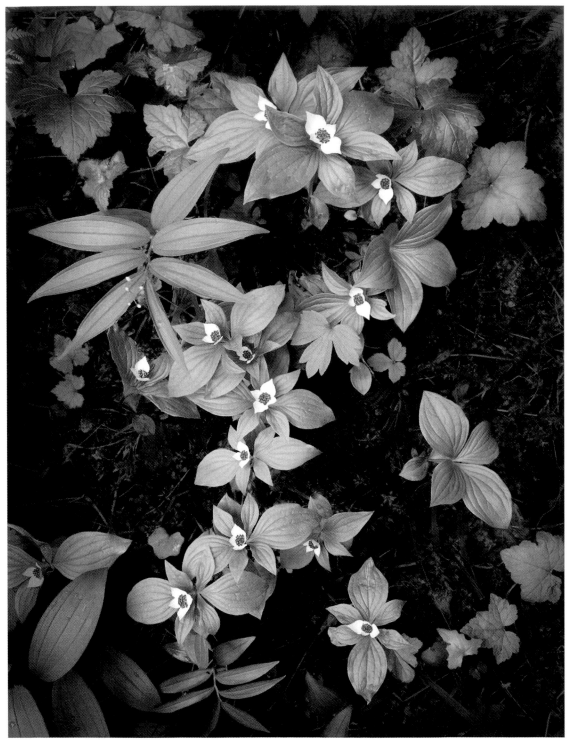

Using Hahnemühle's Photo Rag and Other Coated Watercolor Papers

By Phil Bard

Phil Bard is a photographer and digital output specialist based in Portland, Oregon. Bard began his career in professional photography running a commercial studio in Los Angeles, with clients including Nokia, U.S. Bank, Mattel, Disney, and numerous design firms and ad agencies. His editorial work has appeared in *Life*, *Time*, *Outside*, and *Climbing* magazines. Since 2000, his company, Cirrus Digital Imaging, has supplied drum scanning, Photoshop work, and color and quadtone printing to artists. Bard is a former member of the faculty of Art Center College of Design and currently teaches Advanced Digital Imaging at the Pacific Northwest College of Art. For more information, visit www.cirrus-digital.com.

Though traditional photographic paper was available to photographers in a range of surfaces, the choices were fairly limited. This was especially true when it came to matte papers. As printing technologies have evolved, a number of paper manufacturers have stepped up to the plate with specially coated matte inkjet papers. The tips below apply to many coated watercolor papers, though one in particular, Hahnemühle's Photo Rag (L9.1) will be highlighted because, in my opinion, it's one of the best in this realm.

Photo Rag is 100% cotton rag, has a beautiful matte surface that is smooth with a slight hint of texture. It's available in 188 and 308gsm versions (196 and 316gsm double-sided versions), and the 308gsm weight is substantial enough to lie flat under an overmat in even the largest sheet sizes (35 × 46.75 inches). It holds color extremely well with a very wide gamut and, in my experience, has the best black of any rag sheet on the market. There is a richness to the look of images printed on Photo Rag that must be seen to be truly appreciated.

To find the web links noted in the book (L9.1, etc.), visit www.inkjettips.com or http://www.courseptr.com/ptr_downloads.cfm.

Artist: Phil Bard; **Image title**: *Dwarf Dogwoods*; **Print Sizes**: 11×14 to 24×30 inches; **Paper**: Hahnemühle Photo Rag, Crane Museo Silver Rag; **Printer Name**: Epson Stylus Pro 7600/9800; **Ink Used**: Cone PiezoTone Selenium, Epson UltraChrome K3; **RIP/Driver**: StudioPrint RIP, Standard Epson Driver; **Camera**: KB Canham 8x10; **Lens**: Nikkor 240mm; **Film**: Delta 100; **F-stop**: f/45; **Exposure**: 20 seconds

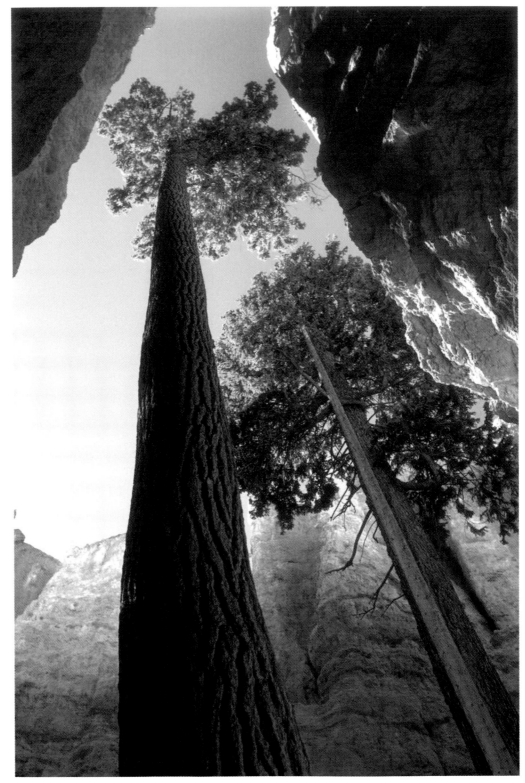

TIP 115 Print with custom profiles and experiment.

You will achieve best results if you create or have a service create custom profiles for you. I use the GretagMacbeth i1Pro Spectrophotometer (L9.2) and i1Match software (both are now produced by X-Rite) to create my custom profiles for color and black and white printing. I suggest using Epson's Watercolor Radiant White as the media setting in the Epson printer driver when using Epson UltraChrome K2 or K3 ink printers (for example, the Epson Stylus Pro 7600 or 9800). This applies whether or not you are using custom profiles, but some experimentation with other media settings is also recommended.

TIP 116 Brush prior to printing to reduce "flaking."

Photo Rag and other fine art papers are sometimes prone to flaking (flaking usually looks like small white spots in the print). They can be retouched after printing if this should happen, but loose coating particles can be removed from the sheet by lightly brushing with a soft brush before printing. I use the wide horsehair brushes available in art stores (L9.3) for dusting off artwork. Brushing must be done with care, as fine scratches will show in broad areas of even color and black if you brush too hard. I also recommend brushing in only one direction.

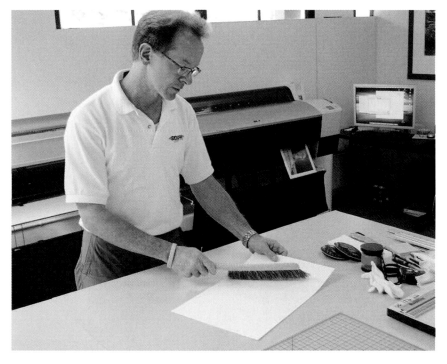

Phil Bard brushing a sheet of Photo Rag with a wide horsehair brush.
Photo © Phil Bard

Artist: Phil Bard; **Image Title**: *Trees in Bryce Canyon*; **Print Sizes**: 8×10 to 20×24 inches; **Paper**: Hahnemühle Fine Art Pearl; **Printer Name**: Epson Stylus Pro 9800; **Ink Used:** Epson UltraChrome K3; **Driver**: Standard Epson Driver; **Camera**: Nikon F4; **Lens**: Nikkor 24mm; **Film**: Kodachrome 64; **F-stop & Exposure**: Unrecorded

229

TIP 117 Cut sheets from roll papers before printing.

When using Photo Rag (or any other fine art paper), I always cut sheets from the roll before printing, and feed them individually. This allows prints to be brushed in a location away from the printer, which reduces the chance for the heads to become clogged by loose particles or dust from the paper's surface. I use roll papers because they allow for a substantial amount of flexibility when making prints for clients and for myself. However, buying paper in sheet form avoids the additional handling and flattening that is necessary when using roll papers.

TIP 118 Avoid using paper near the end of a roll.

As with many papers, when using Photo Rag roll stock (especially the 308gsm weight), the last few feet of a roll generally cannot be used because of extreme curl. There are also subtle creases often visible in the last few feet of a roll, and these will usually show under certain lighting if a print is made using it. Instead of throwing out the paper at the end of a roll, cut it up and use it for proofing, but a small amount of reverse curl is usually necessary to feed it properly into the printer.

TIP 119 Let the paper dry before packing or framing.

One nice feature of using cotton rag paper is the speed at which it becomes dry enough to store in a flat plastic envelope or for it to be rolled up. Depending on humidity in the drying area, prints are usually ready after 24 hours. I use my vintage darkroom print drying rack to lay inkjet prints out for this time period. Print racks in many sizes and styles can be purchased or made. Prints made on Photo Rag from the roll rarely need to have weight applied to them to flatten sufficiently, but some fine art papers will require weight for up to a week to get the curl out.

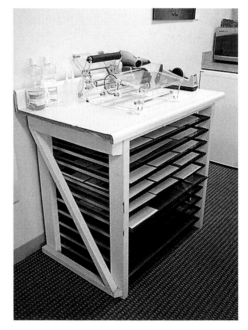

Darkroom print drying rack being used to allow inkjet paper to dry and flatten out.
Photo © Phil Bard

Using Crane's Museo Silver Rag

By Phil Bard

As the owner of a digital imaging business, I'm often asked by clients which paper stock and ink they should be using for black and white and color printing. Many of them are photographers with a history of printing in the darkroom. Until just a few years ago, there were no papers on the market that could compete head to head with the appearance of a traditional silver gelatin print. Though longevity was good, most glossy and semi-gloss papers had a recognizable inkjet look, with the ink right on the surface of the sheet. And cotton rag papers all had matte finishes. That has all changed with Crane's "fiber gloss" paper, Crane Museo Silver Rag (L9.4), and similar fiber gloss papers from other manufacturers.

Silver Rag's base is 100% cotton rag. The surface is semi-gloss (similar to Epson Premium Luster), with slightly less of a pebbled finish once the ink is applied. Epson's UltraChrome K3 inkset has a considerably reduced gloss differential (visual differences between light and dark areas on the paper surface) on most papers compared with the original UltraChrome inkset. Veteran darkroom printers to whom I've shown a monochrome Silver Rag print have had to look very closely to distinguish between it and a gelatin silver print. At 300gsm, Silver Rag has almost the same thickness as a premium weight darkroom paper, and mounted prints of each are virtually identical. Additionally, it prints color extremely well, making it a good all-around choice for fine printing.

TIP 120 Use an inkset with Photo Black.

A number of different pigment-ink printers can be used with Silver Rag. On the Epson Stylus Pro 9800 (the printer I use most with Silver Rag), I recommend using the Photo Black ink instead of the Matte Black. This produces the highest Dmax I've yet seen on a semigloss sheet. I use Epson Premium Luster as the paper setting, with 1440 DPI selected. I also suggest calibrating your printer using Epson's Colorbase Utility (L9.5) for ideal results if you are not using a RIP with a linearization utility.

TIP 121 Print using Epson's Advanced B&W Mode.

If in RGB, convert the image to grayscale mode using whichever method you choose to optimize your images for black and white printing, and print using the Epson printer driver's Advanced B&W fea-

ture. This will employ all three blacks for extremely smooth tonalities, as well as small amounts of color, which allow for subtle toning of the image. Since Silver Rag is cotton rag, the paper white (base color of the paper's surface) is slightly warm. Epson's toning wheel enables you to create many different monochrome tones. I usually set the Color Toning to "neutral," which results in a slightly warm-toned print. If I wanted a more neutral or selenium look (similar to silver gelatin), I would set the vertical shift parameter in the color wheel to −10 or so, as shown in the screen shot.

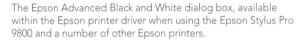

The Epson Advanced Black and White dialog box, available within the Epson printer driver when using the Epson Stylus Pro 9800 and a number of other Epson printers.

TIP 122 Handle Silver Rag with care and avoid rolling.

Until the inks are completely dry, it's possible to leave fingerprints or cause scuffing on Silver Rag. This is not unusual in a gloss stock. However, once dry, the paper is VERY rugged—one of its greatest virtues. I don't recommend rolling and unrolling Silver Rag prints, especially within about eight hours after printing. This is because, like with many cotton rag papers, Silver Rag is susceptible to flaking. Flaking appears as small white spots in certain areas (usually darker tones). These can be spotted with inkjet ink or other spot toning products (L9.6). In addition, dark spots can be etched (removed with a sharp blade or chemical), just like a darkroom print. Though it's easy to retouch, the best prescription is to treat the paper with care. The good news is that Silver Rag roll stock lies very flat after printing—more so than any other roll paper I've ever worked with.

Artist: Phil Bard; Image Title: Eucalyptus Trees; Print Sizes: 8×10 to 20×24 inches; Paper: Hahnemühle Fine Art Pearl; Printer Name: Epson Stylus Pro 9800; Ink Used: Epson UltraChrome K3; Driver: Standard Epson Driver; Camera: Nikon F4; Lens: Nikkor 35-70mm; Film: Ektachrome 64; F-stop & Exposure: Unrecorded

TIP 123 Dry mount and spray if appropriate.

Silver Rag can also be dry mounted in a hot press, and this is my preferred way to display my own work—with a simple overmat of museum board and a 1/2-inch reveal around the print's edges to show the signature and edition number. I have also printed large images (44 × 66 inches) for clients that needed images exhibited without glass, and for these I spray the prints with PremierArt Print Shield (L9.7), a lacquer-based UV protectant. This not only imparts longevity and physical protection, but also completely eliminates any gloss differential that might be present.

TIP 124 Take a look at Hahnemühle Fine Art Pearl.

Another fairly new paper on the scene with many of the same characteristics of Crane's Silver Rag is Hahnemühle's Fine Art Pearl. The paper is 285gsm, lignen-free, 100% alpha-cellulose based, and acid-free. It has a brilliant white surface color, unlike the off-white base color of the 100% cotton-based Silver Rag and most other rag papers. For color prints and for monochrome images where you want a more neutral look and a smooth finish, Fine Art Pearl fits the bill perfectly. For much of my work, I prefer the more stippled surface of Silver Rag, but both papers offer a look and feel that is truly spectacular.

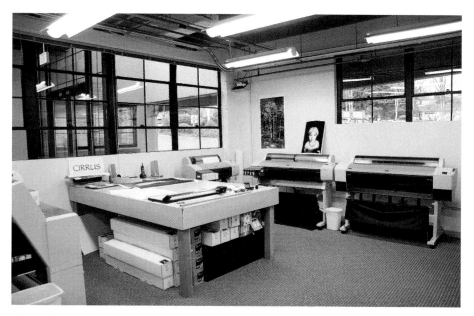

The Studio at Cirrus Digital Imaging. More information about the specific printers and inksets used by the company can be found on its web site.
Photo © Phil Bard

Printing on Uncoated Fine Art Papers

by Edward Fausty

Edward Fausty has been making photographs since age five. He began his exploration of ink on paper in the early nineties teaching himself the obscure technique of collotype. In the early 2000's, he became seduced by digital inkjet on the fine art papers he had formerly used on press. He holds an MFA degree from Yale School of Art, and his work is in national, corporate, academic, and private collections. He also offers personalized collaborative wide format digital printing services to photographers and other artists. For more information, visit www.edwardfausty.com.

Though not a common practice in the world of fine art inkjet printing, it's possible to achieve very good results on uncoated art papers (traditionally used for drawing and printmaking). The vast majority of inkjet papers (matte and gloss) sold for use with inkjet printers have a special ink-receptive coating that keeps inks closer to the surface of the paper. The advantages of coated papers are generally the following: sharper detail; greater shadow density; and a wider color gamut. However, there is a certain quality to uncoated papers that has always drawn me to them, and after testing dozens of papers, I've found a few that give me the look I want—generally at a lower cost, and with better scuff resistance compared with many coated art papers.

The following tips will explore some of the uncoated papers I use with my Epson Stylus Pro 9600. Any high-quality pigment-ink printer should yield similar results, and to achieve the greatest longevity with uncoated papers I generally recommend pigment-based printers over dye-based models.

TIP 125 Choose the right art paper(s) for your work.

There are thousands of papers available from many countries around the world. I recommend choosing papers that don't leave a lot of fibers when you wipe your hand across or cut them. One of the companies I have purchased paper from for more than 20 years is Legion paper (L9.8). The papers I primarily use for my work and the work of my clients are Rives BFK (L9.9), Somerset Velvet Radiant White (L9.10), and

Arches Cover (L9.11). All are relatively soft and absorbent, have minimal shedding, and are able to hold a dense enough shadow for the work I do. I also like the look of uncoated Japanese rice papers such as Gampi and Shiramine (L9.12), but the UltraChrome K2 matte black is not dense enough for my taste with these papers.

TIP 126 Do your own fade testing.

Although only time will tell what effect light, air, and other factors will have on our prints, I recommend doing some basic fade testing to determine how your prints will hold up over time. To do a test, make prints of the same image on a variety of papers, then expose them in bright sunlight and/or extreme temperature, humidity, etc. Also keep a control sample of each print in dark storage. Use a print with a combination of images and color bars to get a better idea of the colors that are fading faster. About 4 × 6 inches is large enough for the sample, which will allow for a test and control sample to be printed on one letter-sized sheet.

Making smaller sized test sheets also allows them to be easily taped to a board then placed near a window. An 8-ply acid free matte board works well for mounting. This also makes it easier for a group of prints to be exposed to a very similar intensity of light. Having the prints on a board also makes it easy to judge the prints for visual changes on a frequent basis. A test chart can be found on this web site (L9.13). My recommendation would be to include a few prints on well-tested coated art papers to see how they perform next to your uncoated samples. To find many papers that have been tested on a variety of printers, visit www.wilhelm-research.com.

TIP 127 Profile and choose the right paper settings.

Custom profiling will improve your results on virtually all papers, and custom profiling on uncoated papers has saved me hours of time compared with what I used to do, which is make custom Adjustment Layer curves in Photoshop. Also, there are very few vendor-supplied profiles available for uncoated papers. I use ColorVision's Profiler Pro software to make custom profiles, and I'm very happy with the results. After printing out the 125 patch color chart, I scan the patches with the ColorMouse II Spectrocolorimeter. My results with the 125 patch chart have looked virtually identical to those achieved with their 750 patch chart, which takes considerably longer to scan. One of the newest software/hardware profiling options from ColorVision is called PrintFIX PRO Suite (L9.14), which includes the Spyder2 display and projector colorimeter, PrintFIX PRO 2.0 software, and a Datacolor 1005 Spectrocolorimeter for scanning profiling targets.

My preferred paper setting in the Epson driver is Enhanced Matte, and for prints over 13 × 19 inches, I usually choose 720 DPI bi-directional (in other words, high speed is checked). It's important to print the profiling target using the same paper settings as those that will be used when making your prints. However, I haven't seen any color shift when checking or unchecking the "high-speed" box in the Epson driver. With the box unchecked, slightly finer detail can sometimes be seen, with the downside being longer print times, so I recommend doing your own tests to decide what's best for you. I often turn off high speed if I'm making prints under 13 × 19 inches, especially if they contain text.

Edward Fausty's Epson printer driver settings, used when making prints on uncoated fine art papers over 13×19 inches. The High Speed box is circled in red. This makes the printer print in bi-directional mode, which is faster than uni-directional mode (unchecked).

TIP 128 Hang your rolls and vacuum your paper.

I buy a number of papers in large rolls (up to 300 feet) and store them in a standing cabinet that I constructed from plywood. If dust is a concern, plastic can be attached to the front of a cabinet, or a sheet of plastic can be loosely wrapped around each roll. A problem with virtually all coated and uncoated fine art papers, but especially uncoated papers, is lint. I have a dedicated vacuum cleaner with a soft bristle brush attachment that I use on both sides of the paper before printing. I make one pass across the front and back side of each print just before feeding the paper through my printer. This avoids the periodic hemorrhaging I used to get in the form of large blobs of ink dropping onto the paper every eight to ten prints. I also periodically vacuum the paper feed area and inside of my printer (after flipping down the front plexi cover on the Epson Stylus Pro 9600). I recommend unplugging your printer first to be safe, and as with any operation like this, proceed with caution.

Edward Fausty vacuuming a sheet of uncoated paper in front of his custom-made paper cabinet.
Photo © Edward Fausty

TIP 129 Send paper through twice for a stronger black.

Uncoated papers almost always produce prints with a lower Dmax (weaker black) than coated papers. When I want a more intense black, I first make a print as I would with any printer. I then create a black layer in Photoshop that represents only the dark areas of my image. I then turn off all the other layers and print just the black areas on top of the image. To register the paper in the printer, I line up the paper using the holes below the print head on the front of the Epson Stylus Pro 9600. Making another mark high up along the right side of the roll paper housing also helps with registration. I find this loading procedure to be more accurate compared with just placing a sheet in the printer and pressing the Pause button.

If the leading edge of the image does not have sufficient blank space, the print head will reject the paper when feeding because it "sees" the ink printed on the paper. To avoid the problem, tape a seven-inch strip of strong but relatively thin paper (about 200gsm and the same width as your print) to the leading edge before making your first print. It should be attached to your paper so that exactly six inches of paper are added to your paper height. This can be achieved by attaching the seven-inch sheet of paper one inch behind your print using tape (such as masking tape) that is strong enough to hold the paper securely, but that can be removed without damaging your print.

Artist: Edward Fausty; **Image Title**: *Bathroom Décor (111 First St.)*; **Print Sizes**: 42.5x48 inches **Paper**: Arches Cover; **Printer Name**: Epson Stylus Pro 9600; **Ink Used:** Epson UltraChrome K2**; Driver:** Standard Epson Driver (Mac OSX); **Camera**: Bronica 6x6; **Lens**: Nikkor 75mm P f/2.8; **Film**: Fuji NPH; **F-stop & Exposure**: unrecorded

239

A sheet of paper shown being loaded on an Epson Stylus Pro 7600 (a number of other large format Epson Stylus Pro printers, including the Stylus Pro 9600, work in the same way). To place the sheet in this way, lift the paper release lever, then align the sheet as shown in the photo (supporting it with your left hand), and then carefully close the paper release lever. The sheet will then automatically load after about 10 seconds. Or you can save a few seconds by pressing the Pause button on the printer after closing the release lever.
Photo © Andrew Darlow

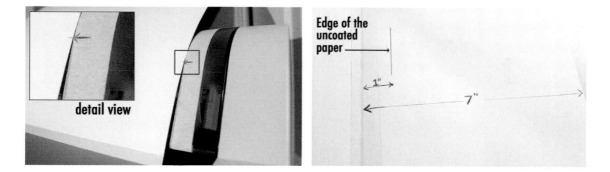

(Left) A light pencil mark can be seen along the right side of the roll paper housing on an Epson Stylus Pro 7600. Masking tape is used as a guide to help line up the paper. By marking the tape and a small area of the sheet of paper before the first pass (see detail area), registration can be more easily achieved because the mark can be used as a guide when loading the paper the second time. This technique will also work on the Epson Stylus Pro 9600, 7800, and 9800 printers. (Right) A strip of paper seven inches long, shown taped one inch behind a piece of uncoated paper prior to making a "double pass" print.
Photos © Andrew Darlow

Artist: Edward Fausty; **Image Title**: *Side by Side (Rooftop of 111 First St.)*; **Print Size**: 42.5x48 inches;
Paper: Arches Cover; **Printer Name**: Epson Stylus Pro 9600; **Ink Used**: Epson UltraChrome K2; **Driver:**
Standard Epson Driver (Mac OSX); **Camera**: Bronica 6x6; **Lens**: Nikkor 75mm P f/2.8; **Film**: Fuji NPS;
F-stop & Exposure: unrecorded

Then add six inches of white space to the top of your file in Photoshop or other application and print both files (first, the normal image, then the black only image). Another option is to leave six extra inches of space at the top of your paper, then print both passes and trim the paper afterward. You can also enhance other colors in your image (not just dark areas) or create interesting "layered" effects by using this technique.

TIP 130 Take special steps when printing with deckled edges.

One of the great advantages of printing on uncoated papers is the fact that many come with deckled edges, which are created during the paper making process. Many fine art papers have natural deckled edges which are created during the paper-making process. The look is similar to what you might see if you fold and tear a sheet of paper by hand. You can learn more about deckled edges and find a link to a tutorial that explains how to make your own hand-torn deckled edges in Chapter 7, Tip 102.

To avoid the common problem of a deckled edge rubbing against the print head (and possibly causing ink splatter), I use a thick paper setting in the Epson printer driver under Paper Configuration (3 or 4 for a 300gsm paper), or I set the platen gap to Wide on the Epson Stylus Pro 9600's LCD panel (most of the other Epson Stylus Pro printers have similar options). I also make sure that no fibers along the edges of the paper are sticking up, or they can create a problem when printing.

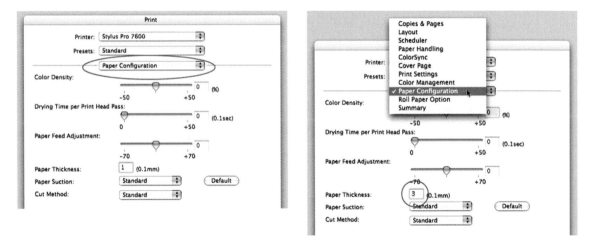

(Left) The Epson 9600 print dialog box with the Paper Configuration option showing. (Right) The Paper Configuration screen's sheet thickness set to .3mm (circled in red).

Displaying Work Using Posterhängers

By Edward Fausty

Over the years, I've presented my work in many ways. Images on uncoated papers, in my opinion, often look best hung right on a wall with a few push pins, or by using print hanging hardware such as the one I demonstrate in the following tip (called Posterhänger, L9.15). This product is strong, inexpensive, and securely grabs onto the top and bottom of a print in a scroll-like fashion. If you are concerned about your prints being exposed to air, there are a number of sprays that can be used to protect your work.

TIP 131 Use multiple Posterhängers to hold a series of tiled prints.

Posterhängers come in sizes from 12 to 60 inches in width and in Black or Silver aluminum. For the installation piece below, three prints, each 42.5 inches in width were printed on Arches Cover paper and attached separately to Posterhängers using the tools provided with the kit.

Macro-Mei by Edward Fausty displayed at the Hofstetter Arts Center at the Pingry School in New Jersey, USA. The piece is displayed in three sections of 42.5 inches each (printed on Arches Cover paper), and secured with three Posterhängers.
Photo © Edward Fausty

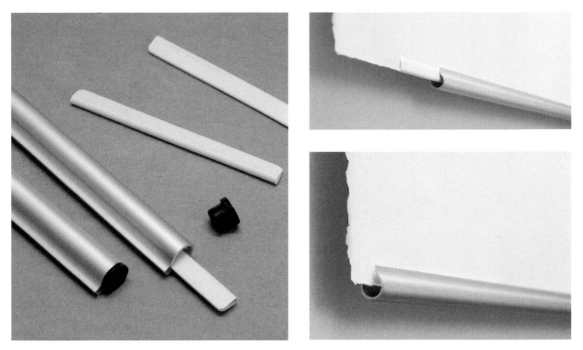

(Left) The parts that make up the Posterhänger system, including end-caps. (Right, top) The white plastic paper holders and protectors, covered by the Posterhänger's aluminum rod. (Right, bottom) The aluminum rod after sliding it into place. No end cap was used for this presentation, but the black caps shown in the previous tip can be added to create a finished edge. Photos © Edward Fausty

Artist: Edward Fausty; **Image Title:** Ladies' Restroom (111 First St.); **Print Size:** 42.5x48 inches; **Paper:** Arches Cover; **Printer Name:** Epson Stylus Pro 9600; **Ink Used:** Epson UltraChrome K2; **Driver:** Standard Epson Driver (Mac OSX); **Camera:** Bronica 6x6; **Lens:** Nikkor 75mm; **Film:** Fuji NPS; **F-stop & Exposure:** unrecorded

Achieving Saturated Color on Art Papers

by C. David Tobie

C. David Tobie has been chasing the rainbow of photographic managed color for many years. He is currently Product Technology Manager at ColorVision, a division or Datacolor, where he develops the Digital Imaging line of products, including the Spyder line of monitor and projector calibrators, and the PrintFIX line of printer profiling products. For more information, visit http://www.flickr.com/groups/friendswithvision (select "See all photos" next to "Group Photo Pool" and search for images from CDTobie).

Though historically printed mainly on high gloss and semi-gloss surfaces, images with saturated color can have great impact when printed on matte art papers. The photograph *Somes Sound* (shown opposite) photographed on Mount Desert Island, Maine, is one example. In the tips that follow, I will cover some of the steps I use to achieve prints with saturated color that approaches (and sometimes even exceeds) the intensity of color found in nature.

TIP 132 Choose a wide gamut RGB space when converting.

The dominant blueness of the *Somes Sound* image is a major part of its impact. This requires careful determination of appropriate image color temperature in the RAW software used, on a calibrated and profiled monitor. I used Adobe Camera RAW to do the conversion, and for an increased cyan range, the image was processed into the AdobeRGB (1998) working space. The few contrasting colors in the middle distance boat, the spruce oars, and the orange life vests become immensely important in the otherwise blue image.

Artist: C. David Tobie; **Image Title**: *Somes Sound*; **Print Sizes**: 13×19 to 17×22 inches **Paper**: Moab Entrada 300 Bright White; **Printer Name**: Canon imagePROGRAF iPF5000; **Ink Used:** Canon LUCIA pigments**; Driver:** Canon Print Plug-in for Photoshop (Mac OSX); **Camera**: Canon EOS 5D; **Lens**: Canon 24-105mm f/4 L IS; **F-stop:** f/22; **Exposure**: 1/50 sec.

TIP 133 Use custom profiles and softproof.

Softproofing in Photoshop CS2, CS3, or other color management-aware application through the actual media profile that will be used for printing is the best safeguard against a waste of paper, ink, and time. Multiple gradated selections of the dark tones were made, and their saturation was increased to assist with both art paper and canvas printing.

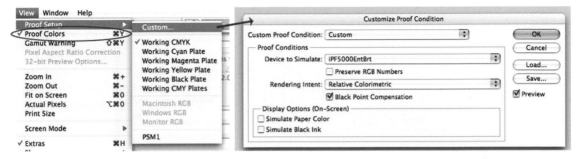

Softproofing in Adobe Photoshop CS2 and CS3 is accessed through View>Proof Setup>Custom. "Proof Colors" should also be checked (circled in red). Photoshop CS3 also now has softproofing capability in the preview window of the Print dialog box (accessed through File>Print).

TIP 134 Choose the right paper or other media.

Final fine art prints were produced at 17 × 22-inch and larger sizes to replicate the wide viewing angle the lens captured. Moab Entrada Bright paper was chosen. Entrada Natural would have been a good choice for a warm-tone or monochrome print, but here a cool paper white was needed. Moab Anasazi Premium Matte Canvas (L9.16) was used for the canvas version of the image. Both manage to convey the cool, slightly unreal feeling of the original scene, beckoning the viewer to row off up the Sound in the wooden dory.

The selective focus image on the facing page, entitled *Tuscan Summer*, includes rich gold tones moving towards rust in the lower corners. Such colors require care in file preparation to get the intended tones. Magenta and Yellow inks blended to create these colors cause illuminant metamerism, so that the level of perceived detail and the degree of rusty tone will vary with different light sources, making this simple looking image more of a color management challenge than would be expected.

Artist: C. David Tobie; **Image Title**: *Tuscan Summer*; **Print Sizes**: 24×36 to 32×48 inches **Paper**: Moab Entrada 300 Natural; **Printer Name**: Epson Stylus Pro 7800; **Ink Used:** Epson UltraChrome K3; **Driver:** Standard Epson Driver (Mac OSX); **Camera**: Canon EOS 5D; **Lens**: Canon 24-105mm f/4 L IS; **F-stop**: f/22; **Exposure**: 1/100 sec.

Artist: Stephanie Ryan; **Image title**: *Blueberry Summer*; **Print Size**: 40×20 inches; **Canvas**: BullDog Platinum Dot High Gloss Canvas; **Printer Name**: Canon imagePROGRAF iPF8000; **Ink Used**: Canon LUCIA; **Driver:** Standard Canon Driver (Mac OSX); **Original Medium**: Acrylic on canvas; **Coating**: Breathing Color Glamour II

Art Reproduction, Canvas, and Finishing

Art Reproduction: Image Capture and Color Management

By Derek Cooper

Reproducing art effectively and efficiently is possible when a proper system is put in place. Whether your originals are drawings, oil paintings, photographs or mixed media, good color management from image capture to print can make a significant difference in the quality of your prints. Image capture of artwork can be done through digital photographic capture, photographic film capture and scanning, or direct scanning. The following tips cover image capture of artwork using a digital camera, with suggestions for using some of the tools I rely on for my work, and for the work of my clients. Based on my experience, I have found that direct digital capture using a high quality digital camera back and camera is superior to film capture and scanning due to the inherent color bias of film, plus the time and effort needed to properly scan and clean up scanned images.

Derek Cooper (www.derekcooper.com) forged a love of the outdoors and nature at an early age. In his 20s, Derek discovered that he could marry his passion for the outdoors with photography, enabling him to interpret its beauty and to share it with others. Derek has trekked into Death Valley National Park in California and kayaked along the Baja Peninsula shooting commercial and editorial jobs. Cooper founded and operates a company that services the art reproduction market in Canada using Epson and Canon inkjet printers. He has taught numerous fine-art inkjet printing and digital imaging workshops with Epson Canada. For more information, visit www.ReproducingArt.com.

To find the web links noted in the book (L10.1, etc.), visit www.inkjettips.com or http://www.courseptr.com/ptr_downloads.cfm.

Artist: Gene Ouimette; **Image title**: *Time and Separation*; **Print Size**: 20×20 inches; **Canvas**: Legion Premium Canvas; **Printer Name**: Epson Stylus Pro 9800; **Ink Used**: Epson UltraChrome K3 (w/ Matte Black); **Driver**: Standard Epson Driver (Mac OSX); **Original Medium**: Acrylic on canvas; **Coating**: Breathing Color Glamour II

TIP 135 Use quality targets when capturing artwork.

When photographing art for reproduction, I almost always include a letter-sized GretagMacbeth ColorChecker target chart (now called the X-Rite ColorChecker, L10.1) in the shot for reference. A Mini ColorChecker chart (3.5 × 2.5 inches in size) is also available for small artwork reproduction. If you want to increase the accuracy of the reproductions, include a black velvet cloth in the background, which can be used as a black reference point (in my experience, the ColorChecker chart's black isn't black enough). And for better white reference than what's offered on the ColorChecker chart, I use a BabelColor White-Balance Target (L10.2), which reflects almost 100% of the light that hits it, making it a terrific white reference. Most white references don't reflect enough light, so you're always guessing. I also use a Robin Myers Imaging DGC-100 Digital Gray Card (L10.3) to neutralize the camera through the capture software. The gray card is neutral, made from a durable and washable material, and reflects light very well.

A typical artwork capture setup. The artwork in this case is an acrylic on canvas painting by Neil Aird. The art is sitting on a black velvet cloth, and a GretagMacbeth ColorChecker target, as well as a BabelColor white reference and Robin Myers Imaging DGC-100 Digital Gray Card are used to help get more accurate color reproduction.
Photo © Derek Cooper; Artwork: *Misty Mission* © Neil Aird (L10.4)

254

TIP 136 Use appropriate lighting and light the art evenly.

For ideal results, ensure that your lighting environment is consistent in both color temperature and intensity. I recommend measuring the color temperature of your lighting with a color meter. The X-Rite i1PRO is capable of measuring the color temperature of strobe (flash) or continuous light. I use Broncolor Grafit A4 3200 watt/second strobe power packs (L10.5) and Broncolor Pulso G 3200 watt/sec. strobe heads (L10.6)—these packs and matching heads allow me to control all aspects of the packs' operations from a computer, so I can save lighting setups and tweak lighting levels in 1/10th of a stop increments, all without leaving my workstation. Especially with larger pieces, it's important to move the ColorChecker chart around the artwork to measure light distribution across the piece. By taking an exposure when tethered to a computer, you can quickly measure the area with your capture software's built-in densitometer. This will ensure that it's evenly lit.

(Left) Broncolor Grafit A2 and Grafit A4 strobe power packs. (Right) Broncolor Pulso G lamp heads (selected in red). Other Broncolor lamp heads are also shown with a range of different reflectors.
Photos Courtesy Broncolor

Other lighting options are available, including tungsten, HMI and fluorescent continuous lighting, but I prefer to use strobes due to their color quality, lack of heat buildup (as long as modeling lights are not kept on) and the ability to retain sharpness with art that is not completely flat (for example, oil paintings). By just increasing strobe output, I'm able to stop down the aperture (for example, from f/5.6 to f/16) without having to increase the camera back's ISO rating.

The white BabelColor Target or white patch of the ColorChecker target can be used as a reference point, and a hand-held light meter will help to assure even light distribution across the artwork. You should get the same RGB readings on the white patch or exposure value on a light meter, at all eight points around the piece of art, plus the center (see diagram). Slight variations are OK, but try to get the lighting within a tenth of a stop at each reference point. If you're struggling to achieve that, the best option is usually to move the lights farther away from the piece of art.

This diagram represents where nine measurements of your white reference target (such as the BabelColor reference) should be taken on the actual artwork to help assure even light distribution. Use the densitometer tool in your capture software to check the RGB values. A hand-held light meter will help speed up the initial measuring process when you are adjusting your lighting since you won't have to wait for the image to appear on the screen to take a densitometer measurement through the software.

TIP 137 After capture, move images through the workflow in the same color space.

I capture all images with a Hasselblad H1 camera with a Hasselblad Ixpress 384 digital camera back (L10.7). Initial RAW captures are photographed with the camera back software's color space (named FlexColor) embedded. I then convert the RAW files to TIFF in high bit color (16 Bits/Channel in Photoshop), with an embedded color space of Adobe RGB (1998). I then keep the files in this color space. I also recommend to my clients that they keep the same color space embedded in case they want to edit the files and send them back to me for output. If you shoot with a Digital SLR or other camera that supports RAW, I also recommend Adobe RGB (1998) for most people's workflow. And in virtually all cases, images should be captured in the RAW file format, compared with shooting in JPG or TIFF. This allows for much greater control when preparing files.

TIP 138 Adjust the colors in the reproduction file using Photoshop and ColorPicker.

X-Rite's ColorPicker 5, part of the ProfileMaker 5 suite of software (L10.8), is a great tool for reading reference colors in the X-Rite ColorChecker chart. There are published numbers for the average ColorChecker chart, but no two targets are exactly the same; each will change slightly with age and under different environmental conditions. It's also best to know the exact colors of the swatches. Additionally, the colors will vary depending on which color space and type of light you're using.

With the ColorPicker software open, you can take spectrophotometer readings of the ColorChecker swatches (I use a hand-held X-Rite i1PRO), as well as other references, such as the BabelColor white and black of the black velvet (see screen shot, left). Those readings can then be used to adjust the colors in the art using curves in Photoshop. To "dial-in" each color, first adjust the black point, mid-point, and white point until they match the numbers you measured (the neutrals will probably not be completely neutral), and then adjust the other colors in the chart as necessary. This should help to achieve a very close color match. Photoshop CS2 and CS3 have the capability of displaying up to four "samples," which is another helpful tool (see screen shot, right). With the eyedropper tool selected, set a new sample point by holding down the shift key when clicking on a swatch.

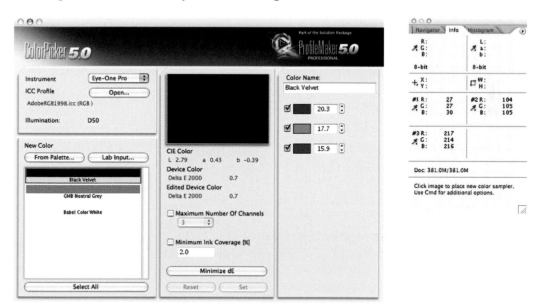

(Left) A screen shot of ColorPicker 5 from X-Rite's ProfileMaker 5 software showing actual readings of the black velvet (R20.3/G17.7/B15.9). A neutral gray swatch and the BabelColor white reference were also measured. (Right) Photoshop's Info Palette showing the readings for a highlight, midtone and shadow target.

257

TIP 139 Use a high quality device to produce custom canvas and paper profiles.

Building custom canvas or paper profiles for each paper and ink combination (or having them built for you) is an absolute must for accurate printing. In the most basic sense, building profiles involves printing a series of color patches on a specific paper or canvas. These color patches can then be read back into the computer using a spectrophotometer or spectrocolorimeter.

I'm currently using the X-Rite i1iO (L10.9) an automated scanning table that scans the color patches using a robotic arm to move an X-Rite i1PRO spectrophotometer over a printed color profiling target. This tool enables the user to generate profiles from a number of different targets, and I generally use a target with 4,000 printed color patches. The profiling software can even create targets with more than 11,000 patches, but the returns are diminishing. In fact, too many patches may result in banding on prints.

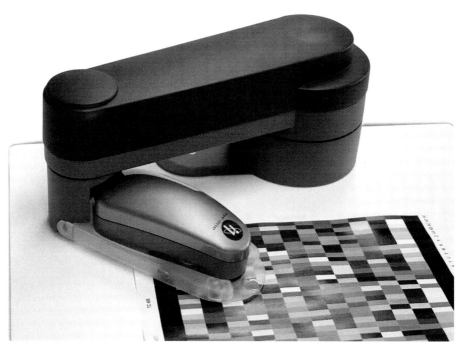

An X-Rite i1iO scanning table, shown with the i1PRO spectrophotometer.
Courtesy X-Rite, Inc.

Printing on and Coating Canvas

By Derek Cooper

nkjet on canvas is something my clients love—whether they paint, draw, make photographs, or produce work entirely on a computer, canvas printing provides artists another creative option. This section covers materials, printing tips and some of the procedures we use for coating canvas.

TIP 140 Choose good quality materials from reliable media suppliers.

There are a number of high quality substrates on the market coated especially to be output on inkjet printers. Three that we really like at our company are Breathing Color Brilliance Chromata White (L10.10), BullDog Platinum Dot High Gloss Canvas (L10.11), and Legion Premium Canvas (L10.12). Once a protective coating is sprayed onto good quality canvas, the final product provides a great reproduction with a look and feel very similar to originals done on canvas. It's also a terrific way to exhibit work because it does not require mounting behind glass (or even a frame). It's also important to find reliable suppliers who have the materials you commonly use in stock, ideally with the ability to deliver within a day in case a rush job comes in.

It's also important to use materials that are designed for the type of printer and inks that you are running. One of the printer/canvas combinations that I've been particularly impressed with is the Canon imagePROGRAF iPF8000 with BullDog Platinum Dot High Gloss Canvas. The combination produces images with a color gamut approaching that of many glossy papers I've used, with superb shadow detail, high Dmax, and excellent sharpness. The natural weave of the canvas also makes it look very "authentic," without being too strong, and after spraying, the canvas is very well protected and can be easily stretched. In addition to working well for reproductions of acrylic and oil paintings, the canvas is also popular with traditional photographic artists who are looking for different ways of displaying their work.

TIP 141 Allow excess border on canvas.

Because canvas has to be stretched and/or fitted to a frame, be sure to print at least a two inch border all the way around the artwork. If you are not going to stretch and/or fit it yourself, check with your framer to see how much of a border he or she will need. The depth of your stretcher bars and whether your art will cover the sides of your stretcher bar will also determine the amount of extra border that will be necessary.

TIP 142 Apply a protective coating and hang the canvas while spraying.

Canvas should be protected with some type of coating primarily because it will generally not be exhibited behind glass. There are a variety of coatings and applicators available on the market, with the option of matte, semi-matte and gloss finishes from which to choose. We use the Breathing Color Glamour II Veneer coatings (Matte and Gloss, L10.13). We generally mix them 50:50 to achieve a semi-matte finish. That mixture is then diluted with water in a 50:50 ratio. The most economical way to apply the product is with a roller, but if you plan to apply a lot of coatings, invest in an HVLP turbine sprayer. We like the Fuji Industrial sprayers, as they apply a very even coating and clean up easily. The model we currently use is called the Fuji Mini-Mite 3 (L10.14), and the spray gun we use with it is the Fuji GT-X2 HVLP Gravity Spray Gun (L10.15). Inexpensive units in the $100 range are available, but I recommend speaking with other users before making any purchase.

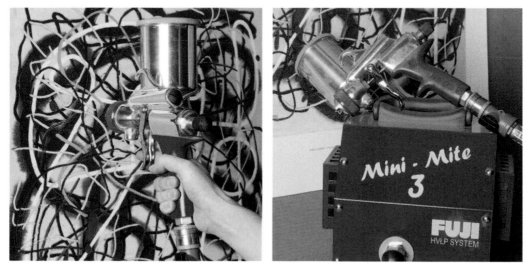

(Left) A demonstration by Derek Cooper showing how he holds a spray gun when coating canvas prints with the Fuji GT-X2 Gravity Spray Gun. (Right) The Fuji Mini-Mite 3 HVLP turbine sprayer.
Photos © Derek Cooper; Artwork: *Fandango Journey* © Ann Clarke (L10.16)

Artist: Derek Cooper; **Image title**: *Prince Edward County – Jackson Falls*; **Print Size**: 20×20 inches; **Paper**: Hahnemühle Photo Rag 308gsm; **Printer Name**: Canon imagePROGRAF iPF8000; **Ink Used:** Canon LUCIA; **Driver:** Standard Canon Driver (Mac OSX); **Camera**: Contax 645; **Back**: Hasselblad Ixpress 384; **Lens**: 80mm f/2 Planar

We almost always hang our canvases while applying the spray coatings. Large sheets of cardboard make great backing boards that you can use to clip the canvas to while spraying. Our clips are fairly small and clamp down tight so that the canvas won't slip. We usually let the canvas hang for 24 hours to dry, even though the veneer (the coating that was applied) will lose its tackiness in a few hours.

A canvas print attached to a cardboard backing prior to spraying.
Photo © Derek Cooper

TIP 143 Keep your coating equipment clean.

After each job, we clean the sprayer to ensure that none of the veneer builds up inside the bowl of the sprayer. It only takes a few minutes to wash the bowl out with warm water. Once the bowl looks clean, we replace the cap and then spray into a cloth held tightly against the opening on the sprayer to blow out any veneer that may have settled inside the spray gun. Make sure you hold the cloth tight, or you'll launch water into your studio! Then remove the cap and towel, and dry the bowl. Most spray guns are made from stainless steel, so you'll want to keep them as dry as possible.

Artist: Derek Cooper; Image title: *Poppy*; Print Size: 20×20 inches; Paper: Hahnemühle William Turner 310; Printer Name: Epson Stylus Pro 9800; Ink Used: Epson K3; Driver: Standard Epson Driver (Mac OSX); Camera: Contax 645; Back: Hasselblad Ixpress 384; Lens: 80mm f/2 Planar

Choosing and Coating Inkjet-Compatible Materials

By John Dean

It's not easy (actually, it's probably not possible) to find the "perfect" inkjet media. There are many coated and uncoated papers, films, fabrics and canvases available, each with their own unique qualities and limitations. The following tips cover recommended materials for prints and books, as well as various coating options and techniques that we use in our studio.

John Dean is an Atlanta-based photographer and printmaker with a BFA in fine art photography from the University of Arizona, Tucson, and an MFA in fine art photography from Tyler School of Art of Temple University in Philadelphia. His work incorporates fabricated elements of still life, combined with architectural and landscape photographs of the real world—often combined in Photoshop. His company makes exhibition-quality color pigment prints and quadtone pigment prints, and he offers reproductions of paintings, drawings and photographs on a variety of substrates. John Dean's work, as well as the work of many of Dean Imaging's clients is available for viewing on his website. For more information, visit www.deanimaging.com.

TIP 144 Choose the right media for the job and be aware of "flaking."

The same image can look dramatically different depending on the media chosen. What's most important is to choose a paper or other material with a color gamut and Dmax (darkest printable tones) that's required for the project. Not everyone requires super-saturated color and ultra-dense blacks. It's a good idea to do some testing on a few different papers, or ask for sample prints from printmakers or media manufacturers.

Papers and canvas made of high quality materials, such as 100% cotton rag and alpha-cellulose are considered the most stable options for inkjet-based printmaking. A paper that I've been using with success is Hahnemühle's Museum Etching, a 100% OBA-free (optical brightening agent) rag paper. Another OBA-free and very resilient 100% rag paper that I've been using is Epson's UltraSmooth Fine Art Paper (available

Artist: John Dean; **Image title**: *Center City*; **Print Size**: 20×30 inches; **Paper**: Hahnemühle Museum Etching; **Printer Name**: Epson Stylus Pro 7000; **Ink Used**: PiezoTone NK6 pigments; **Driver**: Standard Epson Driver (OSX); **Camera**: Hasselblad 500CM; **Lens**: 80mm f/2.8 Planar; **Film**: Kodak Tri-X Pan (ISO 400)

in 250gsm rolls, 325gsm sheets and 500gsm sheets, L10.17). It's an especially good paper for bookmaking projects, and the 325 and 500gsm weights are also double-sided, which can be useful when making books or portfolios. Double-sided papers can also help to cut down on proofing costs when making test prints. Innova Digital Art (L10.18) also produces some fine papers with coatings that have been relatively trouble-free for me, including Innova's Soft Textured papers, Innova's Cold Press Rough Textured Natural White, and Innova's Smooth Cotton line.

With the introduction of high-quality fiber glossy and semi-gloss inkjet media, print-makers now have even more choices. Two papers in this class that I'm using with success are Innova's FibaPrint F-Type Gloss (L10.19) and Crane's Silver Rag (L10.20).

Some fine art papers are prone to flaking. To reduce the chances of small white specks from occuring in your prints due to this problem, I recommend lightly brushing the surface of the paper with a soft brush whether it comes off a roll, or whether it's in sheet form. One of my all-time favorite papers, Hahnemühle's William Turner (L10.21), has a very beautiful but vulnerable surface texture.

TIP 145 Find a good quality lacquer spray for works on paper.

If you are creating work that will be handled regularly, like that found in a limited edition portfolio or book, it's generally a good idea to protect your prints with a protective coating. Although there are brush-on, or spray-on water-based non-toxic coatings available that are especially good for canvas, I have yet to find any such coating suitable for fine surface photographs printed on matte inkjet papers. There are three non-yellowing solvent-based lacquer sprays that I currently use in my studio to protect fine art prints: PremierArt Print Shield (L10.22), Lyson Printguard (L10.23), and Lascaux Fixative (L10.24). The first two contain UV inhibitors and all of them can protect against fading and airborne contaminants, as well as scuffing, fingerprints, and scratching.

For glossy and semi-gloss prints, PremierArt Print Shield and Lyson Printguard can increase the Dmax and color intensity of prints. My procedure is to use UV inhibitors for color work, and if needed, Lascaux for monochrome (black and white) work where Dmax is more critical.

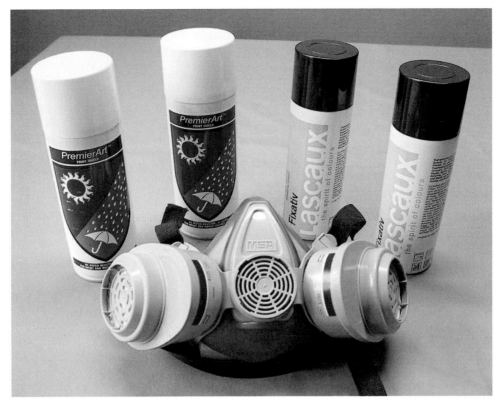

Two solvent-based coating products used by John Dean, and an MSA Safety Works respirator.
Photo © John Dean

When using solvent sprays, it is imperative that you wear a safety-approved charcoal filtered respirator and eye goggles, and have proper ventilation. The respirator that I'm using is made by MSA Safety Works (L10.25) and costs about $30. It meets OSHA and NIOSH requirements for safety. I would much prefer a non-toxic, easily applied, water-based UV lacquer to use in place of the toxic sprays that I'm currently using.

TIP 146 Print on fabrics and silk for a unique look.

There are almost endless possibilities with regard to inkjet-compatible materials upon which you can print. I have worked with several textures of silk, linen, cotton gauze, and canvas over the past five years, and have printed many projects for my clients and myself. One example is the image "Open For Business," printed on Jacquard Chinese Dupion Silk (L10.26), and the other is "Buford Highway," printed

on Jacquard Belgian Linen (L10.27). Both products have a paper backing that allows them to be fed into many inkjet printers. Since both projects were hung without acrylic or glass after printing, I protected them with a UV lacquer spray, which did not degrade the surface or tactile qualities.

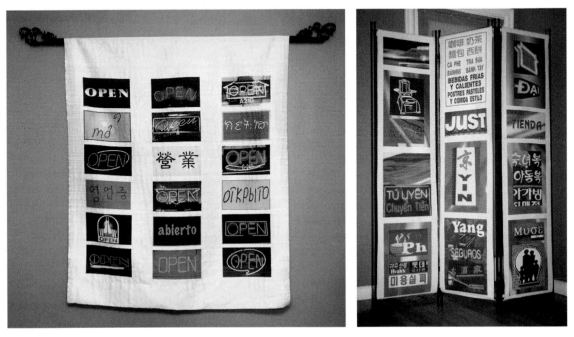

(Left) "Open For Business," by John Dean, shown printed on a piece of Jacquard Chinese Dupion Silk (42×50 inches) and attached to a wooden fabric hanger. (Right) "Buford Highway," by John Dean, shown printed on Jacquard Belgian Linen and attached to a frame as a three-panel folding screen.
Photos and artwork © John Dean

In most cases, when printing on inkjet-compatible fabrics (and many other fabrics), you should apply a bead of "Fray Check" to the edges of the material before peeling the fabric away from the paper backing (L10.28). This will help keep the edges from fraying. Also note that there are different types of inkjet-printable fabrics available—those that require steaming, and those that don't. Those that require steaming are generally used for printed fabrics that are intended to be washed in a washing machine or dry-cleaned. Most of the projects I've done have been with Jacquard's "FabriSign" products, which require no steaming, though I do spray them with a solvent-based spray coating.

Artist: John Dean; **Image title**: *Open For Business*; **Print Sizes**: 42×50 inches (Single print); 15×64 inches (Three separate banners); **Fabric**: Jacquard Chinese Dupion Silk; **Printer Name**: Epson Stylus Pro 9600; **Ink Used:** Epson UltraChrome K2; **RIP**: ErgoSoft StudioPrint RIP (Windows XP); **Camera**: Nikon 35mm SLR; **Lens**: Nikkor 105mm f/2.8; **Film**: Fujichrome Provia

Following are two other fabric-related projects with photographs and descriptions.

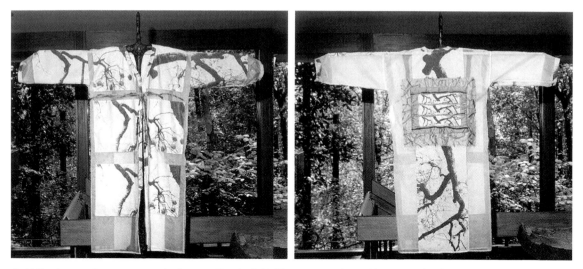

(Left) The images that appear on the front and back of this kimono were derived from a single, drum scanned photograph by Lucinda Bunnen. Assorted parts of the image were cropped and then printed on Jacquard Silk Noil (L10.29) and Jacquard Belgian Linen (L10.30) by Dean Imaging using an Epson Stylus Pro 10000 with Epson Archival inks (the inks that come standard with the printer). The individual pieces were then sewn into a kimono.
Photos of kimono (front and back) © John Dean; Photography on kimono © Lucinda Bunnen (L10.31).

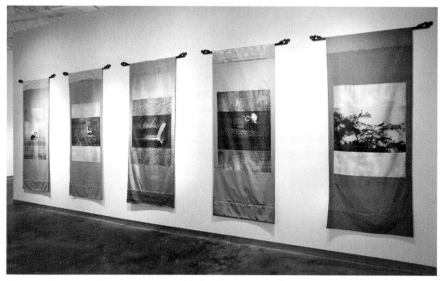

These wall hangings feature the work of Robin Davis, shown during an exhibition at Mason Murer Fine Art in Atlanta, Georgia (L10.32). They were printed by Dean Imaging on Jacquard Indian Dupion Silk using an Epson Stylus Pro 9600 with Epson UltraChrome K2 inks. The silk prints were then sewn at the top and bottom to fabric and attached to fabric hangers made from hand-carved Indonesian wood.
Installation photo © Robin Davis; Photography and silk print wall hangings: Aqua Avia Series © Robin Davis (L10.33).

Techniques for Hand Coating Canvas

By Patrick Carr

The following tips describe a method for hand coating canvas with a water-based coating that can be done quickly, inexpensively and without the type of special ventilation needed with solvent-based coatings.

Patrick Carr began his study of art in California and then moved to the Southwest where he received a BFA at the University of New Mexico in Albuquerque. He continued his studies in design and worked several years as an art director for a number of magazines. The skills he gained through these experiences led him to launch Carr Imaging, a business centering on digital capture and fine art inkjet printing. For more information, visit www.patrickcarrimaging.com.

TIP 147 Choose quality materials and consider canvas shrinkage.

I give my clients several fine art papers to choose from but generally limit canvas choices to one. After experimenting with many different types, I found Breathing Color's "Brilliance Chromata White Canvas" (L10.34) to fit my needs nicely. It is water-resistant with a medium surface texture—enough to tell it's canvas, but not so much that it interferes with the canvas weave that may be part of the original artwork. The canvas is a poly/cotton blend, and offers a color gamut similar to, and sometimes better than, my fine art papers. It also stretches well without cracking or tearing. The coating I primarily use is Breathing Color's Glamour II Veneer (Matte finish).

I apply the veneer (often called "varnish") with a short-napped paint roller (L10.35) rather than the RollerFoam applicator recommended by Breathing Color on its website. I find I can get more liquid on the canvas in a shorter period of time, which is critical to a smooth and even surface, but I'd recommend testing both types of applicators to determine which works best for you. Also take into account the fact that virtually all canvas will shrink in size to some degree after printing and coating, so do a test to see whether you need to enlarge your images. This is especially important if you plan to have the artwork stretched on commercially available stretcher bars. If the canvas shrinks, the image may not reach the edges of the stretcher bars.

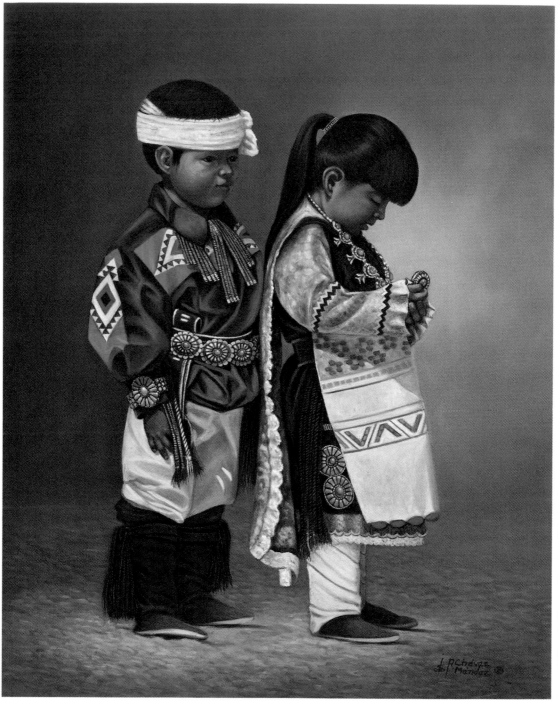

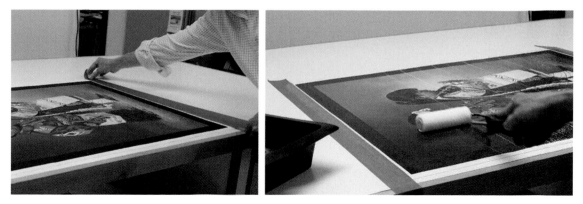

(Left) Patrick Carr taping down a canvas print with blue masking tape prior to coating. (Right) Patrick Carr demonstrating how he applies the varnish using a six-inch-wide short-napped paint roller.
Photos © Patrick Carr. Artwork on canvas © Ricardo Chavez-Mendez.

TIP 148 Tape the canvas, then mix and apply the coating.

After producing a print on the canvas, I recommend waiting 24 to 48 hours for the canvas to dry before coating. I then tape the canvas to a flat, horizontal surface (a table works well) using blue masking tape because it's easy to remove and doesn't leave a residue. I first mix the veneer with 30% distilled water in a plastic cup, then place the mixture into a painter's tray. I then apply the coating with a roller and cover the canvas with a thick, workable coat, moving from one end to the next as quickly as possible, and slightly overlapping my strokes (similar to the process shown on Breathing Color's online videos [L10.36]). Once the canvas is completely coated, I roll over the entire piece again with firm, almost heavy pressure. This seems to keep any pinholes or tiny dry spots from forming. I then go over the piece once more with just the weight of the roller. This will blend out any lines or streaks. In my environment, the varnish will dry to the touch in an hour or two, and the finished canvas will be ready to roll up (or stretch) after about 24 hours.

Artist: Ricardo Chavez-Mendez; **Image title**: *Legacy*; **Print Size**: 24×30 inches; **Canvas**: Breathing Color Brilliance Chromata White Canvas; **Printer Name**: Epson Stylus Pro 9600; **Ink Used:** Epson UltraChrome K2 (w/ Matte Black)**; Driver:** Standard Epson Driver (Mac OSX); **Original Medium**: Acrylic on canvas; **Coating**: Breathing Color Glamour II Veneer (Matte)

Artist: Richard Ehrlich; **Image title**: *Plate BP1*; **Print Sizes**: 44×36 and 20×16 inches; **Paper**: Epson UltraSmooth Fine Art 500gsm; **Printer Name**: Epson Stylus Pro 9600; **Ink Used**: Epson UltraChrome K2; **Driver**: Standard Epson Driver (Mac OSX); **Camera**: Canon EOS-1Ds Mark II; **Lens**: Canon EF 15mm f/2.8 Fisheye; **F-stop**: f/2.8; **Exposure**:1/25 sec.

Portfolio and Marketing Tips

Web Site, Portfolio, and Marketing Tips

By Richard Ehrlich

Prior to focusing on photography, **Richard Ehrlich** was a painter influenced by 19th century artists, especially Cézanne. Ehrlich's inkjet prints are represented by numerous galleries and held internationally in museum and foundation collections including the Los Angeles County Museum of Art, Tennessee State Museum, Santa Barbara Museum of Art, Palazzo Ducale Museum, UCLA Hammer Museum, Denver Art Museum, and the Fredrick R. Weisman Art Foundation. Recent projects include *The Holocaust Archives*, as well as the book *Das Sperrgebiet-The Forbidden Zone* (Nazraeli Press), which features photographs of Namibian landscapes and an abandoned mining village. For more information, visit www.ehrlichphotography.com.

TIP 149 Create a web site.

Most people realize this, but a web site can serve many purposes. It can help open doors to galleries, museums and collectors, and serve as a place to promote your upcoming shows. With regard to design, I believe that a site should be easy to navigate—let the work speak for itself. My work lends itself to specific subjects, and I display groups of photographs under the main heading "Images." I also recommend listing any previous and upcoming exhibitions as well as current galleries where your work can be found. If you represent your own work, a contact phone number is highly recommended, and you should always provide either an e-mail address or a form on your site for people to contact you.

To find the web links noted in the book (L11.1, etc.), visit www.inkjettips.com or http://www.courseptr.com/ptr_downloads.cfm.

Artist: Richard Ehrlich; **Image title**: *Plate HRMS1*; **Print Size**: 36×44 inches; **Paper**: Epson UltraSmooth Fine Art 500gsm; **Printer Name**: Epson Stylus Pro 9600; **Ink Used**: Epson UltraChrome K2; **Driver**: Standard Epson Driver (Mac OSX); **Camera**: Canon EOS-1Ds; **Lens**: Canon EF 100-400mm f/4.5-5.6L IS; **F-stop**: f/22; **Exposure**:1/80 sec.

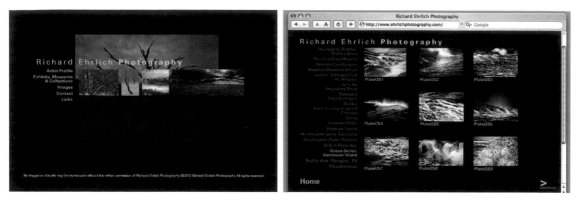

(Left) The home page of Richard's Ehrlich's web site. (Right) A web page from Ehrlich's *Ocean Series: Vancouver Island.*

TIP 150 Have an exhibition catalog/brochure produced.

If you have a solo exhibition, I recommend making an exhibition catalog or brochure. There are many printing options available, and a brochure can consist of just a few pages. However, a book with 15–30 pages will make a stronger statement. A good designer is recommended to make your work look its best. I also recommend making more copies than you think you'll need. Catalogs are a fantastic promotional piece; I send out an average of two to three of my catalogs originally made for my exhibition at the Tennessee State Museum (L11.1) every week to current or prospective galleries or collectors. Catalogs can also be sold at galleries and/or through your web site.

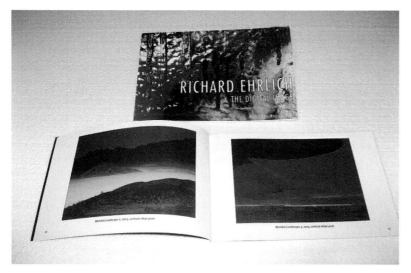

Richard Ehrlich's show catalog, printed via traditional color offset printing, and created for his solo exhibition entitled, Richard Ehrlich & the Digital Image.
Photo © Richard Ehrlich

278

Thanks to advances in color printing, you can also make very high quality on-demand books to use as exhibition catalogs, or to just showcase a specific portfolio or body of work. The layout can be done completely through a web browser, or through software like Apple's iPhoto (L11.2), Adobe Photoshop Elements (L11.3), or Apple's Aperture (L11.4). The book shown here was created through Kodak's EasyShare Gallery (L11.5). I just uploaded images and text, and had the book within a few days. The quality is close to many offset printed books I've seen, and the cost for the 12 × 14 inch 20-page hardcover book I had made was about $70. 8.5 × 11-inch hardcover and softcover books can be created for as low as $20 from some on-demand print services. When you need more, you can order them "on-demand," or in some cases, you can make a link available to others so that they can order a book directly from the on-demand book printer.

An on-demand hardcover book of Richard Ehrlich's work made by the Kodak EasyShare Gallery.
Photo © Richard Ehrlich

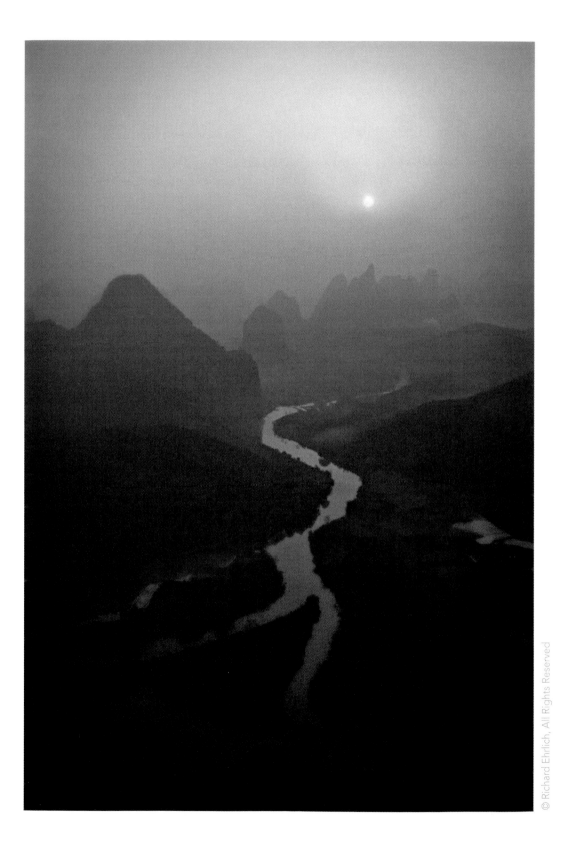

TIP 151 Keep your prints covered.

Many coated inkjet papers can be easily scuffed if sheets are placed on top of one another without a protective sheet. I've had success with two types of protective sheets. First, for my large prints, I use Pellon (L11.6), which is an acid-free spun poly-ester available in some fabric stores (ask for the non-adhesive version). For smaller pieces and for some large prints, I use a thin, paper-based material called Archivart Photo-Tex Tissue (L11.7).

TIP 152 Protect your work in a high quality case.

It's important to keep your work protected when hand-carrying it to galleries, framers or clients. Many of my images are printed on 35 × 47-inch sheets, so I decided to have a hard-sided, foam-lined case custom-made to securely hold the prints. I chose Samy's Camera in Los Angeles (L11.8) to create it, and I've been using the case extensively for more than three years. I recommend using additional foam to hold prints in tightly. Thick and thin foam can be purchased at stores that sell packing material. Thinner, multiple sheets of foam can be stacked to just the right height depending upon what's in the case.

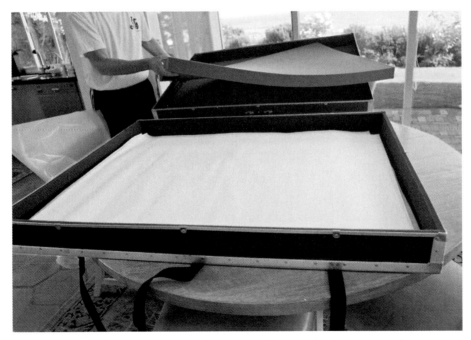

Richard Ehrlich with his custom-made portfolio case and foam insert to keep the work from moving inside the case.
Photo ©Andrew Darlow

Artist: Richard Ehrlich; **Image title**: *Plate CH27*; **Print Size**: 24×30 inches; **Paper**: Epson UltraSmooth Fine Art 500gsm; **Printer Name**: Epson Stylus Pro 9600; **Ink Used**: Epson UltraChrome K2; **Driver**: Standard Epson Driver (Mac OSX); **Camera**: Canon EOS-1Ds Mark II; **Lens**: Canon EF 16-35mm f/2.8L; **F-stop**: f/2.8; **Exposure**: 1/500 sec.

TIP 153 Protect your work for shipping.

When shipping prints around the world, it's very important to pack your prints so that they are well protected from potential damage. My current approach often begins by using the boxes that are sent to me when I order Epson UltraSmooth Fine Art Paper (L11.9). These boxes are very strong, and to best illustrate how I pack my prints, I've put together a series of photographs. To help protect it from abuse (especially with prints over 20 × 30 inches), a box is packed inside of another box. The outside box is made from thick cardboard (this particular type has large lettering that reads "mirror" and "fragile." In between the two boxes, white foam is used to provide a layer of protection for the prints. Corrugated box material and foam can be purchased at many office supply stores, and similar boxes can be purchased from companies such as Light Impressions (L11.10).

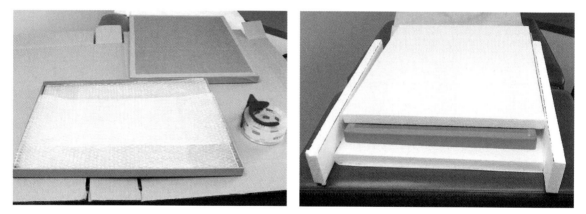

(Left) The box holding the prints is packed with bubble wrap to fill any empty space. (Right) White foam is cut from foam sheets and placed around the inner box, with a small channel for paper to be inserted as a cushion.
Photos © Richard Ehrlich

(Left) The inner box shown inside the larger box with white paper surrounding it for additional protection. (Right) The finished box, taped and ready to ship.
Photos © Richard Ehrlich

TIP 154 Build or buy flat files for your prints.

Keeping fragile art paper protected from scuffing and other damage can be difficult in any studio, so I highly recommend using flat files to store prints. They can be purchased in various sizes and are available in a number of different materials. Another option is to make your own flat files (or have them made), especially if you work with paper that exceeds the size of commercially available flat files. The flat files shown below, which can hold sheets up to 44 × 60 inches, were made for me by a carpenter from wood, and then finished with a black laminate.

Richard Ehrlich's custom-made flat files.
Photo © Richard Ehrlich

TIP 155 Create a boxed portfolio of prints.

A limited edition boxed set of prints, such as the one I created for the series *Graffiti: Belmont Park Los Angeles*, can serve as both a portfolio and a work available for sale. The Graffiti portfolio consists of thirteen 20 × 16 inch prints from the series, printed on Epson UltraSmooth Fine Art 500gsm paper. The black clamshell box was custom made by Portfoliobox, Inc. (L11.11). The company was a pleasure to work with, and I'm extremely happy with the quality of their work.

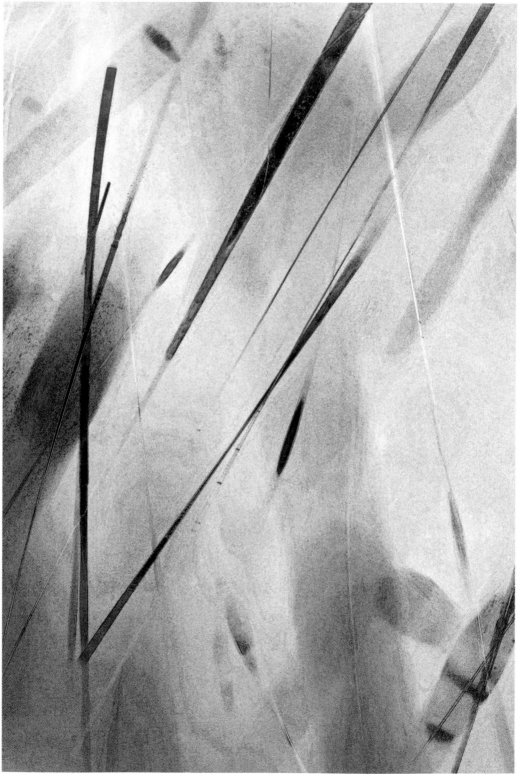

(Top) Richard Ehrlich's limited edition portfolio of prints in a custom clamshell box by Portfoliobox, Inc. (Bottom) Debossed lettering was chosen for the cover of the boxes and was stamped by Portfoliobox, Inc.
Photo © Richard Ehrlich

(See Tip 99 in Chapter 7, "Portfolio and Presentation," for two more examples of how Richard Ehrlich uses portfolio boxes for his prints.)

Artist: Richard Ehrlich; **Image title**: *Plate RC11*; **Print Sizes**: 24x30 and 36x44 inches; **Paper**: Epson UltraSmooth Fine Art 500gsm; **Printer Name**: Epson Stylus Pro 9600; **Ink Used**: Epson UltraChrome K2; **Driver**: Standard Epson Driver (Mac OSX); **Camera**: Canon EOS-1Ds Mark II; **Lens**: Canon EF 24-105mm f/4L IS; **F-stop**: f/4; **Exposure**:1/3 sec.

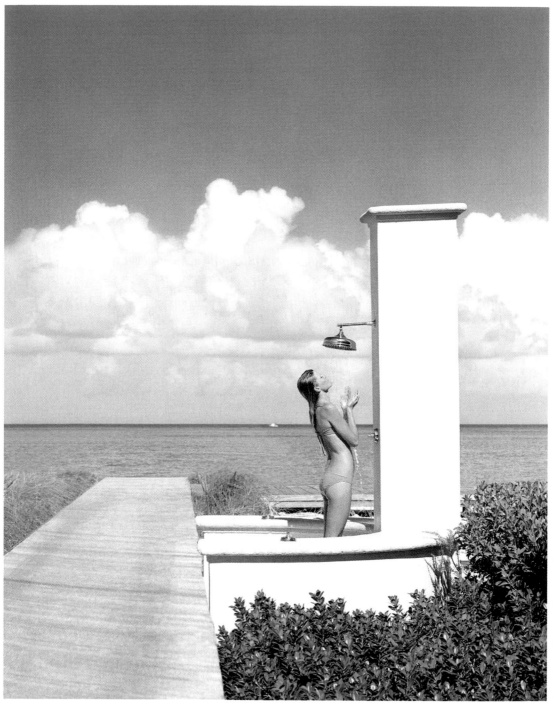

Creating a Commercial Portfolio with Inkjet Prints

By Matthew Wakem

New York-based photographer **Matthew Wakem** has spent the past 15 years traveling throughout North Africa, Asia, Jamaica, Latin America and his native New Zealand. His clients include Condé Nast Traveler, Luxury Spa Finder, The Four Seasons, Ford, Life and Men's Journal. When not photographing, Wakem has a successful career as a world beat DJ and recently completed his first album as a music producer, *The Bambu Brothers*. For more information, visit www.matthewwakem.com.

If you are an advertising or editorial photographer, it's critical to have a well-made, attractive portfolio. It's also important to update your portfolio on a regular basis. It helps keep your existing clients aware of what you've been shooting, and helps to bring in new clients. I try to produce a new portfolio every year or so. In the interim, I am constantly adding and deleting images. My book contains approximately 100 images, and I know it's time to make a major update when I have about 50 new portfolio quality images. The following tips cover the process I use to produce my commercial portfolios.

TIP 156 Choose a look and feel for your book and make multiple copies.

I decided to forego the standard black leather book that most photographers use. After working for years in the photo departments of several magazines, I believe that they just get lost in the pile because they all look so similar. I use a fabric-covered screwpost-bound book with a matching slipcase. The color palette of the portfolio matches the tone of my web site and complements the images without competing with them. Fabric tends to also be less expensive than leather. I had my book produced by House of Portfolios in New York City (L11.12), and specifically chose a design that allows 11 × 14-inch prints to be inserted into clear plastic pages. This makes rearranging and replacing photos very easy, and images don't get as damaged as quickly compared with portfolios with unprotected prints. I also recommend making multiple books because portfolios are not always returned promptly.

Artist: Matthew Wakem; **Image title**: *Untitled*; **Print Size**: 11×14 inches; **Paper**: Epson Matte Paper Heavyweight; **Printer Name**: Epson Stylus Photo R2400; **Ink Used**: Epson UltraChrome K3; **Driver**: Standard Epson Driver (Mac OSX); **Camera**: Mamiya RZ67 Pro II; **Lens**: Mamiya 110mm f/2.8; **Film**: Kodak Portra VC160; **F-stop & Exposure**: unrecorded

In addition, one portfolio should always be in your possession for in-person meetings or other opportunities.

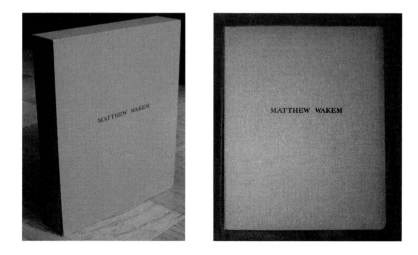

(Left) One of Matthew Wakem's cloth-covered portfolio boxes with a portfolio book inserted. (Right) One of Wakem's portfolio books with the stamped cover showing. Photos © Matthew Wakem

TIP 157 Select, scan, and make digital contacts of new and old work.

I begin the process of updating a book (or creating a new book) by first editing down to my favorite 200–300 images from the previous two to four months. I then go through my contact sheets (if shot with film), and I create low resolution scans of everything that is in the running. These scans are then quickly color corrected and printed on my Epson Stylus Photo R2400 as digital contact sheets using the Contact Sheet II feature in Adobe Photoshop. I usually print nine images up on each 8.5 × 11-inch sheet of Epson Matte Paper Heavyweight. It's important to use the same type of paper that you plan to use for the portfolio. This way tone and color will be a closer match when you make your final prints. Once the digital contacts are printed out, I cut them into individual images and place them in a big pile.

TIP 158 Work with a good designer and prep an online gallery.

A good designer can help make your portfolio look its best, and getting feedback can help you to see your work from an art director's perspective. I've always had another person whom I trust edit my portfolios, and I highly recommend that approach. The designer I consulted with for the last few portfolios I've done is a creative director who lives in another state, so I save each image from the contact

Artist: Matthew Wakem; **Image title**: *Untitled*; **Print Size**: 11×14 inches; **Paper**: Epson Matte Paper Heavyweight; **Printer Name**: Epson Stylus Photo R2400; **Ink Used**: Epson UltraChrome K3; **Driver**: Standard Epson Driver (Mac OSX); **Camera**: Mamiya RZ67 Pro II; **Lens**: Mamiya 110mm f/2.8; **Film**: Kodak Portra VC400; **F-stop & Exposure**: unrecorded

sheets to a .Mac account (L11.13) and store them on an iDisk (storage space on Apple Inc.'s servers). I then create a slideshow from the files and send the link to the slide show to my designer.

After she looks at the images, she prints them out and then cuts them up into single prints. She then chooses her favorite photos and pairs images to create two-page spreads. The paired images are as important as the individual images. Often, images I love on their own don't make it into the final portfolio because we were unable to find a suitable image to place next to it. Once the combinations are made, the designer sends me her suggested spreads via normal mail, or we meet together in person.

An online gallery used by Matthew Wakem's designer for printing thumbnails and editing images.
Photos © Matthew Wakem

TIP 159 Use a bulletin board and carefully consider image placement.

Once the page combinations are made, I tape them in a trial sequence onto a large 32 × 24-inch dry erase board. That way I can write notes below spreads and easily remove the tape to make changes. I then live with it for some time. It's always in a place near my desk where I can see the entire portfolio in one quick glance. I can get an instant sense of the overall feel and see how images relate to one another. Creating a flow and rhythm to the portfolio is very important to me.

To help keep viewers interested in my portfolio, I try to frequently change the subject matter, color combinations, size, and depth of objects in the frame. For example, I will avoid having three images with a lot of blue in them all next to each other. I also won't place several close-up portraits next to each another. I want my viewers' eyes to have to refocus every time they turn the page. This way they have to look at and not just glaze over the pages.

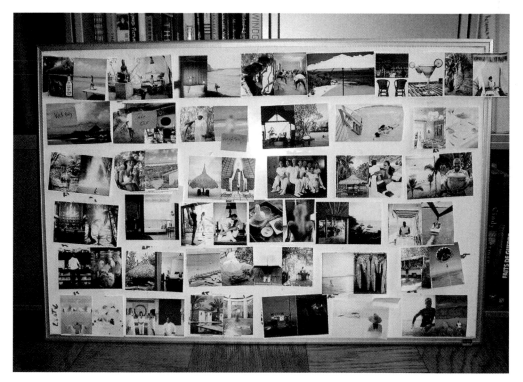

Matthew Wakem's small inkjet-printed portfolio pages attached to a white board.
Photo © Matthew Wakem

TIP 160 Assemble low-resolution composite files.

Once I've finalized my selection and two-page spread combinations, I then go back to the individual low resolution image scans and combine them. I create a blank document in Adobe Photoshop and drop in the two images that will make up the spread. These spreads are then made into digital contacts again, uploaded to .Mac and printed out as noted in Tips 157 and 158. I then replace the individual images with these combined prints on the layout board. I recommend that you keep all of the individual images you originally printed in a large envelope or plastic box because you may want to go back and reconsider certain images.

TIP 161 Scan, retouch, print, and insert.

After final pages have been determined, I then return to my negatives and begin to make large scans (about 14 × 19 inches at 300 PPI) using a Nikon Super Coolscan 8000 ED (L11.14). All images are scanned larger than I need in case I want to crop them or use the files to submit to a stock agency. My final file size use for inkjet output is 11 × 14 at 300 PPI. In addition to doing careful dusting, color correction and sharpening, I will almost always send a certain number of images to a professional retoucher (usually about a third of the portfolio). I recommend you work with a retoucher who knows your style and who can keep the overall look of your images consistent.

Matthew Wakem's portfolio open to a specific page (the same images can be found on the dry erase board shown in a previous tip).
Photo © Matthew Wakem

Artist: Matthew Wakem; Image title: Untitled; Print Size: 11×14 inches; Paper: Epson Matte Paper Heavyweight; Printer Name: Epson Stylus Photo R2400; Ink Used: Epson UltraChrome K3; Driver: Standard Epson Driver (Mac OSX); Camera: Mamiya RZ67 Pro II; Lens: Mamiya 110mm f/2.8; Film: Kodak Portra VC160; F-stop & Exposure: unrecorded

293

Once my files are ready, I begin to make prints. I always print out small test prints on an 8.5 × 11 piece of Epson Matte Paper Heavyweight (the same paper as the final portfolio prints, L11.15). The size and placement is adjusted in the File>Print with Preview window in Photoshop (or File>Print in Photoshop CS3). I usually do the tests at 32% of the original size, which allows for 4–5 tests on one piece of paper. After making small adjustments, I begin to print out final portfolio prints on A3 sized paper (11.7 × 16.5 inch). I then allow them to dry for about 30 minutes to an hour before cutting them down carefully with an X-Acto knife and a 24-inch Standard T-Square. The final step is to insert the pages into the portfolio, which I generally do after allowing the prints to dry for at least 24 hours.

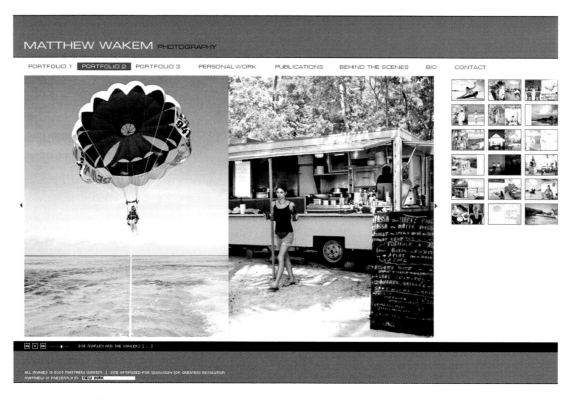

A screen shot from Matthew Wakem's online portfolio. The web site has a very similar look and feel to Wakem's printed portfolio.
Photos © Matthew Wakem

Making Innovative Promos and Portfolios

By Mark Harmel

Mark Harmel's photographs have been used by companies including Orvis, Warner Brothers, Blue Cross, and Cedars-Sinai Health Care System, and his work has been published in *Time*, the *Wall Street Journal*, *Research Magazine*, and *Brandweek*. Harmel's stock photography is available through Getty Images, Workbookstock.com and Alamy. He recently worked with his wife, Dr. Anne Peters, a physician specializing in diabetes, to create a best-selling book on the disease, *Conquering Diabetes*, published by Penguin Books. For more information, visit www.harmelphoto.com.

Affordable and high quality inkjet printers have made it possible for virtually anyone to produce high quality portfolios and promotional pieces. For the last few years, with the help of a designer and book artist, I've made many of my own portfolios, folding cards and postcards.

The following tips give an overview of how I produced my current portfolios (a portfolio of personal work and a commercial portfolio geared toward the medical profession) and various promo pieces. The suggestions are geared primarily toward advertising and editorial photographers, but anyone who wants to produce a promo piece or portfolio can benefit from the advice.

TIP 162 Find a designer to work with.

Before embarking on a project, decide what your goals are. In my case, I wanted to produce a custom "book" called *Sightings*, filled with images from experiences I had during my travels. I found designer Michael Standlee (L11.16). Michael is a talented designer who was in a creative development group with me. He really understood the *Sightings* series, and after seeing his work, I knew he would be an excellent person for the project. Michael developed a new logo for the book, and we worked together to keep the theme consistent for not just the book, but also for a number of other promotional pieces, as well as my web site.

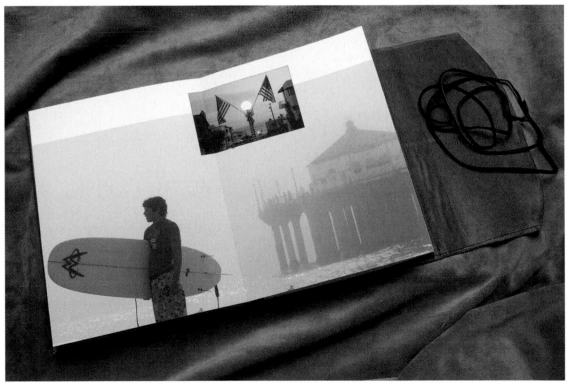

Three views of Mark Harmel's custom-made book, *Sightings*.
Photos © Mark Harmel

Artist: Mark Harmel; **Image title**: *Los Angeles Freeway Interchange*; **Print Size**: 18×12 inches; **Paper**:
Epson Matte Paper Heavyweight; **Printer Name**: Epson Stylus Photo 2200; **Ink Used**: Epson UltraChrome
K2**; Driver**: Standard Epson Driver (Mac OSX); **Camera**: Canon EOS-1Ds; **Lens**: Canon EF 28-70mm f/2.8L;
F-stop: f/11 **Exposure**: 3 sec.

TIP 163 Create small files for the designer to use for layout.

To make the process go more quickly, I recommend producing small image files (about 800 pixels on the longest side) so that the designer can quickly review and lay out the book. In our case, Michael used Adobe InDesign CS (L11.17) and laid out an entire book with me (produced in 18 × 12-inch spreads) in just a few hours. Varying image sizes from page to page allowed for more images to be used, and to keep the layout simple, no captions were inserted. Instead, a poem by Jim Natal (L11.18) ran throughout the *Sightings* book. At the very end of the book, a page of thumbnails was created with the name of the place where each image was photographed. It serves as a recap and quick reference, and I highly recommend this approach for commercial or art portfolios. The thumbnail recap gets positive comments when I show the book in person, and the descriptions serve as photo captions when I'm not with the person who is looking through the book. After the layout was approved and complete, Michael then saved the book as a PDF file, which I used as a template for rebuilding the pages.

A page of thumbnails used at the end of the *Sightings* book, which serves as a recap for the portfolio.
Photo © Mark Harmel

TIP 164 Replace the low-res files and start printing.

The next step was to take the PDF and open it in Photoshop. Photoshop allows you to rasterize PDFs upon opening, which I did, at 240 PPI. I then sized each of the files to exactly the correct print dimension at 240 PPI and pasted the high-res files on top of the low-res files in the layout. After that, each page was saved and printed out on an Epson Stylus Photo 2200 at 18 × 12 inches, centered on 13 × 19-inch sheets of Epson Matte Paper Heavyweight paper. To make cutting and scoring easier, under File>Print with Preview in Photoshop (File>Print in Photoshop CS3), choose Output (circled in red below) and check both "Corner Crop Marks" and "Center Crop Marks."

Screen shot of "File>Print with Preview" from Photoshop CS2, with two Output options selected. Photo © Mark Harmel

TIP 165 Choose a book type.

There are many types of books that can be created. One of the easiest is to cut sheets and insert them into plastic pages. I wanted a more organic look and chose to produce an accordion-fold portfolio. Since this requires precise alignment and a lot of gluing together of pages, I recommend finding a professional in the field; I worked with book artist Tania Baban (L11.19). A book artist can show you samples and help you to determine what will fit your style and budget. After producing a few of these

books, about 25 leaves (50 pages) seems to me to be a good quantity for the accordion-book approach, though you may want to use far fewer or more pages depending on your specific project. Also, if you plan to ship your book and want to save on shipping and packing costs, be sure that it will fit in a USPS, FedEx and UPS standard-size box.

Mark Harmel's medical book photographed from the side, showing the accordion fold.
Photos © Mark Harmel

TIP 166 Cut/score properly and find cover materials.

Tania worked with me to determine how to best cut and score each spread properly. For the most precise cuts, I recommend using a metal ruler and an X-Acto knife (be careful!), or a very precise rotary cutter. For scoring the paper, purchase a scoring tool at an art supply store (made of plastic or bone, L11.20). Then learn how to assemble the book, or leave it to an expert in the field. For the *Sightings* book's cover material, Tania and I went to a shoe repair supply store in Los Angeles named Saderma (L11.21) that carries leather hides and selected a dyed cowhide that fit the overall travel theme. The cowhide was wrapped around a lightweight rubber-like board to give it additional strength.

For my medical portfolio, I chose a more rigid black cowhide that simulated an old-fashioned doctor's medical case, and found all the appropriate hardware (buckles, clasps, etc.) also at Saderma. To insert the printed pages, the first page and last page of the book are slipped into the cover in way similar to how a hardcover book slips into a book cover. This makes it easy to replace the pages or cover of the book if necessary. The debossed stamp for both of the portfolios was done by Beverly Hills Bookbinding Services (L11.22) from black and white prints of my logos. The medical book pages were printed in the same way as the *Sightings* book.

Artist: Mark Harmel; **Image title**: *Taxi Parisen at the Arc de Triomphe*; **Print Size**: 18×12 inches; **Paper**: Epson Matte Paper Heavyweight; **Printer Name**: Epson Stylus Photo 2200; **Ink Used**: Epson UltraChrome K2; **Driver**: Standard Epson Driver (Mac OSX); **Camera**: Canon EOS-1Ds; **Lens**: Canon EF 70-300mm f/2.8L; **F-stop**: f/40 **Exposure**: 13 sec.

Two views of Mark Harmel's medical portfolio.
Photos © Mark Harmel

TIP 167 Make a Z-fold promo piece.

To complement the *Sightings* portfolio, I wanted a promo piece that would convey a similar feeling, without being too complex or expensive. To begin with, I decided to use a heavier paper that would give the piece more stability. I used Lumijet Museum Parchment (L11.23) and printed the promo pieces 4-up on 11 × 17-inch sheets. To produce a piece like this, start with a template (L11.24). Then insert your photos into the template and print. This piece is printed on just one side. After printing, score the appropriate image edges with a plastic or bone scoring tool, and fold carefully. I recommend producing a piece that fits inside a standard sealable clear plastic bag. The ones I use are from Impact Images (L11.25).

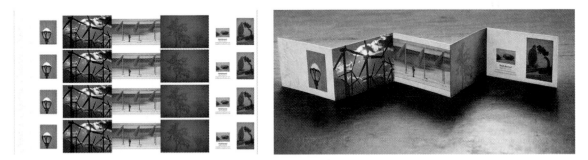

(Left) Mark Harmel's Z-fold promo piece 4-up on a sheet prior to cutting and folding. (Right) The promo piece after cutting, scoring, and initial folding.
Photos © Mark Harmel

Artist: Mark Harmel; Image title: *Ultrasound Exam*; Print Size: 18×12 inches; Paper: Epson Matte Paper Heavyweight; Printer Name: Epson Stylus Photo 2200; Ink Used: Epson UltraChrome K2; Driver: Standard Epson Driver (Mac OSX); Camera: Canon EOS-1Ds; Lens: Canon EF 28-70mm f/2.8L; F-stop: f/4.5 Exposure: 1/20 sec.

TIP 168 Make folding cards and postcards.

Much like the Z-fold piece, custom cards can be excellent leave behinds at ad agencies, or they make great holiday and thank you cards. I often use Red River Paper's pre-scored 50lb. Premium Matte C2S 7 × 10 Paper (L11.26). They are affordable, easy to produce, and each sheet makes a 5 × 7-inch folded card. To use the paper, set up a custom paper size (7 × 10 inches) and make sure that any images and logos on the back are properly centered. To help reduce the number of cards used for testing, cut a few sheets of less expensive paper down to 7 × 10 inches and run tests on that paper until the placement of your images, logo and text are correct.

Having the ability to create instant postcard promos is wonderful. I have used inkjet-printed postcards to write thank-you notes for those who have seen my portfolio, and I've also used them as standalone promotional pieces. I find that heavyweight inkjet watercolor papers such as Lumijet's Museum Parchment have an elegant look and feel, and complement the look of my portfolios. Below is an example of how I gang up multiple cards on an 11 × 17-inch sheet, prior to cutting. After printing, I address them on the reverse side by hand, insert them in clear plastic envelopes from Impact Images, and place a stamp on the outside of the envelope. This eliminates the need for a mailing label.

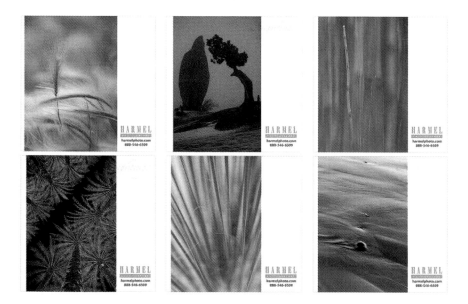

Mark Harmel's postcard template prior to cutting.
Image © Mark Harmel

Making an Advertising Portfolio with Double-Sided Inkjet Paper

By Tom Hassler

Even in this day and age of online portfolios and e-mail, advertising photographers need a printed portfolio. About a year ago, I decided to update my portfolio with a new look. This was to be a "style" portfolio, and I wanted a look that was reminiscent of a high-end coffee table book. I decided to make all the prints in-house with the printing techniques I use for my fine art edition prints. It was also important to be able to change pages easily as new images were created. These tips will take you through the process I used to make three identical portfolios.

Tom Hassler is a commercial and fine art photographer based in Portland, Oregon. His work has been published internationally, and he has won numerous awards. He is currently working on a long-term project documenting the disappearance of remnants of the Old West, and teaching photography workshops in San Miguel de Allende, Mexico. For more information, visit www.tomhasslerphoto.com.

TIP 169 Choose a printer and paper.

It's important to choose a printer that is reliable and which produces quality that reflects your work. The printer I used for these portfolios was the 13-inch wide Epson Stylus Photo 2200. I've since upgraded to the Epson Stylus Pro 4800 (17 inches wide), and all new portfolio prints are now output on the Epson 4800. Both printers produce sharp, pigment ink prints on matte and gloss/semi-gloss papers. After some testing, I selected Hahnemühle Photo Rag Duo 316 (L11.27) as my double-sided portfolio paper. It's a gorgeous, thick, coated fine art paper that feels wonderful in your hands. I felt that texture was very important to the art book experience I was trying to create. Photo Rag Duo takes ink beautifully, and will produce highly saturated or subtle-toned images equally well.

The cover and inside of one of Tom Hassler's custom-made portfolios.
Photos © Tom Hassler

TIP 170 Calibrate and profile and consider ImagePrint.

Without a properly calibrated and profiled monitor and printer, it's difficult to achieve consistent prints. When I owned the Epson Stylus Color 2200, I made my own printer profiles with a ColorVision Datacolor 1005 spectrocolorimeter and ColorVision's PrintFIX PRO software (L11.28), and made monitor profiles with the ColorVision Spyder2 Colorimeter. The ColorVision system served me very well, and I was very happy with the quality of my prints. When I purchased the Epson Stylus Pro 4800, I added ColorByte Software's ImagePrint RIP software for Mac OSX (L11.29). The built-in profiles that come with the software have been excellent, and the layout tools are accurate and easy to use.

TIP 171 Make a full comp of the book.

Any double-sided book takes time to put together, and the best way I've found to create a book is to first print many images out; then arrange them until they come together as a body of work. For this portfolio project, about 100 "semi-finalist" images were all printed 8 × 10 inches on inexpensive paper (Janus Double Sided Matte 44 lb., L11.30). I did a lot of arranging and rearranging of these on a large section of my studio floor before arriving at the final edit and pagination of 40 images (20 pages). I then printed each image on the same inexpensive paper, but at 11 × 16 inches (the book's final size). These prints were paper clipped together back-to-back and along the left edges to make my mock-up. Final print files were renamed to reflect their placement in the book, by spread: 04aLeftPage.psd, 04bRightPage.psd, 05aLeftPage.psd, etc.

Artist: Tom Hassler; Image title: *Garden Gate*; Print Size: 16×11 inches; Paper: Hahnemühle Photo Rag Duo 316; Printer Name: Epson Stylus Photo 2200; Ink Used: Epson UltraChrome K2; Driver: Standard Epson Driver (OSX); Camera: Canon EOS 5D; Lens: EF Canon 24-105mm f/4L IS; F-stop: f/8 Exposure: 1/25 sec.

I carried the mockup around with me during the rest of the process, and it was very helpful to be able to see the "book" as a whole before it was completed. I used it as a guide when making the final two-sided prints, and it was invaluable in helping to avoid mistakes.

Tom Hassler's mock-up book, used as a guide for his final portfolio.
Photos © Tom Hassler

TIP 172 Make test prints on less expensive paper.

Some papers, such as Photo Rag, have thinner or single-sided versions available, which can make the proofing process less expensive, while still producing prints with a very similar looking color and density. Before printing my final 11 × 16-inch portfolio pages, I made about eight test prints using 8.5 × 11-inch sheets of Hahnemühle Photo Rag 188gsm (L11.31). I chose a cross-section of photographs to proof, including both black and white and color images.

TIP 173 Cut down your sheets before printing.

By cutting your paper down to exactly the size you will need for your book in advance, you reduce the chance of damaging prints. However, if you want full-bleed prints, you may need to print first and then cut the paper down. I printed my portfolio pages on 11 × 17-inch paper but cut down the paper to 11 × 16 inches prior to printing.

Artist: Tom Hassler; Image title: *Posos Arch #1*; Print Size: 16×11 inches; Paper: Hahnemühle Photo Rag Duo 316; Printer Name: Epson Stylus Pro 4800; Ink Used: Epson UltraChrome K3; RIP: ImagePrint 6.1 RIP (OSX); Camera: Canon EOS 5D; Lens: EF Canon 24-105mm f/4L IS; F-stop: f/13 Exposure: 1/250 sec.

TIP 174 Make a template for your pages.

Some print drivers will not perfectly center images on a sheet without first making an adjustment in either the image file, the File>Print with Preview screen in Photoshop (File>Print in Photoshop CS3), or the custom page settings. A template can help make sure your work is perfectly centered, or it can be used to print images in a specific area of each page. You can create a template in Photoshop by first creating a blank page at your final print size. Then create guides by dragging them from the rulers along the edges to form a boundary on the page to the place that results in a centered print. Then just paste each photo into the blank page, move it into position, and print. This assumes your images are the same size, but even if they are not, you can use the guides for centering larger or smaller images. Currently, I'm printing with the ImagePrint RIP on the Stylus Pro 4800, and I get correctly centered prints simply by using the RIP's layout window.

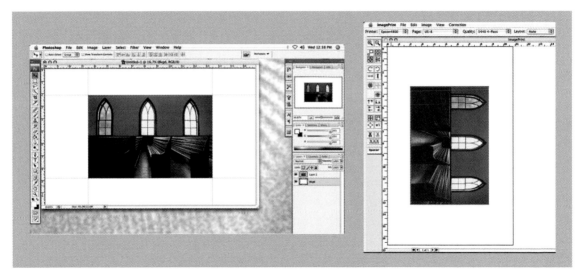

(Left) This screen capture shows a template file in Photoshop. After running a centering test, images can now be placed one by one to help assure proper centering. (Right) The layout window for ColorByte Software's ImagePrint RIP.
Photo © Tom Hassler

Artist: Tom Hassler; **Image title**: *Outside In?*; **Print Size**: 16×11 inches; **Paper**: Hahnemühle Photo Rag Duo 316; **Printer Name**: Epson Stylus Pro 4800; **Ink Used**: Epson UltraChrome K3; **RIP**: ImagePrint 6.1 RIP (OSX); **Camera**: Canon EOS 5D; **Lens**: EF Canon 24-105mm f/4L IS; **F-stop**: f/11; **Exposure**: 1/100 sec.

TIP 175 Print on both sides of the sheets, and spray prints to protect them.

I began the process of making the final prints by first printing the odd-numbered pages of the portfolio. The sheets were then allowed to dry for 48 hours before being run through the printer again to avoid the possibility of damage to the printed surface. The even-numbered pages were then printed on the reverse side. Be sure the sheets are oriented correctly for the second pass so you don't end up with an image upside down on the reverse side! Printing on any heavy paper requires care to make sure the print head does not drag across the surface, which can ruin the print and possibly damage the printer. Even using the thick paper setting, I found that running the leading edge of the paper between my finger and thumb with a pinching motion before loading helped the printer grab the thick sheets.

After thorough drying (24 to 48 hours), I treated all the pages with several light coats of Lyson Print Guard sealant (L11.32). While the latest pigment inks are very long lasting, matte papers are a bit prone to scuffing from repeated handling. The spray does a good job of reducing this effect. There is virtually no smudging of prints where they press up against each other. The prints are also resistant to general smudging and scuffing, though deep blacks do sometimes show some scuffing.

TIP 176 Choose a good book binder and have a few made.

My research into hinging and binding had convinced me that this was a job best left to professionals. The completed pages were sent to Brewer-Cantelmo in New York City for assembly (L11.33). They are well-established portfolio makers, and their work is first rate. I chose gray leather for the cover, with my logo embossed into it. Brewer Cantelmo attached Kingston hinges (made of flexible fabric) and used a "Chicago" binding, which is a screw-post system that can be taken apart for easy replacement of pages. An added benefit of this design is that the pages lie flat as they are turned.

If you are a professional photographer, I suggest you budget for at least three copies of your book, but have one book bound first just to make sure it meets your expectations. Having multiple books allows you to have one or two circulating at all times and a backup that you can show locally. The portfolios are holding up very well over time, and the response to them has been phenomenal. And the satisfaction and control of having made the prints myself is just icing on the cake.

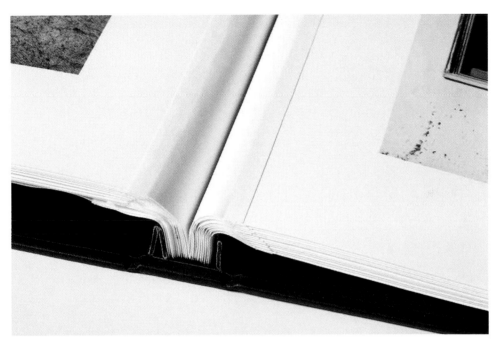

A close-up of the attached hinges and "Chicago" post binding system.
Photo © Tom Hassler

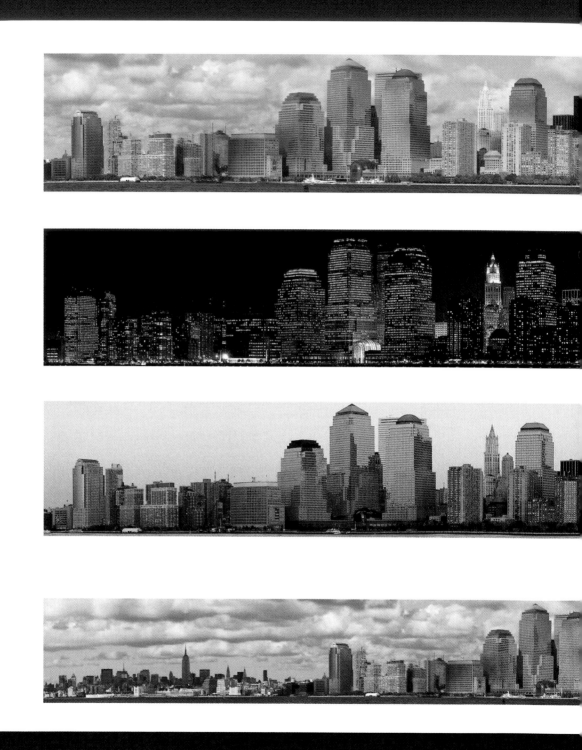

Artist: Ed Nazarko; **Image titles**: *Manhattan* (four prints); **Print Size**: Top three: 122×16 inches; Bottom: 160×16 inches (uncropped version); **Paper**: Epson UltraSmooth Fine Art; **Printer Name**: Epson Stylus Pro 4000; **Ink Used**: Epson UltraChrome K2; **Software/Driver**: Qimage/Epson Driver (Windows XP); **Camera**: Nikon D2X; **Lens**: Nikkor 80-400VR/ Nikkor 80-200AFS; **F-stop**: f/9 and f/11; **Exposure**: varied (8-9 frames shot for each)

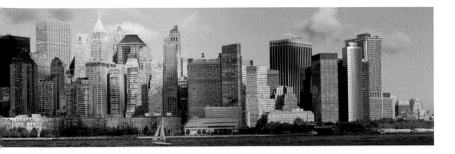

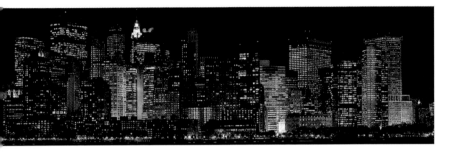

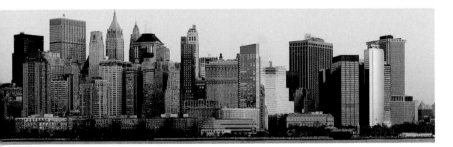

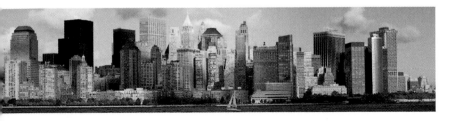

Chapter 12

RIPs, B&W, and Color Management

Using Qimage for Standard and Panoramic Printing

By Ed Nazarko

Ed Nazarko originally trained and performed professionally as a musician, and as an actor and director, across North America and Australia. Much of his music and theater work were improvisational, and he brings that spirit to his work as a photographer. While much of his work includes fine art and travel stock, he has commercial clients in the health, technology, and music industries. For more information, visit www.onemountainphoto.com.

The vendor-supplied Windows and Mac drivers for virtually all printers 17 inches wide and smaller are limited to a maximum length of 44 inches (about 90 inches for printers over 17 inches in width). I wanted to print my panoramas of Manhattan much longer on my Epson Stylus Pro 4000 and couldn't find a way to do that short of spending $500 or much more on a RIP. After much investigation, I came across Qimage by Digital Domain Inc. (L12.1). This is an inexpensive software package ($35–90) that has many of the features of pro-level RIPs (and additional features as well). It's compatible with most versions of Windows and most importantly, allows for printing extremely long images. In fact, I've printed up to 20 foot-long panoramas with it. Another important feature is that the software works with virtually all inkjet printers on the market, including large format printers.

To find the web links noted in the book (L12.1, etc.), visit www.inkjettips.com or http://www.courseptr.com/ptr_downloads.cfm.

Artist: Ed Nazarko; **Image title**: *Buddha Back*; **Print Size**: 11×14 inches; **Paper**: Arches Infinity Smooth 230gsm; **Printer Name**: Epson Stylus Pro 4000; **Ink Used**: Epson UltraChrome K2; **Software/Driver**: Qimage/Epson Driver (Windows XP); **Camera**: Nikon F100; **Lens**: Unrecorded; **Film**: Fuji NPC (Color Neg.); **F-stop & Exposure**: Unrecorded

These tips will help guide you through some of the steps necessary to print a panorama (or virtually any size print) using Qimage. There are currently three versions of the software available. I've been using the Qimage Studio Edition, which has the most features. Qimage has many additional features worth investigating, and the company is consistently improving the software's performance. With regard to panoramic printing for Mac OSX users, most RIPs discussed in this book, including the ColorBurst RIP and the ImagePrint RIP will allow you to exceed many manufacturers' maximum print lengths. And some printers, like the HP Designjet Z2100 and Designjet Z3100, allow print lengths up to 300 feet with the standard driver, according to the company. Also, a good overall guide to the Qimage interface can be found on this web page (L12.2).

TIP 177 Check your image carefully before printing.

Discovering a dust spot, crooked horizon, or the flashing lights of an airplane across the night sky after printing is no big deal with an 8 × 10 or 11 × 14 inch image. But each large panorama can represent a significant investment in paper and ink (and time!). You don't want to waste 20 feet of fine art paper on quality control. I print sections at smaller sizes on inexpensive paper to make sure that all the joined areas look clean (especially since my panoramic files are often built from 5 to 10 separate images).

TIP 178 If you want a border, add white space.

If you're making a wide borderless panorama print (for example 120 × 13 inches), centering your image top and bottom isn't a problem within Qimage. But if you want even borders, you need to create them before printing. If your image is 12 inches high, and you're printing on 13-inch roll paper, use the Canvas Size command in Photoshop or other application to add .5 inch of white space to the top and bottom of your image (see screen shot on page 319). This will assure that your image is centered vertically on the paper when you print the file through Qimage.

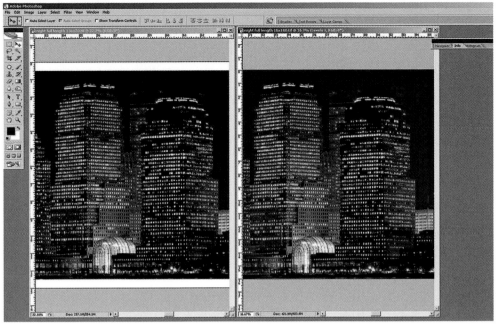

A 12-inch-wide image before and after adding half-inch borders top and bottom using Canvas Size in Photoshop.
Photo © Ed Nazarko

TIP 179 Set up the Windows printer driver.

Set up the printer parameters for Qimage by clicking on the printer icon at the top right of the Qimage screen (Printer Setup tool button, circled in red in the screen shot on page 320). Our print on the Stylus Pro 4000 (17 inches wide) will be 120 × 13 inches on a 13-inch roll. For Paper Size, create a custom paper size that is equal to Windows' maximum page height of 44 inches long. This will allow Qimage to do its magic and print longer than the 44-inch limit. For Paper Source, choose Banner (Borderless) (circled in blue). Also be sure that you've got the right paper type and output resolution selected (for example, Enhanced Matte, 1440 DPI, etc.), and it's important to also set the Epson driver to No Color Management. In addition, set your printer driver to Centered if you have that option. See Tip 287 in Chapter 16 for a screen shot of the Windows printer driver in this configuration.

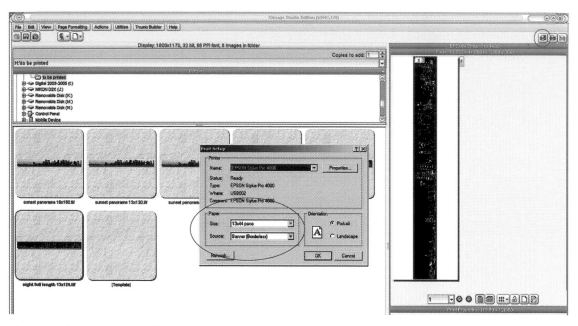

The Qimage layout screen with the Windows Printer Setup dialog box set up properly to make a 120×13-inch print using Qimage.

TIP 180 Select your monitor and printer profiles correctly.

Qimage offers three methods for printer color management, including the ability to use monitor profiles for color-managed screen viewing and printer profiles for specific papers (company-supplied or custom-made) just like you would use if printing from Photoshop or other profile-aware editing software. To select the correct monitor and printer profiles, click on the Mntr ICC and Prtr ICC arrows in the Job Properties window (circled in red in the screen shot at the top of page 321) and for each, select change profile. When the color management screen comes up for each, select the proper monitor profile for the monitor and the printer profile for the paper you're using (in our case, the printer profile is Epson 4000 Somerset PE Velvet).

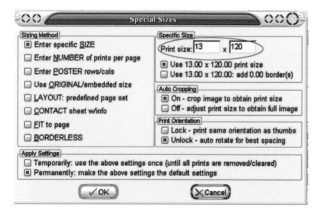

The Qimage color management screens with the monitor and printer profile arrows (used to select profiles) circled in red.

TIP 181 Set your print size to be equal to your paper width.

Under the Print Properties menu in Qimage, select Custom Image Size, which will open a Special Sizes menu. Use the Sizing Method that says Enter Specific Size. Enter your paper's width in the left-hand box and enter the panorama's full length in the right-hand box (circled in red). Make sure that Auto Cropping is set to on—this will evenly cut off any excess white space and center your image top to bottom on

The Special Sizes dialog box with the specified print size circled in red.

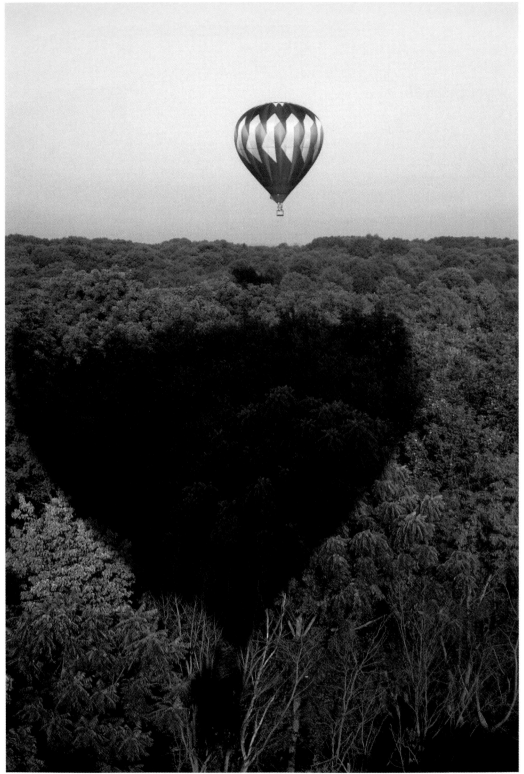

the paper. Print Orientation should be set to Unlock. Qimage will tell you that this may cause you to use multiple sheets—select Yes. Your page will show up now with the entire width shown as printable area.

TIP 182 Select your interpolation options and print.

Qimage has a wide range of built-in interpolation options to optimize print quality. The Qimage default with Epson printers is to interpolate to 360 PPI resolution, which works beautifully with images files up to about 200MB in size (including layers). The interpolation is done in the background during print spooling and will not change the size of your actual file. It's important to know that Windows has file size limits, and I've experienced system freezes when my spooled images exceeded 1GB. For example, a 240 PPI image 160 × 17 inches (448MB) will exceed 1GB if it's processed at 360 PPI in Qimage, which may cause a system crash. That being said, many others have had no problems spooling files over 1GB (even up to about 4GB in size), so the only way to know if you might experience a problem is to test it on your system.

On this topic, Mike Chaney, owner of Digital Domain Inc. and the author of Qimage offered this comment: "The most common limit that people run into is the limit on 'input' image size. Due to Windows memory limitations and other factors, the maximum file size that Qimage can handle for the input image itself is about 900MB. If your file exceeds about 900MB, Qimage may not be able to open the file to print it, and/or it may show an 'image read error' in the thumbnails." This limitation may, of course, change as operating systems are updated and Qimage updates are introduced.

To quickly determine what the size of the spooled file will be, create a new RGB document in Photoshop (File>New) and input your print's dimensions, with a resolution of either 180, 240, or 360 PPI. The file size will change as you change the resolution.

I generally set my very large panoramas to print at 180 PPI in the Job Properties dialog box (poster is where you select PPI for large prints, circled in red in the screen shot on page 324). I've printed samples from my panoramas at 180, 240, and 360, and with my nose virtually on the print, I could not see much difference between resolutions on the fine art papers I use. Qimage also lets you choose your interpolation mode. I've always used Hybrid, and with the newest version of Qimage, I've been using Hybrid SE. You are unlikely to see much difference unless you're taking a smaller image and enlarging it significantly when printing. That's when I've seen Hybrid SE really shine. As with most things related to inkjet printing, experiment to find the best combination of resolution and interpolation mode for your work.

Artist: Ed Nazarko; **Image title**: *Two Balloons*; **Print Size**: 12x18 inches; **Paper**: Arches Infinity Smooth 230gsm; **Printer Name**: Epson Stylus Pro 4000; **Ink Used:** Epson UltraChrome K2; **Software/Driver:** Qimage/Epson Driver (Windows XP); **Camera**: Nikon D2X; **Lens:** Nikkor 24-120VR; **F-stop:** f/8; **Exposure**: 1/60 sec.

The Job Properties dialog box with the poster option circled in red, and set to Max–360 PPI.

To print, choose File>Print as you would with any other printer. Many panoramas are a lot longer than the shelf that catches most prints, and large-format printers' cloth baskets can contribute to damaged prints as they exit the printer. To reduce the chance of damage to the surface of your prints, gently roll the paper from time to time to protect your print surfaces. With some papers, or when printing panoramas on rolls of aluminum, I put long folding tables in front of the printer and let the prints slide flat across the tables. It sounds like a little thing, but I've lost a 20-foot print due to a scuff across the surface—that's an $80 lesson that I'd rather not repeat any time soon!

Printing with the ColorBurst RIP

By Douglas Dubler 3

Douglas Dubler is a fashion, beauty, and fine art photographer based in New York. His commercial successes have been recognized by the industry with awards from Communication Arts, Art Directors Club, Starch report, and Clio, as well as the Silver Seagull Award from Oriental Photo in Japan. Dubler is an Epson Stylus Pro and has active consulting relationships with many digital imaging technology corporations. His fine art prints have been exhibited worldwide and are widely collected. For more information, visit www.douglasdubler3.com.

The ColorBurst X-Proof RIP from ColorBurst Systems (L12.3) is a Mac- and Windows-compatible software RIP that has improved my overall print quality. Epson's built-in driver does a great job without the need for a RIP, but for those who want to have more control and increase the overall quality of their prints, the ColorBurst RIP is an ideal choice. The following tips explain how I use the software to produce all of my black and white and color prints. There are also many step-by-step tutorials on ColorBurst System's web site, including explanations of how to use features like PrintCertification and ColorBurst's AutoSpot technology, which can be used to accurately reproduce many Pantone colors.

TIP 183 Choose the right version for your needs.

ColorBurst Systems makes RIP software for many pro-level inkjet and photo printers on the market (including printers over 100 inches in width). I use the ColorBurst X-Proof RIP with the Epson Stylus Pro 3800, 4800 and 9800 printers. For printers from 17 to 60 inches in width, the RIP varies in cost from about $500 to $2,700. Epson makes available a Professional Edition of their Stylus Pro printers (L12.4) that includes an Ethernet card and a version of ColorBurst's software for approximately $500 more than the cost of the printer alone, which is an excellent value. The Stylus Pro 3800 does not need an Ethernet card, so the additional cost of the Professional Edition RIP for that printer is about $200. The primary limitation of Epson's bundled version is the inability to create custom output profiles. However, ColorBurst provides a very comprehensive set of profiles for many printers and paper types, and new or updated output profiles are frequently added to the company's web site.

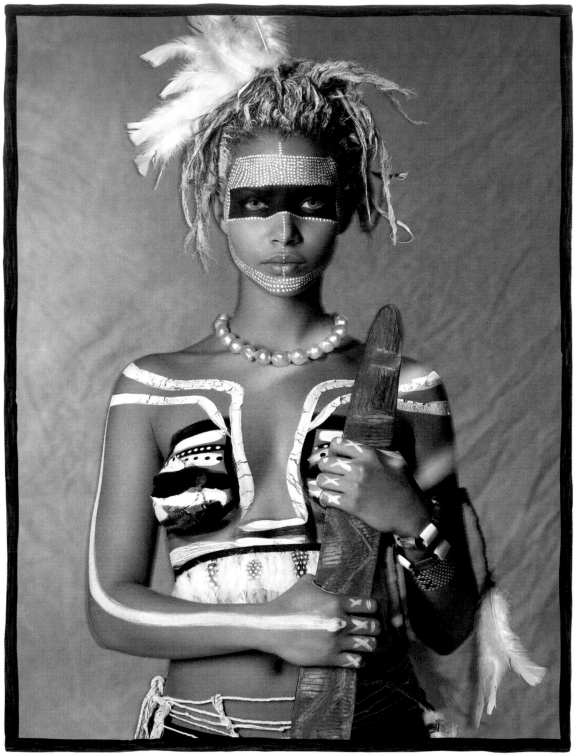

For more advanced users who plan to make custom profiles with the X-Proof RIP, ColorBurst allows you to "get under the hood" and set the total ink limit (to maximize Dmax without over-inking your printing surface). You can also adjust each ink individually through Channel Ink Limiting, including the light inks such as Light Magenta and Light Cyan.

TIP 184 Linearize for best results.

All versions of the RIP come with the built-in ability to make custom linearizations for virtually any paper or material. Although you can make superb prints just using the Epson driver (and no RIP or linearization), this procedure is important to achieve the highest quality and most consistent output over time. Before printing any linearization target, I do a head cleaning, and I also run an auto nozzle check to make sure that the machine is running properly.

After printing a linearization target, I measure it with an X-Rite DTP70 (L12.5) or X-Rite i1iSis (L12.6) automated spectrophotometer (other spectrophotometers are also supported). After creating a linearization file for a specific paper and printer, save it to the Linearization Files folder in the ColorBurst application folder on your hard drive. To apply the linearization file to any existing Environment file, choose Ink & Color from the main RIP Server window, then select the Linearization tab, and under Linearization File choose Open and select the correct linearization file for your printer and paper combination.

(Left) ColorBurst's Linearization tab, where options are set for printing and loading linearization targets. The area where a scanned linearization file can be loaded prior to printing with a ColorBurst supplied ICC output profile, or prior to creating and loading a custom output profile, is circled in red. (Right) A linearization chart inside ColorBurst's SpectralVision Pro software (accessed via the Linearization tab). The chart shown will be printed through the SpectralVision Pro software and, in this case, scanned with an X-Rite DTP70 spectrophotometer to generate the Linearization file.

Artist: Douglas Dubler 3; Image title: Aboriginie; Print Size: 24×30 inches; Paper: Epson Ultra Premium Photo Paper Luster; Printer Name: Epson Stylus Pro 9800; Ink Used: Epson UltraChrome K3; RIP: ColorBurst X-Proof RIP (Mac OSX); Camera: Mamiya RZ67 Pro II; Back: Leaf Valeo 22; Lens: Mamiya 210mm APO; F-stop: f/16; Exposure:1/125

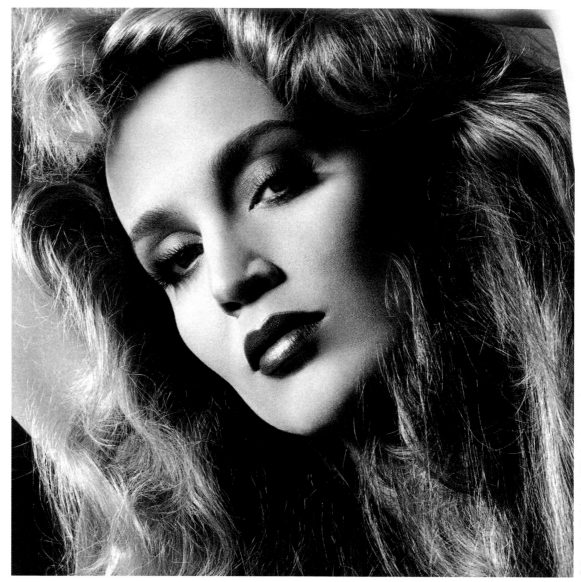

TIP 185 Make custom profiles with Environments.

Another important step in my workflow is the use of custom profiles. ColorBurst provides a number of built-in Environments for many printer and paper combinations. An Environment is a combination of settings that represents all the necessary information to print with a specific printer and paper. New Environments and individual output profiles for many printers and papers can be downloaded from ColorBurst's web site. If you have the bundled Professional version of the RIP from Epson, you would choose an appropriate Environment, choose your paper settings (primarily page size and roll or sheet) and then print. If you are making custom profiles, it's helpful to begin with a supplied Environment for your paper (or a similar paper). Then save a new Environment (under Environment>Save As). Then follow the steps for profiling and saving profiles on ColorBurst's support section of its web site (L12.7). I primarily use the 2989 patch target, accessed through ColorBurst's SpectralVision Pro software. I've found that ColorBurst's profiles work equally well with both grayscale and color images.

ColorBurst's SpectralVision Pro software has many options for printing custom profiling targets. This screen shot shows a target being set up for one or multiple A3 sized pages (11.7×16.5 inches) depending upon the number of patches chosen. In this case, the targets are set to be printed and then scanned on an X-Rite i1iSis Automated Patch Reader. Every spectrophotometer has different capabilities with regard to the paper size, patch size and number of patches that can be used.

Artist: Douglas Dubler 3; **Image title**: *Jerry Hall*; **Print Size**: 24x24 inches; **Paper**: Premier Art Velvet BW 300gsm; **Printer Name**: Epson Stylus Pro 9800; **Ink Used**: Epson UltraChrome K3; **RIP**: ColorBurst X-Proof (Mac OSX); **Camera**: Hasselblad 500ELX; **Film**: Kodak Plus-X; **Lens**: 180mm Sonnar APO; **F-stop**: f/11; **Exposure**:1/125

TIP 186 Enter the correct quality/paper settings.

ColorBurst's Printer Settings window (accessed by clicking on the Printer icon) allows you to set parameters including paper source (for example, front feed or rear feed, page size, roll or sheet, quality level, etc.). I generally use 4-Pass, with Bi-directional unchecked with the glossy and matte papers I use. Those papers include Epson Ultra Premium Photo Paper Luster (L12.8), Oriental Graphica Fiber Based Glossy Inkjet Paper (L12.9), Premier Art Velvet BW 300gsm (L12.10), and Epson UltraSmooth Fine Art Paper (L12.11).

ColorBurst's Printer Settings window, accessed via the Printer icon in the main ColorBurst RIP Server window.

TIP 187 Choose your input and output profiles.

I primarily use ProPhoto RGB as my RGB working space. To make sure that files embedded with a wide gamut RGB working space like ProPhoto RGB are handled properly, first choose the Ink & Color icon from the main RIP Server window and select Use Embedded Profiles under the Input Profiles tab (circled in red on page 332). Alternatively, you can copy your working space profile (if it is not already there) into the ICC Profiles folder inside the ColorBurst application folder and select it from the drop-down menu under RGB Image. Then close and reopen the ColorBurst application, or choose Rebuild Lists, located in the bottom-left area of the Input Profiles tab.

Artist: Douglas Dubler 3; **Image title**: *Puzzle Beauty*; **Print Size**: 24x30 inches; **Paper**: Oriental Graphica Fiber-Based Glossy; **Printer Name**: Epson Stylus Pro 9800; **Ink Used**: Epson UltraChrome K3; **RIP:** ColorBurst X-Proof (Mac OSX); **Camera**: Mamiya RZ67 Pro II; **Back**: Leaf Aptus 75; **Lens**: Mamiya 210mm APO; **F-stop:** f/11; **Exposure**:1/125

In version 5.1 of the ColorBurst X-Proof RIP, the company added Black Point Compensation to the ICC conversion for the Relative Colorimetric rendering intent, which means that choosing either Perceptual or Relative Colorimetric rendering next to the box that reads RGB Image (circled in green below) should result in properly color-managed output when using either custom or ColorBurst-supplied ICC output profiles. Under Output Profiles, a custom profile or ColorBurst-supplied profile should be selected. When you save an Environment, all the settings will "stick" so that you won't have to make any adjustments for future prints apart from your page size and related printer settings (as shown in Tip 186).

ColorBurst's Input Profiles tab under the Ink & Color Settings window.

TIP 188 Flatten file in Photoshop, save, and print.

Once your file is ready for printing, save it as a layered file (I use the Photoshop PSD file format), then flatten it, and save it as an RGB TIFF file with a new name. Other file formats, including PDF, PS, EPS and JPG can also be used, but for images, TIFF files (preferably 16 bits/channel) are the best choice in my opinion.

ColorBurst's RIP Server window contains a print queue that allows for total control over the way in which you send files to your printer. There are four ways to add files to the Job Manager for printing: by selecting File>Open; by dragging and dropping TIFF files into the Job List (my preferred method); by dropping files onto the Hot Folder located in the ColorBurst application folder; or by printing directly from an application. However, when printing files from applications to the ColorBurst RIP, any

embedded profiles are ignored. If you want to print from applications, you must select the Input Profile that matches the embedded working space of the file; the drop-down box to select it is under the words RGB Image in the Input Profiles tab under Ink & Color.

Also, if you decide to print from any application, be sure that under Page Setup in any application, your page size matches your file dimensions (not your final paper size—that is set in the RIP under the Printer Settings window described in Tip 186). A related tip when printing from any application is to create a custom page size that matches the dimensions of your file, but with margins set to 0 (no margins). Otherwise, any margins will be added to your file. That's why I recommend saving the file first and dropping it on the print queue.

An alias (on Mac) or shortcut (on Windows) of the hot folder can also be placed on the desktop or other location on your hard drive, which allows you to just drag and drop a file on top of the alias to add it to the print queue.

The ColorBurst RIP Server window with the Job List for jobs printing or on hold (circled in red), and the Done List for previously printed files (circled in blue).

Printing with the ImagePrint RIP

By Kirk Gittings

I've been using ImagePrint RIP by ColorByte Software (L12.12) for more than two years and find that it is a reliable and well thought-out solution to printing both black & white and color images. I specialize in both commercial and fine art photography, and ImagePrint's straightforward approach has made the printing process much more efficient. Many printer models are supported, from 13-inch-wide Epson printers to 44-inch-wide models from multiple manufacturers, and costs range from about $495 to $2,495. The following tips describe some of the RIP's features that make it indispensable in my studio with an Epson Stylus Pro 3800 and Epson Stylus Pro 7800. Many of these tips will also be applicable to other printers since the RIP is available for a wide range of inkjet printers, and versions are available for both Windows and Mac OSX.

Kirk Gittings is a lifelong resident of New Mexico; his photography has appeared on over 100 magazine covers and is represented in museum collections nationwide. He has been an instructor at The School of the Art Institute of Chicago, the University of New Mexico, the Santa Fe Workshops, and the *View Camera Magazine* workshops. He has received many prestigious awards, including a major NEA grant. He is a member of Polaroid's prestigious Artist Support Group, and he sits on Freestyle Photographic's Advisory Board of Photographic Professionals. *Shelter from the Storm*, a 30-year retrospective, was published in 2005. For more information, visit www.gittingsphoto.com.

TIP 189 Make sure your monitor is calibrated and profiled.

This should go without saying, but to achieve the ideal color and density reproduction of your work, you should purchase a good quality monitor and hardware device. I use two LaCie monitors (a Lacie Electron 22 Blue IV CRT and a LaCie 319 LCD [L12.13]), and I calibrate and profile both with the i1PRO with i1Match software from X-Rite (L12.14).

TIP 190 Prep your files for printing.

All the standard rules apply for preparing files for the ImagePrint RIP. I generally scan my transparencies and negatives (black and white or color) in 16-bit RGB using either an Imacon Flextight 949 (L12.15), Microtek ArtixScan 1800f (L12.16), or Epson V-750M Pro film scanner (L12.17). For grayscale or toned prints, each channel from my

Photographer: Kirk Gittings; **Image title**: *The Homestead, 2004*; **Print Size**: 11x14 inches; **Paper**: Epson Velvet Fine Art; **Printer Name**: Epson Stylus Pro 7800; **Ink Used**: Epson UltraChrome K3; **RIP**: ImagePrint RIP (Windows XP); **Camera**: Zone VI Field 4x5; **Film**: Ilford FP4; **Lens**: Schneider 210mm; **F-stop**: f/32; **Filter:** No. 16 yellow/orange; **Exposure**: 1 sec.

4 × 5 Black and White negative scans are examined in Photoshop (red, green, and blue channels), and the sharpest channel (with the least amount of noise) is usually then chosen. That channel is saved as a single grayscale TIFF file and kept in 16-bit mode for printing with ImagePrint's special *gray* profiles.

For both color and grayscale files, I use layers extensively for various corrections and effects, and ImagePrint handles my layered files without any problem, saving file prep time. Imageprint's interpolation capabilities are superb as well, allowing me to create sharpened files at the largest size I plan to print. ImagePrint will then downsize images behind the scenes when I want them smaller (while keeping them sharp), with no further file adjustments needed.

TIP 191 Use ImagePrint's layout window and print queue.

One of the best features of ImagePrint is the ability to treat your screen as a paste-up board for your files. Drag and drop individual files onto the layout window (set to the size of your paper), either from ImagePrint's integrated File Browser or from your computer's standard file system. On sheet paper, I often add promotional card

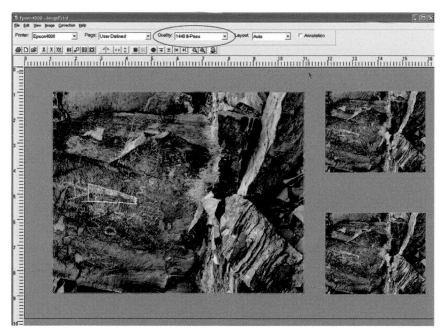

A screen shot of ImagePrint's page layout window with an 8×10-inch print and two cards placed to optimize the use of the space. The Print Quality box offers many different print quality options (speed will vary considerably depending upon what you choose). My standard setting, 1440 8-pass, is circled in red.
Photo © Kirk Gittings

Photographer: Kirk Gittings; **Image title**: *Entity, 2004*; **Print Size**: 11x14 inches; **Paper**: Epson Velvet Fine Art; **Printer Name**: Epson Stylus Pro 7800; **Ink Used**: Epson UltraChrome K3; **RIP**: ImagePrint (Windows XP); **Camera**; Zone VI Field 4x5; **Film**: Ilford FP4; **Lens**: Schneider 90mm Super Angulon; **F-stop**: f/32; **Filter**: No. 16 yellow/orange; **Exposure**: 1 sec.

images to areas of the page that are not being used. Another advantage is that at a later time, I can reprint the whole page just by selecting the print job from the finished print queue. ImagePrint also offers a range of other layout options, including package printing, step and repeat, crop marks, etc. With regard to output quality, I generally set the Quality box to 1440 8-pass.

TIP 192 Use ImagePrint's built-in profiles.

Another great advantage of ImagePrint's software is its built-in profiles. These are made specifically for use with the company's RIP, and the list of available profiles is extensive. I use their gray profiles (optimized for monochrome printing) for all of my black and white and toned prints, and I use their color profiles for my color work. When using the gray profiles, I use the tone picker to select a range of tones that approximate the look of prints I have been making in the darkroom for 36 years (see below). ImagePrint applies the toning for me, eliminating the need for me to create toned RGB files. This also allows me to print black and white images with consistent tones from print to print, which is important when producing a series.

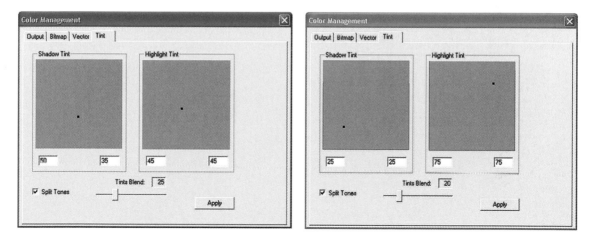

ImagePrint's tone picker with two of the most common tone adjustments I make when using ImagePrint's gray profiles. (Left) A mix that approximates the look of a cool selenium-toned print (similar to the toning shown in the full-page image entitled *Homestead* on page 334). (Right) A mix that approximates a warm-cool split tone (similar to the toning shown in the full-page image entitled *Entity* on page 336.

Photographer: Kirk Gittings; **Image title**: *The McOlash Residence by Westwork Architects, 2003;*
Print Size: 14×20 inches; **Paper:** Crane Museo Max; **Printer Name**: Epson Stylus Pro 3800;
Ink Used: Epson UltraChrome K3; **RIP:** ImagePrint (Windows XP); **Camera:** Calumet Wide Field with
6x9 roll film back; **Film**: Velvia 100F; **Lens:** Schneider 65mm XL; **F-stop:** f/22; **Exposure:** 45 sec.

TIP 193 Choose the right paper and consider the "Phatte Black" option.

I use my printer with ImagePrint to make prints for exhibitions as well as prints for commercial work (client proofs and portfolios). To achieve optimum density in the shadows (Dmax), I primarily use Epson Velvet Fine Art Paper (L12.18) and Crane Museo Max (L12.19), both of which hold a lot of ink. ImagePrint continually updates their library of profiles for gloss and matte papers, and the company makes them available to their customers via ftp download. I have also upgraded the ImagePrint license for the Phatte Black option. See Tip 105 in Chapter 8 for an explanation of ImagePrint's Phatte Black option.

Printing with the StudioPrint RIP

By Phil Bard

If you want a higher level of control over your printing process, I suggest using a software RIP. In my opinion, Ergosoft's StudioPrint (L12.20) is one of the best. It offers a variety of production-level tools and allows for greater control over the inking process compared with the standard printer drivers that ship with most printers. The tips that follow will cover just a few of the RIP's many features. The software is available for Windows only and ranges in price from about $900 for 17-inch-wide and smaller printers to about $2,400 for printers 44 inches wide and smaller. One license may also be used for multiple printers. I use the RIP with two printers and ink sets: an Epson Stylus Pro 7600 with Cone PiezoTone Selenium quadtone inks (L12.21), and an Epson Stylus Pro 9800 with Epson UltraChrome K3 color pigment inks.

A biographical sketch of Phil Bard can be found in Chapter 9.

TIP 194 Choose your layout, and print wide.

StudioPrint allows you to precisely position artwork on the paper, creating complex layouts mixing different images that can be saved to disk for later retrieval. StudioPrint also enables the printing of images longer than 90 inches wide, which is the limit for some large format printer drivers; this is an important function for printing large panoramics.

The main StudioPrint interface and layout window with a single image placed for printing.
Photo © Phil Bard

TIP 195 Linearize for optimum results.

StudioPrint allows for the *linearization* of the printer/inkset/paper combination. The procedure involves printing out a target and measuring it with a colorimeter or spectrophotometer. Using this information, StudioPrint determines the maximum quantity of ink the paper can handle before puddling takes place. It then establishes the correct distribution of densities for each ink along the tonal scale so that values in the print match the monitor. If you print with a variety of papers, you can linearize to each of them for ultimate control over your printing workflow. Additionally, if a paper batch should change, or if your printer alters its behavior over time, you can always re-linearize to bring the output back in line.

A printout of the StudioPrint linearization chart (half of the color channels are shown) for the Epson 7600 and PiezoTone inks. It was then measured with a Spectrophotometer to achieve an ideal tonal range.

TIP 196 Customize your inkset for monochrome printing.

For my own work and for the work I print for many of my clients, an important feature of this RIP is its ability to print with custom dedicated quadtone black inksets, which are used to create beautiful monochrome prints. StudioPrint will allow you to load the inks in any position in the cartridge array and specify the precise areas of the tonal scale where the individual inks print. This allows control over issues such as underprinting, which is the process of printing darker inks under lighter ones to build up higher densities. With variable dot size printers such as Epson's x800 series (for

Artist: Phil Bard; **Image Title**: *Corn Lily Trio*; **Print Sizes**: 11×14 to 24×30 inches; **Paper**: Hahnemühle Photo Rag, Museo Silver Rag; **Printer Name**: Epson Stylus Pro 7600/9800; **Ink Used:** Cone PiezoTone Selenium/Epson UltraChrome K3; **RIP**: StudioPrint (Windows XP); **Camera**: KB Canham 4x5; **Lens**: Schneider 210mm; **F-stop**: f/45; **Exposure**: 12 sec.

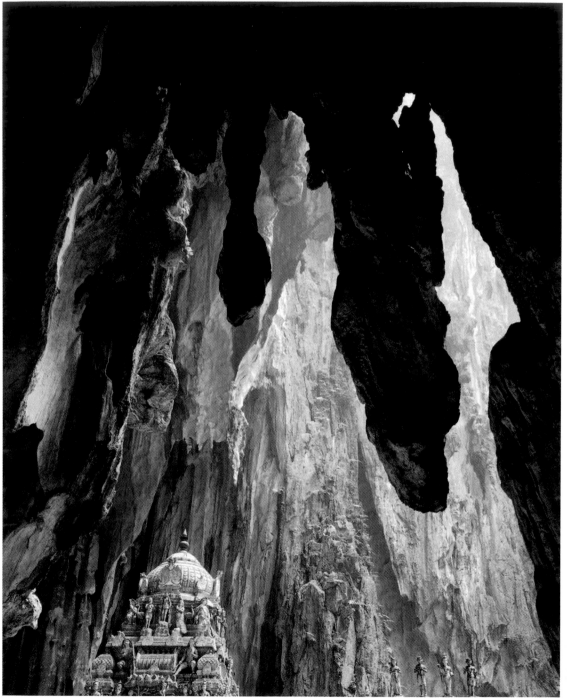

example, the Stylus Pro 3800, 4800, or 7800), you can change the dot size for different areas of tone, using larger ones for the deep blacks (higher Dmax) and smaller ones for highlights (fewer visible dots in the final print).

TIP 197 Find the right speed and dithering settings.

Instead of choosing the dithering pattern and print speed from within the standard driver, StudioPrint takes over the task of creating the dot that is printed. Different dot dithers are available, and different levels of quality can be selected in the printer software. The number of head passes and selection of uni- or bi-directional printing will determine the output speed and overall image quality. For color printing on the Stylus Pro 9800, I find that the following settings give me excellent prints at acceptable speeds: 1440 DPI, Stochastic 8-pass, Unidirectional, and Variable 2. Many people find that bi-directional printing is as good as uni-directional on the x800 series Epson printers, which have the added benefit of considerably faster print times.

In these two screen shots, StudioPrint's speed and dithering settings can be set to optimize speed and quality for specific projects. The Print Settings in this case are for the Epson Stylus Pro 7600 and Hahnemühle Photo Rag.

Artist: Phil Bard; Image Title: *Shrine in Batu Caves*; Print Size: 11×14 to 24×30 inches; Paper: Hahnemühle Photo Rag, Museo Silver Rag ; Printer Name: Epson Stylus Pro 7600/9800; Ink Used: Cone PiezoTone Selenium/Epson UltraChrome K3; RIP: StudioPrint (Windows XP); Camera: KB Canham 4x5; Lens: Schneider 120mm; F-stop: f/45; Exposure: 2 minutes

345

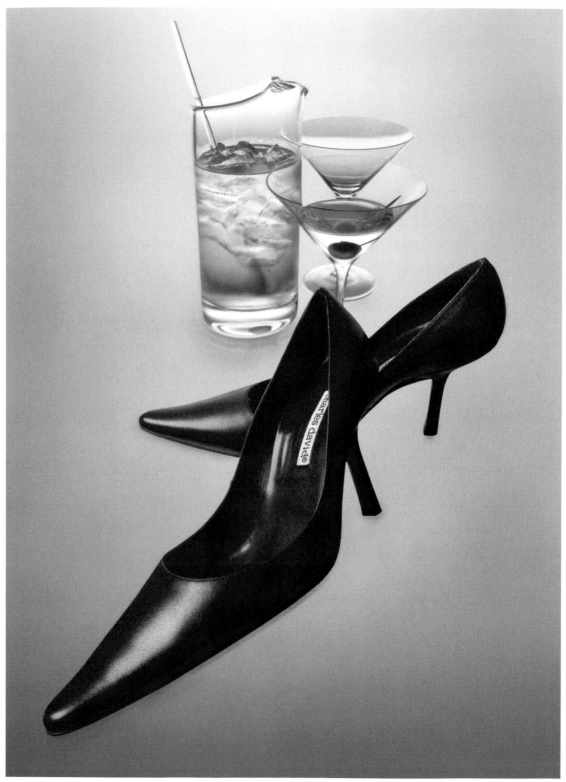

Using Inkjet Printers as CMYK Proofers

By Mark Rutherford

Mark Rutherford is an advertising and editorial photographer specializing in people and still life, with locations in New York and San Francisco. Since the mid-1990s, he has been investigating the burgeoning possibilities of an all-digital workflow. Mark is an Alpha tester for Adobe Systems, Inc., has written on the topics of digital photography and color management for *PC World* and other publications, and is widely sought after as a shooter and color management consultant. For more information, visit mrutherford.com.

About 10–15 years ago, the only quality press-proofing systems available cost tens of thousands (or even hundreds of thousands) of dollars. That made tabloid-sized proofs very expensive—often $100 or more for a single 12 × 18-inch proof. A press proof (or contract proof) can be defined as a hardcopy print used as a guide for judging color, density, sharpness, and the overall layout of a job prior to sending it to be printed on a printing press (usually a sheetfed or web CMYK offset printing press). In the past, multiple rounds of corrections meant multiple proofs, so the cost for proofing even a small advertising or printing project could be staggering. It's now becoming more common for ad agencies and commercial printing companies to utilize inkjet-based proofing systems as an integral part of their workflow. For the last seven years, I have been able to offer high quality CMYK color separations and press-accurate proofs to my clients, and in the tips below I'll cover the procedures I use to produce contract-grade CMYK proofs using affordable inkjet printers and media.

TIP 198 Choose your equipment; then calibrate and profile.

By calibrating and then profiling your display, you can present the colors within your images accurately and consistently; the best way to profile your display is to use a hardware based calibration/profiling system. To ensure consistent, accurate results with your printer, a different profile for each printer and paper combination should be created using printer calibration hardware. I've achieved consistent and accurate

Artist: Mark Rutherford; **Image Title**: *Martini Shoes*; **Print Sizes**: 8×10.5 inches; **Paper**: Epson Proofing Paper Commercial Semimatte; **Printer Name**: Epson Stylus Pro 4800; **Ink Used**: Epson UltraChrome K3; **Driver**: Standard Epson Driver (Mac OSX); **Camera**: Toyo 4x5 View Camera with a Jenoptik digital back; **Lens**: Rodenstock 120mm f/5.6; **F-stop:** f/22; **Exposure**: unrecorded

347

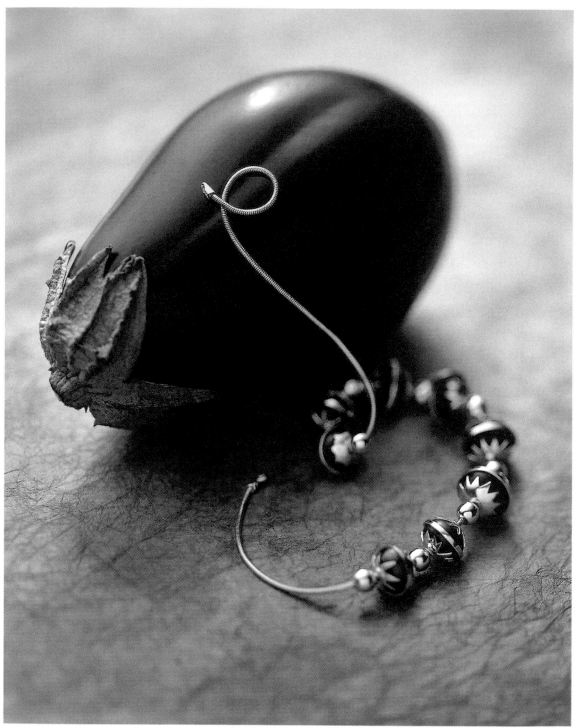

onscreen color by creating custom monitor profiles using the X-Rite Optix XR colorimeter (L12.22), and I've made many custom output profiles using the X-Rite Pulse handheld spectrophotometer (L12.23). I've also successfully used the i1PRO spectrophotometer with i1Match software from X-Rite for creating both monitor and output profiles.

I primarily use an Epson Stylus Pro 4800 (17 inches wide) and Epson Proofing Paper Commercial Semimatte (available in 13 × 19-inch sheets and multiple roll widths) to generate my CMYK proofs. I've also had firsthand experience working with an HP Designjet Z2100 printer (24-inch-wide version). The CMYK proofs that I made on the Z2100 with Epson Proofing Paper Commercial Semimatte after running the built-in linearization and calibration were visually spot-on compared with a Kodak Approval proof from a pre-press company. A number of other inkjet papers and printers from Canon, Epson, HP, and other companies are on the market, and are also capable of producing high quality proofs. You may have heard the terms SWOP certified or SWOP proofer. *SWOP* stands for Specifications for Web Offset Publications, and for more information about the organization, as well as how companies achieve SWOP certification, visit SWOP.org (L12.24).

Because many modern inkjet printers have a color gamut that exceeds most of the colors that can be achieved on a CMYK press, there are ways to proof many of the *spot colors* that fall within the gamuts of the press and inkjet printer. Spot colors are often specified in layout software as Pantone colors with a specific name or number (like PANTONE 164C, which is a very saturated orange solid coated Pantone color). For more on this topic, visit these web sites (L12.25).

TIP 199 Communicate with the printer and "proof to their proof."

If you can communicate with the printer who is handling your job, you will often have a much better chance of getting the type of output quality and color you want. One of the best situations you can have is to have a printer who not only prints their work consistently well on-press, but who also has a high quality proofing system that consistently matches their press within a few percentage points, without having to make special color adjustments on-press. If their proofing setup is good, you can then "proof to their proof."

Sometimes, the printing company will already have a recommended CMYK profile. Likely, it will be a profile of their proofing device using a specific paper, so you will be "proofing to their proof" without having to create your own profile. In that case, add the CMYK profile that they provide to your profiles folder and use it for converting to

Artist: Mark Rutherford; **Image Title**: *Eggplant*; **Print Sizes**: 8×10.5 inches; **Paper**: Epson Proofing Paper Commercial Semimatte; **Printer Name**: Epson Stylus Pro 4800; **Ink Used**: Epson UltraChrome K3; **Driver**: Standard Epson Driver (Mac OSX); **Camera**: Toyo 4x5 View Camera with a Jenoptik digital back; **Lens**: Rodenstock 120mm f/5.6; **F-stop**: f/22; **Exposure**: unrecorded

CMYK as described in Tip 200. If a custom profile is not provided by the printing company, ask for the *TAC* (Total Area Coverage) of their press for the actual stock on which the job will be printed, or if necessary, check their technical specs—they are often available online (especially for magazines). Most jobs will fall under either SWOP (TAC 280 to 300) or a Sheetfed standard (TAC 340 to 360). TAC (also called Total Ink Limit) is the maximum sum of the CMYK values that can safely be printed on the company's press with the paper they've chosen. The maximum possible TAC is 400.

Then choose an output CMYK profile for converting the RGB file based on the printer's preferred TAC (or other parameters). In this case, it will most likely be either U.S. Web Coated (SWOP) v2 or U.S. Sheetfed Coated v2. These and other CMYK profiles are included with Photoshop, and can be selected under Edit>Color Settings (Working Spaces: CMYK). The Total Ink Limit, as well as other parameters can be edited in Photoshop by choosing Custom CMYK from the CMYK Working Spaces drop-down menu.

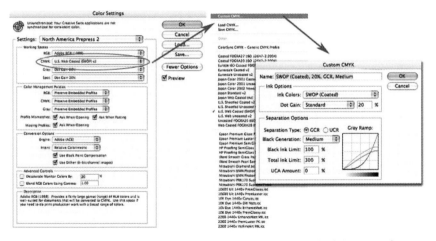

(Left) Photoshop's Color Settings dialog box with the CMYK Working Spaces area circled in red. (Right) Photoshop's Custom CMYK window, where specific parameters for converting to CMYK can be entered.

If the printing company has a consistent and reliable proofing system, I recommend sending them a CMYK profiling chart file (also called a target) and having them output the CMYK target on the same paper and proofing system that they would normally use to proof your job. Then scan the printed chart with a device like the i1PRO spectrophotometer and use the ICC output profile you create to soft proof your files. Though never perfect, soft proofing offers a preview of the press conditions on your display before you make a "hard proof" on the printer. If you weren't able to make a proof and create your own CMYK profile, you can soft proof with the printers' recommended CMYK profile, such as U.S. Web Coated (SWOP) v2. For more about soft proofing in Photoshop, see this step-by-step tutorial (L12.26).

Artist: Mark Rutherford; **Image Title**: *Orange on Green*; **Print Sizes**: 8×10.5 inches; **Paper**: Epson Proofing Paper Commercial Semimatte; **Printer Name**: Epson Stylus Pro 4800; **Ink Used**: Epson UltraChrome K3; **Driver**: Standard Epson Driver (Mac OSX); **Camera**: Toyo 4x5 View Camera with a Jenoptik digital back; **Lens**: Rodenstock 120mm; **F-stop**: f/22; **Exposure**: unrecorded

An adjustment layer can then be created in Photoshop to make adjustments to what you are seeing in the soft-proofed image. Because a CMYK printing press is more limited in its color gamut, you may see significant shifts in some colors (especially vibrant colors) in the soft-proofed image that cannot be "fixed" with one or more adjustment layers. However, you may be able to increase contrast or make other adjustments in specific colors that will improve the overall look of the image. The adjustment layer or layers you create can then be batch-applied to some or all of your RGB image files before converting them to CMYK and sending them to the printer.

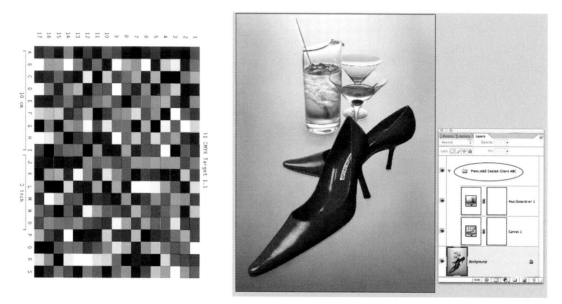

(Left) A CMYK target file included with X-Rite's i1Match software. (Right) After soft proofing using the CMYK profile created from the printer's proof, two adjustment layers were created to increase contrast and improve the look of the saturated pink color of the shoes before converting the file to CMYK.

TIP 200 Convert to CMYK and create your own proofs.

The goal we had from the beginning was to use our own inkjet printer as a contract proofer. If you received a custom profile from the printer, or if you created your own custom CMYK profile as described in Tip 199, you should now Convert to Profile in Photoshop (Edit>Convert to Profile), using that CMYK profile, which will convert the file from an RGB working space to a CMYK working space. Before converting to CMYK, be sure to save your RGB layered file. After converting to CMYK, you should make any additional color or tonal adjustments that you feel are necessary, and then

save the file with a new name with its CMYK profile embedded. In some cases, printing companies will require all CMYK files to be delivered with a specific CMYK working space embedded. In those cases, choose Convert to Profile and select that requested working space. If you are concerned that the printing company or design firm/ad agency might discard your embedded profile during the production cycle, it's safest to convert to one of the SWOP standards for North America—either U.S. Web Coated (SWOP) v.2 or U.S. Sheetfed Coated v.2, and then save the file with the profile embedded.

Many believe that it's a bad idea to print directly to most inkjet printers from a CMYK file using the printer's standard driver. However, by using Photoshop's color management options in conjunction with custom profiles and an Epson Stylus Pro 4800, I've proofed hundreds of jobs accurately. One of the most important steps that I take is to make sure that I have quality custom profiles for all my proofing papers (made using RGB profiling target files). To produce a CMYK proof in this way, choose File>Print with Preview (File>Print in Photoshop CS3) and select the RGB profile from the drop-down menu for the printer and paper you are using, just as you would if you were printing from an RGB file to a sheet of fine art paper. Then print with the same paper type and quality settings used for the profiling target, and make sure that No Color Adjustment is selected in the printer driver. Though I prefer to first convert from RGB to CMYK, another approach commonly used to create simulated CMYK proofs allows you to leave your files in RGB mode. Here are a few links to learn more about that proofing technique (L12.27).

The issue of paper choice is an important one when doing CMYK proofing. There are methods to add tone to the base of the paper when proofing, which can be helpful when proofing work destined for newspapers or other paper stocks that don't have a bright white base. Whenever possible, I recommend matching as closely as possible the proofing paper to the paper on which your job will be printed. Many printing houses doing annual reports and related advertising work use printing papers that have a bright white base, so a proofing paper like the one I primarily use (Epson Proofing Paper Commercial Semimatte) has proved to be a good choice. It's a good idea to keep two or three different proofing stocks on hand to handle a variety of different projects.

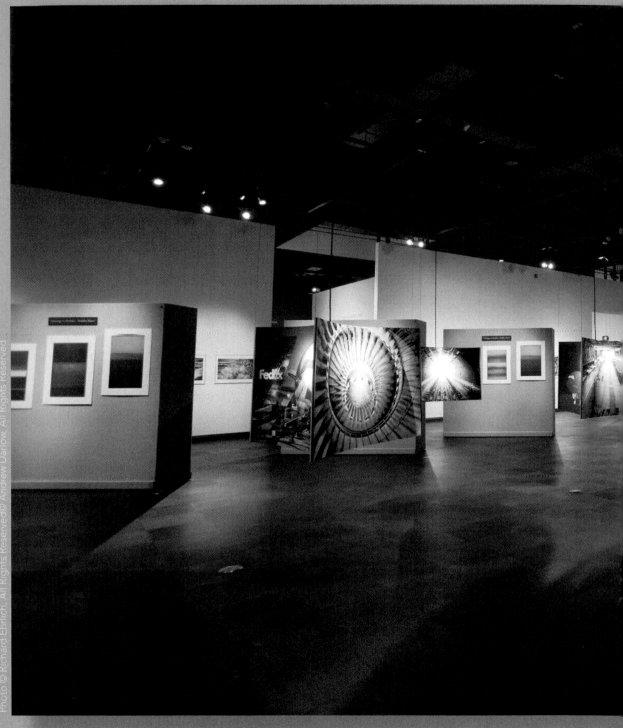

Tennessee State Museum Exhibition: *Richard Ehrlich & the Digital Image*

Exhibitions, Editioning, and Image Tracking

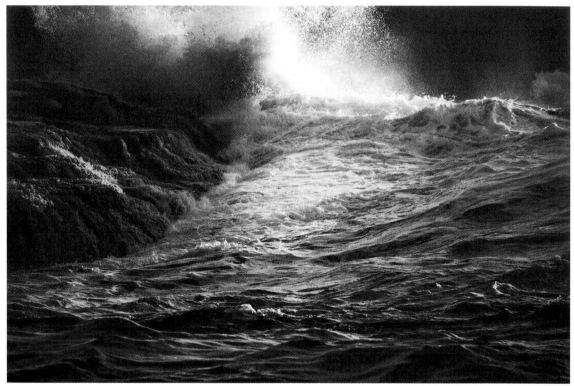

Exhibition Tips and Techniques

By Richard Ehrlich

There are many ways in which work can be displayed in galleries or other spaces. These tips apply primarily to one specific solo show in which a number of my images were exhibited from five distinct themes, photographed over a 15-year period.

See Chapter 11 for a biographical sketch of Richard Ehrlich.

TIP 201 Draw out your exhibition plan.

Prior to my show being hung at the Tennessee State Museum (L13.1), the Exhibitions Director, Philip Kreger, drew a few sketches to help plan the exhibit in terms of feasibility, logistics and general approach. By drawing out rough sketches, one can more easily see the relationship of the images in the space. A photograph of the space where your work will hang can also serve as a template for either drawing on or cutting and pasting photographs digitally into the "room." Having people in the sketches or photographs also helps to give the image scale.

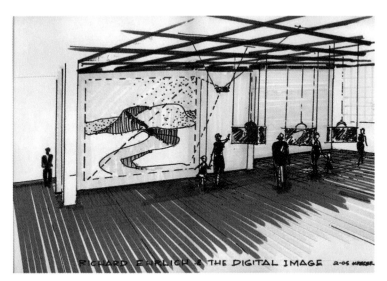

A sketch of Richard Ehrlich's solo exhibition by Philip Kreger.
Courtesy Philip Kreger, Exhibitions Director, Tennessee State Museum

To find the web links noted in the book (L13.1, etc.), visit www.inkjettips.com or http://www.courseptr.com/ptr_downloads.cfm .

Artist: Richard Ehrlich; Image title: *Plate OS2*; Print Sizes: 30×24 and 44×36 inches; Paper: Epson UltraSmooth Fine Art 500gsm; Printer Name: Epson Stylus Pro 9600; Ink Used: Epson UltraChrome K2; Driver: Standard Epson Driver (OSX); Camera: Canon EOS-1Ds; Lens: Canon EF 100-400mm f/4.5-5.6L IS; F-stop: f/5.6; Exposure: 1/4000 sec.

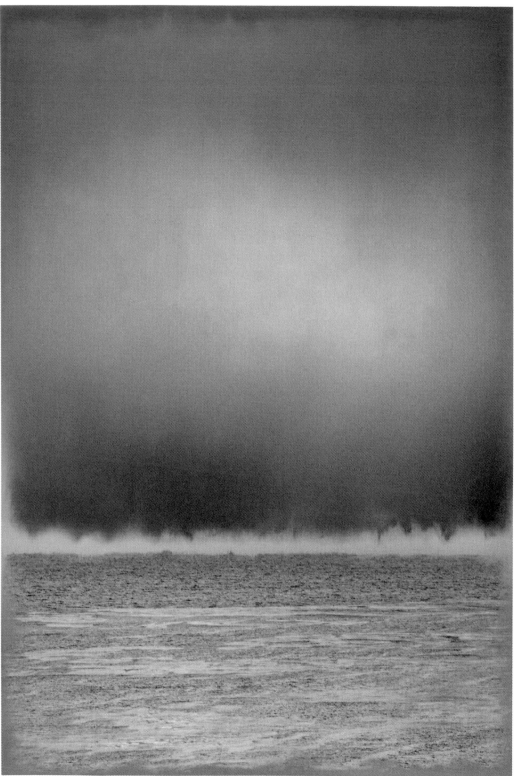

TIP 202 Photograph your exhibitions.

It's easy to forget to photograph your work hanging in a show, but it's something I highly recommend. Exhibition photographs can be used to send to prospective galleries, and they are also useful to submit with press releases during and after the show. I recommend taking photographs with people in them (especially at the opening) and also without people in them, and I also recommend having a few photographs taken of yourself in front of your work.

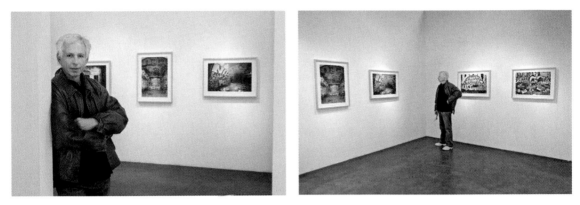

Richard Ehrlich, photographed in front of his exhibition entitled Graffiti: Belmont Park Los Angeles, at Craig Krull Gallery (L13.2), Santa Monica, California, 2005.
Photo © Andrew Darlow

TIP 203 Explore new print options.

If you have an opportunity to exhibit your work, think about the space in which it will be and consider producing prints that complement the space. Prior to the exhibition, I had an opportunity to photograph inside one of FedEx's Memphis, Tennessee, facilities. This led to a discussion about making large translucent prints of the images to complement both the high-tech feel of the work and the space in which they would be exhibited.

I thank Philip Kreger, Exhibitions Director at Tennessee State Museum and his associates at the museum for helping to bring this idea from concept to completion. Technical information for the translucent hanging pieces, shown in the sketch in Tip 201 and in the opening spread for this chapter follows: For each hanging set of backlit images, three separate prints were each sandwiched between two sheets of 1/16-inch optically clear acrylic. Each print was approximately 60 × 40 inches and was

Artist: Richard Ehrlich; Image title: *Plate HRMS10*; Print Size: 36×44 inches; Paper: Epson UltraSmooth Fine Art 500gsm; Printer Name: Epson Stylus Pro 9600; Ink Used: Epson UltraChrome K2; Driver: Standard Epson Driver (Mac OSX); Camera: Canon EOS-1Ds; Lens: Canon EF 100-400mm f/4.5-5.6L IS; F-stop: f/22; Exposure: 1/60 sec.

output on InteliCoat TSG-12 inkjet-compatible film (L13.3) using an HP Designjet 5500 printer with UV pigment inks (L13.4). Each triptych (set of three prints) was then fastened together under tension and compression (where the edges met) using a display material called Connectra. Connectra is an extruded spring steel tubing designed to accept 1/8- or 3/16-inch thick material (L13.5).

TIP 204 Consider alternative display options.

In addition to traditionally matted and framed prints, a number of prints in the exhibition at Tennessee State Museum were exhibited without a frame, glass or acrylic, as can be seen in the opening spread of this chapter. The matted prints are all approximately 30 × 40 inches in size, and are from the series *Homage to Rothko: Malibu Skies*, which I share credit for with R. Mac Holbert of Nash Editions. Each print was output on Epson UltraSmooth Fine Art 500gsm paper on an Epson Stylus Pro 9600. Each print was then matted, and a piece of 3/16-inch white foam was used as the backing material. Velcro brand fasteners (L13.7) were then attached to the backs of the foam boards and the walls. This approach makes the work more vulnerable to damage, but it creates a very strong statement because no glass or acrylic gets between the viewer and the prints.

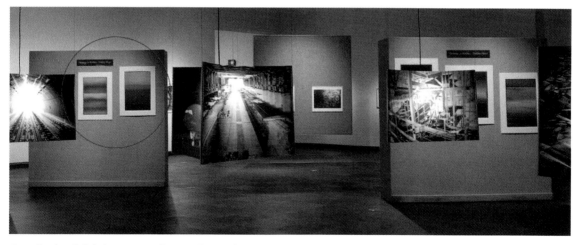

Two of Richard Ehrlich's 30×40-inch matted prints from the series *Homage to Rothko: Malibu Skies* are circled in red. Photo © Richard Ehrlich

Organizing, Tracking, and Documenting Limited Editions

By Amadou Diallo

As a fine art photographer, I need to keep track of edition numbers, artist proofs, print materials, and of course, sales for every image I exhibit. A number of digital asset management (DAM) software programs can be used for this. My choice for the last few years has been Extensis Portfolio (L13.8). In these tips, I will show you some of the ways in which I use this software to organize my fine art images into meaningful categories, store and retrieve critical data about them, and search for images based on custom data fields and keywords.

Amadou Diallo is a fine art photographer and a digital imaging consultant, and he is the author of *Mastering Digital Black and White* (Thomson Course PTR, 2007). Diallo's prints have been exhibited in galleries across the country, and his work has been published in books and magazines. He is the owner of Diallo Photography, a digital printmaking studio specializing in editions for visual artists. For more information, visit www.diallophotography.com.

TIP 205 Import your images.

Extensis Portfolio, like other DAM solutions is fundamentally a database application. So, in order to do anything with images, they must first be imported into a Portfolio catalog. During this import process, Portfolio reads the existing image metadata and creates thumbnail previews (there are a number of preferences available for thumbnails, including size and quality). By default, Portfolio is not copying or duplicating my images during import. It is merely copying metadata contained in the files and creating aliases that point to each image file.

Subsequent changes or additions made to image metadata in Portfolio are written not to the image file, but to the catalog's database. This has many benefits. Because Portfolio has created a link (or reference to the physical file) on my hard drive or other media, I no longer have to open an image to read, or even add, metadata. Once the image has been cataloged, the actual image file does not have to remain online. Because of this, a single item in the Portfolio catalog takes up a tiny fraction of disk space compared with the image file it references. This is a huge time-saver since most of my files exceed 200MB.

TIP 206 Organize your images.

By importing files into Portfolio or a similar application, a catalog window can be displayed showing all imported images regardless of how they are organized on a hard drive. To find an image (even if it is nested in a series of folders), just scroll through the window of the imported disk, instead of opening and closing various folders like you would on a Mac or Windows desktop. Of course, scrolling through hundreds or thousands of image thumbnails is not very efficient; Portfolio allows you to create galleries, which are user-defined subsets of the entire catalog.

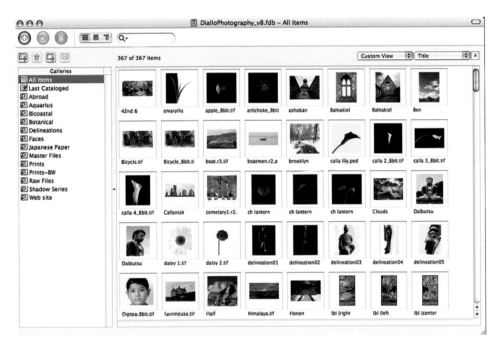

Amadou Diallo's main Extensis Portfolio catalog window.
Photos © Amadou Diallo

TIP 207 Create galleries for specific projects.

The fine art images I create are conceived as parts of thematic projects, or series of photographs, so I usually want to view images grouped by project. Orchid #5 is part of an ongoing botanical portfolio. By creating a gallery named *Botanical*, I can view every image that comprises this project, without being distracted by other images (for example, architecture or landscapes).

Artist: Amadou Diallo; **Image title**: *Orchid #5*; **Print Sizes**: 27.25×42 inches; **Paper**: Innova Cold Press Art 315gsm; **Printer Name**: Epson Stylus Pro 9600; **Ink Used**: PiezoTone Selenium/Sepia blend; **RIP**: StudioPrint RIP (Windows XP); **Camera**: Wista 4×5 view camera; **Lens**: Rodenstock APO Sironar N 150/5.6; **Film**: Polaroid 55P/N; **F-stop**: f/16; **Exposure**: 2 sec.

Portfolio's ability to create and apply custom keywords makes gallery creation a fairly simple process. To do this, begin by displaying a group of images in the main catalog window that have botanical images. Then select and assign all of the images belonging to this series the keyword *Botanical*. Then create a "Smart Gallery" that automatically performs a keyword search for *Botanical* and that displays the matching images. Smart Galleries are dynamic, meaning that as the keyword *Botanical* is applied to additional images in the catalog, they too will automatically appear in this gallery. Keywords can be applied one image at a time, or batch-applied to any number of images in the catalog. I have one Smart Gallery named "Web site" that displays all the images ever published on my web site. It does this by looking at the Web Posting Date field (a custom field) and then returns any items that have text in that field.

TIP 208 Create custom fields and use online resources.

Custom fields (accessible under Catalog>Custom Fields) allow you to make your own metadata labels. For example, you can create a custom field called Paper. In that field, you can enter a number of paper types by choosing "Use predefined list of values" when creating the custom field so that when you make a print or do a search, you can choose from that list of papers. Another example would be to create a field to track the number of prints sold for a single image. To do that, create a new custom field named Prints Sold. Then select "Number" as the field definition (see screen shot). A number field allows you to use math in subsequent searches. For example, you can search not only for all images that have 6 sales, but all images that have greater than 6 sales or less than 6 sales.

The Extensis Portfolio Custom Fields dialog box showing the range of customization that is possible.

The Extensis web site (L13.8) has many tutorials and documents (including movies) to walk you through how to create and edit custom fields, as well as how to use the program's many other features. Other DAM software companies have made similar resources available. Forums run by companies, media outlets and individuals can also be invaluable for getting answers from other users, as well as from company representatives (L13.9)

TIP 209 Create Smart Galleries to help with searches.

In the screen shot below, I've created a Smart Gallery, which when selected, searches the catalog and displays only the images that I've printed on a specific Japanese Mulberry paper. By creating Smart Galleries to match common search queries, you can greatly reduce the need to manually search for images. Just click on the Smart Gallery title (circled in red) to view the thumbnails of the images in the gallery. Then choose the image(s) you want. Of course, if an image you want is off-line, you will need to access the hard drive or other media where the high-resolution file is stored to open and edit the actual file. Custom field options, such as the one for Paper can also be edited, as shown below (circled in blue).

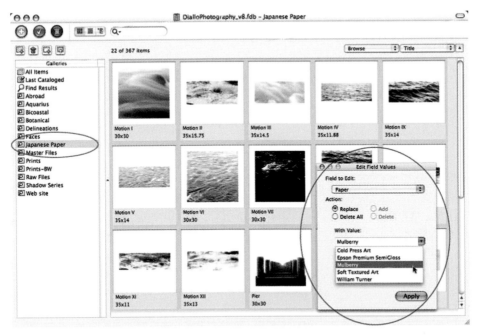

A list of all galleries, including Smart Galleries can be seen along the left column. The Edit Field Values dialog box with the Paper custom field and various paper options. Instructions for how those paper choices were created can be found in the previous tip.
Photos © Amadou Diallo

365

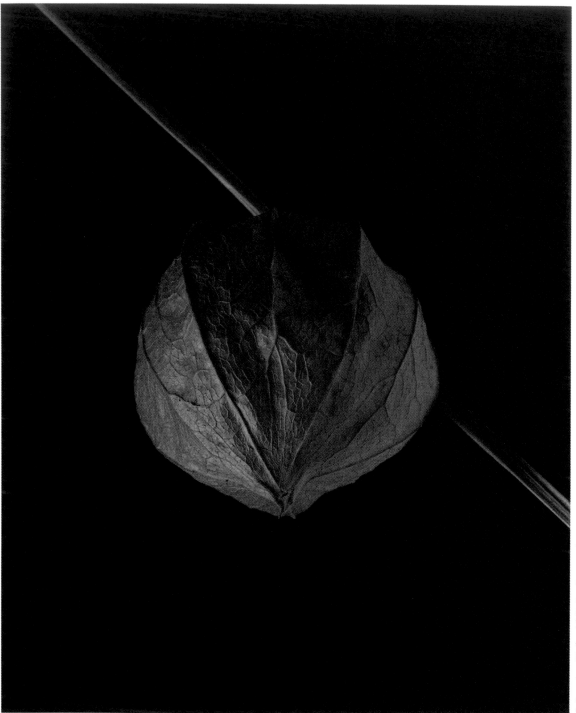

TIP 210 Choose additional custom fields.

No two photographers have the exact same requirements. That's why the ability to create custom data fields helps to establish a tracking and documentation workflow. Some of the other custom fields I use are Image Size, Mat Size, Retail Price, Edition, Print Inventory, Medium, and Buyers. The Buyers field is used for the name and specific print that collectors purchased (for example, 1/15: John Doe from Gallery A). As this information changes over time, the appropriate fields can be easily created. This may seem like a lot of work, but in practice, images can be retrieved faster because of this system, and professional, accurate print documentation can be output for every buyer.

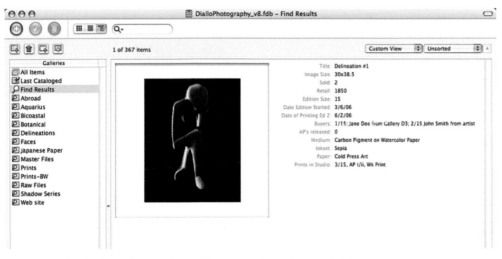

A single thumbnail selected inside of Portfolio with a number of custom fields showing.
Photo © Amadou Diallo

TIP 211 Document limited editions correctly.

Any photographer producing limited editions of his work is essentially selling his trustworthiness with each print. One of the early barriers to acceptance in the fine art market was that a photograph could be mechanically reproduced with no loss of quality. There was no inherent barrier to prevent the abuse of edition sizes. One could simply print a negative over and over, with the last print being as high quality as the first. The rise of digital output has revived this debate since multiple, indistinguishable copies of a film scan or camera file can be produced. Destroying the negative to prevent future prints being made is not an option for the digital

Artist: Amadou Diallo; **Image title**: *Chinese Lantern #1*; **Print Sizes**: 12.5×12.5 inches; **Paper**: Kozo (Japanese Mulberry); **Printer Name**: Epson Stylus Pro 9600; **Ink Used**: PiezoTone Selenium/Sepia blend; **RIP**: StudioPrint RIP (Windows XP); **Camera**: Calumet 4×5 view camera; **Lens**: Rodenstock APO Sironar N 150/5.6; **Film**: Kodak TMAX 100; **F-stop**: f/22; **Exposure**: 1 sec.

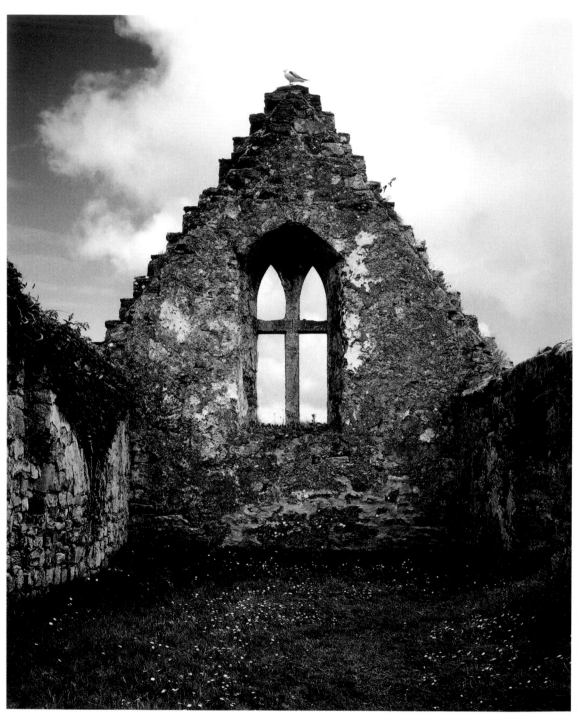

photographer. Simply put, the buyer must trust that you will honor the stated size of the edition. Most collectors would prefer to own print 1 out of 20 instead of print 1 out of 5 million. That is the purpose of a limited edition—to increase the perceived value of a print by guaranteeing a limited production.

One of Amadou Diallo's limited edition print documentation certificates (L13.10).
Courtesy Amadou Diallo

editions@Diallo Photography
347.231.6652 • editions@diallophotography.com • www.diallophotography.com

PRINT DOCUMENTATION

ARTIST Amadou Diallo

IMAGE SIZE 35 x 14 inches

TITLE Rock and Water #4

SHEET SIZE 38 x 17 inches

DATE OF PRINTING July 1, 2002

PAPER Mulberry (Kozo)

EDITION 1/15

MATERIALS Carbon Pigment ink on acid-free paper

DATE OF EDITION July 1, 2002

PROOFS AP i/ii

ADDITIONAL INFORMATION Photographed in June 2002, Big Sur California; ©2002 Amadou Diallo. All rights reserved. Artwork may not be reproduced for resale.

This image was printed by editions@Diallo Photography, in New York City, to the highest standards of image quality and permanence. As with all paper-based artwork, proper care and handling will ensure image stability. We recommend displaying prints under glass or acrylic, with limited exposure to UV rays and direct sunlight.

We assert that the supplied information regarding edition size and number of proofs, accurately accounts for all prints produced in our studio.

Printer _____ Date 8/5/02

Artist: Amadou Diallo; **Image title**: *Balnakeil Church Ruins*; **Print Sizes**: 16×40.75 inches; **Paper**: Hahnemühle William Turner; **Printer Name**: Epson Stylus Pro 9600; **Ink Used**: PiezoTone Selenium/Sepia blend; **RIP**: StudioPrint RIP (Windows XP); **Camera**: Wista 4×5 view camera; **Lens**: Rodenstock APO Sironar N 150/5.6; **Film**: Fuji Provia; **F-stop**: f/22; **Exposure**: 1/8 sec.

TIP 212 Check the laws for limited editions in your place of business.

It is important that aspects of the creation and print process be clearly documented. This demonstrates to the buyer that you understand the responsibility of properly maintaining an edition. Even more importantly, it keeps you in accordance with legal requirements. New York State law (L13.11) requires that the seller of a limited edition work disclose the size of the edition, the materials used in production of the image, the date of the individual print, and consent of the artist that an edition has been authorized. Notification may also be required when artist proofs or unnumbered multiples of the same image exceed 10% of the total size of the edition.

I strongly urge you to consult a professional with regard to the laws of your state, province and/or country. All necessary information about the edition should be included either on the bill of sale, or preferably on a separate Certificate of Authenticity provided to the purchaser at the time of sale. Keeping accurate information about your editions puts buyers at ease and helps to maintain good relationships with galleries.

File Naming, Image Tracking, and Backup

By Derek Cooper

Keeping scans and digital captures properly named, organized and archived is very important, regardless of how many images and clients you may have. The following tips cover these issues and will hopefully help you to move images more efficiently through your workflow from capture to print.

See Chapter 10 for a biographical sketch of Derek Cooper.

TIP 213 Name folders and files consistently throughout the process.

I recommend setting up separate folders for each client and then saving all master files in those folders. Each file should be saved as a layered file (PSD format is ideal) with properly labeled layers to simplify the process of editing the file at a later date. I have a separate folder on my hard drive for prepping my files from capture, to editing, to final master layered file. Only fully edited and artist-approved versions get saved to the master file folder on my servers. The RAW captures and most intermediate files are also archived, but in different folders. Files are given the name of the artwork to simplify the process of locating files.

TIP 214 Use Adobe Bridge to add image information...and consider other applications.

Adobe Bridge (part of the Photoshop Creative Suite, L13.12) allows you to record all relevant data about a photo, and its browser is also very good for viewing image thumbnails at many different sizes.

In addition to the standard EXIF data that is automatically created by digital cameras, I add descriptive text in various fields under the Metadata tab in Adobe Bridge (under IPTC Core, and shown on page 373 under the areas circled in blue and red). Under Description Writer, I add the company that wrote the keywords for me

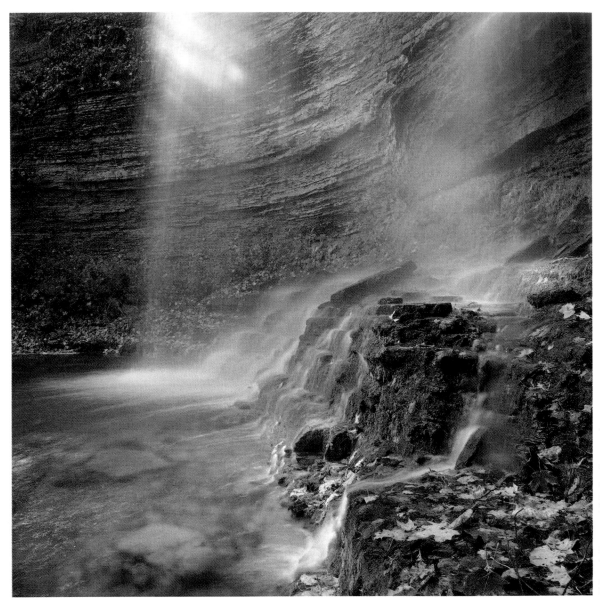

(L13.13). The Instructions field is used for my stock agency name and image ID, property and model release reference numbers, print size, and media type (such as a brand of paper). For art reproduction work, the type of original artwork (acrylic on canvas, oil on panel, etc.), and size of the original piece are also added to that field. If we're doing limited edition runs for clients and producing certificates of authenticity, that information is tracked and updated under the Job Identifier field after each new print is made. There are a number of ways to save metadata and batch apply text to make the process go more quickly. Metadata can also be searched from within Adobe Bridge.

A screen shot from Adobe Bridge showing a folder with Derek Cooper's images. Some IPTC Core metadata has been inserted under the Metadata tab (circled in red). The inset on the right shows a section of artist Stephanie Ryan's folder of images in Adobe Bridge. Metadata has been inserted under IPTC Core under the Metadata tab (circled in blue). Photos © Derek Cooper, Inset images © Stephanie Ryan

Artist: Derek Cooper; **Image title**: *Prince Edward County–Jackson Falls*; **Print Size**: 20×20 inches; **Paper**: Hahnemühle William Turner 310; **Printer Name**: Canon imagePROGRAF iPF8000; **Ink Used:** Canon LUCIA; **Driver:** Standard Canon Driver (Mac OSX); **Camera**: Contax 645; **Back**: Hasselblad Ixpress 384; **Lens**: 80mm f/2 Planar; **F-stop and Exposure**: unrecorded

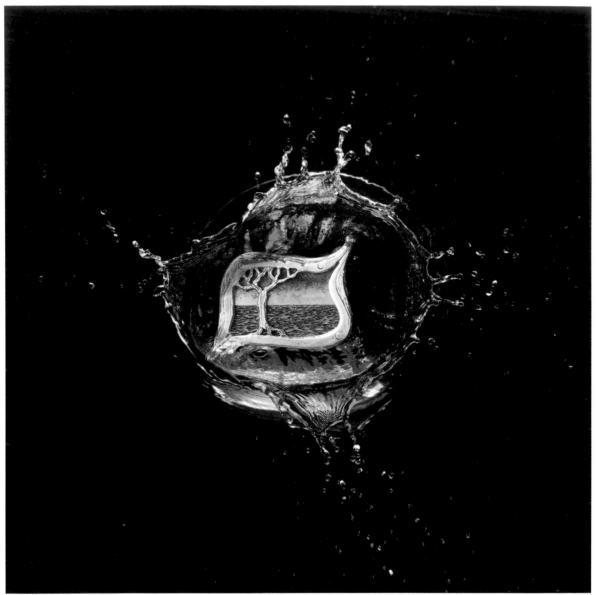

It's good for photographers and other artists to know that they can track their work and set up a reliable system in Photoshop with Adobe Bridge without having to purchase another piece of software. However, it's important to note that Adobe Bridge allows you to browse thumbnails that represent the images on your hard drive (or other media), but it does not create a catalog, and it does not allow the viewing of images or metadata when the source files are unavailable. For that type of asset management application, you might consider Adobe Photoshop Lightroom (L13.14), Apple Aperture (L13.15), Extensis Portfolio (L13.16) or FileMaker Pro (L13.17).

We've considered all of these applications (and others), but we've found that for now, using the IPTC fields built into each image centralizes all the information and serves our needs. IPTC fields aren't as customizable, but the data can always be exported out to another Digital Asset Management program if we decide to implement another system in the future.

TIP 215 Have a good data backup plan.

If you're going to spend hours working on images, then you should definitely back up your data. Hard drives crash, theft is a reality, and fire is a definite possibility. Imagine your predicament if you had to phone all of the clients you've ever had, telling them you've lost their master images of paintings they've long since sold. In the studio, we use an Apple Xserve G5 (L13.18) as our primary server for all of our work. Images from all the Macs in the studio are saved to the central server over hardwired Category 6 Ethernet cables (L13.19) for access from any of the other workstations.

There are three primary workstations: one for retouching, another for printing, and the third for digital capture. Every night, an AppleScript (L13.20) runs on the server and looks in specified folders for new or changed content on the local drives, and incrementally backs up that data to one of a series of fully redundant 2-terabyte RAID 5-disk arrays (L13.21). Once a month, data is then burned to DVD-Rs and stored off site. In any 24-hour period, there are at least two copies of every image in our database. Only working files are saved on the local workstations in the studio.

Artist: Derek Cooper; **Image title**: *Splash*; **Print Size**: 18×24 inches; **Paper**: Hahnemühle William Turner 310; **Printer Name**: Epson Stylus Pro 9800; **Ink Used**: Epson K3; **Driver**: Standard Epson Driver (Mac OSX); **Camera**: Contax 645; **Back**: Hasselblad Ixpress 384; **Lens**: 80mm f/2 Planar; **F-stop and Exposure**: unrecorded

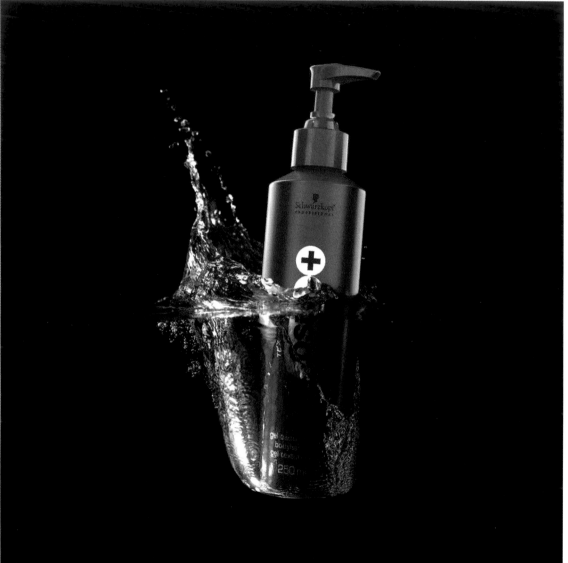

TIP 216 Build a public and/or private web site.

A web site can help to promote your work, or just make it easy to quickly track images when you are in your studio or away from your main image archive. In our case, we have created a public web site (L13.22) where our clients' work is featured (with their approval, of course). Having this online reference simplifies the ordering process for both the artist and for collectors interested in making print purchases.

(Left) A portion of the index page for the public artist galleries on the ReproducingArt.com web site. The galleries feature many of the artists whose works have been printed by the company.
Images © The respective artists (Neil Aird, Paul Cadieux, Barb Carr, and Sally Chupick).

Artist Stephanie Ryan's gallery on the same web site.
Images © Stephanie Ryan

Artist: Derek Cooper; **Image title**: *Osis Gel*; **Print Size**: 20×20 inches; **Paper**: Hahnemühle William Turner 310; **Printer Name**: Canon imagePROGRAF iPF8000; **Ink Used**: Canon LUCIA; **Driver**: Standard Canon Driver (Mac OSX); **Camera**: Contax 645; **Back**: Hasselblad Ixpress 384; **Lens**: 80mm f/2 Planar; **F-stop and Exposure**: unrecorded

Artist: Linda LaSala; **Image title**: *Amsterdam*; **Print Size**: 24×16 inches; **Paper**: Hahnemühle Fine Art Pearl; **Printer Name**: Epson Stylus Pro 7800; **Ink Used**: Epson UltraChrome K3; **Driver**: Epson Standard Driver (Windows XP); **Camera**: Canon EOS-1Ds Mark II **Lens**: Canon EF 70-300mm f/4-5/6 IS; **F-stop**: f/16; **Exposure**: 20 sec.

Packing, Lighting, and Framing

Lighting for Exhibitions and Proofing

By Douglas Dubler 3

Proofing your work under appropriate lighting is as important as calibrating and profiling your monitors and printers. And lighting an exhibition with the right type and combination of bulbs is another critical part of any gallery presentation. The following tips are designed to help with both the proofing and presentation aspects of commercial and fine art photography.

See Chapter 12 for a biographical sketch of Douglas Dubler.

TIP 217 Choose a high quality viewing system.

A high quality viewing system like those made by GTI Graphic Technology (L14.1) is, in my opinion, necessary to achieve a consistent level of print quality. Because I have a large archive of transparencies, I like the flexibility that the GTI SOFV-1e gives me. I can switch from transmissive lighting (primarily for viewing transparencies) to reflective lighting quickly, or I can use a combination of both, and the intensity of the light can be adjusted in very precise increments. The system's D50 light (5000 degrees Kelvin) is excellent for judging monochrome and color images, and it's ideal for viewing proofs that will be sent to magazines and book publishers. For larger prints, I use a large overhead Luminaire GTI lighting system (L14.2).

To find the web links noted in the book (L14.1, etc.), visit www.inkjettips.com or http://www.courseptr.com/ptr_downloads.cfm.

Photographer: Douglas Dubler 3; **Image title**: *Fire and Ice*; **Print Size**: 24×24 inches; **Paper**: Epson Ultra Premium Photo Paper Luster; **Printer Name**: Epson Stylus Pro 9800; **Ink Used**: Epson UltraChrome K3; **RIP**: ColorBurst X-Proof (Mac OSX); **Camera**: Hasselblad 500ELX; **Film**: Fuji RDP (transparency); **Lens**: Hasselblad 180mm f/4; **F-stop**: f/11; **Exposure**: 1/125 sec.

(Left) Douglas Dubler's GTI SOFV-1e viewing system in reflective mode with three profiling target charts, output through the SpectralVision Pro software accessible from within the ColorBurst X-Proof RIP. (Right) The digital readout of the SOFV-1e, showing the current intensity level of the transmissive and reflective light.
Photos © Andrew Darlow

TIP 218 Choose the right bulbs for your home, studio, or exhibitions.

There are many bulbs on the market that can be used to illuminate art. For years, I've been using SoLux bulbs (L14.3) because I believe that they offer the best combination of features. Many galleries and museums use SoLux bulbs due to their high Color Rendering Index (CRI) and low UV output. They are also a good option for highlighting artwork on the walls of homes, offices, or studios.

Most bulb manufacturers offer a range of color temperatures and beam spreads (measured in degrees). SoLux offers 35 or 50 Watt MR-16 (2 pin socket) bulbs in color temps from 3500 to 5000 degrees Kelvin with four beamspreads. I usually choose the

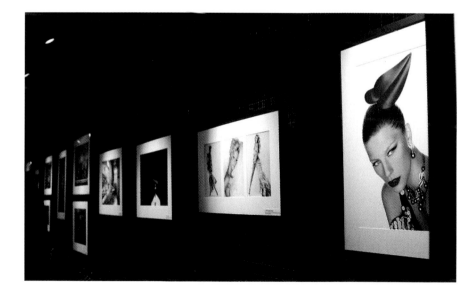

SoLux 50 watt bulbs (4100K, with a 36-degree beamspread) are shown here in the upper-left part of this photo, illuminating four of Douglas Dubler's photographs at an Epson-sponsored event.
Photo © Andrew Darlow

4100K bulbs because the 5000K bulbs often appear too blue on a white gallery wall. One way to find the right combination of bulbs for an exhibition or other use is to buy a few bulbs with different color temperatures and beamspreads, then test them on a few different print sizes wherever your work will be hanging. I recently tested 16 different bulbs for a show, and based on the space, as well as the distance from the bulbs to the art, I decided to primarily use the SoLux Black Back 50 Watt 4100K/17 degree "Spot" bulbs to light a show comprised mainly of 24 × 30 inch-prints. The black back option is relatively new and eliminates stray light coming out the back. SoLux also offers many fixtures for their bulbs, which can be found on the company's web site.

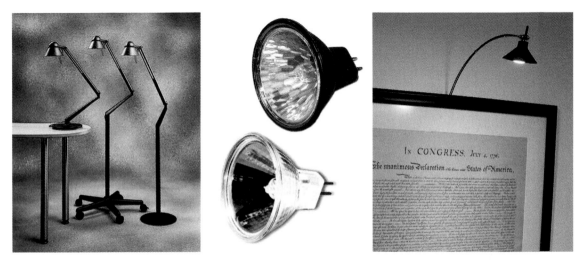

(Left) Three SoLux Task Lamps (L14.4). All ship with a SoLux 4700K 50 watt bulb, and are an excellent choice for viewing prints. The Task Lamps also come with a clamp-on bracket. (Center) A SoLux Black Back bulb is shown above, and a SoLux standard bulb is shown below. (Right) A SoLux Art Light (L14.5) illuminating a piece of art. Each Art Light ships with a SoLux Black Back 50 Watt 3500K/36 degree bulb.
Photos courtesy Tailored Lighting Inc.

Protecting, Framing, and Packing Your Work

By Linda LaSala

C reating inkjet prints of your work is a very important step, but in many cases, it's just the beginning of a process that includes matting, mounting and/or framing. The following tips cover a number of topics, including framing suggestions, how to reduce "outgassing," and how to help reduce the chance of damage when your artwork is shipped. And as noted in the section below, many of the tips and techniques are courtesy of a custom framer that I've been using for years.

For as long as she can remember, **Linda LaSala** has loved the lights and colors of the city. She graduated from the Fashion Institute of Technology with a major in interior design and has always called the New York City area home. While working in the field of fabric design, LaSala studied fine art and art history, and later began shooting weddings and portraits. She has traveled and photographed extensively around the United States and Europe, and her work has been featured in multiple exhibitions, as well as *Digital Imaging Techniques* magazine. For more information, visit www.lasalaphotos.com.

TIP 219 How to reduce print outgassing.

Outgassing is a problem that can occur with glossy and semi-gloss prints made on inkjet printers. If you place a newly made print (or one that has not been properly treated), under plastic or glass, and then expose the glass to bright light (especially the sun), it is very possible that a subtle "fogging," due to the outgassing of glycols that are necessary to keep the inks in a fluid state, will appear on the glass or plastic in the areas where the ink appears. The fogging will generally go away when brought out of the light, but will later reappear if re-exposed.

To reduce this potential problem, I recommend interleaving your glossy and semi-gloss prints with an absorbent paper, which helps to release the glycols. I primarily use Lineco Inc.'s Unbuffered Acid-Free Interleaving Sheets, which are available up to 30 × 40 inches (L14.6). In the past, I've used plain paper (copy paper), or even newsprint, but I'm concerned with the potentially damaging effects of acid migration, so I recommend using only acid-free materials. I had a large paper drawer custom made (42 × 29 × 7 inches tall) to hold and protect stacks of prints. Prints can also

Artist: Linda LaSala; **Image title**: *Movin n Groovin*; **Print Size**: 16×24 inches; **Paper**: Hahnemühle Fine Art Pearl; **Printer Name**: Epson Stylus Pro 7800; **Ink Used**: Epson UltraChrome K3; **Driver**: Epson Standard Driver (Windows XP); **Camera**: Canon EOS-1D Mark II; **Lens**: Canon EF 17-40mm; **F-stop**: f/6.3; **Exposure**: 1.3 sec.

be stacked up on a table with interleaving sheets between them, or placed in flat file drawers or a darkroom drying rack.

I try to allow prints to sit in the drawer for at least a week before framing, and I have not noticed, nor have I had any complaints thus far of, any outgassing problems from galleries or collectors. A week is not always feasible, so you may want to replace the interleaving sheets every few hours to expedite the process. You can also do a test by placing a print in a clear bag, such as the ones sold by Impact Images (L14.7). Then place it in the sun for a few minutes to see if it produces the fogging effect.

One of Linda LaSala's prints, covered with a Lineco Unbuffered Acid-Free Interleaving Sheet.
Photo © Linda LaSala

TIP 220 Keep it simple when choosing frames.

There are hundreds of ways to frame artwork, though I've found that for the vast majority of the inkjet prints I've made, a simple black wood frame with a matte finish and a bright white or warm white 4-ply or 8-ply matte works very well. Of course, a black frame won't be right for everyone's work, but the advantages of using black frames (either wood or metal) with a white matte are many. First, if you enter a competition and have your work selected, a black frame and white mat is often required, so the same framed prints can be used for multiple shows. Another advantage is cost

Artist: Linda LaSala; **Image title**: *Doyers St.*; **Print Size**: 24×36 inches; **Paper**: Hahnemühle Fine Art Pearl; **Printer Name**: Epson Stylus Pro 7800; **Ink Used:** Epson UltraChrome K3; **Driver:** Epson Standard Driver (Windows XP); **Camera:** Canon EOS-1D Mark II; **Lens**: Canon EF 17-40mm; **F-stop**: f/6.3; **Exposure**: 1.3 sec.

and availability. Simple black frames are very popular, so the cost of the frames will generally be lower and the availability will be greater than many other frame types.

If you work with a custom framer, you can often save on the cost of framing if you have multiple frames of the same type produced at the same time, and framers will often keep popular mouldings in stock so that special orders won't be necessary. Also, if you damage a section of a popular wood or metal black frame, and if you or your framer have additional frame sections in stock, it is relatively easy to have just the damaged section repaired or replaced (most metal frames are especially easy to repair since they can be taken apart with a screwdriver).

If you standardize the size of your black frames (and your prints), you can change out the artwork on a continual basis. I do this in my home with a group of 24 × 30-inch framed prints. All of the frames have spacers attached to the acrylic glazing on the front, which avoids the need for a mat. Because there are no mats, the prints are mounted to acid-free foam board, placed in the frame, and "framer's points" are inserted to hold the art securely in. To remove the framer's points, long-nose pliers are used. I recommend wearing eye protection and using caution when doing work like this,

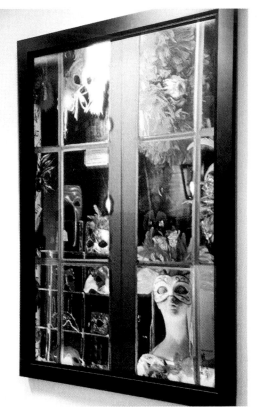

A simple black wood frame, shown with one of Linda LaSala's mounted prints. The framing spacers create about a 1/4-inch space between the artwork and the glazing.
Photo © Linda LaSala

or I recommend having a professional framer do it for you. If you use flexible framer's points, you can bend them up and replace the artwork without having to pull the framer's points out. The metal tabs that come with many frames sold in stores use flexible framers points. I also recommend using small rubber bumpers on the bottom of your artwork where it touches the walls. This not only protects your walls, but also helps keep your artwork from shifting.

TIP 221 Mount prints and display them in different ways.

Sometimes, using no frame is the best way to display mounted prints. For an exhibition in New York City, I made 40 inkjet prints on Ilford Galerie Smooth Pearl Paper (each one 24 × 30 inches), and I had each print cold mounted to 6mm black Sintra (L14.8). Though I did not use any protective spray on these prints, a solvent-based aerosol product like PremierArt Print Shield (L14.9) can help to protect print surfaces from damage due to sunlight, and to some extent, scratches and smudging when displayed without glass or acrylic glazing.

Hanging the work presented a challenge, so we decided to drill holes at a 45 degree angle through the top corner of each Sintra board and out the back. That allowed us to run heavy-duty fishing line through each corner without having any effect on the face of the Sintra. The product we used to hang the work was Ande Premier clear 60 lb. test monofilament (1/4 lb. spool, L14.10). We then hung the prints from hooks attached to a track that ran along the top of the wall. I was extremely pleased with the results; the prints appeared to float in thin air because the fishing line was virtually invisible. Another approach for hanging the prints more traditionally to a wall is to use a Swiss Poster Clip Hangers Kit (L14.11), which is inexpensive (about $12). After assembly, the Swiss Poster Clips can support artwork up to 60 lbs.

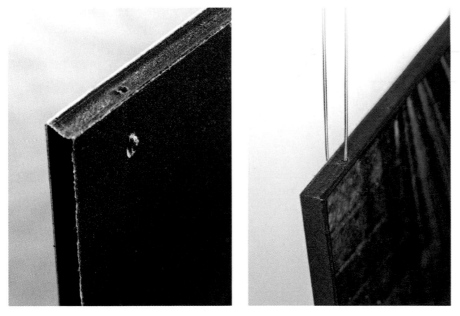

(Left) A close-up of one of Linda LaSala's mounted prints, showing the drilled holes that were made for threading the monofilament (fishing line). (Right) Another look at the print with the monofilament threaded.
Photos © Linda LaSala

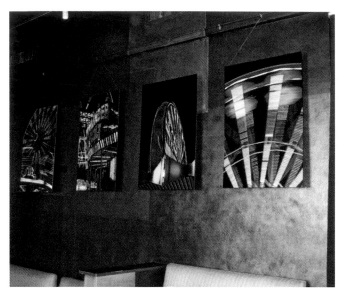

Linda LaSala's mounted prints on display at Kanvas in New York City. Each print is hanging from heavy-duty Ande monofilament fishing line.
Photos © Linda LaSala

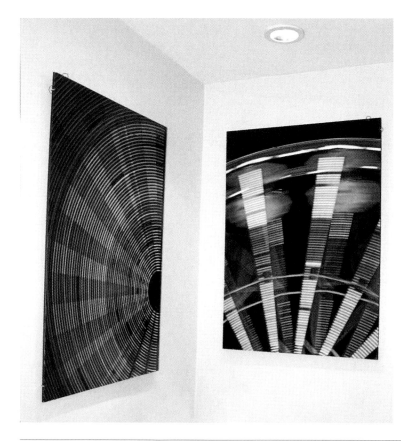

Linda LaSala's mounted prints, shown hanging on a wall using Swiss Poster Clip Hangers and traditional picture hangers. The corner clips are almost invisible, but the thin metal supports can be seen in the corners (circled in red in two corners on both prints).
Photo © Linda LaSala

The images in the following seven tips were photographed at *Art Framing & Home Design*, a frame shop and gallery located in Great Neck, NY. The store's owners, Sima Rafu and Marc Potecha, are also the primary resource for all the mounting and framing tips and techniques throughout this section, and I thank them for sharing so many of their "trade secrets."

—Linda LaSala

TIP 222 Choose a good utility knife.

A good utility knife is an important tool for framers and photographers. One inexpensive and well-made knife is the Husky Folding Lock-back Utility Knife (L14.12). It's ideal for cutting matboard and corrugated cardboard, and it doesn't require any tools to change the blade. It also uses a very common blade type, and replacement blades are both affordable and easy to find.

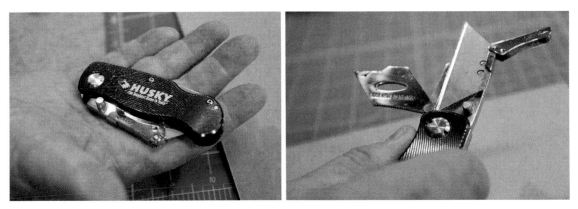

(Left) Marc Potecha holding his favorite utility knife from Husky. (Right) The Husky's knife blade can be quickly and easily changed without any tools.
Photos © Andrew Darlow

TIP 223 Use padded envelopes for protecting frames.

Padded envelopes, or bubble mailers, can be used effectively to protect framed art, matted prints or portfolios. They are widely available in office-supply stores up to about 16 × 20 inches. The Bubble-lite brand (L14.13) mailers are a good choice because they are well made, inexpensive, and can be cut, joined, and taped together quickly to create a well-protected package for artwork. The four steps below illustrate how to put together two padded envelopes to protect a framed

piece. This will not protect a frame with glass for shipping, but it is a good option for hand-delivered frames, or for frames that use acrylic in place of glass. For larger pieces, four padded envelopes can be cut and taped together, and cardboard or other material can be added for extra strength.

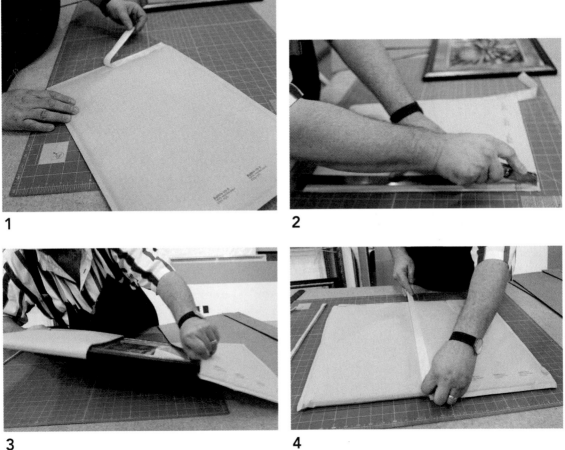

1
2
3
4

Shown above are four steps for making a protective package using two padded envelopes.
Following is a step-by-step description of the four steps: (1) Pull off the envelope's pressure sensitive adhesive strip and seal the envelope securely. Do the same for the second envelope. (2) Use a straight edge and a utility knife to cut one of the longer sides off of each padded envelope (for example, the 20-inch length of a 16x20-inch envelope). (3) Insert one end of the frame into the padded envelope and then cover the other side of the frame with the other padded envelope. (4) Tape it on both sides in the center area where the two intersect.
Photos © Andrew Darlow

Artist: Linda LaSala; **Image title**: *Lily*; **Print Size**: 16x24 inches; **Paper**: Hahnemühle Fine Art Pearl; **Printer Name**: Epson Stylus Pro 7800; **Ink Used**: Epson UltraChrome K3; **Driver**: Epson Standard Driver (Windows XP); **Camera**: Canon EOS-1Ds Mark II **Lens**: Canon EF 70-300mm f/4-5/6 IS; **F-stop**: f/8; **Exposure**: 1/250 sec.

TIP 224 Use book boxes and thin foam.

Literature mailers and easy-fold mailers are box types that are widely available from companies such as Uline Shipping Supplies (L14.14). They can serve as perfect boxes for framed art, matted prints or portfolios. They are pre-scored, which makes the box-making process much faster, and when used in combination with rolled thin foam (L14.15), artwork can be better protected from damage during shipping. Thin foam is sold in sheets, rolls and even in pouch form, which can save time compared with wrapping a piece of art in bubble before packing. Pouches can be used to just add an additional layer of protection, or they can be rolled as shown below.

(Left) A book box shown with a frame that is sized appropriately for it. (Right) The same box with a piece of rolled thin foam to protect the edges of the frame.
Photos © Andrew Darlow

TIP 225 Use quadruple-wall corrugated to protect art and glass.

Glass is always difficult to protect during shipping, and any piece of art that cannot be reprinted should generally not be shipped with glass. Also, most shippers will not insure work shipped with glass. However, if you need to ship glass via your own vehicle, a company such as UPS or FedEx, or other shipping method, quadruple-wall *corrugated* (commonly known as cardboard) is a good choice to put on top of the glass while packing, because of its strength, thickness, and warp resistance. Quadruple wall corrugated (L14.16) can also be used to make a super-strong box of virtually any size, or a "sandwich" for shipments that are thin. To make the sandwich, just place a print (or a few prints) in a protective bag, tape it securely to the inside of a quadruple-wall corrugated sheet (leave at least a three-inch margin all around), cover the sheet with another sheet of corrugated, and tape the edges securely. Double- and triple-wall corrugated (lighter and less expensive) should also be considered depending upon your specific project.

(Left) Quadruple-wall corrugated cardboard shown from the side. (Right) Quadruple-wall corrugated placed on top of a piece of art with glass prior to being cut to size.
Photos © Andrew Darlow

TIP 226 Create a strong hanging system for mounted work.

If you want to mount a piece of art to a board made of foam, such as Gatorfoam (L14.17), a very good product exists called "Kwik Hangers" (L14.18). Each costs about 5 to 15 cents, and they can be affixed by using just one (for hanging smaller boards), or by using two, through which you can run metal picture frame wire and then hang the work on a standard picture hook. This is a much stronger option compared to just taping a wire behind the foam because there are small teeth in the Kwik Hangers that hook securely into the foam.

(Left) A metal Kwik Hanger before and after being attached to the back of a piece of foam board. Picture frame wire is running through it, and a piece of tape is used for extra security. (Right) A demonstration of the final step of attaching the clip to a foam board.
Photos © Andrew Darlow

TIP 227 Use Bubble Wrap and stretch wrap film.

Bubble Wrap (L14.19) and stretch wrap film can be used together to protect artwork that has been placed in a bag, a box, or between corrugated sheets. This is a good choice for protecting art that will be picked up by customers because it reduces the amount of damage that can occur when a lot of tape is used. Tape can stick to canvas or fragile frames, and this combination is also generally faster compared with using tape when the plastic hand-held dispensers are used. The stretch film is also easily removed with a utility knife or scissors. Bubble wrap and stretch wrap can be found at a number of different suppliers. At Uline (L14.20), their hand-held stretch wrap is called the *Mini-Wrap*, and it comes in three- and five-inch widths. United Mfrs. Supply (L14.21) and M&M Distributors (L14.22) are other good sources for framing and packing materials.

Using corrugated cardboard, bubble wrap, and stretch wrap to protect a frame.
Photo © Andrew Darlow

TIP 228 Choose the right glass or acrylic for your projects.

There are many types of glass and acrylic sold, and each one has a different color cast, strength and thickness. The primary advantage of good quality glass is its resistance to scratching and lack of dust attraction. One brand of glass that is used by the framers at *Art Framing & Home Design* is Tru Vue, Inc. (L14.23). Tru Vue offers about eight different brands of glass, and different projects will call for different glass. For example, Marc Potecha explained that non-glare glass or acrylic should not be placed more than a few millimeters away from a piece of art (like it would be in a box frame) because the image will look more blurred as the non-glare glass or acrylic is moved farther from the artwork.

The primary advantages of acrylic are that it's about half the weight of glass, and it's shatter-resistant. For these reasons, it is often required by galleries and museums to be used in place of glass. CYRO (the same company that makes Tru Vue glass) is well known for its Acrylite brand of acrylic sheets (L14.24). Their products, including the Acrylite OP-3 (UV-filtered) and OP-3 P-99 (UV-filtered and non-glare) are used widely for picture framing. Some acrylic is also made with scratch resistance built in. One way to know which is best for you is to visit a frame shop and either buy a few 8 × 10 pieces of several types of acrylic or glass, or inspect some of the framed samples, like the ones shown in the sample below.

A sample showing three different types of Tru Vue branded glass. (Left to right): Conservation Clear Glass; AR Reflection Free Museum Glass; and Conservation Reflection Control Glass.
Photo © Andrew Darlow

Lighting a Space
Effectively and Efficiently

By Jim Benest

There are many ways to light artwork. You can choose different types of light (traditional halogen, fluorescent, LED and others), and many different strengths and focus types (direct, indirect, spot, flood, etc.). These tips offer some suggestions for lighting a commercial gallery, but the suggestions can be used for any location where artwork will be displayed, such as a doctor's office, home or office building.

Jim Benest has been photographing people, places and things for over 20 years. His professional photography career began in 1987 when he opened Moments to Remember Photography, a wedding and portrait studio. Over the years, Jim's love of shooting landscapes and florals has led him to travel to South America, Italy, and the American Southwest. In 2004, he opened The Collective Fine Art Gallery in downtown Fort Collins, Colorado. The 1900 sq. ft. gallery represents approximately 30 local and national artists, offering a diverse selection of art originals, photography, bronze sculpture, pottery, glass, jewelry and furnishings. Benest's canvas prints, which he exhibits at the gallery, are printed and coated by Fine Print Imaging (L14.25). For more information, visit www.thecollectivegallery.com.

TIP 229 Determine how many pieces you will put on each wall.

Depending upon whether you will have one piece in the center of a wall or three or more stacked (like in our gallery), your lighting will be different. Also consider the mood you want to have in the space. You can choose from dark ambient lighting with dramatic spotlights on every piece of art, or you can select a more broadly lit effect, as we use in our gallery.

One section of The Collective Gallery, lit by track lighting containing three types of light.

A view of one side of The Collective Fine Art Gallery (L14.26), with multiple types of lighting shown in the track lighting system. Photo © Andrew Darlow

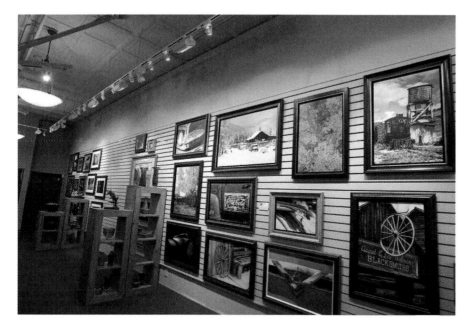

Another section of the gallery with both track lighting and an overhead fixture. Photo © Andrew Darlow

Artist: Jim Benest; **Image title**: *Door #4 - Italy*; **Print Size**: 20×30 inches; **Canvas**: BullDog Matte Canvas; **Printer Name**: Roland Hi-Fi Jet PRO; **Ink Used**: Lyson Pigments**; RIP**: Studio Pro (Windows XP); **Camera**: Nikon F-100; **Lens**: 24-120mm f/3.5-5.6G Nikkor VR; **Film**: Fuji Velvia (ISO 50); **Exposure**: Unrecorded; **Coating**: BullDog Ultra Semi-Gloss

TIP 230 Choose a good quality lighting system.

There are many lighting systems available, from track lighting to individual lighting with an art light above each framed piece. After much research, we chose to install a track lighting system by Nora Lighting (L14.27). Our lighting contractor was given five main objectives: The lighting needed to produce a believable color spectrum; it had to be energy efficient; it had to produce minimal heat; it needed to make the art look its best; and it had to be flexible in an ever-changing gallery environment. He accomplished all five and exceeded our expectations.

TIP 231 Check with your local or state government to see if incentive programs exist.

Unless you plan to use only sunlight, there is a considerable amount of electricity needed to light artwork day and night. When we moved into a larger space, we decided to do some research and learned of the "Lighten Up" program. It is a joint effort between the Platte River Power Authority, which is the main source of electricity for our area, and the City of Fort Collins (L14.28), which buys and distributes the electricity for our city. We applied for the program and qualified, which has resulted in a number of benefits, including a one-time rebate, a projected annual savings of nearly $700; less heat generated, resulting in less need for air conditioning in the summer months; and piece of mind knowing that we are consuming fewer of the natural resources required to produce the electricity.

The overall material costs were initially higher than that of a less efficient system, but the bulbs will last longer, and we estimate that the cost difference will be paid for over the first 3.5 years of use. Many local governments have similar programs for small businesses and homeowners, and even if there are no incentive programs, consider replacing some of your inefficient bulbs and fixtures with more efficient lighting.

TIP 232 Mix halogen with fluorescent (or LED) lighting.

In our gallery, we primarily use a combination of the following: (20) 32 watt Compact Fluorescent (CFL) type T2 fixtures; (6) 39 watt Ceramic Metal Halide (CMH) type T3 fixtures; and (70) low voltage 35 watt MR-16 flood Halogen in a type T1 fixture. The CFLs and CMHs together serve as a broad fill light source. The MR-16s add the highlights where they are needed, and even though they are floods, they punch up the light just enough without being too hot, harsh and narrow like many spotlights.

I was very skeptical about mixing these three light sources and being able to maintain a similar quality of light. The CFLs burn at 2700K, the CMHs at 3000K and the Halogens at 3000K. To my surprise, when mixed and blended, the result is a light system that is very natural and inviting. A similar combination of halogen, fluorescent or LED lights can help to reduce energy consumption in your studio, home or office, while still allowing you to nicely illuminate your artwork. Keeping a set of halogen spotlights on a separate switch, for example, will allow you to highlight your work when you want, but at the same time, the separate switch will help you to save energy (and money) when the lights are off. Here are a few good sources for LED light bulbs and energy-saving lighting success stories: (L14.29).

A close-up of the three types of lights that combine to light most of the artwork throughout the gallery. CFLs are circled in Red, CMHs are circled in Blue, and Halogens are circled in Yellow.
Photo © Andrew Darlow

TIP 233 Have a plan for lighting at night.

If you have a gallery or store with windows that allow people to look in even when you are closed, you can effectively promote the location and light much of the work without wasting a lot of energy. In our case, we installed a two-circuit track system, with one track on a timer. The timer allows us to have only a few selected lights on throughout the gallery during the hours that we are closed. This allows us to show-case key areas while providing additional security. The same approach can be taken in a home or office by setting a timer to control the number of hours that certain groups of lights are on.

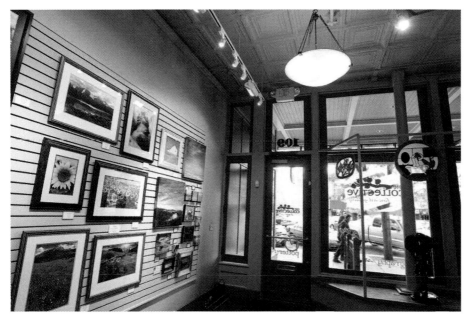

A view of the front of The Collective Fine Art Gallery. A moderate amount of natural light enters the gallery during the day, and the entire gallery can be seen by people after hours through the windows.
Photo © Andrew Darlow

TIP 234 Protect fragile artwork.

Some types of art, such as acrylic painting and some inkjet prints, are more suscepti-ble to fading than others. I recommend keeping fragile artwork away not only from direct sunlight, but also from bright artificial light. All of our MR-16 Halogens are equipped with a UV filter to help protect the artwork from daily exposure. In any home or office setting, you can observe whether artwork on the walls is getting a sig-nificant amount of exposure from natural sunlight, and if so, consider adding blinds or replacing the art if you are concerned about it fading.

Artist: Jim Benest; **Image title**: *Sunflower Head*; **Print Size**: 24x36 inches; **Canvas**: BullDog Matte Canvas; **Printer Name**: Roland Hi-Fi Jet PRO; **Ink Used:** Lyson Pigments**; RIP:** Studio Pro (Windows XP); **Camera**: Nikon F-100; **Lens:** 35-105mm f/2.8-5.6 Nikkor Macro; **Film**: Fuji Velvia (ISO 50); **Exposure**: Unrecorded; **Coating**: BullDog Ultra Semi-Gloss

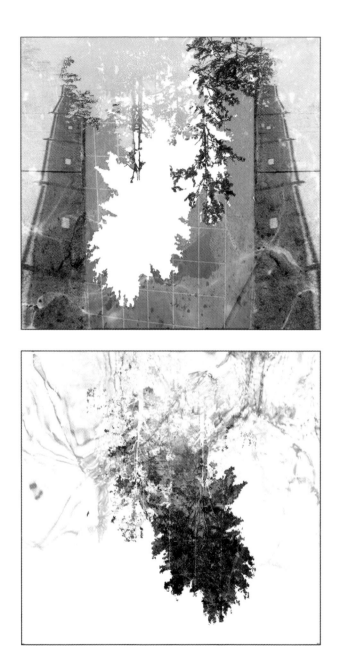

Artist: Bonny Lhotka; **Image title**: *Civic Center*; **Print Size**: 49 × 48 inches (right side image); **Substrate**: 1/4 inch etch acrylic (printed front and back using the two left-hand images); **Printer Name**: Zund 215C flatbed; **Ink Used:** UV-cured pigments; **RIP:** Onyx (Windows); **Camera**: Nikon D70; **Lens**: Nikkor 18-70mm f/3.5-4.5G; **F-stop:** f/5.6; **Exposure**: 1/640 sec.

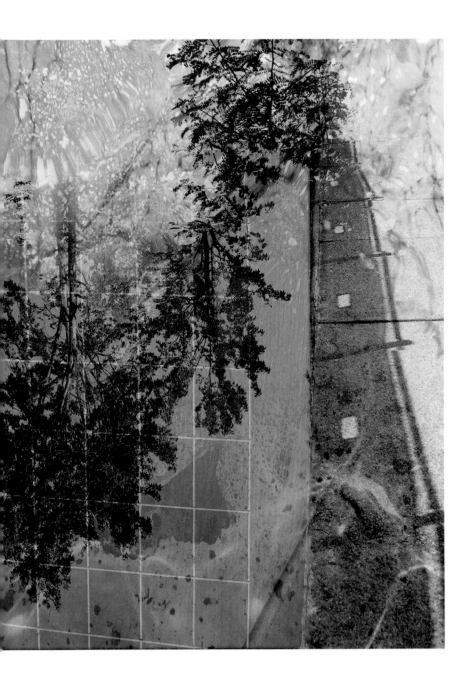

Unique Art Applications

Using inkAID to Precoat Nonporous Surfaces for Printing

By Dorothy Simpson Krause

inkAID (L15.1) manufactures a series of inkjet precoats that give creative digital artists the opportunity to create virtually an unlimited number of surfaces on which to print. inkAid's White Matte product creates an opaque, water resistant finish, while the clear gloss, semigloss, and five iridescent precoats allow the underlying material, painting, or collage art to be seen after coating. The following tips will cover metal and fabric coating, and I encourage you to use these suggestions to find just the right mix of coating type, surface and printer for your projects.

Dorothy Simpson Krause is a painter, collage artist, and printmaker who incorporates digital mixed media into her art. Her work is exhibited internationally, and she is a frequent speaker at conferences and symposia. Krause is Professor Emeritus at Massachusetts College of Art where she founded the Computer Arts Center. She is a member of Digital Atelier®, an artists' collaborative, with Bonny Lhotka and Karin Schminke, co-authors of *Digital Art Studio: Techniques for Combining Inkjet Printing with Traditional Art Materials* (Watson-Guptill 2004). For more information, visit www.dotkrause.com.

TIP 235 Check your printer for "pizza wheels."

Although many larger inkjet printers (usually 24 inches wide and larger) do not have any wheels, tabs, or rollers that contact the image after printing, most desktop printers do. When printing on porous materials like paper, or using the inkAID White Matte Precoat, this usually presents no problem. However, for nonporous materials, like plastic, metal or surfaces covered with acrylic medium or paint, the ink briefly wets the clear and iridescent precoats, and the printers' "pizza wheels" can leave tiny pinhole tracks, or drag the ink and clear precoats. While there are web sites that describe how to raise or remove the wheels on some printers, doing so is likely to void your printer's warranty.

To find the web links noted in the book (L15.1, etc.), visit www.inkjettips.com or http://www.courseptr.com/ptr_downloads.cfm .

Artist: Dorothy Simpson Krause; **Image title**: *Reflections*; **Print Size**: 24 × 24 inches; **Substrate**: Aluminum precoated with Clear Gloss Type II inkAID; **Printer Name**: Epson Stylus Pro 9600; **Ink Used**: Epson UltraChrome K2; **Driver**: Standard Epson Driver (Mac OSX); **Camera**: Olympus C5050 Zoom; **Lens**: Built-in; **F-stop**: f/5.6; **Exposure**: unrecorded

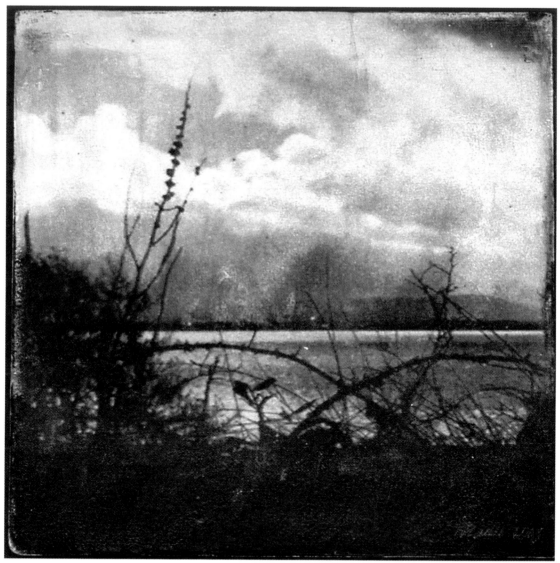

TIP 236 Check the head clearance of your printer and set the platen gap to an appropriate width.

Printers such as the Epson Stylus Pro 4800/7800/9800 series (L15.2) have a head clearance of 1.5mm (approximately the thickness of a new penny). Those printers will take thicker materials compared with printers with less clearance. Most manufacturers will publish the maximum paper/substrate thickness in their specs. Before putting anything thick through a printer, be sure the printer is set up to accept the thicker material. This might require making an adjustment through the LCD panel on the printer, choosing a different paper type in the printer driver, or manually adjusting a lever on the printer. There are also width adjustments that often can be set inside the printer driver's software. Most printer manuals will cover this important feature.

A sheet of aluminum, precoated with inkAID, exits an Epson Stylus Pro 9600 printer after printing. The printer's platen gap was set to Wide from the printer's control panel.
Photo © Dorothy Simpson Krause

Artist: Dorothy Simpson Krause; **Image title**: *Thorns*; **Print Size**: 24 × 24 inches; **Substrate**: Textured nonwoven fabric precoated with Pearl Iridescent inkAID; **Printer Name**: Epson Stylus Pro 9600; **Ink Used:** Epson UltraChrome K2; **RIP/Driver:** Standard Epson Driver (Mac OSX); **Camera:** Olympus C5050; **Lens:** Built-in; **F-stop:** f/5.6; **Exposure:** unrecorded

TIP 237 Check to see if your printer has a straight paper path.

Some materials, like heavy art papers, are thick but not rigid. Rigid substrates, such as thick plastic or aluminum, require a straight paper path. Some smaller printers, such as the Epson Stylus Photo R2400 and the HP Photosmart Pro B9180 have straight paper paths that can accommodate wide materials. A class of high-end print- ers (generally priced over $50,000) named "flatbed printers" can accept considerably thicker materials.

TIP 238 Choose unusual, commercially available substrates.

You can choose from a wide variety of surfaces on which to print. Aluminum and many plastics can be found at companies that supply the POP (point of purchase) display industry. Steel, lead, copper and wood veneer can be found in building sup- ply stores. A few resources for these types of materials can be found here: (L15.3).

TIP 239 Clean the surface, precoat, and let dry.

On a non-porous surface like aluminum, wash the surface with alcohol, then mild soap and water, and then dry the surface well. Then, with a foam brush, paint on a coat of inkAID Clear Gloss Precoat Type II. Let it dry and paint on a second coat per- pendicular to the first coat. This approach will help to assure a very even coating. inkAID can also be diluted and applied using a spray system. See the inkAID FAQs for specific recommendations and other tips (L15.4).

A sheet of aluminum after cleaning, with a container of inkAID Clear Gloss Type II precoat and a foam brush.
Photo © Dorothy Simpson Krause

TIP 240 Print a test image using standard or custom profiles.

When the piece is dry, print your image onto the prepared aluminum. Experiment first with a smaller sheet (approximately 9 × 12 inches) and print an image that you are familiar with, such as a known color reference file (L15.5). You can use standard printer output profiles, or you can make a custom profile for virtually any material.

TIP 241 Use Photo Black ink and a high quality setting.

When printing on the inkAID Clear Gloss on non-porous surfaces like aluminum, I've found that the same inks used for gloss and semigloss papers work best. In the case of the Epson Stylus Pro 9600 (and similar Epson printers), I recommend choosing a gloss or semi-gloss paper setting in the printer driver, which will cause the Photo Black, but not the Matte Black ink to be used. For very good detail and sharpness, 1440 DPI is recommended.

TIP 242 Use nonwoven fabric to create a unique surface upon which to print.

Nonwoven fabric is the canvas of the 21st century. Nonwoven spun-bonded polyester will not curl or warp and can be found in fabric stores. It is also available in garden supply stores, and is sold as "landscape cloth." Suggestions for a few specific nonwoven fabrics can be found here: (L15.6).

TIP 243 Prepare the fabric correctly for printing.

Mist the fabric lightly with soapy water to break the tension; then lightly texture it with Golden's Acrylic Molding Paste (L15.7). After drying overnight, precoat with inkAID Clear Gloss Precoat Type II as described in Tip 239 (without the cleaning steps).

TIP 244 Wrap your nonwoven "canvas" around the edges of your stretcher bars.

Prior to printing, expand the size of your image and make your print three to six inches larger in both dimensions compared with your stretcher bars (for example, a 20 × 30-inch stretched piece should be printed about 23 × 33 to 26 × 36 inches. The size will depend on the depth of your stretcher bars. After printing, wrap the expanded image around the bars and staple to the back to finish your piece, or have a service provider, such as a custom framer, do it for you.

413

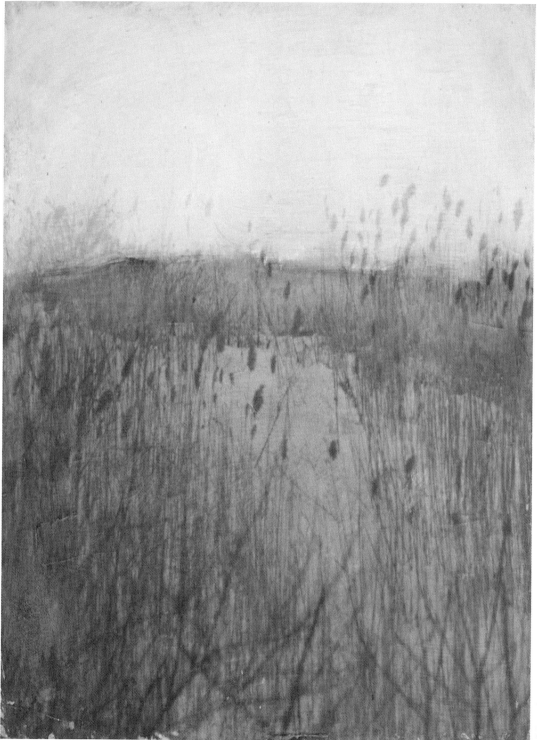

A container of Golden's Acrylic Molding Paste with a plastic applicator, next to a piece of nonwoven spun-bonded polyester.
Photo © Dorothy Simpson Krause

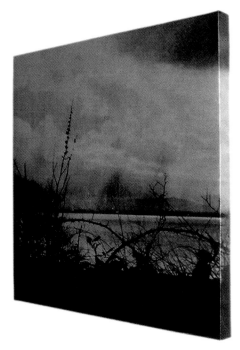

An example of a finished print on the nonwoven material stretched onto one-inch-wide wood stretcher bars.
Photo and artwork © Dorothy Simpson Krause

TIP 245 Mix precoats for interesting results.

Since the white inkAID precoat is opaque and the clear and iridescent precoats are transparent, they can be mixed to create different degrees of transparency. Your substrate can show through in some places and disappear in others. This is especially effective if you are working on top of a drawing, painting or collage.

Artist: Dorothy Simpson Krause; **Image title:** *Beachgrass*; **Print Size:** 32 × 48 inches; **Substrate:** 1/2 inch Polycarbonate with silver leaf on back side; **Printer Name:** HP Scitex Vision VEEjet+; **Ink Used:** UV cured pigment ; **Driver:** Onyx (Windows); **Camera:** Olympus C5050; **Lens:** Built-in; **F-stop:** f/5.6; **Exposure**: unrecorded

Making 3D Stereo Cards with an Inkjet Printer

By Bonny Lhotka

The type of photography known as stereoscopic (or 3D photography) dates back to the mid- to late-1800s. A stereo card is made by taking a photograph of an object from two viewpoints (left and right), about 2.5 inches apart. When printed and viewed through a special viewer, or in a certain way without a viewer, the image appears three dimensional. The following tips will help you to create your own stereoscopic images using a digital camera, Photoshop and just about any inkjet printer.

Bonny Lhotka graduated from Bradley University after majoring in painting and printmaking. Her work has been shown internationally, appears in numerous books and articles, and is included in hundreds of private, corporate, and museum collections worldwide. She is listed in *Who's Who in America* and is a recipient of the Smithsonian Computerworld award. Lhotka has co-authored with Karin Schminke and Dorothy Simpson Krause the book *Digital Art Studio: Techniques for Combining Inkjet Printing with Traditional Art Materials* (Watson-Guptill 2004). For more information, visit www.lhotka.com.

TIP 246 Buy a special lens for capturing stereoscopic images.

A number of twin-lens removable lenses are available for Digital SLRs. I use the Nikkor-mount Loreo 3D Lens-In-A-Cap (T, L15.8), and I use it with my Nikon D70 DSLR. This model is made with mounts for many popular DSLRs with frame sizes smaller than a 35mm camera. A different model is sold for full-frame film and digital SLRs, and there are a number of samples images made with a DSLR available for viewing on the Loreo web site. Other models are available on 3dstereo.com's web site (L15.9).

Artist: Bonny Lhotka; **Description**: *Doll Stereoscopes*: normal (top) and "cross-eyed" (bottom);
Print Size: 3.3 × 5 inches; **Paper**: HP Advanced Photo Paper Glossy; **Printer Name**: HP Photosmart
Pro B9180; **Ink Used:** HP Vivera; **Driver:** Standard HP Driver (Mac OSX); **Camera**: Nikon D70;
Lens: Loreo 3D Lens-In-A-Cap (T); **F-stop**: f/22; **Exposure**: unrecorded

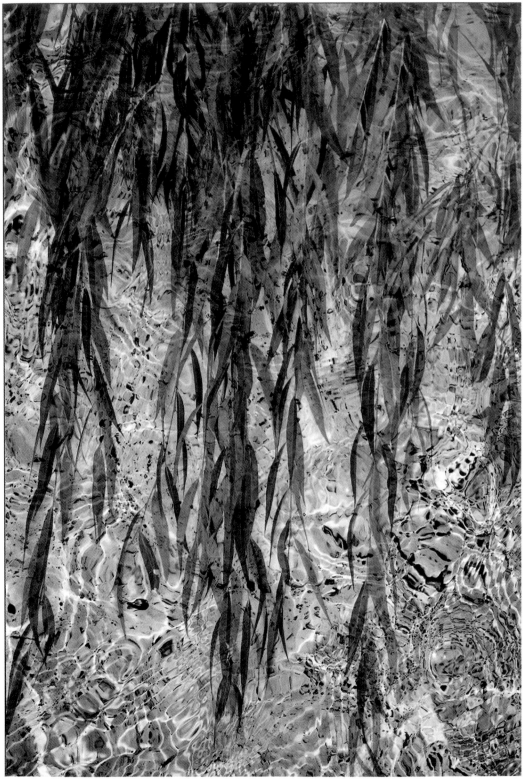

The Loreo Stereo Lens-In-A-Cap
(T) mounted on a Nikon D70.
Photo © Bonny Lhotka

TIP 247 Place the camera on a tripod or shoot in bright sunlight.

There are limited controls on the Loreo lens, but it gets the job done. There are two f-stops: f/11 and f/22, and focusing is done by one of three manual adjustments on the front of the lens (one meter to infinity). Very few of your digital camera's controls will work when using the 3D lens, but your digital camera's color LCD display (and histogram) should help you to achieve good exposures. And setting higher ISO speeds (for example, ISO 400–1000) will allow you to shoot in lower-light situations. When looking through the viewfinder, two side-by-side images are seen. Set the focus and frame the image using either one of the images.

TIP 248 Download, color correct, and adjust the image.

Once you have captured the stereo image, open the file in Photoshop and make color and exposure adjustments as needed. Then place a guide in the center of the two images. Using the selection tool, copy and paste each side into a new layer. Switch the position of these new layers so the right image is on the left and the left image is on the right (top screen shot on page 420). This will create the stereo set needed to create the 3D effect for "cross-eyed viewing" without a special viewer. The following web site explains the cross-eyed viewing technique (L15.10). For use in a viewer, use the stereo image in the same way it was captured. Next, resize the

Artist: Bonny Lhotka; **Image title**: *Blue Willow*; **Print Size**: 36 × 55 inches; **Substrate**: Acrylic with 20lpi lenticular lens; **Printer Name**: ColorSpan DisplayMaker 72UVR and Epson Stylus Pro 9600; **Ink Used:** ColorSpan UV-cured pigment and UltraChrome K2; **RIP:** ErgoSoft StudioPrint and Onyx (Windows); **Camera**: Nikon D70; **Lens**: Nikkor 18-70mm f/3.5-4.5G; **F-stop**: f/5.6; **Exposure**: 1/640 sec.

419

layered file to 300 PPI, 5 inches wide and 3.3 inches tall, so that the images will fit properly in a stereoscopic viewer. Then make a box .18 inches wide, center it on the guide and fill the box with black (bottom screen shot, shown below).

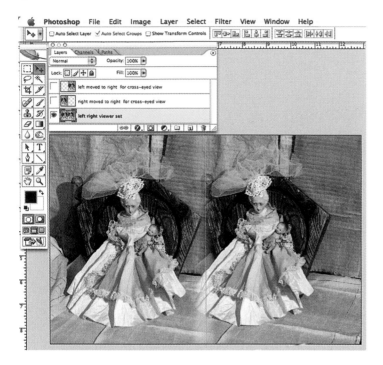

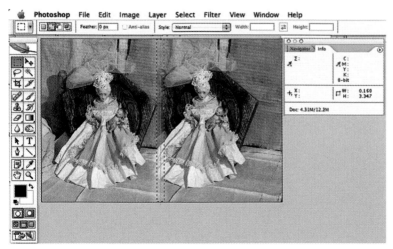

TIP 249 Print the stereo images on glossy paper.

The pigment ink-based HP Designjet Pro B9180 was used to create the prints (L15.11), and the paper chosen was HP Advanced Photo Paper Glossy (L15.12). This combination produces a very sharp and detailed image, with excellent longevity and water resistance. Matte paper is not recommended because the magnifying lens in the viewer will also magnify the paper fibers, which can cause the image to appear fuzzy.

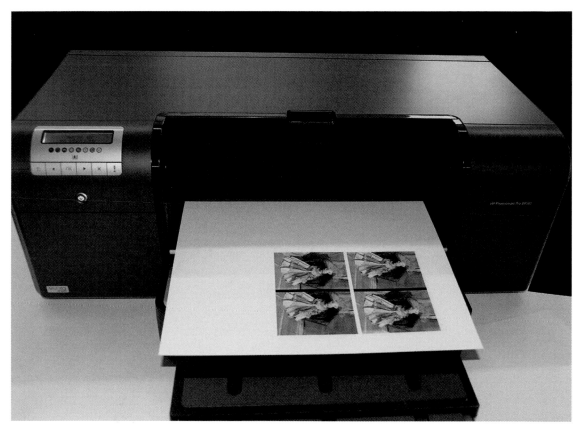

The HP Designjet Pro B9180 with a print made from two sets of stereo prints. One set is for viewing with a special viewer, and the other set is for viewing "cross-eyed."
Photo © Bonny Lhotka

TIP 250 View the print with a stereoscopic viewer.

Modern and vintage viewers are available in many shapes, sizes and price ranges. A wide variety of viewers can be found at 3Dstereo.com (L15.13). A higher-quality viewer will generally offer a better viewing experience, and one called the Deluxe 3D Viewer can be found at Loreo.com (L15.14). Loreo also makes the Lite 3D Viewer (L15.15) that can be used when viewing stereoscopic images on a computer screen, while holding a print in your hand, or while prints are hung on a wall.

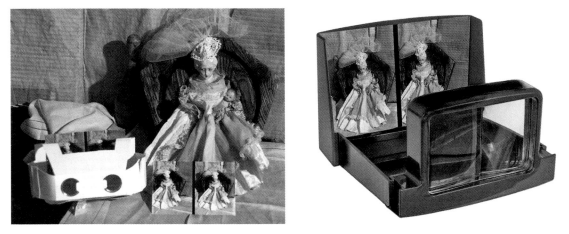

(Left) The inkjet print described in the previous tip and placed in an inexpensive paper squeeze viewer from 3dstereo.com. On the right side is the inkjet print made for "cross-eyed" viewing. (Right) The Loreo Deluxe 3D Viewer. Photos © Bonny Lhotka

Creating and Hanging Irregularly Shaped Art Pieces

By Helen Golden

Most of my work over the years has been done in a fairly typical square or rectangular format. However, a few years ago, I had the idea of producing a group of images that were quite different. These images, which I call Innovations, evolved into unique shapes, which are integral to their content. They have been both a challenge and a joy to produce and the following tips will cover some of the processes and safeguards that I use to produce and display them.

Helen Golden is an artist who creates "tradigital" mixed media images that are products of a synthesis between traditional methods such as monotype and photography and new art-making technological tools. A pioneer in the digital art realm, she is a founding member of 119 Gallery, The Main Gallery, and the pioneering digital art collective, Unique Editions™. Her images are exhibited internationally and are held in private, corporate, and museum collections, including the National Museum of American Art at the Smithsonian Institution in Washington, DC. For more information, visit www.helengolden.com.

TIP 251 Choose appropriate printers and papers.

The images shown on the opposite page (*Swimming Pool* and *Entrance*) were printed using a 42-inch-wide HP Designjet 5000ps inkjet printer (L15.16). The printer has very good image sharpness and beautiful color transitions. The printer's pigment inks contain a nice range of subtle and intense colors, and they have excellent print permanence ratings. I also use an HP Designjet Z3100 (44-inch-wide version, L15.17) and find it to be an ideal printer for the work I do. It is considerably faster than the Designjet 5000ps, and it produces very sharp, vibrant, color-accurate images with a less visible dot pattern compared with the 5000ps. The Z3100 also has excellent print permanence ratings. Two of my favorite papers to use with both printers are Hahnemühle Photo Rag 188 (L15.18) and Hahnemühle Albrecht Dürer 210 (L15.19).

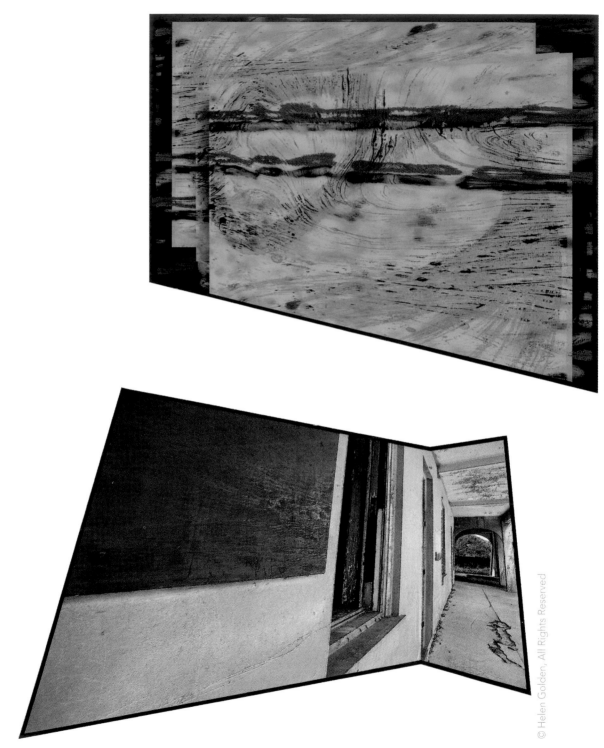

TIP 252 Print and coat the work.

My goal with this series has always been to display the pieces without glass or acrylic over the surface. However, that usually means that the prints will be more susceptible to potential damage from sunlight and handling. I continue to experiment with coatings, and I am committed to using the most benign chemicals I can find that have a good reputation for being non-yellowing. Golden Artist Colors (L15.20) have performed very well for me in this regard.

After they were printed on Hahnemühle Photo Rag 188, *Swimming Pool* and *Entrance* were both coated for protection. The first coat was a very thin layer of Golden Self Leveling Clear Gel (L15.21), which was applied by using an ultra-fine foam roller. It's important not to leave any gaps in the coverage of this layer—the printed surface must be totally protected. The next day, I repeated the process again using Golden Self Leveling Clear Gel and, with the foam roller, painted strokes across the surface going perpendicular to the first coat.

For the final two coating layers, I mixed an equal amount of Golden Polymer Varnish with UVLS Satin (L15.22) with Golden Polymer Varnish with UVLS Gloss (L15.23) to achieve the semigloss finish that I like. I applied these coats as very thin, gapless layers using a clean and flawless ultra-fine foam roller (purchased in a local hardware store) and waited a day between each layer. I have found that all four layers must be applied as thinly as possible so that the end result is very transparent. The protective coating slightly intensifies and brightens the art, which is an effect that I like a lot. I then recommend waiting at least 48 hours before mounting to any substrate.

Three of the Golden Artist Colors coatings used by Helen Golden, with an utra-fine foam roller.
Photo © Helen Golden

Artist: Helen Golden; **Image titles**: (top) *Swimming Pool*, (bottom) *Exteriors*; **Print Sizes**: 35 × 29 inches, 35.5 × 24 inches; **Paper**: Hahnemühle Photo Rag 188; **Printer Name**: HP Designjet 5000ps; **Ink Used**: HP UV Pigments; **Driver**: Standard HP Driver (Windows XP); **Source Artwork**: (for *Swimming Pool*) Two scans of art; **Camera**: (for *Exteriors*) Nikon COOLPIX 5700; **Lens**: Built-in; **F-stop**: unrecorded; **Exposure**: unrecorded

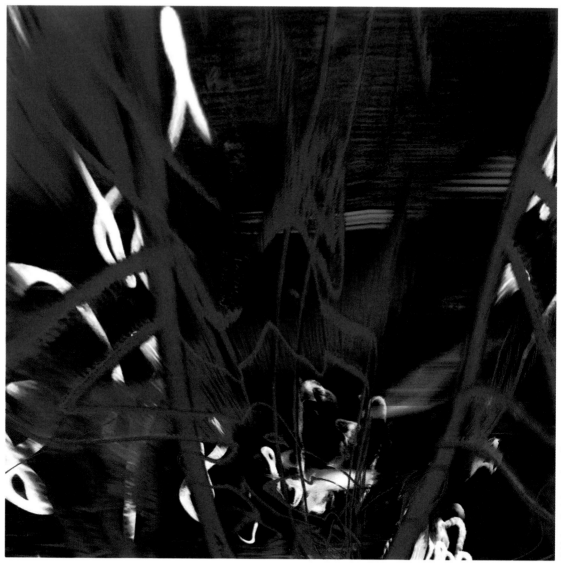

TIP 253 Mount artwork to a board and cut carefully.

For this project, each coated print was mounted to a 1/8-inch sheet of Crescent PerfectMount Acid-Free Self-Adhesive White Mounting Board (L15.24). We then placed a large mounting board over the mounted art and weighed it down with books for 24 hours to ensure good adhesion. We do most of our own cutting on a self-healing plastic cutting board that has grids to assist in alignment, and we generally use a Dahle Safetyedge Ruler (L15.25) that really does a good job of protecting the non-cutting support hand. I also insist that safety glasses are always worn to protect the eyes when doing any work of this type.

On a related note, any time you do mounting or coating, it's important to keep working surfaces as dust-free as possible. To reduce the amount of dust, we regularly use Scotch-Brite High Performance Cloths to wipe down surfaces (L15.26). They don't contain soap or other cleaning agents, are machine washable, and lint free. Another helpful tool we use to remove dust and lint (especially when we do framing), is a 5.5-inch anti-static cleaning brush called the Kinetronics StaticWisk (Model SW-140, L15.27).

TIP 254 Raise artwork by mounting to a second board.

To create a greater feeling of depth, including a small shadow, we then cut another board the same shape as the artwork, but 1/4 inch shorter all around. We usually use AlphaMat 4-ply black mat board (L15.28). We then adhere the mat board to the back of the mounted artwork using Letraset Double-sided High-Tack Tape (L15.29), interspersed with Permanent PVA adhesive (L15.30). We now have a three-piece assembly made up of the original print and two boards. We then need to adhere the three-piece assembly to the front of the custom-cut aluminum, but, first, we need to attach the support backing to the aluminum, which is explained in the following tip.

TIP 255 Attach a support backing and mount the work.

Prior to mounting the art on the aluminum, we attach a wood structural support frame to the back of the custom-cut aluminum using Gorilla Glue (L15.31). After waiting for the glue to dry, we drill four holes through the front of the aluminum into the wood frame. We then screw in four 1/2-inch flat-top metal screws from the front into the wood frame to give additional support. The hanging hardware (in this case, two were used on each side, [L15.32]) is placed inside the wood brace so that when the art is hung on a picture hook from a picture wire, the wire is hidden and the artwork sits flush against the wall.

Artist: Helen Golden; **Image title** *Night Highway: 3 - Variation*; **Print Size**: 35 × 35 inches;
Paper: Hahnemühle Albrecht Dürer 210; **Printer Name**: HP Designjet Z3100; **Ink Used**: HP Vivera;
Driver: Standard HP Driver (Windows XP); **Camera**: Nikon COOLPIX 5700; **Lens**: Built-in;
F-stop: unrecorded; **Exposure**: unrecorded

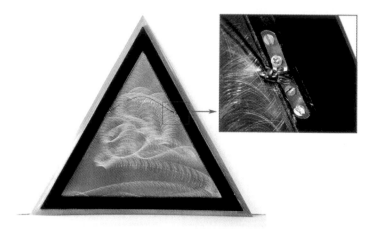

The back of a frame showing the way the wood structural support is attached to the frame, with an inset photo of the hanging hardware.
Photos © Helen Golden

TIP 256 Hang using quality picture wire and hooks.

After the glue sets in, we attach strong picture wire (Anchor Wire Corporation's #3 Zerlon Professional Picture Wire, [L15.33]) to the structural support frame. I also send several of my favorite picture hooks along when the work goes to a customer or to an exhibition. They are Trevco's Quake Hold Model #4338 A-Maze-ing Picture Hooks (L15.34). It's important to attach these hooks securely to the wall to achieve the best results.

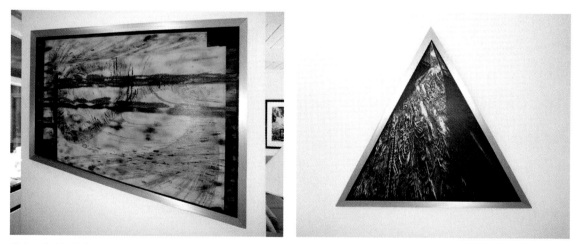

Helen Golden's *Swimming Pool* and *Entrance*, each hanging on a wall with a custom-made aluminum frame.
Artwork and Photos © Helen Golden

A Close-Up Look at
Lenticular Imaging

By Karin Schminke

An advanced form of imaging called *lenticular imaging* requires special software and a specific type of acrylic lens. A lenticular image allows the viewer to see a series of "frames" sequentially. By carefully crafting these frames, the artist can create animation, depth, and/or morphing of images. These tips give an overview of the process, as well as a few resources where you can learn more.

Karin Schminke began integrating digital technologies into her mixed media fine art more than 20 years ago. Her fine art involves combining drawing, printmaking, and photographic techniques with digital technology. A pioneer and educator in this developing field, Schminke's exploratory work has helped to define the role digital technologies play in today's art world. She is a founding member of the digital art collaborative, Digital Atelier®, and co-authored *Digital Art Studio: Techniques for Combining Inkjet Printing with Traditional Art Materials* (Watson-Guptill, 2004) with Dorothy Simpson Krause and Bonny Lhotka. For more information, visit www.schminke.com.

TIP 257 Learn about lenticular imaging and find companies that specialize in it.

I recommend visiting a few web sites dedicated to lenticular imaging. Companies that provide information and products related to lenticular imaging include Micro Lens Technology (L15.35) and Photo Illusion (L15.36). Micro Lens Technology also offers consulting for many types of lenticular projects. A trade organization named FlipSigns makes available a free Windows-compatible piece of software called SuperFlip. To request the software, send an e-mail to the address listed on their web site (L15.37).

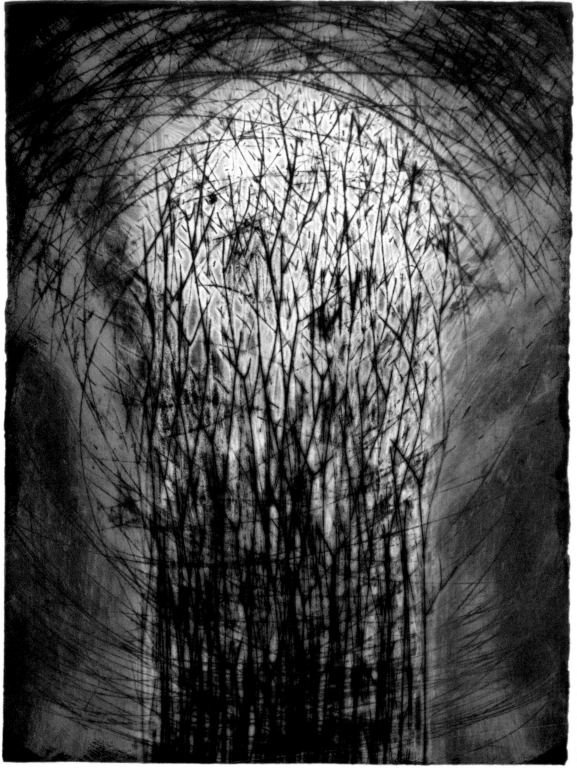

(Left) Micro Lens Technology's lenticular help page is filled with information about the lenticular printing process. (Right) Photo Illusion's web site is another excellent resource for information about lenticular printing.

TIP 258 Create the lenticular image and use software to "interlace" the images.

To create lenticular images, the source images should be brought into image editing software such as Adobe Photoshop. A series of variations on the image should then be saved as separate files. Each of these variations becomes a "frame" in the finished lenticular print. All files should be the same dimensions and resolution.

The images created are then interlaced together in linear strips using a software program that matches the lenticular lens. The lens is a piece of plastic, with a series of parallel lenses, or *lenticules*, embossed into one surface. Lenses are sold in many different sizes, and the material is designed for specific viewing distances, and either 3D or flip-type lenticular imaging.

TIP 259 Print the image on glossy paper and carefully align to the lens.

Inkjet-compatible glossy paper or glossy white film is available from a number of companies and is recommended because images look crisp and sharp when printed on it. In the case of the white film, the material does not tend to shrink or expand much after printing, which can help to achieve precise alignment. After the interlaced image is printed, it is aligned with the lens as precisely as possible, so that the viewer sees only one frame at a time. As the viewer moves by the image (or as the image moves), all of the frames are seen in sequence, creating the illusion of movement, depth, animation, morphing, or three-dimensional space.

Artist: Karin Schminke; **Image title**: *Transition*; **Print Size**: 30 × 22 inches; **Paper**: Arches Cover Black; **Printer Name**: Epson Stylus Pro 9600; **Ink Used**: Epson UltraChrome K2; **Driver:** Standard Epson Driver (Mac OSX); **About the image**: Image was created from drawings and prints which were scanned and compiled in Photoshop.

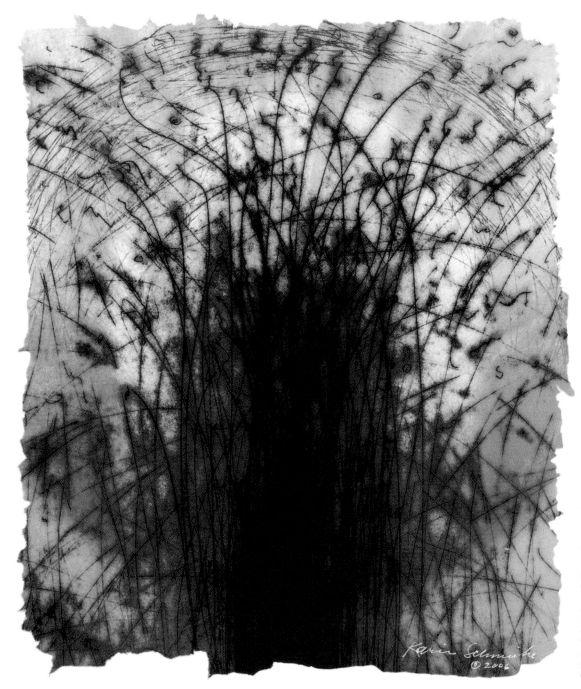

Printing on Uncoated Papers Using inkAID Coatings

By Karin Schminke

Sometimes an artist finds a beautiful paper in her studio or at an art store that would be a perfect substrate to print on using an inkjet printer. Often, printing on these "found" papers results in an image with dull color and poor detail. Commercially prepared inkjet papers have a special coating to hold the ink out on the surface (or very close to the surface) of the paper to keep it from soaking in. To achieve better detail and density on uncoated papers, a precoat made by inkAID (also described earlier in this chapter for use with non-porous materials) can be manually applied.

TIP 260 Look for interesting surface textures.

Some of my favorite papers to coat are handmade papers because they have beautiful irregularities in the surface. You can find handmade papers in art and craft stores such as Michael's (L15.38) or Pearl Art & Craft Supply (L15.39).

TIP 261 Use papers that work well with the inkAID precoat.

Papers often warp when the surface is wetted by the precoat, so thicker papers (about 300gsm and heavier) are better candidates for precoating with inkAID. Test a section first before coating a whole sheet.

TIP 262 Apply inkAID carefully and consider "pizza wheels."

To assure complete coverage when coating papers with inkAID, brush on two coats with a sponge brush, overlapping each stroke slightly. Apply your first coat vertically, let the paper dry approximately 12 hours, and then apply the next one horizontally.

On the topic of "pizza wheels," the same basic information applies with paper as it does with non-porous surfaces (described in Tip 235). Using inkAID White Matte Precoat on printers with wheels will usually eliminate the creation of any visible tracks, and Clear inkAID on paper will often work well if you don't apply it too thickly. Test a paper/precoat combination by precoating a small strip across the area of a

Artist: Karin Schminke; Image title: *Useless Bay at Daybreak*; Print Size: 10 × 12 inches; Paper: Artist's handmade paper; Printer Name: HP Photosmart Pro B9180; Ink Used: HP Vivera; Driver: Standard HP Driver; Info: Image created from drawings and prints which were scanned and compiled in Photoshop.

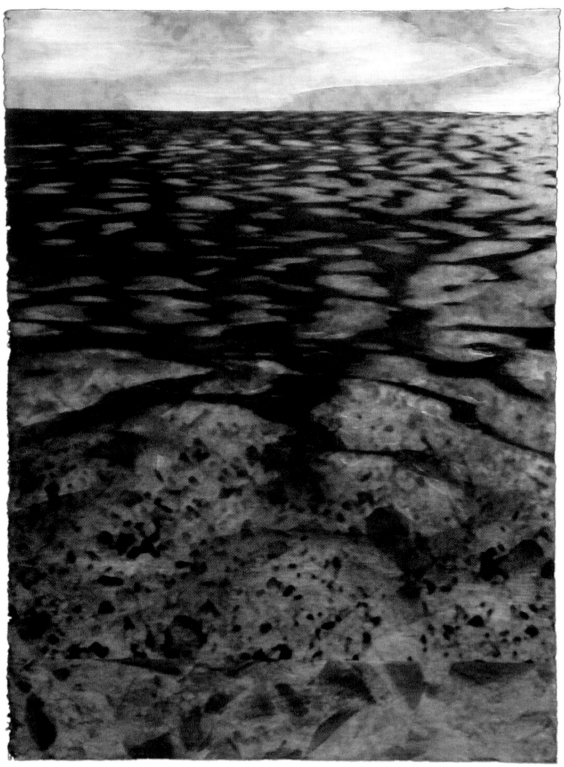

sheet of paper where the wheels will make contact, and then print on it to determine if you see wheel marks or smearing.

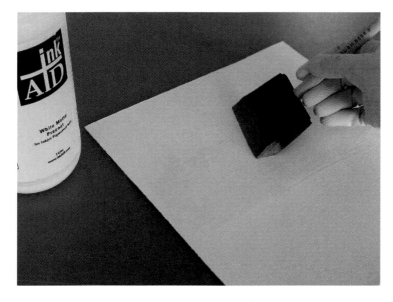

Applying the first coat of the inkAID White Matte Precoat onto a sheet of heavy art paper.
Photo © Karin Schminke

TIP 263 Apply inkAID in a more random way for different results.

For prints on papers that have color or pronounced texture, you may want a bit of the paper to show through. You can spread the inkAID in two uneven coats for a more nuanced surface (see photo below).

Detail photo of white inkAID after brushing it unevenly on black paper.
Photo © Karin Schminke

Artist: Karin Schminke; **Image title:** *Epiphany*; **Print Size:** 10×15 inches; **Paper:** Artist's handmade paper; **Printer Name:** HP Photosmart Pro B9180; **Ink Used:** HP Vivera; **Driver:** Standard HP Driver; **Info:** Image created from drawings and prints which were scanned and compiled in Photoshop.

TIP 264 Flatten papers after coating to avoid printhead strikes on the print.

As soon as the inkAID precoat has dried enough not to run, hang it by one corner or edge to help eliminate warping. I add a masking tape tab to the back edge of the paper to facilitate hanging prints so they don't get damaged. When dry, press the paper flat under a large board for 8–16 hours. If the paper does not flatten completely, roll the paper up in a loose cylinder for about ten minutes just before printing, keeping the precoated side out.

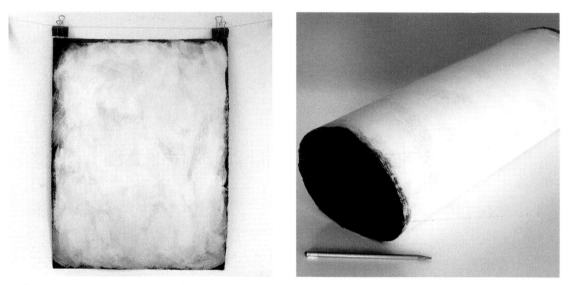

(Left) Precoated paper hanging to dry from binder clips. (Right) Precoated paper rolled in a loose cylinder to smooth out remaining wrinkles.
Photos © Karin Schminke

TIP 265 Iron your paper if the curl is severe.

Some smaller papers may be ironed flat with a standard iron. If you do decide to iron your paper, experiment with different heat settings and protect the paper with a thin cloth while ironing.

TIP 266 Trick your printer into seeing the black paper.

Using dark papers, especially black, can be problematic when trying to load them into some printers that look for the paper to reflect light in order to load. You may need to paint the back side of the paper white, or attach a thin sheet of white paper on the back to get it to load.

How to Print Over Deckled Edges

By Karin Schminke

Some watercolor and handmade papers have beautiful irregular edges (deckled edges), formed by the frame used in production. To integrate these into finished art, you can print over these edges and display them without a mat when framed. The technique shown here will show you how to artificially extend the size of your paper to achieve this effect.

TIP 267 Prepare your paper for printing and do a test.

Precoat your deckled-edge paper with inkAID, then dry and flatten the paper using the techniques described in the previous series of tips. Make a test print first on a smaller piece of precoated paper and record your print settings so that your final print will look the way you want it to.

TIP 268 Prepare your carrier sheet.

Cut a piece of glossy photo paper about one inch larger in both width and length than your paper with deckled edges. This will be your carrier sheet. Remember that the thickness of the carrier sheet plus the deckled paper must be within the allowed paper thickness that can feed through your printer. For carrier sheets up to 13 inches wide, a printer like the HP Photosmart Pro B9180, which can take thicker papers and which has a flat paper feed, works great for this technique.

TIP 269 Prepare your image and carrier sheet for printing.

Make your digital image file about one inch larger in both width and length than your deckled edge paper. For example, if your deckled edge paper is 10 × 12 inches, make your digital file 11 × 13 inches. In this case, a 13 × 15-inch sheet of glossy paper will work well as a carrier sheet because it allows a proper amount of space all around.

TIP 270 Mark the carrier sheet to help in positioning your deckled paper.

In Photoshop, create a black-edged box the same size as the image file that you are going to print onto the deckled paper (11 × 13 inches based on the example in Tip 269). Also, before loading the paper to print the black-edged box, mark the edge that will go into the printer first. Then print the black-edged box onto the center of the paper, and after printing the box, position your deckled paper centered within the square on the carrier sheet and trace the edge with a pen that will not smear.

Marking the glossy carrier sheet by tracing the edge with a pen. Notice the printed box just outside the traced area. Also notice that the carrier paper is about an inch larger on all sides compared with the deckled paper.
Photo © Karin Schminke

TIP 271 Attach your paper to the carrier sheet.

Apply double stick tape to the carrier sheet just inside the traced edge. I usually use 3M Scotch Double Stick Tape (L15.40) for this task. Position the deckled paper over your traced edge and press just enough to lightly adhere it to the carrier. If your paper is very fragile, you may want to "detack" the tape a bit by rubbing it with a cloth or your fingers. The idea is to hold your paper firmly in place during printing but release it later without destroying it!

TIP 272 Print using the same settings as your tests.

Feed the edge of the carrier sheet you marked in Tip 270 into the printer first. Also, use the same page setup and margin settings you used to print the black-edged box in Tip 270, and the same color settings as your test in Tip 267.

Loading the paper attached to the carrier sheet into the HP Photosmart Pro B9180's manual feed tray.
Photo © Karin Schminke

TIP 273 Remove print from the carrier sheet and display!

After the print feels dry to the touch, turn it face down on a table and peel the carrier sheet away from the print. These prints tend to look best displayed hinged to a mat in a frame with spacers. This allows the print to breathe, and shows off the look of the deckled edges.

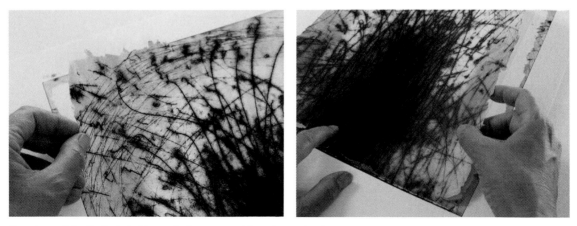

Two views of the final printed image being removed from the carrier sheet.
Photos © Karin Schminke

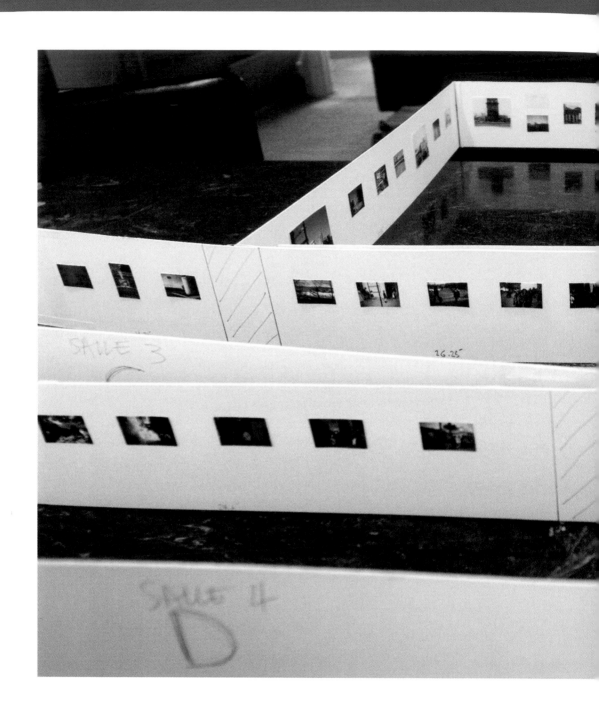

Photo of scale model © Andrew Darlow

Scale model of the exhibition: *Joel Meyerowitz, Out of the Ordinary, Photographies 1970-1980*, Jeu de Paume, Paris, France. All photographs displayed on the walls of the scale model © Joel Meyerowitz, All Rights Reserved. Courtesy Edwynn Houk Gallery, New York.

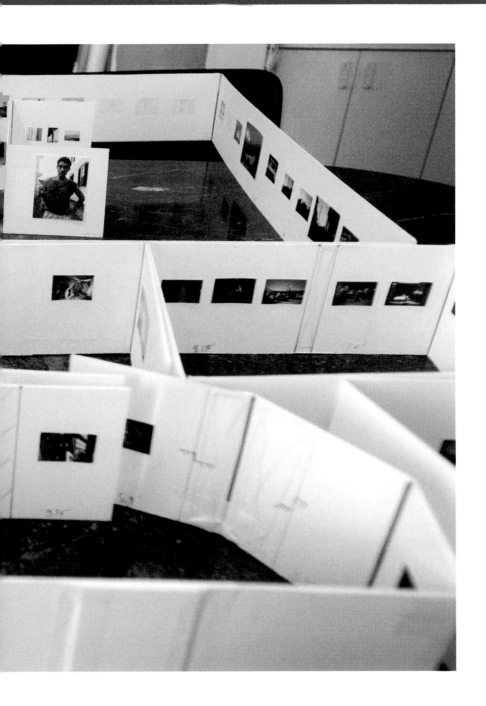

Additional Tips and Print Permanence

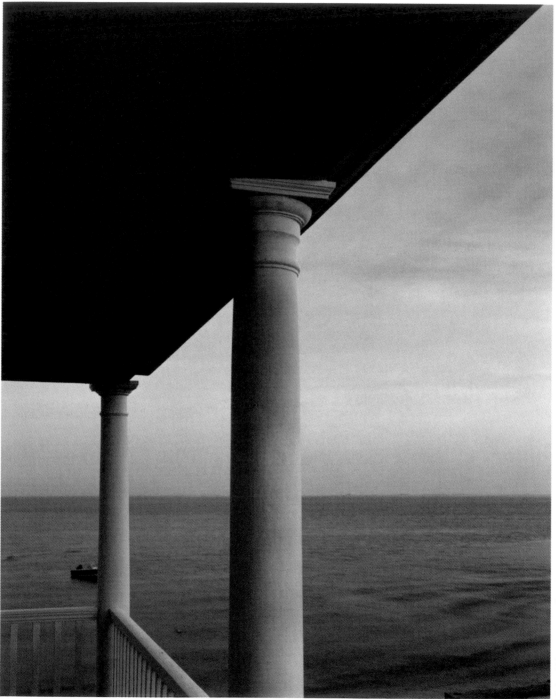

Creating an Exhibition Scale Model

By Joel Meyerowitz

Whether you have an upcoming gallery exhibition of 100 prints, or are planning to add a collection of framed pieces to the walls of your home, office or studio, a scale model can be an excellent tool for both planning and visualization. These tips cover the steps we took to prepare a basic but very functional scale model for an exhibition of over 115 images at the Jeu de Paume, Paris, France (L16.1).

Joel Meyerowitz is an award-winning photographer whose work has appeared in over 350 exhibitions in museums and galleries around the world. He is a "street photographer" in the tradition of Henri Cartier-Bresson and Robert Frank, although he works exclusively in color. Meyerowitz is a Guggenheim fellow and a recipient of both the NEA and NEH awards. In 1998 he produced and directed his first film, *POP*, an intimate diary of a three-week road trip he made with his son and his father. He is the author of 14 other books, including *Bystander: The History of Street Photography* and *Tuscany: Inside the Light*. In 2006 Phaidon Press published over 400 of Meyerowitz's World Trade Center Archive photographs and over 100 stories in a monumental book entitled *Aftermath: World Trade Center Archive*. For more information, visit www.joelmeyerowitz.com.

I'd like to thank my studio staff, including Jon Smith, Ember Rilleau and Rob Stephenson, for their contributions to the projects and tips described here.

TIP 274 Obtain a floor plan or measure the space.

The first step in producing an exhibition scale model is to obtain accurate floor plans or measure the location. Ceiling heights are also important to know, especially if you have large framed prints to hang. Since the gallery was located in France and we were in New York, we requested floor plans for all the areas where images would be displayed. In addition to getting room dimensions, we made sure that we knew where all the doors were, and where work could not be hung. We then scanned the floor plans and later added the numbers, each of which represents an individual print.

To find the web links noted in the book (L16.1, etc.), visit www.inkjettips.com or http://www.courseptr.com/ptr_downloads.cfm.

Artist: Joel Meyerowitz; **Image title:** *Porch Series, Provincetown 1977*; **Print Size:** 8×10 inches; **Print Type:** Vintage C-print; **Camera:** Deardorff 8×10 Field Camera; **Film:** Kodak Vericolor II Type L (8×10 inch negative); **Lens:** 10-inch Wide Field Ektar; **F-stop:** f/45; **Exposure:** 1 sec.

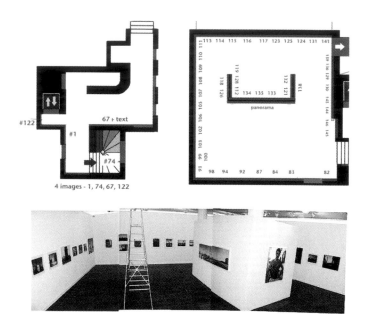

(Top) Two of the supplied floor plans from the Jeu de Paume. On the right is the 35×35-foot "Grand Salle," the largest of the four main exhibition rooms. (Bottom) A composite photograph showing the Grand Salle prior to the opening of the exhibition. Floor plans courtesy Jeu de Paume, Paris, France. Composite photo © Harald Johnson

TIP 275 Determine the scale of your model.

To ensure that the actual walls of a gallery will correlate properly to your model, it's important to choose an appropriate scale. For the Jeu de Paume model, we decided to use 1 inch=2 feet (a 1:24 scale). Most of the prints were 20 × 24 inches (though one was 120 × 30 inches), so this scale allowed us to produce a model that was small enough to fit on an average sized table, but large enough to allow for the placement of detailed thumbnail prints, which we used for planning and visualization.

TIP 276 Print the images for the scale model.

By printing your images at the same scale as your model, you can place the thumbnail prints on the walls, knowing that they will appear similar to the way they will look in the actual space. Be sure to consider the size of any matting and framing when making scaled down prints. To prep and output the prints, we split them into groups based on their sizes, then batch resized each group separately to the size that they would be printed. We then made a contact sheet in Photoshop and printed them at the appropriate sizes for the scale model.

Most of the scaled down prints were output on an HP Designjet 130 24-inch-wide printer (L16.2) on HP Premium Plus Satin Photo Paper (L16.3). This paper worked well because it is heavyweight and does not easily tear, which allowed us to move prints around the scale model's walls multiple times, using double stick tape to affix them, and without damaging the prints. It's a good idea to number each thumbnail print on the front and/or back, and add the numbers to a floor plan. In our case, each print was represented by a number in red, as you can see in the floor plan images in Tip 274.

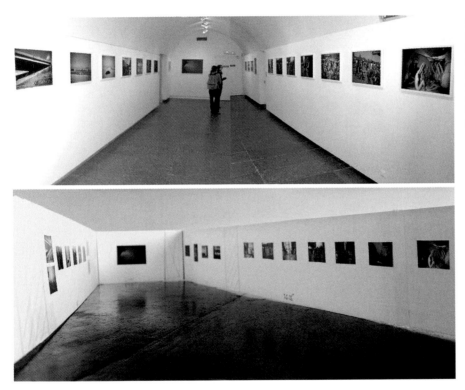

(Above) A composite photo of one of the show's exhibition rooms. (Below) A photo of the scale model, shot from a similar vantage point. Photos © Joel Meyerowitz.

TIP 277 Make the scale model.

There are many materials that can be used to create the walls of your scale model. We had multiple rooms and a number of different areas on which to hang work, so we opted to build our scale model in separate sections, and made them in a way that allowed them to be easily folded. The board we chose was 8-ply Rising Museum Board (L16.4), due to its strength, weight and ability to be folded. Most of the scale

model rooms had four walls, which were made from four cut pieces of board, connected on the edges by 1/2-inch-wide white artist's tape. Depending upon the room, tape was applied to only two or three of the corners where the boards met, which made them easy to fold up. We indicated on the side of the walls what the actual dimensions were of the room, and we also marked out the areas where doors were located.

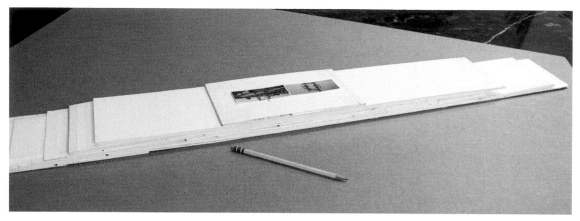

The entire exhibition scale model folded down into a very manageable stack.
Photo © Andrew Darlow

TIP 278 Hang the work, using the scale model or detailed floor plan.

The scale model can be helpful on location when hanging work, but we decided not to bring ours to Paris with us. Instead, we relied upon the original floor plan, with numbers added to represent each print (as shown in Tip 274). On the back of every framed or mounted print was the corresponding number, which worked out perfectly. Only a few images were adjusted from the original plan after we arrived in Paris to hang the show. Because of the way we planned for the exhibition with the scale model, the production and installation of the entire show went very smoothly, and we plan to follow the same procedure for many upcoming exhibitions.

Creating a Digital Composite

By Joel Meyerowitz

One of the fastest and easiest ways to help determine what your work might look like on the walls of a gallery, home, office or other space is to combine photographs of a space with your image files to produce digital composites. Composites can help you to get approval for exhibitions, they can be sent to prospective collectors who want to know what your work might look like in their homes or offices, and they can also serve as portfolio pieces. You can digitally place your work in many different settings, from living rooms to the sides of large buildings. We've used this technique successfully on a number of projects, and the following tips cover a few specific examples.

TIP 279 Start with good quality photographs from a few angles.

Whether you take the photographs yourself, or whether you ask someone else to take them, a tripod is recommended, and whenever possible, you should take photos from various angles. In 35mm terms, a 20mm lens is generally a good choice for most spaces. For scale, I also recommend adding people to the frame. It's preferable to have people in the photographs during the photo shoot, though in some cases, we've had to add them afterward. Think cinematically, and include an overview photo, plus a few close-ups of various sections of the space, especially if your framed work is not very large.

TIP 280 Determine scale by replacing existing art.

One of the easiest ways to accurately place your images onto an existing photograph is to replace art that is already on the walls. By measuring the art on the walls, you can then determine how much of the wall your prints will cover. If the walls are empty, consider taping up a piece of paper or foam board to the wall, cut to the same size as your framed pieces. If that's not possible, you can use the floor to ceiling height of the space, or a window as a reference for sizing.

When you need to add art to a wall that is shot from an angle, one approach is to hang a series of empty frames or foam boards across the surface of the wall, replacing them later with digital versions of your images. If you're unable to do that, Photoshop CS2 and CS3 have a tool called Vanishing Point (L16.5) that allows you to clone, paint and transform image objects while retaining visual perspective. With the

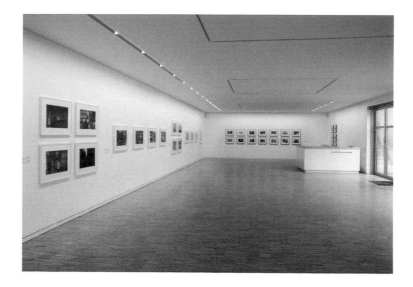

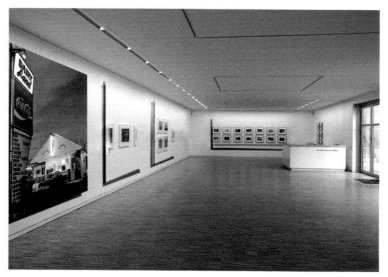

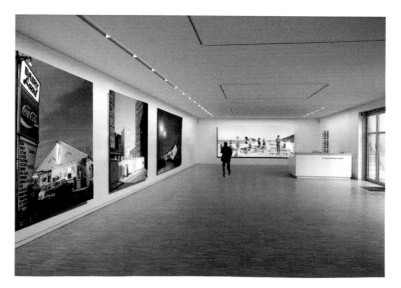

tool, you can make additional copies of a frame on a wall (or one you've created yourself) while keeping them in proportion. Photoshop's Free Transform tool (L16.6) also does a good job when you want to adjust images manually.

TIP 281 Look at existing lighting to create shadows and reflections.

Most galleries will have spotlights illuminating work. This will usually create shadows along the bottom of artwork, and the effect should be created when producing a composite so that the overall image looks natural. Depending upon the depth of the artwork, you can also add shadows to the sides of the work. To create the digital composite images in the full-page, three image example on page 448), we used Photoshop's Free Transform tool to size and adjust the images (the tool can be used to distort the image in many ways), and we gave the mounted pieces depth with shadows created in Photoshop.

For the images that accompany this tip, Photoshop was used in a similar way. But in addition to adding the photos to the walls, a reflection of the print along the back wall was added by first placing a copy of the image on its own layer. That copy was then rotated 180 degrees and sized with Photoshop's Free Transform tool. The image was then flipped horizontally, its opacity was reduced, and a soft brush was used to feather the edges to make it look natural. Also note how the person in the photo adds scale.

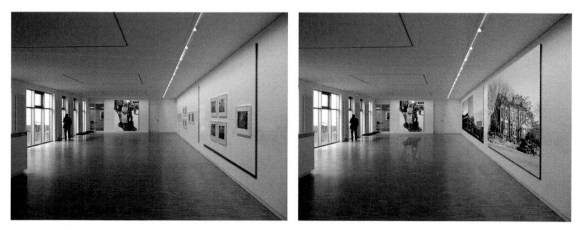

(Left) From this supplied photograph, taken inside Galerie Thomas Zander, one of Joel Meyerowitz' images was added using Photoshop (the large photograph along the back wall). A very subtle reflection was also added to the floor in front of the large photograph. (Right) Large images have replaced the smaller framed prints from the original photograph, and a stronger reflection was added to the image on the back wall.
Photographs courtesy Galerie Thomas Zander, Cologne, Germany. All color photographs displayed in the digital composites © Joel Meyerowitz.

(Top) Photograph of Galerie Thomas Zander prior to any digital compositing. (Center) The gallery with one of Joel Meyerowitz's images added. (Bottom) The gallery with four of Joel Meyerowitz's images and a person added for scale. Original photograph courtesy Galerie Thomas Zander, Cologne, Germany. All color photographs displayed in the digital composites © Joel Meyerowitz.

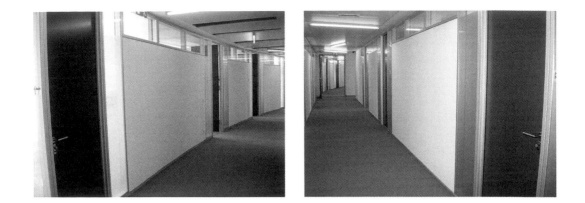

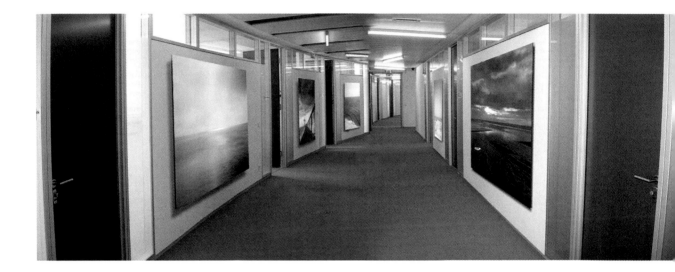

Creating a Magnetic Wall for Print Viewing

By Joel Meyerowitz

After making prints, it's very helpful to be able to put them up on a wall for inspection quickly, and in a way that will not damage them. For the last few years we have been using a custom-made metal wall and magnets to hold our prints for viewing. These tips discuss how you can create your own magnetic wall and how you can find the right magnets to use with it. Also available for purchase is magnetic paint (L16.7), which can be used on materials such as wood. It can even be coated with acrylic paint after applying, but we have not tested its effectiveness.

TIP 282 Find appropriate sheet metal.

The size and type of metal you choose will determine its strength, as well as the number of prints that can be placed on it. We purchased two sheets of metal, each 4 × 6 feet in size, from a steel mill. They are approximately 1/16 inch (16 gauge) thick, and either a sheet-metal fabricator or home improvement store would be good places to get more information or to purchase sheet metal. It's also a good idea to bring some magnets and prints to test the metal before you make a purchase.

TIP 283 Affix the metal to a wall.

It is important to securely attach the metal to a wall. We used sheet metal screws and attached both sheets side by side to a wall, which gives us an 8 × 6 foot area on which to attach prints. Another approach is to frame a piece of sheet metal and hang it like a print. Just be sure to firmly secure the frame to your wall.

TIP 284 Cover the metal with paper or paint.

In order to make the wall appear seamless, and to also make it more attractive, it's a good idea to cover the wall with paper. We use 9-foot-wide light gray seamless background paper (L16.8) and have not had to change it, even after a few years of use. If you are having an exhibition and know the color of the walls on which your work will

(Top) Photographs of a corporate office prior to any digital compositing. (Center) A composite of the two photos above, with Joel Meyerowitz's images digitally added. (Bottom) Before and after photos with images dropped into a different area of the same corporate office. All color photographs displayed in the digital composites © Joel Meyerowitz.

451

hang, you can test what it will look like by attaching a piece of similar color paper to the magnetic wall, followed by your print. Sheet metal can also be painted, but it's best to get professional advice before painting any metal surface.

A section of a paper-covered metal wall in Joel Meyerowitz' studio, with an inkjet print being held up by four magnets.
Photo © Andrew Darlow
Photograph on wall © Joel Meyerowitz

TIP 285 Use good quality magnets.

Not all magnets are created equal, and it's important to find magnets that hold your work without damaging it. We like magnets that have handles, such as the ones shown in the photos that follow. We've found the large magnets (L16.9) to be very strong, but they can create small kinks in prints when used on our metal wall. Our current favorite magnets for just about any size print are called Fridge Super Magnets (L16.10). Another advantage of using a magnetic wall is that multiple prints can be stacked on top of one another without causing damage to the prints.

Artist: Joel Meyerowitz; **Image title**: *Eli, Provincetown 1981*; **Print Size**: 40×50 inches (for exhibition); **Paper**: HP Premium Instant-dry Satin; **Printer Name**: HP Designjet Z3100; **Ink Used**: HP Vivera (Pigment); **Driver**: Standard HP Driver (Mac OSX); **Camera**: Deardorff 8×10 Field Camera; **Film**: Kodak Vericolor II Type L (8×10 inch negative); **Lens**: 10-inch Wide Field Ektar; **F-stop**: f/45; **Exposure**: 1/2 sec.

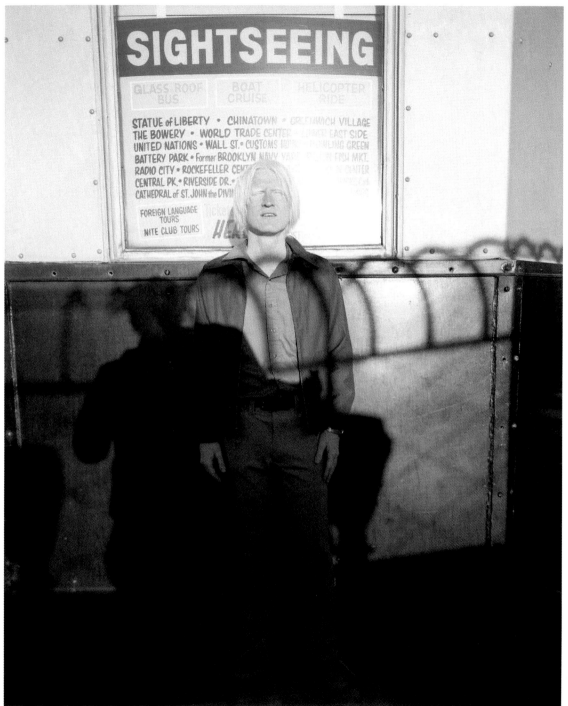

The following text appears within the image on the sightseeing poster:

SIGHTSEEING

GLASS ROOF BUS | BOAT CRUISE | HELICOPTER RIDE

STATUE of LIBERTY • CHINATOWN • GREENWICH VILLAGE
THE BOWERY • WORLD TRADE CENTER • LOWER EAST SIDE
UNITED NATIONS • WALL ST. • CUSTOMS HOUSE • BOWLING GREEN
BATTERY PARK • Former BROOKLYN NAVY YARD • FULTON FISH MKT.
RADIO CITY • ROCKEFELLER CENTER
CENTRAL PK. • RIVERSIDE DR.
CATHEDRAL of ST. JOHN the DIVINE

FOREIGN LANGUAGE TOURS
NITE CLUB TOURS

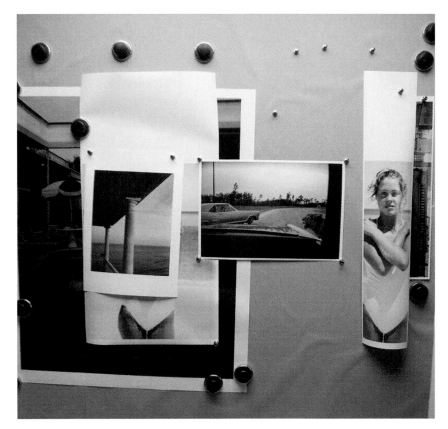

A section of the metal wall with assorted test prints and two types of magnets.

(Left) A close-up of the two types of magnets used on the wall. (Right) A single Fridge Super Magnet.
Photos © Andrew Darlow
All photographs displayed on wall © Joel Meyerowitz

Artist: Joel Meyerowitz; **Image title**: *Tommy, Albino man, Empire State Building*; **Print Size**: 20×24 inches (for exhibition); **Paper**: HP Premium Instant-dry Satin; **Printer Name**: HP Designjet Z3100; **Ink Used**: HP Vivera (Pigment); **Driver**: Standard HP Driver (Mac OSX); **Camera**: Deardorff 8×10 Field Camera; **Film**: Kodak Vericolor II Type L (8×10 inch negative); **Lens**: 10-inch Wide Field Ektar; **F-stop**: f/16; **Exposure**: 1/30 sec.

Windows Printing and the Epson Stylus Photo R1800

By Raphael Bustin

The Epson Stylus Photo R1800 is my sixth Epson printer since 1998, but the first one I've owned that's designed for use with pigment inks. The gamut and Dmax of the printer's UltraChrome Hi-Gloss inkset has really impressed me, particularly on Epson Premium Glossy Photo Paper (now called Premium Photo Paper Glossy). I have yet to see bronzing, gloss-differential, or a significant color shift when moving the prints between different light sources when using the Stylus Photo R1800 on Premium Glossy Photo Paper (with the gloss optimizer option on). Following are a few tips for printing on Windows XP with the Stylus Photo R1800; these tips can be applied to many other inkjet printers from Epson or other manufacturers.

Raphael Bustin has been toting cameras since his early teens. An engineer by trade, he never lost interest in photography over the years, and he always has at least one camera with him when he travels. His landscape and nature works have been included in numerous books and other publications, including *Cape Ann: A Photographic Portrait*, and *The White Mountains: A Photographic Portrait* (both published by Twin Lights Publishers, Rockport, Maine). Bustin has exhibited his inkjet prints in art shows and other venues in the New England region, and he offers his prints for sale through his online gallery. For more information, visit www.terrapinphoto.com.

TIP 286 Download driver and add profiles.

After downloading and installing the most recent printer driver from the Epson web site, a small set of ICC output profiles for various ink and paper conditions will appear in the Windows XP system folder. Here's the specific location: C:\WINDOWS\system32\spool\drivers\color. A more complete and current set of profiles can be found and downloaded from Epson's web site (L16.11). I haven't yet attempted to build my own profiles for the R1800 because I've been quite satisfied with the Epson-supplied profiles (at least for the papers I use most), which are Premium Glossy Photo Paper and Enhanced Matte.

Artist: Raphael Bustin; **Image title**: *Coffin Beach Sunset*; **Print Sizes**: 5×8 to 13×19 inches; **Paper**: Epson Premium Glossy Photo Paper; **Printer Name**: Epson Stylus Color R1800; **Ink Used**: UltraChrome Hi-Gloss (Pigment); **Driver:** Standard Epson Driver (Windows XP); **Camera**: Ricoh KR-5 (35mm); **Film**: Fuji Reala; **Lens**: 50mm (manual focus); **F-stop**: unrecorded; **Exposure**: unrecorded

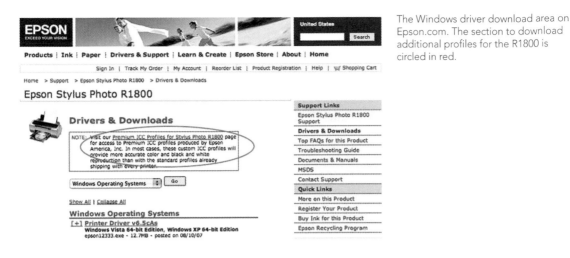

The Windows driver download area on Epson.com. The section to download additional profiles for the R1800 is circled in red.

TIP 287 Soft proof, make any adjustments, and print.

Using Epson's profile for Premium Glossy Photo Paper, I have found Photoshop's "Proof Colors" view under File>View>Proof Setup on my calibrated and profiled monitor to be extremely accurate for the vast majority of my images. In the *Coffin Beach Sunset* image (page 456), the soft-proofed view (with Perceptual Intent), shows no detectible color shift when it is soft proofed. If it did, I might tweak the file using an Adjustment Layer before printing. The Gamut Warning view (View>Gamut Warning) also showed no significant issues.

Printing using the supplied paper profile is done according to the instructions from the Epson R1800 User Guide (L16.12). In Photoshop's File>Print with Preview dialog box (File>Print in Photoshop CS3), I "Let Photoshop Determine Colors," and select the same profile and rendering intent as I used for the Proof view. Then, in the printer driver, I make the following adjustments before printing:

- Paper type: Premium Glossy Photo Paper.
- Quality: Photo RPM (5760 × 1440 DPI).
- Paper Size: Letter.
- High Speed: Off (unchecked).
- Gloss: On, Auto (this tells the printer to use the gloss optimizer only on the image area).

Artist: Raphael Bustin; **Image title**: *Carlyle Snow Trees*; **Print Sizes**: 5×8 to 13×19 inches; **Paper**: Epson Premium Glossy Photo Paper; **Printer Name**: Epson Stylus Color R1800; **Ink Used**: UltraChrome Hi-Gloss (Pigment); **Driver**: Standard Epson Driver (Windows XP); **Camera**: Shen-Hao 4×5; **Film**: Kodak Portra 160; **Lens**: Nikkor SW 90 f/8; **F-stop**: unrecorded; **Exposure**: unrecorded

- Color Adjustment: ICM, Off (No Color Adjustment). This allows the printer driver to work without applying any color profile at the printer driver level. Because Photoshop was already set to make the conversion under its File>Print with Preview dialog box, it's important to keep ICM off.

I then recommend saving your printer driver settings by clicking on Save Setting and giving the combination of settings a name that reflects the printer, paper and DPI that you are using. You can then quickly access that saved setting from the same location, which can save time and reduce the chances for error.

Photoshop's Proof Setup dialog box, with the Stylus Photo R1800 Premium Glossy profile chosen under the Profile drop-down menu. You can toggle soft proofing on and off to see the effect that the profile has on the image by using the shortcut Ctrl + Y (Windows) or Cmd + Y (Mac).

The Windows XP driver options for the R1800 printer with the Save Setting option circled in red.

460

Printing on CDs and DVDs

By David Emerick

Every year new printers are released that support CD or DVD printing on com-patible media. Printing directly on CDs and DVDs can make your discs look nearly as good as those made by music and movie companies, and in my opin-ion, direct printing is a far better option compared with printing on labels and stick-ing them to the top of discs. It's easier for me to get professional-looking results that way, and I prefer to not have adhesives in contact with my discs. Labels also add thickness to discs that can result in problems on some computers. My primary experi-ence with printing on CDs and DVDs has been with the Epson Stylus Photo R800 (L16.13), an 8.5-inch-wide pigment-based printer, but much of the advice offered here can be applied to other brands and models of printers, including the 13-inch-wide Epson Stylus Photo R1800, which uses the same inkset as the R800.

David Emerick is a Digital Media Specialist with St. Mary's College of Maryland. He previously taught pho-tography at St. Mary's and was the Galley Director for the Boyden Gallery. Before coming to St. Mary's, he received an MFA from the University of Nebraska and a BFA from the University of Kentucky. He was the Executive Director of the Washington Center for Photography and has taught at the Corcoran School of Art, the Smithsonian Institution, and Northern Virginia Community College. His work is widely collected and has been widely exhibited. For more information, visit www.emerick.blogspot.com.

TIP 288 Choose appropriate CDs/DVDs.

There are hundreds of brands of inkjet printable CDs and DVDs, but some are better made than others. I've had success with the following brands of printable media: MAM-A (Mitsui, [L16.14]), Sony (L16.15), Taiyo-Yuden (L16.16), and Primera Tuff Coat (manufactured by Taiyo-Yuden, [L16.17]). All have good longevity ratings, good coat-ings, and a high success rating when burning data to the discs. Some printable CDs and DVDs are more water-resistant than others. One product I've tested and found to be far more water- and scratch-resistant compared with most other discs are the AquaGuard CD-Rs from Imation (L16.18). A lot of good information about CD and DVD media quality can be found at DigitalFAQ (L16.19), and information on the care and handling of media is available from the U.S. Commerce Department (L16.20).

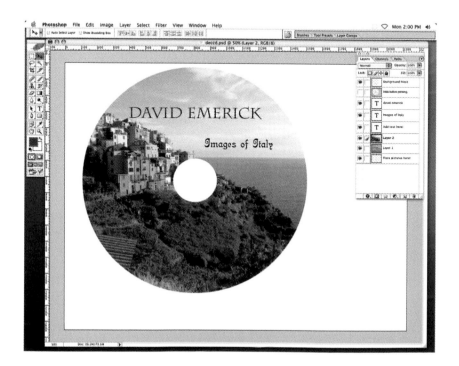

TIP 289 Set up your file for printing.

There are many software programs available for printing on CDs and DVDs (L16.21). I initially tested the Epson Print CD software that shipped with the printer, but I wanted additional control over the look of my CDs (especially the text), so I searched the Epson web site and found a template for a different printer, as well as developer guidelines for their CD/DVD capable printers. I then created a new template based on those files, which can be downloaded from this book's companion web site (L16.22).

To use the template, which is compatible with the Epson Stylus Photo R800 and a number of other Epson printers capable of printing on CDs/DVDs, open it in Photoshop, drop in your art and/or text in the "Place pictures here" and "Add text here" layers (or on separate layers as shown on the facing page), and print directly from the application as if you were printing on a letter-sized sheet of paper (8.5 × 11 inches). The template has a "Background Mask" that is enlarged by an eighth of an inch, so the image will print slightly larger than the disc. The template can also be adjusted for use with printable center or clear center discs. The one I created was made for discs with printable centers.

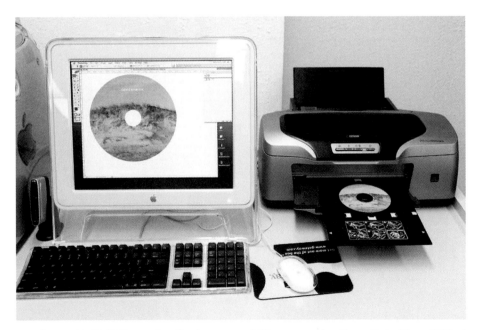

David Emerick's CD/DVD template file shown on an LCD screen, and an Epson Stylus Photo R800 printer with a printable CD shown in its holder after printing.
Photo © David Emerick

Artist: David Emerick; Image title: *CD Portfolio*; Print Size: 4×4 inches; CD: Primera Tuff Coat;
Printer Name: Epson Stylus Photo R800; Ink Used: UltraChrome Hi-Gloss (Pigment); Driver: Standard
Epson Driver (Mac OSX); Camera: Sony Cyber-shot DSC-F828; Lens: Built-in Carl Zeiss 28-200mm;
F-stop: f/5.6; Exposure: 1/250 sec.

TIP 290 Print using the correct driver option.

Before printing, check the printer manufacturer's web site for the latest drivers and instructions, and be sure that you install ALL the driver options in Mac OSX–manual feed, roll paper, etc. (the Windows printer driver will have them all installed when you install the driver). Then choose the manual feed driver setting when printing on CD/DVD's—no other driver will work. Before printing, be sure to hide the gray layer named "Hide before printing." There is no need to flatten your file before printing, and for best results, I generally choose the highest quality printing option.

TIP 291 Load the holder consistently.

The carriage that holds the CD/DVD will have about 1/16 inch of space on the left or right when loading it into the printer, so I recommend keeping the holder against one edge or the other every time you use it. You can mark it to be sure. As mentioned in the previous tip, I overprint the outside of the disc slightly to make sure the ink covers the entire disc. This means the holder needs to be cleaned of residual ink after each print.

TIP 292 Try different media settings.

I have tried using different settings for the paper type (including matte settings), but haven't seen a big difference in the quality of my discs. I recommend testing a small calibration file (L16.23) so that you can see which profile and paper settings work best for your discs. A curves or levels adjustment layer can then be created to improve color and density. Custom profiles can also be made by first printing color targets on a CD/DVD and then reading the color patches off of the disc with a spectrophotometer or spectrocolorimeter (L16.24).

The Epson R800 print driver, with the CD/DVD Premium Surface Media Type and the highest quality printing option selected (Best Photo).

Artist: David Emerick; Image title: (top) *Fire* (bottom) *Signs*; Print Size: 44×20 inches; Paper: Epson Premium Glossy Photo Paper; Printer Name: Epson Stylus Pro 9600; Ink Used: Epson UltraChrome K3; Driver: Standard Epson Driver (Mac OSX); Camera: Sony Cyber-shot DSC-F828; Lens: Built-in Carl Zeiss 28-200mm

Better Printmaking

By R. Mac Holbert

R. Mac Holbert is the co-founder of Nash Editions, widely regarded as the world's first digital printmaking atelier. For more than 15 years, Nash Editions has had an international reputation for fine art photographic digital output. Holbert has lectured extensively and has conducted workshops on digital output, digital imaging/scanning, and fine art printing. He and Graham Nash are the recipients of numerous awards, including the 2007 DIMA Lifetime Achievement Award. In August 2005, Nash Editions was honored by having their original IRIS printer included in the permanent collection of the National Museum of American History at the Smithsonian Institution in their *History of American Photography Collection*. For more information, visit www.nasheditions.com.

TIP 293 Adopt a non-destructive workflow.

The first step of a non-destructive workflow is to back up your data. Then, I recommend making a duplicate copy of your working file. Next, I will often do editing that I never want to revisit (like basic dusting and cleanup) on the Background layer in Photoshop. This eliminates the immediate doubling of file size that occurs when you duplicate the Background layer in the Layers palette. Any and all further changes are made with Adjustment Layers, composites, or additional copies of the Background. This way, any and all alterations can be tweaked to increase or reduce the intended effect. A non-destructive workflow allows for straightforward corrections of any of the changes made to your image. Without such a workflow, one risks creating changes that could ultimately degrade the quality of the final output.

TIP 294 Watch your image alignment.

Image alignment is an often overlooked aspect of proper image making. I've printed many an image over the years where the client inadvertently left the horizon off kilter or ignored the proper orientation of a key visual element in the image. While this effect may be purposeful in some instances, it is subtly disconcerting to the viewer. In most cases, when I point out the problem, the attitude is, "Well, if you think it's important. It doesn't really bother me." However, when I correct it, most are amazed at the effect it has on the final image. Minor misalignment of key elements can create visual "static" for the viewer. Correct them when appropriate, and you will create a more palatable visual impression.

Artist: R. Mac Holbert; **Image title**: *SideWalk Fireplace*; **Print Size**: 13×19 inches; **Paper**: Epson UltraSmooth Fine Art; **Printer Name**: Epson Stylus Pro 3800; **Ink Used**: Epson UltraChrome K3; **Driver**: Standard Epson Driver (Mac OSX); **Camera**: Canon EOS D60; **Lens**: EF Canon 24-85mm f/3.5-4.5; **F-stop**: f/5; **Exposure**: 1/125 sec.

TIP 295 Enhance mid-tone contrast.

Insufficient mid-tone contrast is a common output problem. While most who use Photoshop and other image editors are aware of setting a proper black and white point, many overlook mid-tone contrast. I tried many different approaches to increase mid-tone contrast and finally created my own using bits and pieces from existing techniques. The effect is very subtle but powerful. By creating separation in the mid-tones, one can compensate for the flatness introduced by matte papers as well as create an increased sense of dimension in the image itself. I've created an action that does the following steps for you (with any necessary updates for Photoshop CS3), and it can be downloaded from this link: (L16.25).

1. Highlight the top layer in your Layers palette.

2a. In Photoshop CS: Select Layer>New>Layer to create a new, blank layer at the top of your Layer Stack. Then, holding down your Opt Key (Mac) / Alt Key (PC), select Merge Visible from the drop-down menu on the right side of your Layers palette. Be sure to keep Opt/Alt depressed until you see the blank layer update. You should now have an additional layer at the top of your layer stack. It represents how the image would appear if you had flattened your layers. Rename this layer "Midtone Contrast."

2b. In Photoshop CS2 or CS3, make sure you have at least two layers in your image. If not, follow the instructions in 2a. Holding down your Opt Key (Mac) / Alt Key (PC), select Merge Visible from the drop-down menu on the right side of your Layers palette. Be sure to keep Opt / Alt depressed until you see the blank layer update. You should now have an additional layer at the top of your layer stack. It represents how the image would appear if you had flattened your layers. Rename this layer "Midtone Contrast."

3. Next, double-click on the Midtone Contrast layer icon to bring up the Layer Style palette (see screen shot on page 471). Change the Blend Mode to Overlay and lower the Blend Mode Opacity to 20%. Now move the left This Layer slider to 70 and split away the left side of that slider by holding down the Opt / Alt key and moving it to 50. Repeat the same process on the right This Layer slider, moving the sliders to 185 and 205, respectively. Then select OK.

Artist: R. Mac Holbert; **Image title**: *Don't Walk*; **Print Size**: 13×19 inches; **Paper**: Epson UltraSmooth Fine Art; **Printer Name**: Epson Stylus Pro 3800; **Ink Used:** Epson UltraChrome K3**; Driver:** Standard Epson Driver (Mac OSX); **Camera:** Canon EOS D60; **Lens**: EF Canon 24-85mm f/3.5-4.5; **F-stop**: f/9.5; **Exposure:** 1/250 sec.

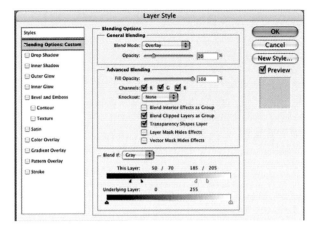

The Layer Style palette after making the adjustments described in Step 3.

4. Now select Filter>Other>High Pass. In the High Pass palette, set the radius to 50 and select OK. Now select Image>Adjustments>Desaturate. The Midtone Contrast layer is now complete. At 20% opacity, it should be very subtle but noticeable. The effect can be decreased or increased by raising or lowering the Midtone Contrast Layer opacity. I've found that the proper setting can usually be found between 20% and 40% opacity. Above 40% one risks creating "halo" artifacts that are visually distracting.

TIP 296 Sharpen properly.

Sharpening is an image-dependent, substrate-dependent, resolution-dependent process. Output sharpening should be performed on a separate layer, properly labeled to reflect the substrate and the output size for which it is intended, and as a last step prior to output. Never sharpen your Background layer, as this will preclude optimal sharpening for alternate sizes.

TIP 297 Use the Notes tool in Photoshop.

The Notes tool is easy to use and can be found in the Photoshop two-column toolbar just above the Hand tool (two rows above the Hand tool in Photoshop CS3's single column toolbar). With the Notes tool selected, click anywhere on your image, and it will create an electronic "yellow sticky note" on your image. You can then type any pertinent information onto the note, and once you save your image, it will remain attached until you decide to edit or delete it. The note will not print. It can also be collapsed into a smaller icon by clicking on the small box in the top-left corner of the

Artist: R. Mac Holbert; **Image title**: *Self Portrait-Strand*; **Print Size**: 13×19 inches; **Paper**: Epson UltraSmooth Fine Art; **Printer Name**: Epson Stylus Pro 3800; **Ink Used:** Epson UltraChrome K3; **Driver:** Standard Epson Driver (Mac OSX); **Camera**: Canon EOS 20D; **Lens**: Canon EF 24-85mm f/3.5-4.5; **F-stop**: f/5.6; **Exposure**: 1/60 sec.

note. The smaller icon can then be moved anywhere on your image. I usually place it in the upper-left corner of my images.

Double clicking on the note icon in the image will open the note and allow you to edit it. To delete the note permanently, hold down the Ctrl Key (Mac) and click on the note's icon, or right-click on the note's icon (Mac or Windows). A Contextual Menu will drop down and allow you to perform several functions, including deleting the note. Multiple notes can be placed in a document, and notes can be moved around your document by clicking and dragging them. With proper annotations, you'll never open a print file and find yourself wondering exactly how you printed the image.

One of R. Mac Holbert's images with the Notes tool open, and with some print-related data recorded.
Image © R. Mac Holbert

TIP 298 Annotate your printed proofs and files.

Keeping track of pertinent data relating to the output of your image can save you time and money. Having a proof without the information on how you created it can mean additional unnecessary paper, ink, and time. To prevent this from happening, I suggest that you not only physically annotate each physical proof, but I also recommend that you annotate the file itself using either the Notes tool or by making screen captures of the print dialog boxes and pasting them as separate layers into your image. You can then select those layers and choose New Group from Layers from the drop-down menu on the right side of your Layers palette. They can then be turned on for reference or turned off for printing or imaging. Keeping proper records will end up saving you time and money and ensure the visual continuity of your output.

Doing Your Own Print Permanence Testing

By Harald Johnson

P rint permanence is an important topic for serious photographers and artists. In addition to studying the permanence ratings from manufacturers or research organizations, you can do your own tests. There are many different ways to test the expected permanence of your own prints, but the goal is usually the same: to accelerate the influencing factors that can damage a print over time so you can pick the right combination of inks and paper that are best for you. A relative comparison using the same printer and inks, but varying the paper choices, is a popular way to test. Following are some tips for setting up your own "testing lab." Many factors, including light, UV rays, environmental pollutants, temperature, and humidity can affect any print, so keep them in mind as you are doing your testing. To learn more about longevity permanence testing and to read about estimated longevity print permanence ratings for many different printer, paper and ink combinations, visit www.wilhelm-research.com and www.aardenburg-imaging.com. Other resources are also listed on this book's companion site: (L16.26).

Harald Johnson has been immersed in the world of commercial and fine art imaging and printing for more than 30 years. A former professional photographer, designer, and creative director, Harald is an imaging consultant, the creator of the web site DP&I.com (www.dpandi.com), and the author of the groundbreaking books, *Mastering Digital Printing: The Photographer's and Artist's Guide to High-Quality Digital Output* (2003), *Mastering Digital Printing, Second Edition* (2005), and *Digital Printing Start-Up Guide* (2005). Harald is also the founder of Yahoo!Group's *digital-fineart*, the world's largest online discussion group on the subject of digital fine art and digital printing.

TIP 299 Organize your equipment and choose an image.

Organize your printer, paper, and ink options, plus items like scissors and aluminum foil. Make careful notes of everything you do. For the test image, you can use either a photograph or other working image, or you can use a standard test image file. You can find links to a few test images here: (L16.27). You can also make your own custom test image as I did (shown on page 475).

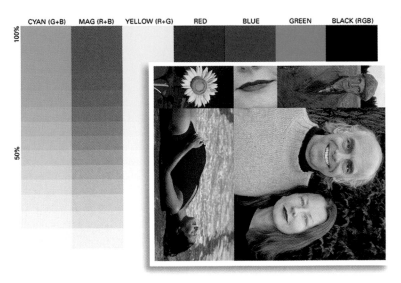

Portions of two different custom images used as test "targets" by Harald Johnson. One is a mix of primary colors in graduated densities, and the other includes personal images and stock images. *Test target images courtesy Harald Johnson.*

TIP 300 Set up the test conditions, print your samples, and begin the test.

The setups on page 477 show a simple lightfastness "window test" and a lightfastness test using artificial light. For the latter, you can test under tungsten or fluorescent lights by building a light-testing apparatus—the fluorescent light and fixture shown in this tip were inexpensive, costing less than $50 (L16.28). When you print your sample prints, output them at the same size and at the same time. After letting them dry for up to 24 hours, place them in your test environment, either storing a duplicate set in a dark drawer or cabinet in the same room, or simply covering half of the prints with aluminum tape or foil. You may also want to place your prints in sealed bags, or behind glass or acrylic, to test them under different conditions. Label your prints carefully. For a more scientific approach, use a code system by writing letters such as A, B, C on the prints, instead of writing the actual printer and paper data on the prints. You can then make visual observations about the prints, or you can use a spectrophotometer to measure color values before, during and after the test. I recommend keeping a log to track changes over time.

Artist: Harald Johnson; **Image title**: *Pool 1*; **Print Sizes**: 7×5 to 24×18 inches; **Printer Name**: HP Photosmart Pro B9180 (Vivera Pigment); HP Photosmart 8750 (Vivera Dye); and HP Designjet 130nr (Vivera Dye); **Driver:** Standard HP Driver (Mac OSX); **Camera**: Nikonos II underwater camera with built-in 35mm lens; **Film**: Fujichrome Velvia 100; **F-stop & Exposure**: unrecorded

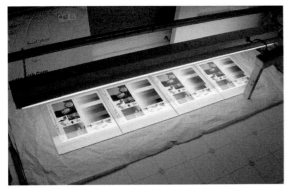

A simple fluorescent light-testing setup with multiple copies of the same image, printed on multiple papers and with multiple printers. The print samples shown are covered with standard window glass to reduce airflow over print surfaces, thereby eliminating one of the print-fading variables. Photo © Harald Johnson.

A natural light "window test," with multiple copies of the same image, printed on multiple papers and with multiple inks and printers. The aluminum foil protects the print from virtually all light exposure from the front, but does not protect from heat and other environmental factors. The inset photo shows the difference between a covered and uncovered section of a print after nine months of window exposure. The print was made on a printer with dye-based inks on a poorly matched paper. Different types of papers (especially when printed with certain dye-based inksets) will often show very different levels of fading over time. Photo © Harald Johnson

TIP 301 Make your evaluations over time, and complete the test.

After a certain amount of time or print deterioration, evaluate your exposed print samples. You can simply do this by eye, or you can do before-and-after measurements with colorimetric devices such as spectrophotometers or spectrocolorimeters. You can also use Blue Wool References or "Blue Scale Textile Fading Cards" from Talas (L16.29) or another supplier as *dosimeters* to time the length of your test. When done, compare the exposed prints among themselves, or compare them to the stored control prints (or do a combination of both). For a full explanation of my results from some of the tests I've done, I created a dedicated Print Permanence page on www.dpandi.com (L16.30).

Artist: Harald Johnson; **Image title**: *Pink Bow Looks at Art*; **Print Sizes**: 10×8 to 40×30 inches; **Printer Name**: HP Designjet Z3100 (Vivera Pigment); **Driver:** Standard HP Driver (Mac OSX); **Camera**: HP Photosmart R707 compact digital camera; **F-stop & Exposure**: unrecorded

"Alphabet Soup" and Standard Cut Paper Sizes

One potentially confusing part of inkjet printing (or virtually any project that includes paper), relates to paper sizes. The following chart is included as a reference to help make some of the most common standard cut paper sizes more understandable when you are purchasing paper or when you hear or read the sizes used online or in conversations. The Metric system for weights and measures is used by most of the world, but the United States and Canada commonly use a different group of standard page size names, and both are listed separately.

The chart can be helpful when using the Page Setup dialog box (or Page Size drop-down menu) in many applications because the choices will often state the paper size name, but will not display the equivalent size in inches or millimeters. The chart can also be helpful when setting the page size on some printer LCD displays that require it. A very good overview of paper sizes can be found by searching for "paper size" on www.wikipedia.org.

Standard Paper Sizes

U.S. Name	U.S. Size	Metric Equivalent (rounded to nearest mm)
ANSI A (letter)	8.5 × 11 inches	216 × 279 mm
Legal	8.5 × 14 inches	216 × 356 mm
ANSI B (ledger/tabloid)	11 × 17 inches	279 × 432 mm
Super B/Super A3	13 × 19 inches	330 × 483 mm
ANSI C	17 × 22 inches	432 × 559 mm
ARCH C	18 × 24 inches	457 × 610 mm
ANSI D	22 × 34 inches	559 × 864 mm
ARCH D	24 × 36 inches	610 × 914 mm
ANSI E	34 × 44 inches	864 × 1118 mm
ARCH E	36 × 48 inches	914 × 1219 mm

Metric Name	Metric Size	U.S. Equivalent (rounded to nearest 1/10 in.)
A5	148 × 210 mm	5.8 × 8.3 inches
A4	210 × 297 mm	8.3 × 11.7 inches
A3	297 × 420 mm	11.7 × 16.5 inches
A3+	329 × 483 mm	13 × 19 inches
A2	420 × 594 mm	16.5 × 23.4 inches
A1	594 × 841 mm	23.4 × 33.1 inches
A0	841 × 1189 mm	33.1 × 46.8 inches

Paper Size Chart courtesy Harald Johnson (adapted from the original chart at www.dpandi.com/paper/index.html)

Index

C

M